MORE ADVANCE PRAISE FOR
DESTRUCTION WAS MY BEATRICE

"An informative, lively, and entertaining narrative of Dada, a veritable biography of an enormously influential art movement on the 100th anniversary of its birth."

—**Francis M. Naumann, curator and author of**
The Recurrent, Haunting Ghost: Essays on the Art,
Life and Legacy of Marcel Duchamp

"A readable narrative that rejoices in the spirit of Dada's fleeting existence, never alighting on the precast definitions that have often shackled previous explanations. Rasula brings the Dadaists to life in vivid accounts of their interactions, aspirations, mishaps, and triumphs."

—**Timothy O. Benson, Curator, Robert Gore Rifkind**
Center for German Expressionist Studies,
Los Angeles County Museum of Art

DESTRUCTION WAS MY BEATRICE

DADA AND THE UNMAKING

OF THE TWENTIETH CENTURY

JED RASULA

BASIC BOOKS

A Member of the Perseus Books Group

New York

Published by Basic Books,
A Member of the Perseus Books Group

Books published by Basic Books are available at special discounts
for bulk purchases in the United States by corporations, institutions,
and other organizations. For more information, please contact the Special
Markets Department at the Perseus Books Group, 2300 Chestnut Street,
Suite 200, Philadelphia, PA 19103, or call (800) 810-4145, ext. 5000,
or e-mail special.markets@perseusbooks.com.

Designed by Cynthia Young

Library of Congress Cataloging-in-Publication Data
Rasula, Jed.
Destruction was my Beatrice :
Dada and the unmaking of the twentieth century / Jed Rasula.
pages cm
Includes bibliographical references and index.
ISBN 978-0-465-08996-3 (hardback)—
ISBN 978-0-465-06694-0 (e-book)
1. Dadaism. I. Title.
NX456.5.D3R37 2015
700'.41162—dc23
2015004226
10 9 8 7 6 5 4 3 2 1

TO JERRY ROTHENBERG, PIERRE JORIS,
AND ALL MY FELLOW TRAVELERS IN DADA

CONTENTS

INTRODUCTION

Zurich in February is deep into winter. The street has a dusting of fresh snow on accumulated layers that crunch underfoot; cheeks and noses of pedestrians glow in the mountain cold. In the old bohemian district, a block from the river that feeds into the lake from the north, the door opens at number 1 Spiegelgasse (Mirror Street: what a name), emitting a dense cloud of tobacco smoke. The year is 1916, and the place is Cabaret Voltaire.

The space is crammed with tables, which are full to bursting; there's barely seating for fifty, and the performance platform's a tight squeeze. The walls—painted black, under a blue ceiling—leer with grotesque masks and artworks by Pablo Picasso, Amedeo Modigliani, and August Macke.

A slightly pockmarked, emaciated man plays honky-tonk piano to set the mood. After crooning a tender ballad, a slender, faintly wasted-looking ingenue abruptly lurches into a ribald number. Then, with the demeanor of a madonna, she does the splits. A few others join her for a vaudeville skit, followed by a recitation from Goethe, Germany's Shakespeare and Ben Franklin rolled into one. A short young fellow with a monocle delivers a Maori tribal spell ("Ka tangi te tivi / kivi / Ka tangi te moho"), spinning and wiggling like a belly dancer. A pianist and cellist indulge in a heartfelt lyrical movement from a forty-year-old Saint-Saëns sonata. Then three of the performers pair up, knocking out a poem for three voices in three languages (French, German, English), babbling simultaneously. Students from Rudolf Laban's nearby academy of modern dance stomp out an Expressionist number. A menacing, sneering figure glares at the audience as he snarls and roars

his way through one of his "Fantastic Prayers," while pounding a big bass drum and swishing a riding whip. The gaunt pianist, back at the keyboard, launches into a Hungarian Fantasy by Franz Liszt.

It's a variety show, after all, and the audience gets bits and pieces of what they'd expect in the usual venues. But here it's different—very different. There is a palpable fever in the air at Cabaret Voltaire—an electric sensation that persists for the five months the cabaret is open. And by the time it closes down, this primordial environment has borne an offspring.

They call it Dada. Who named it will remain permanently in dispute. An entry in Hugo Ball's diary indicates only that he had discussed the word with Tristan Tzara on or before April 18, 1916. All that's certain is that the word emerged by chance from a French dictionary. In French it can mean "hobbyhorse" and "nursemaid." Researching the word, the cabaret's artists are delighted to find *dada* also means the tail of a sacred cow for an African tribe, and in certain regions of Italy it indicates a cube and a mother. For the Rumanian artists who congregated at the cabaret, it was a word they said to each other all the time in conversation: *da, da,* meaning "yes, yes." A perfect word, they decided, for a mood coming over them. But what does it mean?

"Of making many books there is no end," the book of Ecclesiastes observes. The same could be said of definitions of Dada, the most revolutionary artistic movement of the twentieth century. "Dada is daring per se." "Self-kleptomania is the normal human condition: that's Dada." "Dada is the essence of our time." "Dada reduces everything to an initial simplicity." These are among the characterizations of Dada by Dadaists themselves. But because Dada arose in defiance of definitions—ridiculing complacency and certitude—the cascade of definitions it has spawned should be taken with a grain of salt. Those grains accrue, becoming heaps, of which it could be said, there is no end.

"The true dadas are against DADA," observed one of the cabaret's Rumanian founders, Tzara. But he said it in a manifesto, and the avant-garde manifesto tends to be a farrago of provocation and nonsense, into which adroit explications and gems of wisdom are sprinkled. How do you come to grips with such a thing, parsing seriousness from buffoonery? Richard Huelsenbeck, a German medical student and another early Dadaist, trumped any straightforward answer by ending one Dada manifesto: "To

be against this manifesto is to be a Dadaist!" And Tzara himself cheekily said (in a manifesto, no less): "In principle I am against manifestos, as I am against principles."

Dada resounds with contradictions. Its artistic productions were pledged to anti-art. Wily in its hoaxes, it could nonetheless be resolutely moral. It was often understood to be an expression of the times, a characteristic outburst of the moment. Yet the Dadaists gladly acknowledged the existence of "Dada before Dada," something as old as Buddhism, something attuned to what German philosopher Mynona called "creative indifference." This propensity to balance opposites, to be at ease with contradiction, led one of its proponents to call Dada "elasticity itself." The affinities with Buddhism have at times drawn attention to a presumed negativity at the heart of Dada, which some Dadaists encouraged. But Dada's *no* comes with a question mark, as does the affirmative: *yes* and *no* as parts of speech, not signs for stop and go.

The unsettling conundrum at the heart of Dada negation is that saying no is still saying *something*. The negative adds to a positive sum. In a Dada skit performed in Paris in 1920, the French writer André Breton would reveal a blackboard with an insult composed by his friend, French painter and poet Francis Picabia; then, as soon as the audience got it, he'd erase the text. This performance captures the Dada strategy of giving and revoking in a single gesture.

Instead of a definition, a more appropriate summation of Dada might be an image by French artist Georges Hugnet, 1932: "Dada, a scarecrow erected at the crossroads of the epoch." This book tells the story of how that scarecrow came to be: how a nonsense word *dada* was hatched in neutral Switzerland amid the calamitous Great War a century ago, spreading across Europe and eventually around the globe like a "virgin microbe"—as Tzara memorably called it. The story is a tangle of vivid personalities intersecting at cross-purposes and in momentary alliances, variously taking up the Dada label. For some, Dada was a mission; for others, it was no more than a convenient tool or weapon for advancing their own artistic ends. One of Dada's early wielders, Hannah Höch, neatly summed up her compatriots' attitude: "We were a very naughty group."

Dada emerged from particular historical circumstances, but each time it migrated, it adapted to different local situations, scrambling genealogy. Its

adaptability made it hard to pin down, but also made it effective as a weapon and a strategy. It amounted to a sort of cultural guerrilla warfare, breaking out in the midst of a catastrophic *official* war, the officiousness and obtuseness of which galvanized the soon-to-be Dadaists in the first place, agitating their emphatic *no* with an equally emphatic *yes*. As this yes-no took on the charge of an alternating current, it proved to be ungovernable, thwarting every effort by its patrons and its inventors to channel it into a predictable outcome. In the end, most Dadaists were happy to affirm Dada's unpredictability, thankful to have gotten the full current, however it hit them and for as long as it did.

The story of Dada doesn't conform to the usual narrative arc. There's a beginning, sure enough, in Zurich, but there was a prolonged episode in New York around the same time, historically commemorated as Dada even though its participants didn't learn of Dada till later. There's also an apparent *end* of Dada in Paris, but that didn't deter others from mounting a Dada tour of Holland. There were even Dada start-ups as far afield as Eastern Europe and Japan after its ignominious collapse in France. It was a "dancing epidemic," said Huelsenbeck, with "simultaneous and spontaneous beginnings in different parts of the world." Rather than cut back and forth in a strictly chronological account, then, the following chapters focus on key locales and personalities, some returning from time to time as they moved on, carrying the spark of Dada with them.

The half-dozen participants in Dada's birth at Cabaret Voltaire found themselves caught up in a creative whirlwind exceeding anything they'd experienced before—and they would carry this seething energy with them for the rest of their lives. "Dada came over the Dadaists without their knowing it; it was an immaculate conception," observed Huelsenbeck. After the cabaret closed, these progenitors ran a Dada art gallery for a few months, started a publishing program, and sponsored a few uproarious public events—but the true action would commence when they left Zurich, spreading Dada around the globe.

Huelsenbeck returned to Berlin from Zurich in 1918, while the war was still raging. So deluded was the German high command that they were still predicting victory just weeks before the Allies prevailed. When they did, the German nation collapsed, undergoing the fraught transition to parliamentary democracy in the Weimar Republic.

As revolution broke in Berlin and elsewhere, a resurgent Dada hit its stride. Although still in the hands of artists, it became a medium for political agitation. The maverick touch of Dada contributed to the general bewilderment and squalor in Berlin, openly challenging all values, all assumptions of cultural norms. In that combustible milieu, Dada briefly seemed as if it were a contender in the public sphere of politics, like Communism.

Unlike complacent Zurich in neutral Switzerland, Berlin at the end of the war was a cauldron of political strife. In Berlin, Dada was less artistic in outlook, more confrontational and anarchic. Upon his return to Berlin, Huelsenbeck started up a local chapter of Dada, calling it a club, and a number of his recruits spearheaded incendiary public events and publications. Several of the key participants—George Grosz, Wieland Herzfelde, and John Heartfield—joined the German Communist Party as soon as it was formed. Others in Club Dada, like Huelsenbeck himself and Raoul Hausmann, were just as aggressive without claiming any political allegiance.

While Club Dada in Berlin was going strong, the German cities of Cologne and Hanover hosted Dada seasons of their own. In Cologne, recently demobilized soldier-artist Max Ernst discovered that his prewar friend Hans Arp was one of the conspirators behind Dada. Its creative agility, along with its insolence, provided just the ticket for Ernst, who leaped onto Dada like a hobo jumping a freight car. Before long he was part of the Dada scene in Paris. Dada in Hanover, on the other hand, was a solo affair. Kurt Schwitters wanted to join the Berlin group, but they thought him too provincial. No matter, he did his own thing and called it Merz. Thanks to his publisher's ad campaign, promoting it as a Dada work, a book of Schwitters' poems became a bestseller. So much for custodianship of the movement in Berlin!

In time, the Berliners Hausmann and Höch became fast friends of Schwitters, traveling with him to Prague on a tour called "Anti-Dada-Merz." Later, Schwitters made a similar tour of Holland with *De Stijl* editor Theo van Doesburg, another unofficial escapade that was invincibly Dada, unleashing in polite Dutch audiences the kind of mania Tzara relished.

Schwitters, van Doesburg, Hausmann, Höch, and Hans Richter (an artist and combat veteran) were among the Dadaists who joined forces with exponents of Constructivism in the early twenties. Constructivism, coming from the fledgling USSR, envisioned a new role for the arts by diverting artistic talent into social engineering. In the West this inspiring prospect was not the

same, since capitalist commerce had risen from the ashes of the late war with a vengeance. Still, with the aid of Dada's scorched earth instincts, Constructivism became defiantly utopian in venues like the new arts and industry school, the Bauhaus. This alliance gave a strikingly progressive face to Dada, which until then had been seen as a high-spirited malignancy, a clever ruse, or, in the best light, a salutary rebuke of the status quo.

When the convulsions in Germany died down, Dada itself had little work left to do. Or so it seemed. Actually it just moved elsewhere, like a gunslinger in the Wild West.

Nothing could be further from Berlin Dada than the escapades of a community of European exiles in New York during the war, a clutch of artists whose spirits (both alcoholic and temperamental) soared to rare heights of inventive fantasy. One of the exiles, Marcel Duchamp, took to designating everyday objects as artworks and even thought about signing the Woolworth Building. But it was his pseudonymous signature (R. Mutt) on a urinal that took the cake, persisting to the present as Dada's most recognizable product. Ironically, although Duchamp is perennially associated with Dada, he never called himself a Dadaist and would simply say he found it agreeable. But then he said that about everything—verification, perhaps, of Huelsenbeck's opening sentence in his 1920 *Dada Almanac*: "One has to be enough of a Dadaist to be able to adopt a Dadaist stance toward one's own Dadaism."

Meanwhile, back in Zurich, Tzara kept the torch burning, publishing the periodical *Dada* and fielding a vast international public relations operation on behalf of what he was calling the Dada movement. It gradually came to his attention that something similar had been afoot in New York, centered around two wartime European exiles, Duchamp and Picabia. What's more, their movement seemed to be spreading just like Tzara's; their presence in New York had created a force field into which the American-born Man Ray found his natural inclinations come to life, and he would follow his friends back to Paris after the war.

For Tzara, isolated in the Alps, correspondence was the means by which Dada persisted, and that was how he developed a rapturous rapport with Picabia and with Breton in Paris, both of whom would avidly take up the Dada cause. Breton was young, brash, and already aspiring to authoritarian leadership; Picabia was brilliant, original, and as self-indulgent as his considerable wealth enabled him to be. For many, he epitomized all the wit,

aggression, and devil-may-care spirit of Dada long before Dada was discovered. He seemed proof of its immortality. But he was capable of washing his hands of it when the time came: "I don't keep the butt after I've finished a cigarette," he said. When Tzara finally joined Picabia and Breton in Paris in 1920, Dada became official. But that unlikely combination proved fatal, and the "movement" soon collapsed.

Tzara's characterization of Dada as a virgin microbe is apt. Wherever it migrated, however briefly in some cases, it didn't necessarily need a cabaret, a club, or even a group to take hold; an individual could suffice. Dada took on a peculiar glow, as though it were a radioactive element emitting a hallucinatory pulsation. That's why there's little sense in making Dada out to be a unified enterprise, with a single collective focus. Its identity multiplied with its occasions and its participants. It is fitting, then, that lists of Dada presidents were regularly published: everyone who was known to have participated in any Dada activity was listed as president—with a few honorary ones thrown in for good measure, like Charlie Chaplin.

The story of Dada is, at its core, the story of those who embraced it, and others who found themselves singled out by Dada's spotlights and agreed to go along with it for a while. Definitions and characterizations will emerge in the narrative, in the heat of the moment, since that's how it happened. "Everyone has become mediumistic," the early Dadaist Hugo Ball observed of his initial cohort in Cabaret Voltaire. The founding Dadaists were indeed channeling something, like a medium in a séance, transmitting vitalities from beyond, with little personal initiative. That spooked Ball in the end. He quickly grew wary of whatever it was that Dada had unleashed and escaped, he felt, in the nick of time.

Dada "jes grew," in the felicitous expression in Ishmael Reed's novel *Mumbo Jumbo*, his subject being the growth of jazz. Like Dada, jazz made its first impact during the Great War and overflowed the banks afterward, making the twenties roar. For a while, many took jazz and Dada to be two faces of the same thing. The Dadaists encouraged the association, sometimes using jazz bands in their public performances. The early course of jazz was dominated by novelty and humor, and if the musicians heard about Dada, they probably would've agreed with Hoagy Carmichael that jazz was Dada's twin. Either way, blues singer Mamie Smith and Her Jazz Hounds had a hit record in

1922 called "That Dada Strain." For a Dada retrospective thirty years later, Duchamp included the 78 rpm disc in the display.

Dada was animated by the same spirit as jazz, but it was also a response to the most recent avant-garde activities in the arts: Italian Futurism, German Expressionism, and French Cubism. These were the latest currents being assimilated by the artists who found themselves in Zurich in 1916, like a birdcage surrounded by roaring lions as Hugo Ball put it. The cataclysm of the war weighed heavily on them all, corroding the assumption that civilization was progressive and beyond barbarity. Yet the original Dadaists found that the means of coping with this bitter truth were all around them. Expressionism and Cubism had benefited from the discovery of tribal artifacts from Africa, Oceania, and elsewhere. For the Dadaists at Cabaret Voltaire, this current of primitivism served a revitalizing role. If civilized man was bent on exterminating his fellows, it was better to regress, become "primitive."

The initial precondition for Dada was war, but Dada got a new lease on life in the state of unrest characteristic of *postwar*. After so catastrophic and prolonged a conflict, the legal fabrication of an armistice didn't return everything to normal overnight. Cologne, for example, was in occupied Rhineland. The presence of British military inspired a Dada splinter group to adopt the English name Stupid. In postwar Paris, as foreigners streamed back into the city of light, there were cries of a "return to order," which sounded to some like a resurgence of nationalist xenophobia. For the young writers who would soon cluster around Dada, this tendency was repugnant. It was a repudiation of everything that made Paris a beacon for advanced art regardless of where the artists came from.

As postwar unrest subsided across Europe, Dada changed with the times. Once it had been an agent of destruction, but Dada's alliance with Constructivism reflected its newfound role as creative agent. It was a partnership founded on a principle of international cooperation; Constructivism and Dada were adamantly international in outlook, so theirs was a natural alliance. Since its inception, Dada had recoiled at the malignancy behind nation and nationality, in which blind tribalism overtook reason and carnage followed in its wake.

Predictably, Dada's international alliances singled it out for persecution during the increasingly nationalistic 1930s. In Germany, as the political programs of the Third Reich began to be realized, Dada and Constructivism

were the first artistic movements to be stigmatized. The Nazis shut down the Constructivist-influenced Bauhaus as an objectionable haven for international modernism in 1932, and in 1937 they pilloried Dada and other isms in their infamous exhibition of "degenerate art."

After the prolonged conflagration of another World War and the toppling of the Third Reich, Dada's distant provocations began to be heard again, delayed like a sonic boom. Nascent groups around the world acknowledged a debt to Dada, from Gutai in Japan to Fluxus in New York and the Nouveaux Réalistes in Paris, and many more. John Cage and Jasper Johns, Joseph Beuys and Andy Warhol, prominent among legions of others, would take off in various directions unthinkable without the destructive fervor with which Dada cleared the ground. Without Dada we would have no mash-ups, no samplings, no photomontages, no happenings—not even Surrealism, or Pop art, or punk . . . Without Dada, modern life as we know it would look very, very different—in fact, barely even modern.

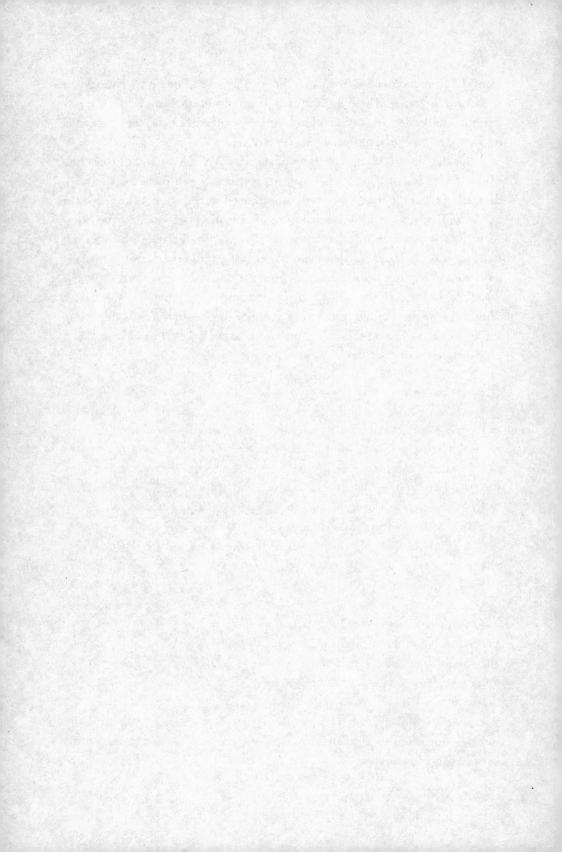

1

CABARET VOLTAIRE

Hugo Ball was one of those moony souls at the dawn of the twentieth century whose sensibility was ravaged by reading Nietzsche ("God is dead") and the anarchist philosophy of Bakunin ("the state is like a gigantic slaughterhouse"). He was consumed with the Wagnerian desire to reunite all the arts into some overwhelming theatrical extravaganza. But he was also handicapped by a sense of being out of step with his time. As he sadly confided to his diary, "I have difficulty in feigning a real existence to myself." Dealing with a sales clerk was a trial by fire: "My shy tone of voice and hesitant behavior have long since shown . . . that I am an 'artist,' an idealist, a creature of air."

Ethereal, creative, and introverted, Ball was at odds with the brutally mechanized combat ravaging Europe. A German citizen, he was twenty-eight when World War I erupted in August 1914, but poor health kept him from service, although he tried to enlist three times. Whatever shred of national allegiance he had evaporated when he visited the Belgian front a few months into the war, in November 1914. Soon he was joining antiwar protests, while his paramour Emmy Hennings was forging passports for draft resisters. She was caught and did some jail time, but this seems not to have dented her resolve—for when she and Ball finally fled Germany in May 1915, they did so with forged passports.

Arriving in Zurich, Switzerland, Ball became Willibald, and later Gèry, while receiving mail under his own name. This eventually got the attention of Swiss authorities, and Ball, too, spent some time behind bars until his proper identity was verified. He was allowed to remain in Zurich with Hennings, even though the police suspected Ball of being Hennings' pimp, a reputation that had followed them from Germany. In truth, the pair could hardly have been considered a couple in any conventional sense before they arrived in Zurich, considering the roll call of Hennings' lovers during the years in Munich and Berlin.

Ball and Hennings eked out a living in Zurich, barely scraping by as they slid lower on the social ladder. Although Zurich was a haven from Germany, things got so bad for the two that Ball may have attempted suicide in October, possibly by flinging himself into Lake Constance. Details are sketchy, but it seems that a policeman intervened, preventing Ball from going through with his plans.

As the cowed couple walked the streets of Zurich after Ball's act of desperation, they happened on a work opportunity with a variety show, the Maxim Ensemble, and joined up. "We've got contortionists, fire eaters, tightrope artists, all one could want," Ball wrote an old friend, mentioning that he also worked with a tattooed lady with butterfly wings on her buttocks; for a special fee, the butterfly would take flight in a private showing.

Despite Ball's scholastic temperament and spiritual yearning, the lean months in Zurich exposed him to society's lower dregs, working the midway with sword swallowers and geeks. Yet Ball stood out from this crowd, in it but not of it. He was a capable pianist, adaptable enough to play a berceuse by Chopin or belt out popular hits of the day, and such cultured talent put him at odds with his new surroundings.

The world of the demimonde was more familiar to Hennings, who'd been a chanteuse on every kind of stage, from fashionable showcases to dives—with more of the latter. She'd taken a lot of drugs and lived the kind of bohemian life that made her an easy target for charges of prostitution, and she had been arrested several times for petty crimes.

After a couple of months on the road with the touring variety show, immersed in a milieu of snake charmers and contortionists, the couple ended up back in Zurich, where Ball approached a retired Dutch seaman who owned a café in the bohemian district. Ball pitched his notion of turning the place into an artists' cabaret, and the intrigued owner consented.

It all came together rather quickly. Ball placed an ad in a local newspaper on February 2, 1916: "Young artists of Zurich, whatever their orientation, are invited to come along with suggestions and contributions of all kinds." There wasn't much time to plan anything, since opening night was only three days later.

At six in the evening on the day the cabaret opened—strategically, on a weekend, Saturday, February 5—as Ball was frantically hanging futuristic posters and hammering together a small stage, several Rumanians arrived, like magi bearing rolled-up artworks and manuscripts instead of frankincense and myrrh. One of these Rumanians was Marcel Janco, an artist and architectural student. Another was Tristan Tzara, a small and dapper teenager. A handsome and level-headed fellow, Janco immediately set to work hanging his art on the cabaret walls. Tzara won everyone's hearts that first evening by reading poems he fished out of various coat pockets—a precursor of poets today who try to make fumbling ineptitude look stylish. The poems were in his native tongue, which added to the charm and gave an international character to the occasion, even if only his fellow countrymen could follow them.

At first, the venue was advertised as Künstlerkneipe Voltaire, not a cabaret exactly but something between a saloon or pub and a student club—a beer joint, in other words. Since this venue was in the student quarter, the audience reliably contained some beer-swilling undergraduates out for kicks. Later Ball and Hennings, veterans of the sawdust circuit, began calling it a cabaret, which specified exactly what they had in mind: a little bit of everything, from highbrow to low, but always entertaining.

The ad Ball placed in the papers drew many other sorts, as well. A contingent of Russian balalaika players were there on opening night, a dozen or more of them crammed onto the tiny stage. Locals appeared, wanting to try out their modest little poems. It was like open mic today: then, as now, likely the moment someone started reading, everybody in the room tried to hide his or her embarrassment.

Because Ball and Hennings kicked off the enterprise with a wing and a prayer, they had to count on these serendipitous arrivals to fill up an evening. Luckily, a handful of artists appeared who instantly bonded, and before they knew it they had become a performance troupe.

Tzara and Janco were the first diamonds in the rough. Another was Hans Arp, an accomplished artist well connected in international circles. Less than

a week after the cabaret's opening, another gem arrived from Germany: an old pal of Ball's, poet and medical student Richard Huelsenbeck.

Huelsenbeck's arrival fortified the determination of Ball and the other participants to have their cabaret absorb some of the avant-garde spirit the Italian Futurists had initiated before the war. The previous May in Berlin, Ball and Huelsenbeck had organized an arts evening to show solidarity with F. T. Marinetti, leader of the Italian Futurists. Marinetti was the archetypal ringmaster of the avant-garde. Scion of a wealthy Italian family, raised in North Africa, he had been brazen enough to buy three and a half columns on the front page of the leading Paris newspaper *Le Figaro* in 1909 to announce his launch of Futurism. The piece opened with his jubilant recollections of a car wreck (he was one of the few in Europe who actually owned a car), segueing into an avowal of speed and danger and a testament to the purifying powers of war.

Imagine the idle *boulevardier* sipping his morning espresso and reading the paper, only to find this intemperate Italian declaring war "the world's only hygiene" and insisting that his Futurists were out to destroy the museums and libraries and wage combat on moralism, feminism, and "utilitarian cowardice." As for *art*, that bastion of French civilization, it was "nothing but violence, cruelty, and injustice."

Marinetti was firing the opening salvo in a culture war. His primary aim was to shake his fellow Italians out of the cultural complacency that had turned the country into little more than a tourist destination: Marinetti wanted factories, not picturesque ruins. The regressive bourgeois tendency to hanker after models from a moribund aristocratic past was too big a target. How could he miss?

Soon Marinetti was putting his money where his mouth was in every way possible, churning out incendiary broadsides ("Down with Parsifal and the Tango," "Let's Murder the Moonlight!"), publishing books, arranging art exhibitions, and even turning Futurism into a road show. Driving their cars through sleepy rural towns, honking horns and scattering flyers everywhere announcing an evening program, the Futurists would then set to work insulting the packed house every way they could, reading their manifestos, reciting poems that often consisted of little more than sound effects, performing incendiary skits, and brandishing their paintings like visual firecrackers.

They taunted and berated the onlookers, demanding outrage. And they got it—usually as a shower of fruits and vegetables pelting the stage.

Having declared the virtue of war, the Futurists didn't shrink from confrontation, and when the real war came, they were among the first to enlist. In fact, when Ball and Huelsenbeck put together their evening of support for Marinetti in Berlin, the Italian had been doing everything he could to get his country into the war—against the Germans. By then, Ball himself had turned against his homeland and was in touch with Marinetti. The poems he received from the Futurist leader astonished the expat German. Dynamically scattered across the page, these explosive provocations surpassed literature altogether: they were, as Ball called them, "poems you can roll up like a map." Marinetti had a lasting effect on the German poet: his deconstruction of language would become an increasing part of Ball's preoccupations during his involvement with the cabaret to purify, cleanse, and liberate language from the scourge of journalistic xenophobia and heedless nationalism.

Hugo Ball was a deeply conflicted individual, but he had a gift for embracing opposites. He would follow the manic nightlife in the cabaret with a kind of scholastic retreat, during which he worked on a book of political theory and a study of early Christianity. Ball's last years before his death in 1927 would be spent high in the Alps, living an impoverished but saintly life, as if to confirm a diary observation from November 1913: "The demonic no longer differentiates the dandy from the commonplace. You just have to become a saint if you want to differentiate yourself further." Dandy and saint were the poles he felt himself batted between like a shuttlecock. "I think in opposites," he realized. Active as he could be as dandy, or devoted as saint, the transit between them felt helpless. "I never bring all my forces into play," he once wrote, "I only dabble." He wanted to be a firebrand without forfeiting the monk.

Although nowhere near over, the Great War had already left deep scars on Ball's psyche. "The stamp of the times has been put on me," he wrote in August 1915, adding: "It did not happen without my help." While other artists washed their hands of warmongering, denouncing it as the tainted fruit of a militarism they wanted no part of, Ball felt vaguely culpable. When he reflected, "I tend to compare my own private experiences with the nation's," he was coming to the realization that he couldn't achieve any real self-appraisal

without dragging national identity into it. Such thoughts tend to arise during wartime. Any war will do it, force the discomforting equation: if my country is doing this, am "I" doing it too? If a war defines a German as one who kills a Frenchman, what does the German do with his love of Paris? Hugo Ball was never quite secure in his sense of self to know what it was he'd be defending. Where was a "self" amidst all his vacillations?

Since Ball, like so many other artists, flinched at the platitudes used to whip up martial fever, he felt that language itself was being poisoned. Wasn't it the writer's obligation to preserve and protect the language? That's what he thought, so "it is we, the poets and thinkers, who are to blame for this blood bath and who have to atone for it." Opening Cabaret Voltaire was the first step in his personal atonement, nothing less than a program of "self-help" as he called it, embarking on the venture with this formula: "Make your own existence the subject of energetic experiments in revival." The phrase *experiments in revival* sounds more like voodoo than lab work, and there was something about the cabaret that would fuse its core participants into a tribal unit. Their performances were ritualistic: they sought not applause but a constant upping of the ante by fellow members of the tribe. There would be an aura of ghost dance religion in the nightly goings-on at the cabaret, as well as an air of exorcism, a ritual cleansing to purify a world mired in senseless slaughter.

First and foremost, Cabaret Voltaire was a *cabaret*, and that was a fairly new phenomenon in Zurich, the sort of thing being organized by the exiles flocking to the city, intent on rekindling a bit of the cosmopolitan milieu they'd left behind. The vogue for artist-run cabarets began with the Chat Noir in Paris in 1881, quickly traversing Europe from Barcelona to Moscow. Ball, Hennings, and Huelsenbeck were veterans of the most renowned cabarets in Munich and Berlin.

Ball had the benefit of a long theatrical apprenticeship, as well as his variety show experience, but he couldn't have made the cabaret work without Hennings. Photos taken throughout her life reveal the chameleon-like character of a stage personality. It's easy to imagine her being a screen star, given the opportunity. She was slim and shapely, and for most of her life she wore her hair in a pageboy cut, framing her attractive face. But there's something enigmatic in that face as well.

It would be challenging to arrange photos of Hennings chronologically, at least after 1909 when she still had the healthy roundness that in America was

the mark of the Gibson Girl. Once she got into the theater circuit, hanging out with a bohemian set and starting to use drugs, her looks tilted ever so slightly, so in one photo she might look angelic, in another impishly fetching, and in yet another old before her time. She wore the signs of the hardscrabble life she lived as if it were part of a costume. At thirty, she could look forty or twenty, depending.

This temporal indeterminacy was even more striking in Hennings' singing voice. Contemporaries remarked on its frailty when crooning sentimental ditties of the belle époque, and the shocking contrast when she'd launch into the vulgar fare of the demimonde. A reviewer described it in 1912: "Her voice hops across the corpses and will mock them, soulfully trilling like a yellow canary." Imagine Shirley Temple shading over into Marlene Dietrich—then back again.

Hennings spooked Hans Richter, who knew her in prewar Berlin. "I never felt at ease with her, any more than I did with the black-clad, priest-like Ball," he wrote. "But the reasons were different. I found her child-like mysticism as hard to believe in as Ball's abbé-like earnestness. Her child-like manner, the deadly earnest in which she said the most wildly improbable things, were a mystery to me." Only someone like Ball could really appreciate Hennings, Richter felt. Ball—the gaunt Ball, who could've been a model for Kafka's "A Hunger Artist"—was fortified in her presence; whereas, for Richter, "I was ashamed, unconsciously, of my robustness."

The relationship between Ball and Hennings comes across vividly in an anecdote by Friedrich Glauser, who met them courtesy of Tzara in Café Odeon. Glauser was struck by Ball's gaunt face, wrinkled with little traceries of spiritual distinction, like hieroglyphs. Ball smiled but didn't speak much, as if nursing his words, carefully breathing life into them. Suddenly the door was flung open, and a small, delicate blonde in a green sweater appeared, her face powdered like a clown. After Tzara introduced her, "She looked at me somewhat suspiciously," relates Glauser, noticing her nibbled fingernails as he shook her feverishly hot hand. She was so animated, he says, that she seemed to vibrate like a piece of paper in front of a ventilator as she recounted how her dead grandmother had appeared to her out of the foggy boulevard the night before. Tzara laughed, and another at the table said, "Emmy, you're tipsy." A brief trace of irritation crossed Ball's brow before a faint smile appeared on his thin lips; he remarked that of course the

grandmother would come to console a grandchild, helpless and shivering in the cold winter fog. Enfolding Hennings' hands in his own, Ball silenced the others at once with this protective gesture. "Ball was such a rare person," Glauser observed, "that vanity and posturing were completely alien to him. He didn't make an impression, he *was*." Hennings' life had been so varied, but also so desperate, before meeting Ball, that his steady protective aura became her lifeline.

Despite his apparent steadiness, Ball was undergoing constant bouts of torment and self-doubt. Claire and Yvan Goll knew the couple in Zurich, and in her memoirs Claire pegs Ball as "the opposite of a happy man," citing as if it were proof the fact that she never saw him wear anything but black. It was on the inside, though, that he carried his most oppressive blackness. Some Dadaists recounted how Hennings took up with a Spanish journalist for a time, and Ball followed them around Zurich with a pistol in his pocket. Claire, without justification, accused Ball of killing the life spark awakened in Hennings by her affair with the Spaniard once he got her back. Nothing could be further from the truth, as the couple by all accounts had the closest relationship from then on until Ball's death in 1927, after which Hennings spent the rest of her life commemorating him in a series of memoirs.

As the weekly performances got under way at Cabaret Voltaire, a kind of social-artistic dance evolved among the participants as they got to know one another. They learned what each could bring to the show and how their different trajectories could intersect for moments of onstage brilliance. They tried a little of everything. For Ball and his crew, managing the cabaret was a fantastically stimulating and completely exhausting experience. Because the whole enterprise was done on the fly, no routines were ever formalized. If something worked, it wasn't necessarily repeated. The impetus behind it might persist, but these people were averse to routine in any aspect of their lives.

Each member of the core group of participants—Ball, Hennings, Tzara, Janco, Arp, and Huelsenbeck—contributed something unique. When Huelsenbeck arrived, he promptly demanded more intensity. "He pleads for stronger rhythm (negro rhythm)," Ball confided in his diary. "He would prefer to drum literature into the ground." Huelsenbeck read his poems with snarling aggression, pounding on a drum and brandishing a riding whip or

a cane. "The Gorgon's head of a boundless terror smiles out of the fantastic destruction," Ball observed.

What was being destroyed? First and foremost, Huelsenbeck's target was genteel verse decorum. He longed for the primitive origins of humankind; his poems plunged consciousness into a cauldron of primal forms, bits of raw terrestrial matter out of which anything might emerge in the evolutionary spiral: "pig's bladder kettle drum cinnabar cru cru cru" begins one of his "Fantastic Prayers." He liberally sprinkled his poems with faux African lingo, like *sokobauno sokobauno, O hojohojolodomodoho,* or *Avu Avu buruboo buruboo,* tossing in an impromptu *umba umba* in a performance like a hi-hat cymbal crash in a strip joint.

Huelsenbeck had first tried out these jungle fantasies in Berlin, where he and Ball had mounted their evening of Futurist poetry. The sound effects were embedded in poems full of non sequiturs and free association of a sort that the Surrealists later made their own. "The End of the World" begins with a perfectly straightforward line and then caroms off like a billiard ball smacking everything in sight:

> Things have really gone too far in this world
> Cows sit on the telegraph poles and play chess
> The cockatoo under the Spanish dancer's skirts is singing
> as sadly as a regimental bugler and the cannon wail
> the whole day long
>
> . . .
>
> Ah ah you great devils—ah ah you beekeepers and sergeant majors
> Wanna woof woof woof wanna where where where who today has not
> heard what our Father Homer wrote
> I have both war and peace in my toga but I'll take a cherry-brandy flip

When his book *Fantastic Prayers* was published as one of the first titles bearing the imprint Collection Dada in 1916, Huelsenbeck gave a copy to his mother, who promptly burst into tears, fearing for his sanity.

Huelsenbeck wasn't the only one afflicted by the lure of "darkest Africa." Tzara, too, composed "African poems," and indeed in the decade before the war broke out in 1914, many artists in Germany and France had become entranced with African and Oceanic tribal artifacts, the booty of imperial

powers filling up warehouses in the capitals. Some artists simply admired the workmanship, but others like Picasso found these "fetishes" genuinely frightening. "They were weapons," the Spaniard realized, as he embarked on his *Demoiselles d'Avignon* in 1906. "My first canvas of exorcism," he called it, in which he painted grotesque renderings of African masks over the faces of brothel nudes.

Around the same time, German artists associated with the Brücke movement traveled to Africa and the South Pacific as rejuvenation from a decaying Europe, immersed in primal sources of rebirth. With their woodcuts especially, the Brücke artists made a show of deliberately unrefined, even childlike figuration. Their outrageously bold colors and deliberately slapdash application of paint were a rebuke to the fine arts strictures of the academy. The provocative green and red faces painted by Kirchner, Schmidt-Rottluff, Heckel, Nolde, and Pechstein looked like sheer insolence to a scandalized public, but fellow artists and writers of the avant-garde recognized that such renderings made the face a mask—and a mask, wrote Carl Einstein in his prescient 1915 book on African sculpture, is "fixed ecstasy."

The masks provided for Cabaret Voltaire by Janco were clearly influenced by this primitivist legacy. They also turned out to be a key to unlock the mysterious powers of dance. Janco was an avid participant in all the mayhem, involved in performances as well as contributing his artwork. Near the end of May he brought a bunch of masks to show the others, who started trying them on. The masks, they felt, demanded complementary motions and gestures. Soon Ball, Tzara, Huelsenbeck, Arp, and Janco were dipping and looping around the room, convulsed in an impromptu swoon, as if the goddess Terpsichore had waved her magic wand and set the bodies in motion. Ball, naturally, perceived this joyous outbreak as a "tragic-absurd dance" in which "the horror of our time, the paralyzing background of events, is made visible." For the others it was simply a liberation in the realm already pioneered by the "witch's dances" of Rudolf Laban, dance master and guru figure whose school was nearby. Laban himself was inspired by Janco's masks to create a menacing costume for one of his own solo outings. Laban frequently attended the cabaret and sometimes his dancers participated. In April, five of them performed a *danse nègre*, led by Tzara's girlfriend Maja Kruscek.

Tzara would go on to become a major player in the international avant-garde and self-appointed director of *le mouvement Dada*. At first, though, he

was the junior member of the tribe. Born in 1896 as Sami Rosenstock, a well-off member of the Jewish merchant class, he was Ball's junior by a decade, eight years younger than Arp, and a year younger than Janco, with whom he had launched a literary magazine called *Simbolul* back in Rumania in 1912. In a photo from that year, Janco looks unmistakably the leader of the group, his hat rakishly angled in a show of imperturbable confidence. Tzara at fifteen seems too earnest, trying to don the demeanor of the modern poet in a bit of desperate guesswork, Bucharest hankering after the Left Bank.

Janco had arrived in Zurich with two brothers and registered for classes at the University of Zurich in November 1914. When Tzara arrived in Zurich a few months later, Janco was expecting him. The younger Rumanian took his lodgings in the same building as Janco, Pension Altinger on 21 Fraumün-sterstraße, where he lived throughout the run of Cabaret Voltaire, even after the Janco brothers had moved on.

Tzara, precocious beyond his years, was never intimidated by his older collaborators. Having been sent abroad by his parents to avoid the military draft—to which Jews were subject, though generally denied Rumanian citizenship—the cabaret was for him a site of rebirth. No longer would he be a bourgeois poseur, writing Rumanian poems in the style of the French Symbolists from decades earlier. Writing poems was a way of trying on a new identity—the perennial sport of adolescence. In *Simbolul* he'd ventured another name for his poetic alter ego, S. Samyro. The year before he came to Zurich he'd finally settled on Tristan Tzara, after a few other trial names. Tristan was a nod to his favorite poet Tristan Corbière (itself a nom de plume invented by Charles Cros). The name Tristan also has affinities with *triste* or sad, and Tzara is a phonetic spelling of țara, the Rumanian word for homeland. Sad in his homeland, Tzara would burst into ebullience in Zurich, his native intelligence unleashed by the madcap cabaret, and his instinctive talent for confrontation honed to perfection onstage.

Tzara's fellow participants at the cabaret could not have been more un-alike, and together they formed a motley ensemble whose crisscrossing tensions animated their art. Ball and Tzara—the "great matadors" of Dada, Arp would later call them—were a study in contrasts. Their age difference was magnified by their faces, Ball's haggard, Tzara's still round with baby fat. In any photograph, Ball's the tallest person in a group, Tzara the shortest. Arp and Huelsenbeck, meanwhile, were both of average height, filling in the

middle range in more ways than one. Huelsenbeck's brutality in performance was an act, but it encouraged Tzara to liberate his inner prankster. Huelsenbeck and Tzara were both prone to sporting a monocle, affectations of the dandy—a role Ball was obsessed with. Arp was more reserved, an artist not a performer, but he dutifully played assigned roles and was unstinting in support of the others. His hair, cut in a bold chevron, gave him a faintly military look. Above all, he had an infectious sense of fun.

Janco and Hennings were every bit as matchless as the others in the group. Janco was debonair, a lady's man. An artist like Arp, he was inclined to take a backseat where antics were concerned. Game for anything, Hennings stood out as the star of the cabaret. A pro at turning a tune on a dime from sweet and winsome to vulgar insinuation, she was also an old hand as an actor. Photographs from the Flamingo Ensemble she'd worked for the previous year reveal the range of her repertoire in that peculiar venue: in military getup, with pitchfork as a hell maiden, and as a spider. She brought that same range to the cabaret. The combination of such diffent personalities and the range of the talents they brought to Cabaret Voltaire ensured some kind of success. As it played out, though, the participants became welded into a peerless unit through their nightly exertions.

In time other artists became quasi-regulars at Cabaret Voltaire as well. Richter, for instance, had stumbled into this honeypot by chance—though chance is Dada's oldest friend (courtesy of that French dictionary). In 1914, just before military duty, he made a pact with two companions, poets Ferdinand Hardekopf and Albert Ehrenstein, to meet up on September 15, 1916, at Café de la Terrasse in Zurich—providing, of course, they were still alive. As that date approached, and finding himself in Munich where a gallery had mounted a show of his paintings, Richter decided to go on over the border where, lo and behold, there were his friends at the café as planned. In an unplanned but serendipitous twist, a lively group at the next table included Janco and Tzara, and Richter was soon embroiled in their unfolding adventure. (It was in his flat that Hennings and her Spaniard hid from Ball with his revolver.) Getting to know these intrepid artists was just the ticket, Richter found, for someone seasoned by actual combat experience. Here, as he put it, "the safety-valve was off," and the practice of art was unshackled from convention.

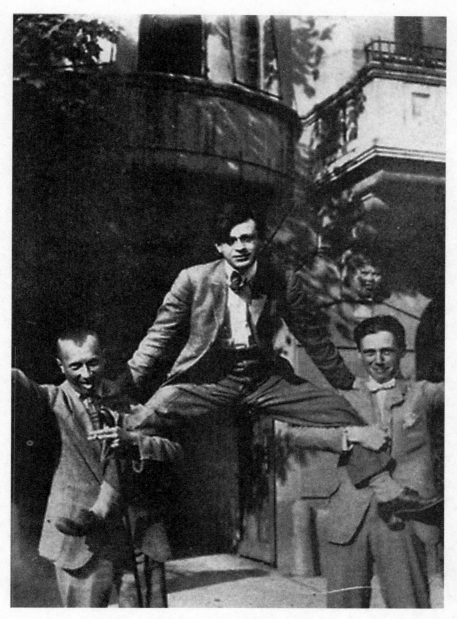

*Hans Arp, Tristan Tzara, and
Hans Richter (left to right), circa 1917.*

The first purely abstract art Richter encountered was in Zurich, where he found works by Arp's friends Otto van Rees and his wife, Adya. They were feeling out the basis for an elementary art—an art that turned to the elements, to nature, but also *elementary* in the sense of primary and preliminary: back to the basics. In a world of fussy ornamentation and decorative overload, the basics would naturally seem crude, uncouth, even obscene—the art of the flasher. An unadorned circle next to an equally bare square could only be some devious visual pederasty. Van Rees and Arp were commissioned to do frescoes for a local school, but parents were outraged by their abstract designs and ordered them painted over as if they were a moral threat to the children. Arp registered his indignation decades later, when he observed of the bourgeois consumer, "Straight lines and honest colors exasperate him above all." They were taken aback by abstract art, but for Arp such work was *concrete*, manifesting its own naked existence, unpretentiously: "a picture or a sculpture without any object for model is just as concrete and sensual as a leaf or a stone." Tellingly, when Arp, along with Otto and Adya van Rees, participated in an exhibition billed as *Modern Tapestries, Embroidery, Paintings, Drawings* at Galerie Tanner in Zurich the year before Cabaret Voltaire opened, Arp called his works *travaux*, a term usually applied to handiwork and the building trade. The term made art seem less elite.

At the opening in Zurich, Arp had met Sophie Taeuber, the great event of his life. In poems and recollections he conveys a sense of infinite balance emanating from Taeuber. In front of a camera, some people emit smiles like coded messages. Not Taeuber. In photographs her smile is like a glow she just stepped into. Effortless radiance. She was a dancer, as well as a teacher at the Zurich School of Applied Arts. Emmy Hennings remembered Taeuber dancing between two Wassily Kandinsky paintings, as if his swirling lines set her in motion. When she danced, "the ineffable tenderness of her movement made you forget that her feet were in touch with the ground, all that remained was soaring and gliding."

Arp and Taeuber resolved to shun oil painting, which seemed to them tainted by arrogance and artistic pretention. So they took up other media—embroidery, paper, woodworking, watercolors—as a kind of spiritual exercise in humility. Tzara took it as the "wish to lead a simple life." Huelsenbeck described it as a way of making art "in which all difficulties are relieved, just as cramps and spasms are relieved," evidence, he thought, that "a new will

for spirituality has returned to us." In his *Pisan Cantos* (1948), Ezra Pound rises to a crescendo with the famous refrain, "Pull down thy vanity!" More than thirty years earlier, Arp and Taeuber had pioneered that outlook and practiced it for the rest of their lives.

Hugo Ball may have encountered Arp in Munich before the war, as both were close to Russian painter Kandinsky and members of his Blue Rider art movement, which Kandinsky had launched with Franz Marc. Arp was as cosmopolitan as the expatriate Russian. He'd spent several years studying art in Paris, but was equally at home in the burgeoning milieu of Berlin Expressionism. As a German citizen, Arp was unable to extend his residency in Paris when hostilities broke out in 1914. He ended up in Switzerland where, called before the German consulate for military service, he convinced them he was addled in a clever gambit characteristic of his contribution to Dada. Asked for his birth date, he wrote down the figures then added them up as if it were an arithmetic problem.

In Zurich, Ball found Arp a captivating ally. "Arp speaks out against the bombast of the gods of painting (the expressionists)," the cabaret's founder wrote. Among these bombastic deities was Marc, an early World War I combat casualty, famous for his vividly colored cows and cats and horses. Ball noted with evident amazement in his diary a few weeks after the cabaret opened that Arp "recommends plane geometry rather than painted versions of the Creation and the Apocalypse."

He found his new ally "concerned not so much with richness as with simplification." This was in keeping with Arp's distinctive style; exercises in plane geometry are precisely what Arp had exhibited at Galerie Tanner the previous fall. But as the cabaret got under way, he continued to move away from standard artistic media like oil paints, turning more and more to chance procedures and the use of untraditional materials, ranging from wood scraps to colored papers and string. Unsurprisingly, very few of these creations have survived to the present day.

Despite an abundance of recollections, most written decades later, little is known about what was performed at Cabaret Voltaire other than whatever Ball happened to record in his diary. As house pianist, he made a point of noting when he played pieces by Max Reger, Franz Liszt, Alexander Scriabin, and Sergei Rachmaninoff. Other musicians at the cabaret offered up

a sonata for cello and piano by Saint-Saëns—lovely stuff, but such nine-teenth-century romantic fare is light years from Dada.

Hennings also had a considerable repertoire to draw on, not least the ma-terial she and Ball had performed since arriving in Zurich. Her ability to charm an audience was reported in the *Zürcher Post*, transcribed by the grat-ified Ball into his diary on May 7, four months into their run with Cabaret Voltaire.

> The star of the cabaret, however, is Mrs. Emmy Hennings. Star of many nights of cabarets and poems. Years ago she stood by the rustling yellow curtain of a Berlin cabaret, hands on hips, as exuberant as a flowering shrub; today too she presents the same bold front and performs the same songs with a body that has since then been only slightly ravaged by grief.

Hennings was not the only singer: a Madame Le Roy or Leconte (the name changes in different accounts) was also a regular. And music at the cabaret took more exotic forms, as well.

The Russian balalaika group that came on opening night continued to perform throughout the run of the cabaret, infusing the atmosphere with a Russian presence that extended to literature. Hennings and Ball read *The Life of Man* by Leonid Andreyev, a play Ball loved, in which "even the commonplace verges on horror." Stories by Ivan Turgenev were read, and although they're not terribly long, it's hard to imagine such works taking less than thirty minutes, which would have impinged on the festive atmo-sphere of Cabaret Voltaire. To listen to a whole story read aloud, or the piano pieces Ball performed, the audience would most likely have been quiet and attentive—perhaps expecting that something lively might be right around the corner.

Many poems were recited at Cabaret Voltaire, most of which demanded close attention, especially Expressionist lyrics by prewar friends of Hennings and Ball, like poets Else Lasker-Schüler and Jakob von Hoddis and play-wright Frank Wedekind. Kandinsky's experimental abstract poems, pub-lished in 1912 under the title *Sounds*, were first performed at the cabaret. The "gallows songs" of Christian Morgenstern were also popular. Tzara was fixated on French verse, reading work by Max Jacob and André Salmon—friends of Picasso—and by nineteenth-century poet Jules Laforgue. Laforgue

was a major influence on T. S. Eliot, whose plaint "The Love Song of J. Alfred Prufrock" had recently been published across the English Channel.

Arp performed scenes from Alfred Jarry's notorious play *Ubu Roi*, which had scandalized Paris in 1896 with its very first word: *merdre* ("shit" in English but deliberately misspelled)—an occasion witnessed by Irish poet William Butler Yeats, who wondered, "What more is possible? After us the Savage God." Jarry is the supreme prankster of literature, and the fact that Arp sampled *Ubu Roi* at the cabaret offers a clue to the kind of humor that appealed to him. His poems are unfailingly whimsical; Arp drew vocabulary for them from newspapers, eyes closed, finger pointing to a spot on the page. When he sent a longer sequence called *The Cloud Pump* to the printer, he deliberately wrote it out in small obscure handwriting to prompt typesetter's errors, errors he faithfully preserved in subsequent printings.

Cabaret Voltaire had an open stage policy, encouraging impromptu performances that varied wildly. Once, a Serbian recently arrived from the eastern front sang war songs. On another occasion, a Russian read some humorous pieces by Chekhov and offered up renditions of folk tunes. One evening a bunch of students from Holland swarmed in with banjos and mandolins, cavorting about and dancing eccentric steps—much to the delight of the Dutch proprietor in whose establishment the cabaret was housed—stirring up a paroxysm until they went trooping out into the street.

The performances ran the gauntlet, from tender ballads to raucous stomping, and the artists were increasingly swept up by a devil-may-care attitude. On February 26, only three weeks after opening night, Ball wrote: "Everyone has been seized by an indefinable intoxication. The little cabaret is about to come apart at the seams and is getting to be a playground for crazy emotions." On March 2, by which point the cabaret had become a staple of Zurich nightlife, he sized up the situation: "Our attempt to entertain the audience with artistic things forces us in an exciting and instructive way to be incessantly lively, new, and naïve. It is a race with the expectations of the audience, and this race calls on all our forces of invention and debate."

It *was* a race, and the runners were starting to feel it. "As long as the whole city is not enchanted, the cabaret has failed," Ball wrote on March 14, setting an impossible goal. Not surprisingly, the next day he registered an imminent collapse. "The cabaret needs a rest. With all the tension the daily performances are not just exhausting, they are crippling." Not yet six weeks into it,

the prospects for continuing the cabaret were looking slim. Ball and company were on the verge of imploding. But something happened, a second wind that kept the caper spinning and raised the intensity to an even higher pitch.

The group started coming up with innovations of their own. Rather than relying on a repertoire of literary and musical works they knew and liked—performed as set theatrical materials—they rekindled their interest in the little cabaret by experimenting. It may have started with Ball noticing what happened to a poem when read aloud. He discovered that most poetry was little more than something "worked out as a problem at the desk," a specialist delicacy "made for the spectacles of the collector instead of for the ears of living human beings." Why read a poem when you could *make a sound?* And the sound could explicitly take the place of the poem. He was beginning to see that what Arp was doing with his art—abandoning the manger and the apocalypse for pure geometric forms—could be extended to language. "The image of the human form is gradually disappearing from the painting of these times and all objects appear only in fragments," Ball wrote. "This is one more proof of how ugly and worn the human countenance has become, and of how all the objects of our environment have become repulsive to us. The next step is for poetry to decide to do away with language for similar reasons."

Even though the nightly performances still weighed on his shoulders, Ball was beginning to glimpse resurgence. "Adopt symmetries and rhythms instead of principles," he prompts himself in his diary. Then, as a kind of evolving credo: "The distancing device is the stuff of life. Let us be thoroughly new and inventive. Let us rewrite life every day." Such a grandiose aspiration couldn't help but exacerbate his idea that the whole of Zurich had to be shaken to its foundations for the cabaret to succeed. But at least there was, now, fire in the belly.

What Ball and his co-conspirators had going was new and unprecedented, but what did it mean? What could it amount to? He had an inkling: "What we are celebrating is both buffoonery and a requiem mass." From this little glimmer on March 12, terms were laid out that would eventually capsize the whole enterprise. Having glimpsed the requiem, Ball would grow increasingly wary of the buffoonery. In the meantime, the buffoonery would boost his theatrical gambit, for as always the show must go on.

Marcel Janco, lost painting of Cabaret Voltaire, 1916.

The breakthrough came from a key insight about language. Normally, language is regarded as a receptacle into which cognitive content is poured. You might appreciate the language if a poet makes it sound agreeable, or if a politician makes the right rhetorical moves. Even then, though, the point is not to admire the language at the expense of what it conveys. But during the Great War, the most costly war ever waged, continuing without letup in the flatlands west and east of cozy Switzerland, the horrifying persistence of patriotic platitudes had become simply revolting. "What can a beautiful, harmonious poem say if nobody reads it because it has nothing to do with the feelings of the times?" Ball wondered.

How could the calamity of the times be expressed? The Futurist Marinetti had proposed one model. Inspired by the 1912 Italian campaign in Tripoli, Marinetti had produced poems that were basically performance scripts in which he thunderously declaimed the sounds of bombs, machine guns, and small arms fire. In contrast, English artist Wyndham Lewis found actual combat less alarming. "My equanimity when first subjected to the sounds of mass-bombardment in Flanders was possibly due to my marinettian preparation," he wrote. "It seemed 'all quiet' to me in fact, by comparison." With hindsight (this is from *Blasting and Bombardiering*, 1937), Lewis observed: "You will be astonished to find how like art is to war, I mean 'modernist' art."

But the denizens of Cabaret Voltaire had no interest in infusing their words with martial cadences. Huelsenbeck's thrashing "Fantastic Prayers" went about as far in that direction as they wanted, but his approach was "primitivist," not really in Marinetti's clamorous vein. The solution they struck on hailed from prewar Paris, where Henri-Martin Barzun and Ferdinand Divoire had experimented with choral effects in poetry. They'd called the procedure "simultaneous poetry," and it was unfurled at the cabaret at the end of March.

For the cabaret's rendition of simultaneous poetry, Huelsenbeck, Janco, and Tzara went onstage, bowed formally like a yodeling trio, and performed their collaborative composition "The Admiral Looks for a Place to Rent" in German, English, and French simultaneously, with a drum, whistle, and rattle as accompaniment. These were conspicuously the main combatant languages. Tzara provided a conceptual itinerary for the piece in his explanatory "Note for the Bourgeois," citing the visual precedence of Cubist artists Picasso, Braque, Picabia, and Delaunay, as well as the typographic

innovations of the poet Mallarmé and the calligrams of Apollinaire. He dutifully acknowledged Barzun and Divoire, but said the musical effect they were striving for was not what he was after. He wanted to provide a template for improvisatory contributions by the performers, a coherent structure to channel the extemporaneous flow. Its intertwining voices would have blended into cacophony in the cabaret, so Tzara suggests that elements of the text like "ahoi iuché" were meant only to suggest what happened impromptu onstage.

Each of the three languages in which the piece was performed brought its own particular flavor. Under its French title—"L'amiral cherche une maison à louer"—it would take pride of place at the front of the anthology *Cabaret Voltaire*, published in May, emphasizing its importance for the group. The German portion, performed by Huelsenbeck, is full of his characteristic sound effects, splintering any sense the piece might otherwise make. There's a reference to the admiral of the title with his pants ripped, and a monkey and a manatee take a bow, but the text is dominated by sounds like *chrza prrza chrrrza, Yabomm hihi hihi hihiiiii, uru uro pataclan patablan pataplan*, and *taratata taratata tatatata*. Sound effects infuse the French portion too: the *boum boum boum* of frogs in a swamp that somehow takes Tzara back to a snake in Bucharest. The rest chatters along until it ends in a slaphappy cluster of nonce words (*prore, adore, sycomore*).

The English part of "The Admiral Looks for a Place to Rent" is grammatically uncertain at times and full of spelling errors. Janco performed it, and the text indicates it was sung, not spoken. It opens with a winsome scene evoking a genteel bygone world: "Where the honny suckle wine twines itself around the door a sweetheart mine is waiting patiently for me I can hear the weopour will around around the hill." It gradually turns into a romp, picking up music-hall cadences and touching on stereotypical English pastimes, from "I love the ladies I love to be among the girls" to "when it's five o'clock and tea is set I like to have my tea." From there it lurches into the world of Irving Berlin, actually quoting from his ragtime hit "Everybody's Doing It Now": "Every body is doing it doing it see that ragtime coupple over there see that throw there shoulders in the air"—at which point the piece switches register suddenly, riding out to the end with a cascade of affirmatives: "oh yes yes yes yes yes yes."

(Although not as famous, this jubilant conclusion anticipates the ending of James Joyce's *Ulysses*, with Molly Bloom's monologue: "he could feel my

breasts all perfume yes and his heart was going like mad and yes I said yes I
will Yes." That's the end of Joyce's novel, but the *book* itself ends with a few
more words: *Trieste–Zürich–Paris, 1914–1921.* Yes, Joyce was living in Zurich
the whole time Cabaret Voltaire was thriving. There's no proof he visited the
establishment, but he did like to drink and soaked up the café life everywhere
he lived. Is it too much to imagine he channeled Marcel Janco's rendering of
Irving Berlin for the benefit of Molly Bloom?)

Ball thought this three-headed performance put all the styles of the pre-
ceding twenty years into play, emphasizing above all "the value of the voice,"
elucidating "the fact that man is swallowed up in the mechanistic process."
Increasingly, for Ball, life at the cabaret would be for the highest stakes, a
matter of survival. "Our debates are a burning search, more blatant every day,
for the specific rhythm and the buried face of this age." Having identified the
search, Ball decided it wasn't about art: art was only a tool or weapon in the
struggle. But was there anything redemptive to be unearthed from the horror
spawned by the age?

"Our cabaret is a gesture," Ball wrote in April, fortified by the collective
focus achieved by his group. "Every word that is spoken and sung here says at
least this one thing: that this humiliating age has not succeeded in winning
our respect." How could it, with its idiotic state-sanctioned carnage? In the
safe haven of Zurich, at least, the combatant nations could be defied—and
at the very least, "they cannot persuade us to enjoy eating the rotten pie of
human flesh that they present to us."

With grim determination, Ball and the others flung themselves into their
performances. The participants became gears in a mechanism, the mov-
ing parts momentarily conjoining. "The remarkable thing, is that we are ac-
tually never in complete or simultaneous agreement," remarked Ball. "The
constellations change. Now Arp and Huelsenbeck agree and seem insepa-
rable, now Arp and Janco join forces against H., then H. and Tzara against
Arp, etc."

This was a recipe for conflict, maybe, but it kept the cabaret in a state
of creative turmoil. It also marked the group in the public eye as a most
peculiar and unprecedented phenomenon. "They are men possessed, out-
casts, maniacs, and all for love of their work," observed a journalist at the
time. "They turn to the public as if asking its help, placing before it the

materials to diagnose their sickness." When he opened the cabaret, Ball had approached the local papers for press coverage, and a few months after the debut of "The Admiral Looks for a Place to Rent," he took it a step further and signed up for a press clipping service. This fueled Tzara's documentary compulsions.

Tzara was naturally motivated to see his poetry in print, and he hankered after a literary journal, something more than the solo publication *Cabaret Voltaire*. "Tzara keeps on worrying about the periodical," Ball impatiently noted on April 18, 1916. And then, in the very next sentence of the same letter, he dropped the bombshell: "My proposal to call it 'Dada' is accepted." The inaugural issue of *Dada* would not appear for more than a year, but the word *dada* got the immediate attention of the group.

Just like that, the group had a name, a word that agreeably slips around between languages. It could sound like the "yes, yes" in Rumanian the others often heard when Janco and Tzara spoke to one another in their native tongue. The word also means "hobbyhorse" in French. Ball thought it suggested "a sign of foolish naïveté, joy in procreation" for Germans, and Tzara noticed it meant the tail of a sacred cow for a certain African tribe. There was a commercial prompt as well: the German manufacturer of soaps and perfumes, Bergmann and Company, patented one of its products as Lilie-milchseif-Crème-Dada, to which Ball referred in his Dada manifesto of July 14, 1916.

The coinage of the word *dada* would later become a source of lifelong acrimony between Tzara and Huelsenbeck, but in Zurich in 1916 their identity as Dadaists provided the basis for a spirited camaraderie at Cabaret Voltaire. It gave the group a moniker, but something different from other avant-garde groups whose names specified an outlook or activity, like the Futurists, Expressionists, or Cubists. Dada was a cipher, an invitation to wonder. What was Dada? What did a Dadaist do? For decades the Western world had been alarmed by the threat of anarchism, but how could you know who was an anarchist until a bomb blew up a café? Likewise for a Dadaist, whose explosives were literary, artistic, philosophical, and zany all in the same gesture. For several years to come, as the mysterious "virgin microbe" of Dada (as Tzara called it) spread around the globe, the meaninglessness of the word itself enthralled, agitated, and threatened in equal measure. The nightly audience at the cabaret, of course, could care less what the performers called themselves.

But once the term was there, it was like an egg: Ball and the others watched, enrapt, to see what would emerge when the shell cracked open.

Like an anthropologist, Ball started jotting down the characteristics of this new human type. "The Dadaist loves the extraordinary and the absurd. He knows that life asserts itself in contradiction." Adapted to constant change, the Dadaist "no longer believes in the comprehension of things from *one* point of view." It's not surprising that Ball drew on his own propensity for crisis as a symptom of the Dadaist, someone he describes as "still so convinced of the unity of all beings, of the totality of all things, that he suffers from the dissonances to the point of self-disintegration." Ball had been besieged by these dissonances for years, and they would soon come to a head, reducing him to an almost infantile collapse.

Ball wrote a nativity play, which was performed at the beginning of June 1916, some four months after the cabaret opened. The notion may have come from his fascination with the world of early Christianity, about which he later wrote a book. "There is a gnostic sect whose initiates were so stunned by the image of the *childhood* of Jesus that they lay down in a cradle and let themselves be suckled by women and swaddled," Ball wrote. "The Dadaists are similar babes-in-arms of a new age."

The nativity play was one of Ball's rare opportunities to write, cast, and direct a full production. When Ball first dreamed up Cabaret Voltaire, he had envisioned it as a theater where he might have his own ensemble and write plays suited to the individual talents involved. It was to be the fruition of his prewar theatrical career. Now, Ball had a chance to realize that dream.

Drawing on the talents of Arp, Tzara, Janco, Hennings, and another woman, Ball's nativity play was a familiar depiction of the manger in the Holy Land that doubled as a *bruitist* or noise concert. It was performed behind a semitransparent screen, so the cast needn't bother with costumes and the sound world they created could issue from mysterious sources. Interlocking rhythms knocked out on the floor with fists and elbows were meant to register the apparition of the angel and the star, descending to the sound of an airplane propeller phonetically performed by Ball: "Zcke, zcke, zcke, zzcke, zzzzzcke, zzzzzzzzcccccccke zcke psch, zcke ptsch, zcke ptsch, zcke ptsch." The familiarity of the biblical subject meant the whole presentation could

revolve around such atmospheric sound effects, many of them drawing on that unique power of the human voice the group had pioneered with their "simultaneous poem" about the admiral. Indeed, simultaneity contributed to the nativity play in a highly original way in the final act, when the nativity was performed concurrently with the crucifixion. The sounds of adoration from the Three Kings and Mary gradually morphed into lamentations amid the steady *plonk* of nails being hammered and chains being rattled.

By all accounts the performance was very moving. Its "gentle simplicity surprised the audience," Ball wrote. "The ironies had cleared the air. No one dared to laugh. One would hardly have expected that in a cabaret, especially in this one. We welcomed the child, in art and in life."

Ball was welcoming another child to Zurich around this time. Hennings' nine-year-old daughter had just arrived after the death of Hennings' mother with whom the child had lived since birth. Although he was not the father, his new role was embraced by Ball with pride and more than a little consternation. It brought changes, not least in the daily routine. As he wrote to a friend, he and Hennings were now getting up at six every morning to get the girl to school at seven, but they usually didn't get home from the cabaret until around 1:30 a.m.—a schedule that must have further worn down the already exhausted couple.

In the wake of the nativity performance, Ball could feel the Dada experiments coming into focus even as they were driving him to the breaking point. He realized that the avant-garde milieu he'd long been immersed in mixed false promises with genuine discoveries. "We are Rimbaudists without our knowing it or liking it," he found. "He is the patron of our many poses and flights of fancy; he is the star of modern aesthetic desolation."

Ball's comparison of his cohort to Arthur Rimbaud, the French poet, was telling. Rimbaud had dazzled his contemporaries with *A Season in Hell* (1873) and *Illuminations* (1886). Even more astonishing is that all his literary work was produced before he was twenty, after which he lived an itinerant life, including many years in Africa, before he died in 1891 at age thirty-seven. Ball certainly detected a kinship with this young Frenchman, who wrote to his friend Paul Demeny that a true poet becomes a visionary through a "long, gigantic, and rational *derangement of all the senses*"—a self-mutilation, he suggested, like growing warts on your face.

When Ball implored himself in his journal to "seek out the absolute in your person in order to live it," he was standing in Rimbaud's shadow, wondering whether all the bother with mere *literature* was worth it. He worried that the cabaret performances might amount to little more than Rimbaud's aesthetic desolation.

Dada meant something different to each of the participants, but for Ball it named this predicament of using culture to escape from culture—a zany bootstrapping operation. "What we call dada is a farce of nothingness in which all higher questions are involved; a gladiator's gesture, a play with shabby leftovers, the death warrant of posturing morality," in relation to which "the only thing left is the joke and the bloody pose." This splenetic outburst is typical of Ball confronting the plight of his daily life, vacillating between the nightly cabaret performances, his own fraught inner world, and the constant news of combat stalemate on the western front—news of which he was absorbing, while out of financial necessity, he translated the work of combat veteran Henri Barbusse.

If Ball despaired during the summer of 1916, he was also filled with hope. The other side of Ball's mind was fixated on the radiant dream of a purified language, balancing anarchy with devotional meditation. "We have now driven the plasticity of the word to the point where it can scarcely be equaled," he wrote on June 18. "We have loaded the word with strengths and energies that helped us to rediscover the evangelical concept of the 'word' (logos) as a magical complex image."

Ball's two competing strains of thought—nihilistic and aspirational—would soon come to a head in a choreographed performance that would define Dada for the ages. It was a culmination of his Dada endeavors, a farewell, he thought afterward—but did he plan it that way?

Near the end of June, just before Cabaret Voltaire closed down, Ball went onstage wearing a "magic bishop" outfit—a cardboard costume resembling the Tin Man in *The Wizard of Oz*, which would not be filmed for another twenty years. His legs were in blue tubes, his torso wrapped in a gold coverlet (red on the inside), with winglike flippers he could wriggle by moving his shoulders. Topping it off was a "witch doctor's hat," as he called it, a tubular concoction with vertical blue and white stripes.

The constraints of this cardboard outfit meant Ball had to be carried on-stage and positioned before three music stands on which his manuscripts were arrayed. This was done in the dark. When the lights came up, his extraterrestrial figure began intoning a language of magical potions:

> gadji beri bimba
> glandridi lauli lonni cadori
> gadjama bim beri glassala
> glandridi glassala tuffm i zimbrabim
> blassa galassasa tuffm i zimbrabim

For Ball the experience was convulsive, transformative. Midway through the recitation of his nonsense script, he sensed a liturgical momentum arising from the intonation of the vowels, and he surrendered to it. He became the "magic bishop" after all, subsiding into a sweet profundity of babbled bliss, so overcome that when his sweating, trembling body was carried offstage after the performance, he knew he was done with Dada as an avant-garde movement and borne beyond into a kind of Dada sainthood.

There's a famous photograph of Ball in costume. It would have been posed, not captured in the moment onstage. Onto this photo, a multicolored rendering of one of his sound poems was superimposed for a 1920 anthology of Dada that reached proof sheets but was never published. Still, the image circulated and made him the definitive Dada Man. In the decades since the magic bishop's debut, Ball's performance has been much memorialized, from the Talking Heads' song "I Zimbra" to Marie Osmond's recitation of it on the ABC television show *Ripley's Believe It or Not*. In a single evening's ten- or fifteen-minute performance, Hugo Ball became the century's poster boy for the avant-garde.

2

MAGIC BISHOP AND MR. ASPIRIN

The cabaret closed in early July 1916, almost a month before Hugo Ball, Emmy Hennings, and her daughter, Ammelie, left Zurich for Vira-Magadino on Lake Locarno. Though the cabaret was gone, Dada performances or soirées continued. Before Ball and Hennings departed, the first Dada soirée was held on Bastille Day, July 14, in Zunfthaus zur Waag, an old guildhouse on Münsterhof Square, one of the more prominent and upscale sites in Zurich. With this change of venue, Dada instantly shed the knock-about connotations of the cabaret and entered a new phase of its short but growing history. This swank locale imbued whatever Dada might mean with an air of seriousness.

The group presented a reprise of material from Cabaret Voltaire, along with the debut performance of Tristan Tzara's play *First Celestial Adventure of Mr. Antipyrine*. Hennings performed three Dada dances, with masks by Marcel Janco and music by Ball, and Ball read his sound poem "Gadji Beri Bimba," which he had premiered at Cabaret Voltaire in the magic bishop costume. This time, though, the trappings of the cabaret were gone, and he looked the well-attired gentleman addressing a "new tendency in art." He rattled off the multilingual associations of the term *Dada*, then splintered the names of his collaborators into a verbal stew: "Dada Tzara, dada Huelsenbeck, dada m'dada, dada m'dada dada mhm, dada dera dada, dada Hue, dada Tza."

Much to the amazement of the audience, Ball then switched gears abruptly and began to read his Dada manifesto. "How does one achieve eternal bliss?" he asked. "By saying dada." Dada was the inauguration of a new mode of speech, a new outlook on life, in which "I let the vowels fool around. I let the vowels quite simply occur, as a cat meows." Dada was the soap that washed the grime off language, that precious instrument for elevating animal sound into intelligible human expression. "Dada is the heart of words," Ball said. "The word, gentlemen," he concluded, "is a public concern of the first importance."

A few weeks later, basking in blissful August weather on the Alpine heights north of Milan, Ball reflected on his Bastille Day manifesto-lecture, realizing it was a "a thinly disguised break with friends" and adding, "they felt so too." He wondered, "Has the first manifesto of a newly founded cause ever been known to refute the cause itself to its supporters' faces?"

Ball had felt the end approaching even earlier, back at Cabaret Voltaire, and he now rued his "regrettable outburst" in the magic bishop outfit, even as he remained preoccupied with it. He wanted transfiguration, yearned for personal tranquility, and was deeply moved by the Catholic services he began attending—seeing in them a reflection of the same sort of absolution he sought in his art. "It is with language that purification must begin, the imagination be purified," he wrote in his diary. Clearly, such purification was an incentive behind his "wordless poems" as he called them, even if he felt himself carried away, irrationally, in the delivery. There was something essential in them, a key somehow to the bracing challenge of an adage he transcribed from the German Romantic poet Novalis: "Becoming a human being is an art."

If Ball was intent on the art of becoming human, the others back in Zurich were determined to become Dadaists by way of art. Ball and Hennings had been indispensible in the cabaret, but for publishing and arranging exhibitions, they weren't strictly necessary.

After *Cabaret Voltaire* appeared, Tzara was bent on launching another journal with the name *Dada*, along with a book series. The first title was a handsome production of his play *First Celestial Adventure of Mr. Antipyrine*, eight pages of text with six full-page two-color woodcuts by Janco. Antipyrine was the brand name of a headache remedy—a malady to which

Tzara was prone—so the titular figure is a Mr. Aspirin or Mr. Tylenol. Ostensibly a play, it was little more than a verbal onslaught distributed among characters with names like Mr. Blueblue, Mr. Shriekshriek, Mr. Bangbang, Pipi, and a Pregnant Woman. A hefty dose of Tzara's Africanisms (*zdranga, zoumbye, affahou,* etc.) are distributed throughout, as if to certify the nonsensical character of lines in apparently normative speech:

> pregnant birds who drop turds on the bourgeois
> the turd is always an infant
> the infant is always a goose
> the turd is always a camel
> the infant is always a goose
> and we sing
> oi oi oi oi oi oi oi oi oi oi oi oi oi oi oi oi oi oi

It's not known who performed the play at the Bastille Day soirée, though undoubtedly the cast included the other Dadaists. A provocative debris of words rained down on the audience until, in the middle of the play, Tzara himself delivered a speech. "Dada is our intensity," he began, "it erects inconsequential bayonets"—a nod to the equally futile military campaigns being waged across Europe. This interlude only took two or three minutes of the program, and while reinforcing the play's effect of words being *sprayed* at the audience, Tzara took care to insert an intelligible aside: "Dada is not madness—or wisdom—or irony." He also came up with a memorable pronouncement: "Dada remains within the framework of European weaknesses, it's shit after all, but from now on we want to shit in different colors in order to embellish the zoo of art with all the flags of all the consulates clo clo bong hiho aho hiho aho."

Years later, when Tzara published his collection of Dada manifestos in 1924, this theatrical aside from *Antipyrine,* now a manifesto, was positioned first in the book. It's an interesting reflection on Tzara's role in the Dada group that his first manifesto would appear, furtively yet dramatically, in the middle of a play—which was not even listed in the printed program for the soirée. Maybe he wasn't kidding when he remarked in a 1918 manifesto, "in principle I am against manifestos"—adding the stinger: "as I am against

principles." In fact, neither was Ball's Dada manifesto listed on the program, that "thinly disguised break" with his friends.

These manifestos were an impromptu sort of sparring between the older man who founded Cabaret Voltaire and the younger one on the cusp of assuming the mantle of Dada leader. There's no hint of hostility between them, but since Ball and Hennings left Zurich within two weeks of the Bastille Day event, it's likely their departure had been in the air during the preparations for the soirée. The writing was on the wall for Tzara to read, at least: if Dada was going to amount to anything, the July soirée had to be billed as inaugural. The program lists "Dada-Evening" as the first, suggesting a series. It was also advertised as an "Authors' Evening," listing Hans Arp, Ball, Hennings, Richard Huelsenbeck, Janco, and Tzara. The nature of the program is parenthetically indicated as well: music, theory, manifestos, poetry, pictures, costumes, masks, and—last but not least—dance.

Dance had been part of the entertainment offered at Cabaret Voltaire, but its small stage cramped movement. In one performance Hennings wore something like the magic bishop costume that had so constricted Ball's movement he had to be carried onstage. Not surprisingly, Hennings "couldn't do anything else but clatter her feet or tilt the whole costume like a chimney," Suzanne Perrottet, a dancer and musician from the Laban dance school in Zurich, recalled, "and sometimes she let out a scream, one scream."

After the cabaret closed, the Dadaists began hosting, over the next several years, events in more ample venues, and dance became increasingly prominent. For the Bastille Day soirée, for instance, in addition to Hennings' dance performances, the program concluded with a Cubist dance arranged by Ball, involving Hennings, Huelsenbeck, Tzara, and Ball himself.

True to the provocation of Cubism, this and other Dada dances were jerky and asymmetrical. They'd been incited, after all, by Janco's grotesque masks. But the Dadaists were not making it up entirely on their own: they had the benefit of the nearby academy of modern dance run by Rudolf Laban.

The lifelong mission of the charismatic Laban was to emancipate dance from its traditional subservience to music and drama, and in this he had a profound influence on the Dadaists. Laban wanted to make dance a primary expression of the life force. An inspirational figure, he could be cruelly demanding, but always in the service of liberating individual potential. He had

"the extraordinary quality of setting you free artistically, enabling you to find your own roots," one of his students, Mary Wigman, recalled.

Laban didn't need to recruit followers, being a gravitational force unto himself. "A person's proper aim," he wrote, "is his own festive being." Movement was the inauguration of living form, and dance was its festive outcome. Under his guidance and instigation, ecstatic self-empowerment was a plausible goal. Photos of the time show groups of gesticulating dancers invariably in the open air, responsive to the Alpine mountains and lakes. There's no choreographic unity to be seen, just figures absorbed in communal ecstasy, some of them naked, others clothed in heraldic robes like Laban himself.

Such ritualistic bliss could strike outsiders as perverted, charges bound to accrue to a man who by the advent of Dada had nine children by four different women. As his dancers readily attested, it was hard to resist such personal charisma, especially in one as handsome as Laban. Wigman recalled his particular magnetism in terms that evoke the spirit of Cabaret Voltaire: "There was always Laban, drum in hand, inventing, experimenting. Laban, the magician, the priest of an unknown religion." He had the mercurial ability to slip from one role to another, guru to playmate: "How easily he would change from the gallant knight into the grinning faun!" The faun was often what outsiders saw, or whispered about, because his "school" resembled nothing so much as a seraglio.

The young Dadaists made a beeline for the alluring young women of this emancipated sanctuary. "Into this rich field of perils we hurled ourselves as enthusiastically as we hurled ourselves into Dada," recalled Hans Richter. "The two things went together." In fact, Richter found a wife among the dancers, a woman who'd previously been involved with Janco's brother. The marriage didn't last: "It was very stormy," he wrote, "because she was so very pretty, and everybody wanted to have her. Some did, so that was not my idea of married life."

As Richter's experience suggests, sexual openness was part of the attraction—and risk—for the young Dadaists as they mingled with Laban's acolytes. Arp was involved with Sophie Taeuber, a Laban dancer who already had a career as an art teacher. Tzara had a long stormy affair with Maja Kruscek.

Not all the Dadaists focused their romantic efforts on the Laban dancers. Janco played the field, while poor Huelsenbeck missed out on these erotic delights, being involved with a proper middle-class Swiss girl whose upbringing

made her sexually unavailable. In his desperation, Huelsenbeck confesses he even went so far as to offer to repudiate Dada altogether if she'd make that concession—but to no avail.

The cultural significance of Laban's school is evident in the care with which Ball notes their attendance at Cabaret Voltaire. Clearly the Dadaists had some sense of performing for the eminent dancer who, "drum in hand," incited a similar kinetic anarchy in his nearby school. Laban himself never participated in Dada, nor did Wigman, though a photographic motion study of her dancing appeared in the Dada journal *Der Zeltweg*. They were content rather to be spectators of the more general phenomenon of Zurich transfigured by wartime refugees. (In a letter of the time, Laban informed a friend, "all the cafés with delusions of grandeur in the world have sent their greatest heroes to Zurich.")

Still, a number of Laban's dancers did perform at the cabaret and became crucial contributors to the Dada soirées during 1917. On the "Evening of New Art," April 18, 1917, Laban dancer Käthe Wulff recited poems by Wassily Kandinsky and Huelsenbeck, and Perrottet performed piano works by Arnold Schoenberg. The arrangement was reciprocal; a friend of Arp's, dressed in a turban, performed the artist's *Cloud Pump* poems at Laban's school on March 18, 1917 (around the same time Wigman held a costume party at which, Ball records, he heard Arp's poems for the first time).

Foremost among the Laban dancers was Taeuber. A photograph survives of her, decked out in a collage-based costume by Arp at a performance in March 1917. Billed as "Abstract Dance," Taeuber's performance was set to Ball's poem "Song of the Flying Fish and the Seahorses" ("Little seahorse" was Ball's pet name for Hennings).

As Ball noted afterward, "A gong beat is enough to stimulate the dancer's body to make the most fantastic movements. The dance has become an end in itself. The nervous system exhausts all the vibrations of the sound." In this particular instance, "a poetic sequence of sounds was enough to make each of the individual word particles produce the strangest visible effect on the hundred-jointed body of the dancer . . . a dance full of flashes and edges, full of dazzling light and penetrating intensity." It's easy to imagine this "poetic sequence" squeezing movements directly out of the sounds, with its "tressli bessli," "flusch," "ballubasch," and "zack hitti zopp," especially if enunciated with the care Ball put into devising and spelling them out in the first place.

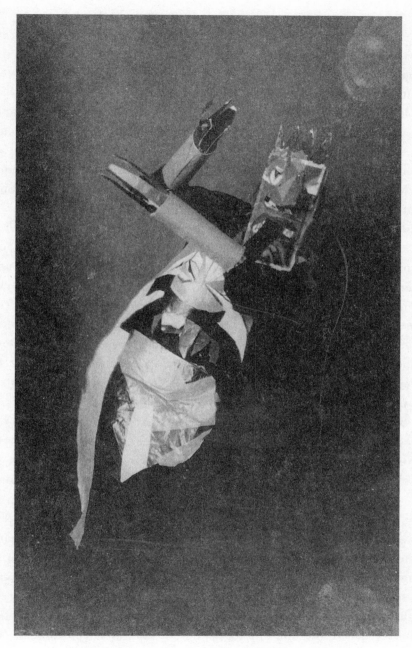

Sophie Taeuber dancing with Marcel Janco mask,
Zurich, 1916–1917.

Archives Fondation Arp, Clamart, France.

Ball returned to Zurich in the fall of 1916, coaxed back by Tzara. The return was fraught. The magic bishop performance at Cabaret Voltaire had presaged the onset of Ball's nervous breakdown—not all at once, but in stages. From the vantage of Vira-Magadino in August 1916, Ball had even fancied that performance as his break with Dada.

Ball's friends in Zurich seem to have understood his need to get away, but they also felt acutely their need for his involvement if Dada was to continue. And why shouldn't it? Cabaret Voltaire had been rough going, night after night, but it had been an incubator and the egg had hatched. Now Dada had a publication program, with books and a journal. As the Bastille Day soirée had proved, it even had box office potential.

Tzara was obsessed with bringing Ball back into the fold. On August 4, Ball wrote his Rumanian ally, "I'm a bit distant from Dada for the moment," adding "but I do have an appetite 'also for roaring'—later." Some consolation, that "later," but Tzara kept pestering. He wanted Ball to use his literary connections in Berlin to publish Tzara's manifesto (presumably the one from *Antipyrene*). The problem was, it was in French. Ball wrote back, astounded, telling Tzara to imagine a French journal publishing a German manifesto while the war was still raging. At least he could console the aspiring poet: his friends in Germany (including Wieland Herzfelde, who would participate in Berlin Dada) had said good things to him about Tzara's *Antipyrine*.

By the end of September Ball sent a mixed message to Tzara, repudiating the avant-garde roots of Dada and the movement's baiting of the bourgeoisie. "No more anti-bourgeois," he said—enviously eyeing the middle class from a position of poverty (he'd even irked Huelsenbeck because he had no money to contribute to Dada publications). "Being bourgeois, that's very interesting," he now found, "and likewise difficult."

But Ball and Hennings had not altogether repudiated the life of the music hall. Ball confessed to his friend, "I have a burning desire for drumming. Always drrrrrrrrrrrumming." But then he asked, warily, "Are you trying to seduce me to return to the Varieté?" When he and Hennings had left Zurich, they had promoted themselves as a touring couple for "Modern Literary Cabaret-Evenings" in tourist hotels. They even had a promotional flyer printed, with accolades from Cabaret Voltaire and earlier performances printed on the back, and prospective program material on the front,

including (for Hennings) Paris boulevard songs, Chinese ballads with pup-
pets, and Dada dances; and (for Ball) piano music by Debussy, Schoenberg,
plus poems by Baudelaire, Rimbaud, Kandinsky, and others. The impover-
ished couple had no choice but to draw on their old repertoire to get by. Still,
it was a struggle, and they had to confront the need for some kind of stability.

By October 1916, Ball was taking on writing and translating assignments
back in Zurich. But he swore that this time would be different. "I won't be
involved in a cabaret again," he wrote his sister, "even though we could make
a good living doing it. I prefer to write. That's my goal."

Dada was at low ebb when Ball returned to Zurich. Huelsenbeck had been
beset with insomnia and gastric ailments. Ball wrote to Hennings about
the plight of their friends: "I ran across Tzara in [Café] Terrasse. He's very
worried about what's happening in Rumania. His parents have probably lost
their entire fortune. He hears nothing from them anymore. The country is
in a state of catastrophe." (In fact, Tzara's father had cut off funds, frustrated
that his wayward son was neglecting his education.)

Tzara's plight must have struck Ball, ever sensitive to human suffering,
since he takes it up again the next day, in another letter to Hennings. "Tzara
has become impoverished," he informed her, and "Janco is quite desperate,
can't work, moans and laments." Despite their misery, however, "fundamen-
tally, they all remain Dadaists. Tzara and Janco are especially urging me to
stay, I must stay, I could stay. But I want to get on. I'm not 'desperate,' not
a Dadaist, not 'weary'," he adds, his scare quotes suggesting he was prone to
conflate Dada with desperation, a desperation he was anxious to overcome.
Assessing the situation, Ball confided to a friend, he now had to "reacquaint
myself with Dada, which I myself founded."

Pressed into service on behalf of the cause, Ball rekindled the old spirit
with a new enterprise, Galerie Dada. Technically, the Galerie began as an
exhibition at the gallery of Hans Corray in January 1917, consisting of work
by Arp, Janco, and Richter, along with Arp's pre-Dada friends Otto and Adja
van Rees and a few others. The press regarded them as Cubists, which sug-
gests that this show was not billed as a Dada occasion. But when the group
arranged for continued use of some of the gallery's rooms in March, Dada
got top billing.

For the most part Galerie Dada was run like a normal gallery, selling art and exposing the public to current trends. In this sense, at least, the venue and the undertaking it hosted could not have been more different from the goings-on at Cabaret Voltaire: not spontaneous but carefully planned as befitted an upscale venue on the west bank of the city, located above a chocolate emporium. Guest lists were compiled, invitations printed. Public events cost three or four Swiss francs—far from cheap, since the most expensive theater seats in town went for that price. But they always had a full house. "Everything had become very distinguished," Hennings wrote later on, "and one had to keep up appearances."

If the cabaret thrived on the sort of entertainment Hennings and Ball had provided in music halls and dives to a risible audience, now they could winnow out the mob and deal directly with the cultural elite, people who would pay dearly to experience the latest art and poetry. "We have surmounted the barbarisms of the cabaret," Ball triumphantly decided, just a few days after the gallery opened. There were no more students and nocturnal revelers at the new venue—just paying customers. Discomforting though it may have been, Dada was inching toward respectability.

Ball took the cues for Galerie Dada from his experience with the Blue Rider movement in Munich before the war. Prewar Munich had been one of the cultural capitals of Europe, rivaling Paris and Berlin, with its Bohemian Schwabing district an international cultural melting pot. In 1912, Kandinsky and Franz Marc published the legendary *Blue Rider Almanac*.

The innovations of the almanac influenced the way the Dadaists approached art. This famous publication was an inspiring catalogue of progressive tendencies in modern art. Although it embraced a spectrum of modern tendencies (Impressionism, Fauvism, Cubism, Futurism, Orphism, Expressionism), the real innovation of the almanac was its emphatic expansion of the very concept of art. Children's drawings; "primitive" artifacts from African, American, and Oceanic cultures; Russian folk icons; and Bavarian glass paintings were plentifully distributed throughout, where they were often conspicuously paired with historical masterpieces of Western art. Such juxtapositions were characteristic of the two Blue Rider exhibitions as well. *The Blue Rider Almanac* is, among other things, an early example of what André Malraux

later dubbed the museum without walls, a global portfolio of visual activity unencumbered by inherited canons of taste.

Kandinsky and Marc intended the almanac as the advent of a spiritual awakening. The subscription prospectus declared: "We stand before the new pictures as in a dream and we hear the apocalyptic horsemen in the air. There is an artistic tension all over Europe. Everywhere new artists are greeting each other." Despite the reference to pictures and artists, the editors promoted the almanac as a forum for all the arts, a prospect that would undoubtedly have been fulfilled had the war not intervened. The almanac did prominently feature the music, writings, and even paintings of Viennese composer Arnold Schoenberg, whose piano compositions were frequently performed in the Zurich Dada context. Schoenberg spoke of emancipating dissonance, construing dissonance as a consonance yet to be attained. Resolution and irresolution could coexist. Music critics were aghast at Schoenberg's impertinent "sound effects," his "hair-raising cacophonies," frivolities at best, more likely a seditious brand of "mischief" threatening civilization.

Kandinsky, being a theosophist, consistently expressed his vision of artistic transfiguration in spiritual terms. Even his most radical ventures, like the breakthrough into abstract painting, came across as common sense. "In daily life we would rarely find a man who will get off the train at Regensburg when he wants to go to Berlin. In spiritual life, getting off at Regensburg is a rather common occurrence." While Dada is better known for its caterwauling tactics of confrontation, the convictions behind it remained close to that of Kandinsky and the Blue Rider, convictions regarded as unobjectionable, like the Russian Nikolai Kulbin's "Free Music," his contribution to the almanac in which he says that "a nightingale sings any note it likes" and such elasticity should hardly be denied the musician.

Hugo Ball first met Kandinsky in 1912, at the pinnacle of the artist's flourishing career, a year in which the publication of the almanac was complemented by two more titles: *Concerning the Spiritual in Art* and a collection of woodcuts and prose poems, *Sounds*. Ball would later take pride that these poems were first performed at Cabaret Voltaire. He had tried unsuccessfully to produce Kandinsky's play *The Yellow Sound* in Munich before the war.

Not surprisingly, then, Ball's major contribution to Galerie Dada was a lecture on Kandinsky on April 7, 1917. It was an ambitiously comprehensive

account, beginning with a broad sketch of the prevailing symptoms of the age, like the decline of religion and the rise of the modern metropolis. Accordingly, "the artists of these times have turned inward," he informed his audience. "Their life is a struggle against madness," he added—far more applicable to himself than to Kandinsky.

Ball could almost be describing the walls of Cabaret Voltaire when he observes, "The strongest affinity shown in works of art today is with the dread masks of primitive peoples." He took solace in Kandinsky's art as a moral anchor. "One should go to his pictures as on a pilgrimage," he suggested, making a contrast between "Picasso the faun and Kandinsky the monk." The concluding section of his lecture emphasized the comprehensiveness of Kandinsky's artistic aspirations as they touched on theater, dance, and poetry. *Sounds*, in Ball's estimation, constituted a "daring purification of language"—which, he would have been justified in adding, had been unsurpassed until Dada.

Ball's lecture on Kandinsky was in keeping with the offerings of Dada's new space. Special tours were arranged for various constituencies. On one occasion a tour for the working class was advertised, but only one workman showed up, along with a mysterious stranger of another class who bought half the paintings on display, including works by Picasso, Kokoschka, and Janco. Tzara gave a series of lectures on modern art, and there were gallery talks on individual artists. Once, after a lecture on Paul Klee, the artist's elderly father arrived too late. Ball felt for the poor fellow and consoled himself that the father at least had the pleasure of seeing his son's work on display. "They will scarcely be seen again in such a beautiful and lively setting," he said.

Without existing photos or detailed descriptions of Galerie Dada, it's hard to know what Ball meant by "lively setting." It seems to have been more dignified than lively, given the steep admission price for events; even access to the gallery cost a franc. There were teatimes, but no alcohol could be sold. Ball's description reveals the gallery's high-toned character. "By day it is a kind of teaching body for schoolgirls and upper-class ladies. In the evenings the candlelit Kandinsky Room is a club for the most esoteric philosophies. At the soirees, however, the parties have a brilliance and a frenzy such as Zurich has never seen before." That was saying a lot, given the record of Cabaret Voltaire.

If the soirées at Galerie Dada were not as raucous as the performances at Cabaret Voltaire, they were animated by the same spirit. At the opening, Taeuber performed her "Abstract Dance" to Ball's seahorse poem. Tzara reprised his African poems; some of Arp's poems were performed though not by him; Hennings read some of her own work; Perrottet played piano, as did Hans Heusser, a composer who's vanished from the annals of music altogether despite his contributions to Dada (the gallery devoted an entire evening to his compositions).

Subsequent soirées became increasingly coordinated with the mission of the gallery to profile "modern art" in all its manifestations. The next event was billed as a Sturm soirée, a reference to Herwarth Walden's legendary Berlin gallery and journal. Tzara made the introduction, and the program covered Futurism (via Marinetti), Simultanéisme (Guillaume Apollinaire and Blaise Cendrars), and more of the abstract poems from Kandinsky's *Sounds*. The first half concluded with "Negro music and dance," for which Ball choreographed five Laban dancers wearing Janco's contorted masks. The second portion of the soirée was given over to poems by regular *Sturm* contributors like Jakob van Hoddis and August Stramm, recently dead in combat. The evening culminated with Kokoschka's play *Sphinx and Strawman*, starring Ball wearing a mask so large it was lit from inside so he could read his lines. "It must have looked strange in the darkened room," he reflected, "with the light coming out of the eyes." Tzara proved to be a totally inept stage manager, producing thunder and lightning effects in all the wrong places; but this being a Dada affair, everyone thought it was intentional. Knowing Tzara's anarchist penchant, maybe it was.

The soirées continued in this vein, with the Dadaists each getting a moment in the spotlight. Janco, for instance, gave a talk called "On Cubism and My Own Pictures." Tzara kept experimenting with his "simultaneous" poems for multiple speakers. As an acquired trait of his theatrical background, Ball donned costumes, even when reading a lengthy prose piece. Perrottet played Schoenberg. Hennings read some of her own poems and stories, including a lugubrious tale about a corpse's struggle to preserve itself.

Most surprising was a soirée called "Old and New Art," which was successful enough to merit an encore a week later. Despite the billing, emphasis was on the *old* as the Dadaists read obscure medieval writings, with Heusser setting the musical tone with processionals and fugues. Indifferent to this

indulgence in historicism, Tzara didn't participate. The occasion left Ball wondering who among modern authors would bother publishing books if their names weren't emblazoned on the covers. A few years earlier he'd considered that "if poets had to cut their poems or only their archetypal images into their own flesh, they would probably produce less." In a similar vein, he fantasized that if all the libraries burned down a new era of legend would dawn, as people would have to resume storytelling from scratch—a dream that anticipated Ray Bradbury's science-fiction vision in *Fahrenheit 451*.

Galerie Dada lasted until mid-May. Ball was sorry to see it fold, but the finances were a mess. He left Hennings to sort it out while he fled south again to Magadino, licking his wounds and ruminating, as ever, on the great enigma that was Dada.

Ball's experience of Dada pointed him in another direction, away from Tzara and the others. Whereas Tzara had been swept up in the bear-baiting side of Dada, following in the footsteps of the Futurist Marinetti, for Ball those liturgical cadences he'd performed in costume epitomized Dada. He'd gone into the endeavor obsessed with the notion that a reckless or abusive relation to language was responsible for the war, but the revelation of "verses without words," poems consisting of nothing but sounds, moved him closer to a reverential outlook on Dada. The Futurists, he reckoned, had unleashed the word from the shackle of the sentence and "nourished the emaciated big-city vocables with light and air," warming them up, stroking life back into enervated limbs. Dada, though, had gone a step further. "We tried to give the isolated vocables the fullness of an oath, the glow of a star." Behind the closing exhortation of his Dada manifesto in July 1916 was this consideration of the word as a matter of first importance.

The word, for Ball, was by this point synonymous with the mystical logos of Neoplatonic philosophers and early Christianity. Moving vowels and consonants around was a devotional exploration of the living word, *word* as consonant with "image," both merging in the figure of the crucified Christ. "Artistic creation is a process of conjuring," he astutely observed, "and its effect is magic." But he worried that the Dadaists were "magical eclectics," not adepts. The inspiration they thrived on felt like divine providence, yet how could he be sure it wasn't just whimsy run amok? "We are playing with a fire that we cannot control," he feared.

What Ball and his cohort were actually playing with was the fate of art in the modern age. Numerous nineteenth-century thinkers, like Friedrich Nietzsche and Mathew Arnold, had observed that poetry and the arts were now taking the place that religion once had. This supposition was a commonplace for someone of Ball's education and outlook. But the convulsions of Cabaret Voltaire, extended in the more refined milieu of Galerie Dada, had the effect of making him *live* this condition that others only spoke of. He concurred that "modern artists are gnostics and practice things that the priests think are long forgotten." Citing Nietzsche, Baudelaire, Wilde, and the famous dandy Barbey d'Aurevilly, he noted that "there is today an aesthetic gnosis, and it is due not to sensation but to an unprecedented pooling of the means of expression." As boundaries between the arts were being blurred—as artists aspired to paint sonatas and fugues, and composers sought to unfurl aural landscapes—it was all becoming one vast adventure without constraints, but also without any safety net.

This prospect had been gleaned as early as the 1790s by German Romantic writers like Novalis and Friedrich Schlegel, who decided that each artwork in any medium was obliged to convene its own genre. That is, the work was simultaneously performance and theory. Ball felt this pressure in conspicuously religious terms. Works today, he wrote, "all contain a philosophy of their own justification . . . the works all contain a ground plan," by which he meant something like a blueprint (he was delighted to find Janco agreeing with his notion that Picasso's Cubist works resembled architectural plans). "The painters and poets become theologians," because "art is being changed into philosophy and religion in its principles and on its very own territory."

Unlike other theorists and commentators on the arts, Ball had little interest in writing a treatise and making a case for Dada. He simply wanted to know what was happening to him and his friends. "The nervous systems have become extremely sensitive" as the arts bled into one another, filling the gap previously filled by religion. "Absolute dance, absolute poetry, absolute art—what is meant is that a minimum of impressions is enough to evoke unusual images. Everyone has become mediumistic."

As Galerie Dada ran its course, Ball reflected on the abstract art it championed. Would it merely revive the ornamental and decorative? Were Kandinsky's bold and colorful abstract swirls ultimately destined for sofa fabrics, something to sit on rather than hang on a wall? He worried about

the consequences. We only have scruples about the artwork, he thought, and leave the artist behind as a lost cause, a sorry case. But *that* was to reduce the artist to an ornamental adjunct of the work—ultimately a pauperized outcast, the dregs of *la bohème*.

Then, Ball scribbled down this bolt out of the blue: "It is perhaps not a question of art but of the uncorrupt image." He was returning to a thought he'd ventured the previous year: "To understand cubism, perhaps we have to read the Early Fathers." Dada, finally, had pointed Ball back to the roots of Christianity.

Ball still harbored dreams from before the war, when he was in Kandinsky's circle, and Dada was as close as he'd come to realizing them. This set him apart from the others in his cohort, for whom Dada was beginning to seem like a precious stone in a fairy tale—the key to the kingdom, but what kingdom? Tzara felt there was nothing magical about Dada; it was simply a vocational opportunity, one that he tackled with the diligence of an aspiring law clerk. Ball didn't have career ambitions like Tzara, but he had many interests ranging from politics to mysticism, with Dada tantalizingly dangling midway between the two.

Ball's "break" with Dada after the magic bishop performance was tentative at first, but after another round in Galerie Dada he stepped away for good. As he had promised his sister upon returning to Zurich, he would finally focus on his writing—but he would do so from the mountains, rather than from Zurich. He and Hennings left the city again in June 1917.

Ball was off to higher altitudes again in a "flight out of time"—the title he gave his Dada diary. When the book finally appeared a decade later in 1927, it had the same title—*Flight Out of Time: A Dada Diary*—but it left unanswered the question of what Dada was. In it, instead, Ball documented what Dada had seemed to be in the heat of the moment. He also labored over his own past, preserved in countless diaries, with the tenacity of a wood carver fashioning a nativity scene out of a walnut. Ball's return to Catholicism—a transformation that would occur in 1920—had by this time definitively marked the Dada years as a time of spiritual exile for the poet, and it was only late in the book's composition that he realized it needn't be issued by a Catholic publisher. It was, after all, a record of personal struggle that had the universality of St. Augustine's *Autobiography*, Rousseau's *Confessions*, and Baudelaire's *Intimate Journals*.

Ball struggled with the task of shaping his diaries; preserving their fragmentary nature wasn't an obvious solution. He even considered drawing on them for a work of fiction in the venerable German tradition of the bildungsroman, the novel of personal development. In the end, he opted to preserve the spirit in which the notes had accumulated over the years, a potpourri of quotations from his eclectic readings, accounts of events, private handwringing, transcriptions of memorabilia, and aphorisms lodged into the prose like precious stones glinting out from the trodden ground—remnants of spiritual detonations.

As the record of a struggle, Ball recognized that *Flight Out of Time* needed to align the personal with the political, so the entries begin in 1914, just after the war was under way. The decade following the Great War yielded several combat masterpieces: *Storm of Steel* by Ernst Jünger, *All Quiet on the Western Front* by Erich Maria Remarque, and *Under Fire* by Henri Barbusse (which Ball translated into German). Maybe *Flight Out of Time* belongs in this august company, as a record of another sort of trial in the midst of the war, however far from the trenches.

Yet confining it to the category of war literature doesn't do justice to Ball's strangely insinuating book, acknowledged by other Dadaists as a genuine work of wisdom literature, as intense, probing, and enigmatic as its author, "a great artist and even greater human being," in Huelsenbeck's estimation. "Discard the Ego like a coat full of holes," Ball ruminated in *Flight Out of Time*. "But man has many Egos, just as the onion has many skins. It is not a matter of one Ego more or less. The center is still made of skins."

In composing his diary of the Zurich days, Hugo Ball had shed the skin of Dada—yet he did so knowing that another layer of Dada would be found beneath it, in an endless process of self-overcoming powered by Dada's peerless dynamic of yes-no. "Hardly anyone has exceeded my really intractable self-will," he observed. "It went politically as far as anarchy and artistically as far as dadaism, which was really my creation, or rather, my laughter."

Beyond the laughter, and beyond despair, was Ball's personal pledge, his affirmation of life against the odds: "I realized that the whole world, falling into nothingness all around, was crying out for magic to fill its void, and for the word as a seal and ultimate core of life. Perhaps one day when the files are closed, it will not be possible to withhold approval of my strivings for substance and resistance."

3

FANTASTIC PRAYERS

Dada, which came to fruition first at Cabaret Voltaire and then Galerie Dada, was uniquely suited to the milieu of wartime exiles in Zurich. The Dadaists, like other exiles, were all too aware that the artistic milieu they'd left behind was in danger of extinction. At the same time, their international orientation made them receptive to avant-garde initiatives wherever they arose. Because the Dadaists were in contact with other vanguard artists and writers in the combatant nations, news of Dada spread. Local press coverage from Zurich was also disseminated abroad. As long as the war kept free movement in check, however, there was little chance of Dada crossing the border.

Or was there? Not all the Dadaists were content to linger in Zurich. Tristan Tzara's dreams of getting to Paris were on hold, but his case was complicated; he was formally stateless, his native Rumania withholding citizenship from Jews. Arp's ties in Paris were extensive, meanwhile, but he was a German citizen, with no inclination to be back in Germany—especially given his newfound life with Sophie Taeuber. Hugo Ball and Emmy Hennings, for their part, were happily ensconced in the Alps once more. Richard Huelsenbeck had gone into a tailspin of despondency after Ball and Hennings decamped to the mountains from Zurich for a second time.

Without the bearings provided by Ball, the grand circus of Dada seemed to have packed up its tents, leaving behind little more than an empty sawdust ring and nostalgic memories. It was some consolation, perhaps, that the publishing initiative launched with *Cabaret Voltaire* was gaining momentum. In September and October two more books appeared, each by Huelsenbeck with illustrations by Hans Arp: *Fantastic Prayers* and *Schalaben Schaolomai Schalamezo Mai*. By the end of the year, though, Huelsenbeck still had trouble sleeping and continued to be beset by a mysterious stomach ailment, which made his days miserable. In January 1917, he decided to return to Germany—and when he did, he carried with him the spores of Dada, transmitting them to a whole new, fertile host. Indeed, Berlin seems to have been waiting for Dada.

What Huelsenbeck found in Berlin was an inflammation of the body politic that could only have arisen from the demoralized milieu of the imperial capital as the nation slogged into its fourth year of war. Being in Berlin was like "bedding down on a volcano," Huelsenbeck wrote. Dada, he sensed, was just the thing for seismic events in the offing.

Huelsenbeck could hardly help recalling that only two years earlier he and Ball had hosted a poetry reading protesting the war in the German capital. Such a thing had been bold at the time, but the Berlin Huelsenbeck had left in 1916 was no longer convulsed with the patriotic fever of 1914, although it was still smugly confident of victory. This confidence, however, was unwarranted.

Public awareness of Germany's actual plight was compromised by the censorial grip of the German high command on the press. In the first two years of the war, lists of the fallen were posted in public, but by 1916 the practice was discontinued to stifle awareness of the escalating stakes of that quagmire, trench warfare on the western front.

Ordinary Germans may not have known the true extent of the horrors on the battlefields of Europe, but the home front offered plenty of hardships of its own. The effects of food rationing were compounded by the winter of 1916–1917, the legendary "turnip winter"—among the coldest in living memory, with temperatures dipping to minus 22 degrees Celsius (7 degrees Fahrenheit). The scaffolding around the patriotic *Iron Hindenburg*, a statue by the Victory Column, was being pilfered in the dead of night for firewood, which was strictly rationed.

For most of the populace, hardships were to be expected after several years of war, and making do was the price they were willing to pay for victory. Each new assault was touted as a "final push"—until the next one. For some of the poets and artists Huelsenbeck met or reconnected with in Berlin, the whole affair reeked of a swindle. "None of us had much appreciation for the kind of courage it takes to get shot for the idea of a nation which is at best a cartel of pelt merchants and profiteers in leather, at worst a cultural association of psychopaths," Huelsenbeck attested. Belts were tightened all around, but high society—the court of Kaiser Wilhelm, the military staff, and industry elite—was not subjected to the shortages and rationing. "If you had the money you could go into the back room of almost any restaurant and get roast goose and strawberries and cream, and wash it all down with as much beer and champagne as you could hold," a Berliner later recalled. "Meanwhile, ordinary people were making do on sparrow stew." With wartime constraints, Huelsenbeck wrote, Berlin had become a "city of tightened stomachers, of mounting, thundering hunger, where hidden rage was transformed into a boundless money lust, and men's minds were concentrating more and more on questions of naked existence."

The contrast between high and low in Berlin was muted by the prodigious bustle of a European metropolis second in population only to London. The face of the city, Huelsenbeck found, had "undergone a fantastic change" in little more than a year. The symptoms of modernity had accelerated; the pace of everyday life was frenetic. Compared with Zurich, Huelsenbeck found, "I felt as though I had left a smug fat idyll for a street full of electric signs, shouting hawkers and auto horns."

For one armed with the Dada knack of turning every norm upside down and inside out, "naked existence" was tempting material. The first target of Huelsenbeck's scorn was a compensatory spirituality. "Germany always becomes the land of poets and thinkers when it begins to be washed up as the land of judges and butchers," he observed, applying his rhetorical whip to the afflatus of soul-mongering he found rampant in German art.

Huelsenbeck had been in this position before. As soon as he got back to Berlin, he started frequenting the old Expressionist circle at the Café des Westens. When he and Ball had struck up their friendship in the city several years earlier, their relationship had thrived on the general atmosphere of Expressionism. "We consider everything Expressionism," he wrote to a

friend at the time, "since we pay less attention to the paintings than the life style. We want a new style of life; we want a new kind of activity; we want a new skin color." (Huelsenbeck premiered his "Negro songs" in Berlin before reprising them at Cabaret Voltaire.) Now, back in Berlin, he was once again on the case of the "new." With his prompting, Dada was about to be the next new thing in the capital, taking its place as one of the many movements now collectively known as modernism.

M odernism is often associated with American poet Ezra Pound's rallying cry to "make it new," which was the title of a collection of his essays published in 1934. Yet his exhortation was a late entry in a litany that went back before the turn of the century, when Symbolism and Decadence were the first indicators of a widespread modern movement. By the time Dada was born in 1916, the roster of isms had multiplied, with Fauvism, Cubism, Futurism, and Expressionism among the more prominent, with the mantra of the new linking them all. "I tried to invent new flowers, new stars, new flesh, new tongues," Arthur Rimbaud enthused in *A Season in Hell* (1873); and in the second edition of *The Gay Science* (1887), Friedrich Nietzsche envisioned a "great health" awaiting special souls in the future. "We who are new, nameless, hard to understand; we premature births of an as yet unproved future—for a new end, we also need a new means, namely a new health that is stronger, craftier, tougher, bolder, and more cheerful than any previous health."

By the time Viennese novelist Robert Musil was writing *The Man Without Qualities* in the twenties, the *new* had become the mantra of the age. "No one knew what exactly was in the making," he wrote, looking back on the golden haze before the war, "nobody could have said whether it was to be a new art, a new humanity, a new morality, or perhaps a reshuffling of society. So everyone said what he pleased about it."

Huelsenbeck's own interpretation of the creative ferment gripping Berlin upon his return in 1917 arose from his prewar ties to Expressionism compounded by the Dadaist insolence he'd honed at Cabaret Voltaire. "The New Man" was his opening salvo in Berlin, an article published in May 1917 in a journal named, fittingly, *Neue Jugend* (New Youth). "The new man transforms the polyhysteria of the age into a genuine understanding of all things and a healthy sensuality," he wrote, forecasting a figure he would soon promote as the Dadaist, although the article itself made no mention of Dada.

But there was nothing uniquely Dadaist about the expression *the new man*. As Huelsenbeck and his Berlin allies would eventually discover, the new man was equally eligible for service on the right as on the left. The Freikorps (Free Corps) also fancied itself a breeding ground of "the new man, the pioneer of the storm." A volunteer paramilitary group, the Freikorps smashed the Spartacist uprising, a general workers' strike, in January 1919. Ernst Jünger in his popular book *Sturmgewitter* (Storm of Steel, 1920), an account of his experiences in World War I, wrote about this pioneering "new man." His book would later fortify the nerves of those rallying around a youthful Adolf Hitler.

Neue Jugend was edited by Wieland Herzfelde, an aspiring young poet who'd become an ardent pacifist after the horrors of his military duty. He knew of Dada through his correspondence with Hugo Ball. Herzfelde wanted to launch a new periodical, but strict wartime censorship made it difficult to establish provocative publications. Herzfelde came up with an ingenious solution: he bought the rights to *Neue Jugend*. The journal had been pro-war, so retaining the name would give Herzfelde a veneer of respectability. He produced the journal under the imprint of Malik Verlag, a small publishing house he had founded. The word *malik* is partly of Turkish origin, and Herzfelde shrewdly surmised that a company bearing a Turkish name would be perceived as boosting morale, since the Ottoman Empire was a German ally, and therefore not seen as a threat by the authorities.

After a few monthly issues *Neue Jugend* was banned, but Herzfelde found a legal loophole that enabled him to publish weekly. With the precaution of a false address, he produced two weekly editions in May and July 1917 in a tabloid format that gave the publication a thoroughly different look from anything else on the scene. Although not yet presented under the auspices of Dada, the audacious front and back cover design of the July issue has been reproduced in nearly every book written about Dada. Red, blue, and green letters added color to an eye-popping design, from the striking photo on the front page of New York's iconic Flatiron building (with "Advertising Consultation" emblazoned in a red slant across its upper stories—a wry comment on America's recent entry into the war) to the skull and crossbones in a swirl of letters and print icons on the back page. This arresting typographic explosion was actually an advertisement for the first Malik book, a collection of lithographs by George Grosz, whose art and pugnacity would be central to Dada in Berlin.

Advertisement for Kleine Grosz Mappe by George Grosz,
from Neue Jugend, *Berlin, June 1917.*

Wieland Herzfeld and his brother Helmuth had first met Grosz at the studio of Ludwig Meidner. The meeting place was auspicious. Meidner was attuned to the apocalyptic spirit of the age even before the war broke out. "We all hung like Absalom by the hair from the branches of the Zeitgeist," he recalled. "We were confused, high-strung, and irritable. We were driven to the breaking point by the approach of world catastrophe."

Meidner's canvases, full of explosions and carnage and silhouettes of burning cities, are iconic images of a war they oddly predate. Urban squalor, combined with the impact of the Italian Futurists' dynamic city paintings, inspired Meidner to his visions of cataclysmic excess. Walls, bridges, and streetlamps tilt as though buckling with inner unrest, giving way to convulsive hallucinations of total destruction.

It's tempting to suppose Meidner possessed some clairvoyant sense of the imminent war, but the provocation was more mundane. In the torrid summer

of 1912, he was exuding these apocalyptic visions like a fever sweat. "July had beaten my brains to a froth with its implacable brightness and the white, noiseless heatstroke. But August pinioned me like a bird of prey, hacking at me with its beak," he recalled. "August has a stale, sour smell of diarrhea and dead bodies." Accordingly, "My brain bled dreadful visions. I could see nothing but a thousand skeletons jigging in a row."

For the Herzfeld brothers and Grosz, there could've been no more fitting venue for their first meeting than Meidner's studio. Grosz stood apart from Meidner's bohemian circle by his dapper appearance: "His ash-blond hair was flawlessly cut, and the part as precise as the crease in his trousers," Wieland recalled. Grosz prided himself on his stylish American clothes. ("Being German always means: to be tasteless, crude, ugly, fat, inflexible—it means being unable to climb a ladder at forty, and being badly dressed," he wrote to a friend.) So debonair did Grosz appear, in fact, that he succeeded in presenting himself as a businessman from Holland with a zany scheme to conscript war cripples to fabricate desk ornaments out of spent shells from the battle zone. These would be hand-painted with Iron Crosses framed in ivy, bearing inscriptions like "Every Shot Hit the Spot."

Herzfelde was unsettled by this odd fellow: Was he really Dutch with such a perfect Berliner accent? How did he end up in the bohemian atelier of an artist like Meidner? So he later tracked Grosz down in what turned out to be an artist's studio, a kind of "wigwam" someone called it, the walls covered with sketches and memorabilia of the Old West, along with photographs of Thomas Edison and Henry Ford on which Grosz had forged their signatures. Thus began a fast friendship that made Malik Verlag into a publishing force for years to come and cemented Grosz's reputation as an artist.

Although his father had died when he was six, Grosz had a happy childhood, roaming freely in the woods playing cowboys and Indians. His lifelong adoration of America fed on the mythos popularized by the novels of Karl May, which established a vogue for the American West that persists in Germany to this day. His artistic inclinations bloomed early, with a humorous bent that over time grew more sharply satirical. Even before the war he had a dim view of humankind, confirmed during his military service. In a letter to a friend he concluded a desperate rant with a quote from Zola: "Hatred is holy." As German artist Hans Richter later reflected, "Grosz was a genius of hatred, but he hated his need to hate." He finally snapped, assaulting a

sergeant, and was on the verge of being executed, saved only by the interven-
tion of Count Harry Kessler, lifelong godfather of artists everywhere. As a
result, Grosz was deemed "permanently unfit for war"—to which he might
have said he was born that way.

By the time Grosz met the Herzfeld brothers, he'd developed a style
befitting his outlook and a channel for his rage. Inspired by bathroom graf-
fiti and children's drawings, Grosz reduced the world to a tangle of sticks
from which human features jut out as part of the general wreckage. An
apparently bucolic scene is revealed by its title to be the setting for a mur-
der. Streets seethe with purposeless animation. A group of sex murderers
calmly play cards next to a mutilated corpse. He drew his inspirations from
the den of iniquity Berlin was becoming. His head was filled with Meidner-
like visions of a cityscape careening out of control. Writing to a friend, he
revealed:

> I am up to my neck in visions—and this work means to be exclusive emo-
> tions, bouncing excitement, buzzing street front on paper! or whoosh!
> a starry sky circling above a red head, a tram bursting into the picture,
> telephones ringing, a woman in labor crying out, while knuckle-duster
> and flicknife sleep peaceably in the pimp's sticky trouser pocket—ah
> and the labyrinths of mirrors, you magic street gardens! where Circe
> changes men into swine, funny loden hat with tuft of feathers or the rum-
> tum-tiddly walk at the Pathéphon, where the receiver clings to the ear and
> the music of the gramophone, palm trees are ships in which you sail away
> on the songs of the signboards, you golden umbrella, the round dance of
> the letters—and the port-red, wine-sodden nights where the moon is side
> by side with infection and cursing cab drivers, and where strangulations
> take place in dusty coal cellars—oh emotion of the big cities!

One of Grosz's ways of handling this sensorial onslaught played out along
lines diagnosed by sociologist Georg Simmel and numerous psychoanalysts:
that is, through an alter ego, or in this case a plurality of them. Lord Hat-
ton Dixon, Dr. William King Thomas, Graf Ehrenfried, Ritter von Thorn,
Edgar A. Hussler, and Graf Bessler-Orffyré were among the names Grosz
signed to letters during the war years. They were not all fictitious. Bessler
was a notorious con man, and Grosz had in his possession the death mask

of Dr. Thomas, a ship owner who blew up his own vessel for the insurance windfall (killing the passengers, he miscalculated, would surely make it seem like an accident).

Grosz's dalliance with names took a personal turn when he changed his own from Georg Gross to George Grosz. The added *e* Americanized his name in keeping with the stylish American wardrobe he favored. The Herzfeld brothers followed suit. Wieland Herzfelde added the *e* to his last name after his poet friend Elsa Lasker-Schüler spelled it that way in print, and brother Helmut adopted a common English first name, John, with an anglicized version of his last name, Heartfield. Like Grosz, he was taunting his fellow citizens in the midst of the war with this enemy moniker. After all, he'd been ignominiously dismissed from the army as "unworthy of wearing the Kaiser's uniform." But the same qualities that made him anathema to wartime Germany made him a perfect fit for Dada.

Huelsenbeck found in *Neue Jugend* and its ferocious trio—Grosz, Herzfelde, Heartfield—a vehicle for resuming Dada in a new locale. In May 1917 he confided as much in a letter to Tzara; by August he was boldly declaring, "We have created a movement here in Berlin, which in size compares to the Dada movement in Zurich." Huelsenbeck went on to outline plans for more publications and for an exhibition, asking Tzara for publicity materials, stressing that "everything depends on quick action."

It was not until January 22, 1918 that Dada made its premiere in Berlin, but even then it was unofficial and seemingly impromptu. The occasion was a literary evening in which Huelsenbeck was slated to read with a few prominent Expressionist writers at the I. B. Neumann Gallery, which had recently emerged as a prominent venue for dissident art.

Huelsenbeck usurped the occasion by announcing to the audience that the evening was intended as a show of support for Dada, "a new international 'art movement' founded in Zurich two years ago," and that he was honored to be its official delegate. He gave a quick synopsis of Cabaret Voltaire with its "beautiful negro music," its "frenzy of kettle-drums and tom-toms," and its "ecstasy of two-step and Cubist dances." All very fine until he took the pacifist crowd by surprise, declaring (untruthfully, but in the spirit of Dada contradiction): "We were pro-war and Dadaism is still pro-war today. Collisions are necessary: things are still not cruel enough."

Gallery owner Neumann was on the verge of phoning the police, but Huelsenbeck's friends dissuaded him. Compounding the impression of Dada as uninhibited insolence, Grosz also read a few poems, written with dashes indicating pauses when he'd do a little dance. At one point he flamboyantly mimed pissing on a painting by the eminent artist Lovis Corinth, assuring the outraged audience that urine made a wonderful varnish. Afterward, the other participants were chagrined to find themselves identified in the press as proponents of Dada, when in fact only Huelsenbeck and Grosz had demonstrated any understanding of what that actually meant.

A few days later Huelsenbeck announced in a press release the formation of Club Dada, which henceforth became a clearinghouse for the movement in Berlin. Finally, on April 12 an official Dada evening was held, at which Huelsenbeck regaled the audience with a typical Dadaist manifesto, mingling perspicacious observations with taunts and buffoonery. Lauding the most exceptional artists as those who "every hour snatch the tatters of their bodies out of the frenzied cataract of life"—life recast in the image of the trenches—he went on to offer a cogent characterization of Dada as "the international expression of our times." As he explained, "The word Dada symbolizes the most primitive relation to the reality of the environment; with Dadaism a new reality comes into its own. Life appears as a simultaneous muddle of noises, colors and spiritual rhythms, which is taken unmodified into Dadaist art." But this was an odd art, one that "for the first time has ceased to take an aesthetic attitude toward life." This challenging assertion might be grasped by the audience, but Huelsenbeck had the temerity to close his address by insisting "to be against this manifesto is to be a Dadaist!"

Berlin's Club Dada now had an ad hoc contingent, consisting of Wieland Herzfelde and his brother John Heartfield, Huelsenbeck and Grosz, along with funerary architect and megalomaniac Johannes Baader, the artists Raoul Hausmann and Hannah Höch, poet and cabaret performer Walter Mehring, anarchist Franz Jung, and a few others. Although Huelsenbeck appended nineteen names to the "Collective Dada Manifesto" he read in April, the only Berliners were Grosz, Hausmann, and Jung. It was rare for all the Berlin Dadaists to be unanimous in their views and projects. In Zurich there had always been shifting if momentary alliances within the group—Ball found the tendency curious enough to comment on it in his diary—but it was different in Berlin, where personal connections preceded Dada.

There quickly emerged two central cliques of Dadaists in Berlin. The Herz-feld brothers were inseparable. Having been orphaned when quite young, their "family" was just the two of them. When Grosz came along, then, they idolized him, making the trio a primal unit with or without Dada. Grosz's fiancé was alarmed, actually, by the puppy-like devotion showered on him by Heartfield in particular. Hausmann and Baader had been friends for a decade, forming the core of another duo, complicated by Hausmann's relationship with Han-nah Höch, a stormy extramarital affair that persisted for six years.

A handful of other participants rattled around the periphery of these two trios. In the public events the group organized, up to a dozen people might be involved, but afterward the organizers and other participants tended to retire to their separate cells. As it evolved, then, there would never be any fully inclusive Dada enterprise in Berlin. Even the most comprehensive event—the 1920 Dada Fair—went on without Huelsenbeck, though his many publications that year made him conspicuous as the foremost spokesman for the movement.

Huelsenbeck's sporadic involvement in Dada activities after the initial eve-nings in 1918 reflected his professional obligations, though others presumed he was just reluctant to put himself on the line for the cause. Resuming med-ical studies after returning from Switzerland, Huelsenbeck was obliged to do his residency and eventually became a certified practitioner. Much of the twenties, in fact, he spent globetrotting as a shipboard physician, and after emigrating to the United States, he had a successful psychiatric practice in New York. His psychiatric training was put to good use in a novel, *Doctor Bil-lig at the End*, chronicling the downward spiral of its protagonist as he plunges deeper and deeper into the hedonistic, profiteering mood of wartime Berlin. "People accumulated like high waves, breaking over his head," Huelsenbeck wrote, finally drowning Billig altogether.

With his own involvement diminished by professional obligations, and the personal alliances preceding Club Dada, odds were against Berlin Dada becoming the cohesive movement Huelsenbeck had intended. Instead, Dada became a banner flown over artistic tendencies already under way, a flag marking an island in the midst of a city, and a nation rapidly coming apart at the seams. Germany seemed to be disintegrating—but for Dada the collapse offered a unique opportunity to make an impact.

The April 1918 Dada evening was held a few weeks after Germany launched its costly and ineffectual spring offensive on the western front, the last gasp of

Prussian military arrogance. As Dada established its foothold in Berlin, the nation precipitously lurched toward a disastrous end of the war. Signs of crisis arose four days after the first Dada evening, when three hundred thousand marched in the capital to protest a 50 percent reduction of the bread ration. Despite the inability of the German army to sustain its vaunted spring offensive and the losses incurred by the Allies' counteroffensive, delusions of glory persisted. As late as September 27, Berlin newspapers were announcing that the war was won, and military commander Erich Ludendorff assured the kaiser that victory was in his grasp. Yet within forty-eight hours the kaiser was advised to seek an armistice and establish a parliamentary government. "My abdication is out of the question," he proclaimed. "The army and the people are firmly behind me! It's just that damned Berlin that's against me!"

Things rapidly unraveled from there, and the imperial house of cards collapsed in November. The navy mutinied at the Kiel shipyards, which averted a lunatic suicide mission sought by the top brass. The mutiny instigated more revolutionary action, as strikes and demonstrations spread throughout Germany. The kaiser was forced to abdicate on November 9, and the armistice was signed two days later. Simultaneously, a German Republic was declared by rival groups: Philipp Scheidemann of the German Socialist Party and Karl Liebknecht, leader of the Spartacus League. The stage was set for violent civil strife that would play out in the streets of Berlin into the following spring.

For the Dadaists, much of this unfolding cataclysm still lay in the future—but for the time being, Germany's worsening condition put them at risk. Three days after the Dada evening, Raoul Hausmann was arrested and briefly detained. The police commissioner "naturally treated me like a criminal, a conspirator against the government," but Hausmann was intrigued to find that "he took my Dadaist typography of the cover of *Freie Strasse* as a secret code." His reference was to a special issue of an older journal sometimes taken to be a one-off issue of the *Club Dada* periodical. The authorities were just as likely to suspect something clandestine in the publisher's ad for Huelsenbeck's novel *Billig*, decked out in typography indebted to the Italian Futurists' "words in freedom." Adapting display type practices from commercial media like posters and newspapers, *parole in libertà* (words in freedom or free-word poetry) exploded the prim decorum of the literary page. (Tzara, back in Zurich, was urging the same approach: "Each page must explode,"

he stressed in a manifesto.) Berlin Dada became a hothouse of liberated typographic design.

The emancipated aesthetic of *Die Freie Strasse* (The Open Road, a title inspired by Walt Whitman's "Song of the Open Road") carried other resonances, since the journal was edited by Franz Jung, anarchist exponent of the sexual liberation preached by renegade psychiatrist Otto Gross. Anyone familiar with David Cronenberg's film *A Dangerous Method* will have seen Gross portrayed by Vincent Cassel as an impish threat to the psychiatric propriety of Sigmund Freud (Viggo Mortensen) and C. G. Jung (Michael Fassbender). Gross was an incendiary figure, disseminating his controversial views in professional journals as well as organs like the avant-garde Berlin magazine *Die Aktion*. He claimed that the Freudian psychology of the unconscious was inherently a revolutionary doctrine and should lead to a sexual revolution that would depose patriarchy. He practiced what he preached: in a single year he fathered children with three different women. In 1913, at the age of forty, he was committed to an insane asylum at the behest of his father, a prominent high court judge, who also seized custody of Otto's son against the mother's wishes. Artists and intellectuals throughout Germany rallied to Gross' defense, inveighing against the father's actions as the height of patriarchal abuse. Hugo Ball's Munich journal *Revolution* devoted an entire issue to rally support for Gross.

By presenting the Club Dada issue of *Die Freie Strasse* at the Dada evening in April 1918, Dada made its debut in a loaded ideological framework. This was clear enough in a subsequent ad for Club Dada, which listed among the perks of membership some putative "Dada-medical facilities" as well as a "Dada-detective institute; the advertisement section; the central institution for private male and female care; the Dada-school for the renewal of psychotherapeutic life-relations between children and parents, spouses, and those that once were or intend to become such." Similar appeals soon filled the flagship publication *Der Dada* (The Dada), a taunting title that turned Dada into a thing or artifact, but without any clarification as to what it was. Even *Der Dada* seemed uncertain: "What is Dada?" the journal asked, "an art? a philosophy? politics? a fire extinguisher?" Keep the public guessing, that was the strategy. Behind it all was that universal language of the twentieth century, the sales pitch. "Advertise with Dada! Dada spreads your business around the world like an infection!"

Der Dada was filled with such tongue-in-cheek appeals. In an article called "Invest Your Money in Dada!" in the first issue, a religious note intrudes. "Gautama thought he was going to Nirvana, but when he died he found himself not in Nirvana but in *dada*. The *dada* hovered over the waters when the dear Lord created the world, and as He spoke: Let there be light! instead of light there was *dada*." This pastiche blending Buddhism and Christianity is silly and serious at once, poised on the fulcrum of what the German philosopher Mynona called "creative indifference": *believe it or not*, Dada seems to say, stealing some thunder from Robert L. Ripley's syndicated feature.

Raoul Hausmann frequented Franz Jung's circle, and when Dada came along it seemed natural to him that Jung would be part of it. But it was a fitful match at best, since Jung was more interested in the unfolding political crisis than in making (or unmaking) "art." He could even be dangerous: when drunk, he had a nasty habit of discharging his pistol into furniture and walls, seemingly oblivious of others. He also passed on a cocaine addiction to John Heartfield. In the spring of 1920, shortly after the Kapp Putsch (an attempted right-wing military coup), Jung somehow commandeered a boat and sailed it to Russia, where he presented it to the Bolshevik government in tribute. "Communist, Poet, and Pirate" read headlines in the press. For his part, Hausmann got to work organizing Dada evenings, resentful that Jung wasn't pitching in. No matter, as he found the Herzfeld brothers and Grosz had energy and ideas to burn. Besides, his old pal Johannes Baader formed a lunatic fringe of the Dada movement all by himself.

Nobody else in Club Dada got as much press coverage. An architect specializing in funerary monuments and a decade older than any of the others, Baader's notoriety preceded Dada. He had been discharged from the military with an official certification of insanity—something that proved a godsend, as it provided a buffer of legal immunity for his flamboyant public actions. In July 1918 Baader issued a proclamation demanding he be awarded all five Nobel Prizes. In the ensuing flap in the press, a journalist called him the Oberdada, or Superdada.

Other members of Club Dada lost no time in finding suitable honorifics for themselves: Propagandada (Grosz), Weltdada (Huelsenbeck), Progressdada (Herzfelde), Monteurdada (Heartfield), Pipidada (Mehring), and male and female Dadasoph and Dadasophin (Hausmann and Höch). In addition,

they came up with several compound names they called "psychofacts": Grosz-field, Hearthaus, and Georgemann. Hausmann and Baader sealed their part-nership with several photomontages merging their heads like Siamese twins. Not content with being the Oberdada, Baader amplified his title to the max: he was "Superdada, President of the Earth and the Globe, Chairman of the Last Judgment, Real Secret Chairman of the Intertellurian Superdadaist League of Nations."

On November 17, less than a week after the armistice, the Oberdada in-terrupted a service in the great Berlin Cathedral, berating the priest and the parishioners. A few weeks later he declared himself president of the earth. The next summer, on July 16, he put in an appearance at the National Assembly in Weimar, nominating himself for the presidency and showering the con-stituents with Dada propaganda. When the Versailles peace treaty was being negotiated that year, he offered his services. He also ran a candidacy for the Re-ichstag as representative for Saarbrücken, capital of a southern German state.

A figure of topical notoriety—catnip to the press—Baader's rank as Su-perdada seemed unimpeachable. He'd been drawn into the developing ma-trix of Dada by Hausmann, who sensed that his old friend was a suitably loose cannon: "Baader was just the man for Dada, owing to his native unre-ality, which went hand in hand with an extraordinary practical awareness." Huelsenbeck was not so sure and warned Tzara: "Watch out for Baader, who has nothing to do with our thoughts. He is at best a crazy theosopher and has compromised Dada in Berlin to such an extent with his idiocies that I can't even get small items into the press."

Huelsenbeck had reason to complain, as Baader's exploits were reported as far afield as Chicago. In the windy city's *Daily News* for Friday, May 9, 1919, a headline read: "Berlin Has New Art as Outlet for Ennui," with the subhead-line, "Da Da Ismus is latest fantastic fad to smooth nerves of German capital." The article was on the page reserved for bulletins by foreign correspondents, and the author was the American journalist Ben Hecht, assigned to report on the demoralizing impact of draconian reprisals imposed on Germany by the Versailles Peace Treaty. (Hecht would go on to become a screenwriting ace in Hollywood, with *The Front Page, Scarface, The Twentieth Century, Nothing Sacred, Spellbound,* and *Notorious* among his credits.) As Hecht later admit-ted, he knew nothing of German politics and less about art, so he was easily beguiled into reporting that "Da Da is a new art of government." At one of the

Dada soirées, he found it attended by "women of wealth and men of distinction," who reveled in its disclosure of "the imbecility of life."

Hecht filed a follow-up report depicting the Oberdada as leader of the movement: "Stands on His Head to Conduct Meeting" read the headline. Most of Hecht's coverage consisted of quotes from Baader, who comes across as a sensible guide: "In the nonsense of Dadaism lies the only real sanity Germany has ever achieved. The only sane people in Berlin tonight were those who attended our evening."

As Huelsenbeck feared, Baader was an old hand at dealing with the press. What's more, he was a megalomaniac of the first order. In one issue of *Der Dada* he published "An Advertisement for Myself," insisting that only he among the prominent personalities of the age was truly world historical. "Hindendorf, Ludenburg are not historical names," he wrote, swapping syllables in the names of German military commanders (Hindenburg would become president of Germany in 1925, and Ludendorff was allied with Hitler in the 1923 Beer Hall Putsch). Such outsized personalities became too much for Huelsenbeck to bear. Eventually, he would be edged out of Club Dada, if not by Baader himself then by Hausmann—although not before the three of them took to the road with their incendiary Dada program, which played in a half-dozen German cities.

But as Dada negotiated the rocky political shoals of revolution and the shaky commencement of the Weimar Republic, Baader proved to be the figure it needed: outsized, verging on self-parody, yet completely straight-faced and altogether unembarrassed. Only Baader would have the gall to write his own obituary—and then, the next day, follow it up with an announcement of his resurrection. The first issue of *Der Dada* was published in June 1919, but is prominently dated AD1, with an explanation: "The new era commences with the death-year of the Oberdada."

To be sure, others in Club Dada played an essential role in Dada's spread too. A manifesto by Hausmann, Huelsenbeck, and Jefim Golyscheff, "What Is Dadaism and What Does It Want in Germany?" was inserted in the inaugural issue of *Der Dada* as a flyer. In it, they demand the Dadaist "simultaneous poem" be adopted as the Communist state prayer, the "obligation of all clergy and teachers to abide by the Dadaist articles of faith," and "immediate regulation of all sexual relations in compliance with the views of international Dadaism through establishment of a Dadaist sexual center." The manifesto was reprinted in papers throughout Germany. Baader's

shenanigans, along with any reports of Club Dada, were likewise gobbled up by the press, which was only too happy to add a bit of levity to the grim fodder that made up the daily news.

Even today it's impossible to distinguish between Baader the megalomaniac—he consistently presented himself as the prophet-successor to Jesus (using the pseudonym Johannes B. Krystuus)—and Baader the conceptual artist, whose art was consumed and extinguished in performance. His treasured manuscript HADO (Handbook of the Oberdada) disappeared, a monumental scrapbook about which Baader wrote at length and with unrestrained hyperbole to Tzara, calling it nothing short of the Last Judgment, and "its author is the Supreme Judge more truly than WILSON and CLEMENCEAU and LLOYD GEORGE. Despite the fact that the peace instrument was signed on June 28 at that Versailles carnival, the book HADO was given to the public in the silence of Berlin at the same hour." He'd tried unsuccessfully to get Hecht to buy HADO: asking price, $50,000 (roughly half a million today).

In the aftermath of Germany's collapse, Berlin filled up with demobilized soldiers. "Each evening these idle hordes are sucked up like a thin layer of sludge into their houses," wrote Alfred Döblin in his novel about the November revolution of 1918. "But in the morning some gigantic hose sprays them back out into the streets, where they trickle about for hours on end." In January 1919, Spartacus League leader Liebknecht and the German Marxist Rosa Luxemburg were murdered while under detention. The killers were as good as pardoned: one was charged not with murder but with illegally disposing of a corpse, another of attempted manslaughter.

In February the Dadaists published a striking newspaper with the saucy name *Everyman His Own Football*, a title perfectly capturing the political chaos. The front page brandished an image of a ladies' fan bearing the heads of leading politicians, with the headline "Who's the Fairest of Them All?" Walter Mehring came up with a unique way of distributing the publication: with a horse cart carrying a brass band, the Dadaists traversed the city, each hawking the titles of his personal contributions. Going from fashionable Charlottenburg in the west to the working-class district in the east, they managed to sell all 7,600 copies.

Malik, Club Dada's official publishing house, was fast becoming a successful commercial venture, its fortunes buoyed by the explosion of leftist

sentiment in Germany. When the Spartacists founded the Communist Party of Germany at the end of 1918, Grosz and the Herzfeld brothers were among the first to join, and in January they launched a magazine called *Die Pleite* (Bankruptcy) as a political organ relying largely on Grosz's spidery drawings, like his depiction of a skeleton before a military board being declared "Fit for Service." It says much about the mood of the time that they were able to sell as many as twelve thousand copies of each issue.

Political commitment was not made lightly. During the Kapp Putzsch in March 1919, Grosz was forced into hiding after the right-wing vigilante Freikorps burst into his studio. He survived by claiming he was someone else, producing false papers to prove it; Grosz's near-pathological maintenance of multiple identities had saved his life. Such incidents motivated him to obtain a license for a pistol, no doubt gratifying to someone who'd idolized the Wild West in his youth. Meanwhile, Herzfelde was arrested for publishing *Football* and spent two weeks in prison, released only through the efforts of Kessler. After hearing Herzfelde's account of his experiences while in lockup, the count wrote in his diary: "His descriptions of them are so dreadful that I feel sick with nausea and indignation."

Meanwhile, Berlin thrived. Kessler was amazed at the sight of streets full of brightly lit jewelry stores imperturbably doing business as sounds of machine guns and grenades were audible just blocks away. "It's as if Berlin were an elephant," he observed, "and the revolution were a penknife. It sticks into the elephant, which shakes itself, but then strides on, as if nothing in the world had happened."

If the revolution amounted to little more than a pocketknife, Dada's chances in the public sphere may have seemed about the size of a toothpick. But Germany, fancying itself the bastion of *Kultur* and self-appointed guardian of civilization, had a weak point. And that's where Berlin Dada aimed its modest means, right at the soft center of art, with all its prideful smugness still intact after years of carnage. The "indefinite, general swooning about the world," as Hausmann characterized the newfound glamour of Expressionism, would have to go. As the revolution fitfully persisted, along with the counterrevolutionary reprisals of the Freikorps, Grosz framed the most pertinent question: "The shooting goes on, profiteering goes on, hunger goes on; why all that art?" It would be up to the Dadaists themselves to deliver the point through their own art, a battle of cunning and wit—art against art.

4

DADA HURTS

I
n the first issue of *Der Dada* Raoul Hausmann wrote, "The masses couldn't care less about art or intellect. Neither could we." Perhaps unsurprisingly, given comments like this, Dada has been pegged as an anti-art movement; to wit, Hans Richter's classic study was titled *Dada, Art and Anti-Art*. But the truth is more complicated.

What the Berlin Dadaists had in common (most of them being artists, after all) was their disdain for art institutions like the academies, juries, dealers, and complicit art stylists who promoted an elitist mystification of *Kunst und Kultur* (art and culture). The Berlin Dadaists repudiated the art *racket*, monopolized by "the professional arrogance of a haughty guild," observed Herzfelde. The kaiser patronized the most conservative art, casting over even French Impressionism an aura of ill repute. The Dadaists regarded such patronage as part of a larger delusion evident in German glorification of the military. Conventional art, from the Dadaist perspective, amounted to "a large-scale swindle" and "a moral safety valve." "Dada is forever the enemy of that comfortable Sunday Art which is supposed to uplift man by reminding him of agreeable moments," Huelsenbeck wrote, adding "Dada hurts" to drive the point home.

An example of Dada's rapier wit and its sting is evident in an article penned by Heartfield and Grosz. "The Art Scab" denounced Expressionist painter

Oskar Kokoschka's lament that during the Sparticist uprising a stray bullet had struck a Rubens painting in the Zwinger Museum in Dresden. "The Art Scab" reads like the snarl of a rabid hound with teeth bared and fur bristling, exhorting fellow citizens to beware of the "fangs of the bloodsuckers" like Kokoschka. "We summon all to oppose the masochistic reverence for historical values," Heartfield and Grosz cried, "to oppose culture and art!"

> The title "artist" is an insult.
> The designation "art" is an annulment of human equality.
> The deification of the artist is equivalent to self-deification.
> The artist does not stand above his milieu and the society of those who approve of him. For his little head does not produce the content of his creations, but processes (as a sausagemaker does meat) the worldview of his public.

The concision and clarity of these remarks is meant to cut, leave a raw mark on the mind like the dueling scars famous among the Prussian military caste. But it's also meant in deadly earnest.

Der Blutige Ernst, the title of a journal published by Herzfelde at Malik, translates as "bloody serious." The journal's pages boiled over with Grosz's barbed cartoon sketches. Their stance was explicit and confrontational: "There is no longer room for pretty scribblings and idolization of form." Such artistic niceties had, the Dadaists argued, been complicit in the downfall of Western civilization. In the words of Herzfelde's prospectus, *"Der blutige Ernst* nails down the maladies of Europe, it records the utter collapse of the continent, fights the deadly ideologies and institutions which caused the war, establishes the bankruptcy of Western culture."

Grosz's calculatedly puerile art had a distinctly political edge, challenging the notion of art as "an aesthetic harmonization of bourgeois ideas of ownership." Yet Dada wrath was aimed at a closer target. "Who is the German petit bourgeois to be getting cross about Dada?" Hausmann wondered.

> It's the German poet, the German intellectual bursting with rage because the perfect form of his lardy sandwich-soul has been left stewing in the sun of laughter, raging because he was hit right in the middle of his brain,

which is what is he sitting upon—and now he has nothing anymore to sit on! No, don't attack us, gentlemen, we are already our own enemies.

Artists who pandered to this lardy soul were regarded with utter contempt by the Dadaists.

If Grosz intended his doodles as insults, other Dada innovations were less polemical but no less incendiary, simply because of their novel means of production. Hausmann maintained, "The child's discarded doll, or a colorful rag are more notable expressions than those of some ass who wants to transplant himself in oil forever in the salon." He preferred "the simultaneous perception and experience of the environment": that is, enrichment of the perceptual capacity of the individual, not obsequious catering to the money trail of the art market.

Grosz's sympathies likewise favored the enrichment of perception by any means. For him, the conventional distinction made between fine art and the applied arts was a vestige of the class system. As he developed his expressive style, Grosz's inspiration came not from the fine arts but from children's drawings, graffiti, pornography, even kitsch—anything done with personal urgency. These sources helped him develop the means to fit the moment. As philosopher Hannah Arendt attested, his "cartoons seemed to us not satires but realistic reportage: we knew these types; they were all around us." A *type* doesn't need lavish detail to be recognizable. The smug capitalist, the harried prostitute, a war cripple begging on the street: these were the primal figures Grosz sketched time and again.

Grosz's choice of subjects repeatedly got him into trouble. The first Malik publication of his drawings was confiscated and the plates destroyed by the authorities. He and Herzfelde were fined and later found themselves facing the same charges again: Malik kept publishing and selling Grosz's unflattering visions in more books and journals.

The most prolonged litigation lasted from 1928 to 1931 in a series of trials and retrials arising from his memorable sketch *Christ with Gasmask* for Erwin Piscator's staging of *The Good Soldier Schweik*. The press branded Grosz a political agitator, Bolshevik, and nihilist—not an artist. But his friend and occasional patron Count Kessler saw through the intimidating façade:

The devotion of his art exclusively to the depiction of the repulsiveness of bourgeois philistinism is, so to speak, merely the counterpart to some sort of secret ideal of beauty that he conceals as though it were a badge of shame. In his drawings he harasses with fanatical hatred the antithesis to this ideal, which he protects from public gaze like something sacred. His whole art is a campaign of extermination against what is irreconcilable with his secret 'lady love.'

Grosz's truculent drawings mesmerized his contemporaries. When *The Face of the Ruling Class* was published in 1921, its 6,000 copies quickly sold out, as did two more printings the same year of 7,000 and then 12,000. It may have seemed "propaganda" to political adversaries, but propaganda sells when its target is clear and its message is recognized and appreciated.

Ben Hecht's account of his first encounter with Grosz's drawings in his studio has the snap and crackle that a journalist cum Hollywood screenwriter could summon. Written nearly fifty years later, Hecht sounds like he's still reeling under the impact:

Fever-thin lines, quaint spurts of ink that seemed to crawl on the paper, tipsy walls, spidery streets, leering windows; a half-ghostly goulash of breasts, buttocks, thighs, drooling mouths, murderous eyes, crafty fat necks, and all the strut and coarseness of the overfed subhumans who ran the German world and sported in its German cafes . . . Grosz, as fine a draftsman as Delacroix, and as disillusioned an eye as Daumier, omitted nine tenths of anatomy and structure from his drawings. The result was a "tenth" full of nightmare. It was life that was being violated. His figures scratched at your eyes. Immorality, heavy lipped and heavy uddered, rolled a bovine eye at army officers and financiers who sat belching aloofly on their large, authoritative rumps. Lust, gluttony, brutality, and all the tricks of wearied evil snickered out of the half humans who kissed and killed one another in a world that looked like a demented strawberry box.

Except for writers Huelsenbeck and Mehring, the Berlin Dadaists did produce artworks, though their contemporaries wouldn't have called them that. Heartfield became famous (especially as the Nazis rose to power) for his political photomontages, an artistic innovation that the Dadaists pioneered.

A Dadaist was not an artist but a *monteur*, the German word for "mechanic," and the Dadaists called the work they produced *montage*, a cognate term for assembly-line work. Photomontage and collage would have a huge effect on global culture in the years to come and would become ubiquitous from the 1960s to the Internet age.

Heartfield and Grosz had started doing cut-and-paste works soon after they met. Höch and Hausmann were also immersed in collage. Baader followed suit. Erwin Blumenfeld, like others only momentarily affiliated with Dada, also excelled at the new technique before he rose to eminence as a fashion photographer. Much ink has been spilled identifying who originated the technique, but in fact the explosion of print material in the nineteenth century stimulated ordinary people to cut and paste without claiming the results as art. Picasso snipped bits of newspaper and glued them onto his paintings during the heyday of Cubism before the war. But it was in the Berlin Dada circle that photomontage took wing, "an explosion of viewpoints and an intervortex of azimuths" in Hausmann's heady evocation.

In keeping with the new practices, the Dadaists thought of themselves as mechanics or technicians more than artists in the traditional sense. In one of his collages, Grosz included the line "Marshal Grosz Demands Taylor's System in Painting"—that is, Taylorized production efficiency as in a factory. Grosz had a rubber stamp made, which he used to apply his name to his works in lieu of a signature. Grosz and Heartfield advertised their art in these terms: "Great quality guaranteed in every type of art: expr. futur., dada, meta-mech." This is a send-up of prevailing styles (Expressionism, Futurism, Dada), of course, but the final term was the Dada favorite, standing for metamechanical production. As Hausmann saw it, "The beauty of our daily life is defined by the mannequins, the wig-making art of the hair stylist, the precision of a technical construction!" Accordingly, "we will have to get accustomed to seeing art originating in workshops."

A wave of mechanistic painting and drawing swept through Club Dada in late 1919 after the Dadaists discovered the metaphysical paintings of Italian artist Giorgio de Chirico, and a world of mannequins and jaunty automata blossomed in Berlin. The point was to do away with "expressionistic brightly colored wallpapers for the soul," Grosz declared, replacing it with the "objectivity and clarity of engineering drawing." Inspired by Chirico, Dadaists and other artists populated their works with enigmatic objects (like the outsized

rubber glove suspended from a wall in Chirico's *Song of Love*) and reduced the human form to the anonymous figure of the artist's dummy. This movement spread throughout Europe, ranging from Carlo Carrà in Italy to René Magritte in Belgium and Balthus in France, but German artists seemed acutely receptive in the postwar turmoil—especially Max Ernst during Dada's brief heyday in Cologne. Ernst, a combat veteran, emerged from the war determined to throw caution to the winds in his pursuit of art, expressing it in unsanctioned or unconventional ways. He was wary of Berlin Dada's political aims, but shared the enthusiasm for Chirico. The metaphysical anonymity of Chirico's work proved readily agreeable to the Berliners, who repudiated anything that smacked of self-expression in art.

As Dada took on new forms in Berlin, the man who had brought it there in the first place struggled to keep pace. Despite his medical studies, though, Huelsenbeck found time to write numerous expositions of the Dada movement. It became something of an addiction as the decades went on, his collected ruminations adding up to more than six hundred pages. Between 1918 and 1920, he published eight articles on Dada and three books, as well as preparing a grand compilation called *Dadaco* he'd started planning as soon as he returned to Berlin in 1917. It was never published, but surviving multicolor proof sheets have graced the pages of books about Dada ever since, most famously that of Hugo Ball as the magic bishop.

Huelsenbeck lacked the sense of humor other Dadaists possessed; he brought to Dada a diagnostic outlook befitting a physician. He could even sound pedantic, itemizing the characteristics of Dada like spots on a toad: "One cannot understand Dada; one must experience it. Dada is immediate and obvious. If you're alive, you are a Dadaist. Dada is the neutral point between content and form, male and female, matter and spirit." This is from his introduction to *Dada Almanac* (1920), which opens with an attempt at the sort of conundrum Tzara specialized in: "One has to be enough of a Dadaist to be able to adopt a Dadaist stance toward one's own Dadaism." In this version, Dada sounds uncomfortably close to irony, but even Huelsenbeck would have known there was nothing ironic in the relentless zeal Dadaists applied to their activities. At other points, Huelsenbeck could make Dada sound like a healthy, robust outlook more readily associated with Americans: "Dada is the scream of brakes and the bellowing of the brokers at the

Chicago Stock Exchange." When he declares Dada to be "the international expression of our times," you can faintly feel the tip of the whip he's cracking in the face of Germans, for whom "international" was suspect, as it is for many Americans today.

From the first Dada evening in April 1918 through the end of 1919, there were a dozen public presentations in Berlin, as well as numerous impromptu actions along the way. Grosz would dress up as death, wearing an outsized skull, and, while smoking a cigarette and twirling a cane, stroll up and down Berlin's fashionable Kurfürstendamm. Its commercialism revolted the artist: "Something like a public lavatory atmosphere, you understand, as well as a smell of very rotten teeth." For a politically shrewd April Fool's prank in 1918, Hausmann and Baader notified the authorities of the Berlin suburb Nikolassee that they were dispatching forces to establish a Dada republic there. The alarmed community mobilized its militia in response, two thousand strong, warily awaiting the onslaught of Dada hordes.

Dada seemed exceptionally suited to this time of extreme political volatility. A short-lived Soviet Republic was established in Munich in April, and more than a thousand died in the streets of Berlin in March. While those who attended its soirées might think of Dada as an artistic venture, for most the name circulated in the newspapers as a vaguely revolutionary threat, even a plausible political organization. In any case, programmed Dada evenings were chock-full of unmitigated aggression. Insulting the audience was de rigueur ("you're not going to hand out real art to those dumbbells, are you?"). The Dadaists were out to pick fights, with bared fists. But they also put on skits.

Ben Hecht, the American correspondent who had introduced Dada to the readers of Chicago's *Daily News*, continued to document some of its activities. It's hard not to imagine the punchy dialogue of Hecht's film *His Girl Friday* transmitting some of the Dada spirit, with its mile-a-minute wit, ferocious verbal pace, and political sympathy for the underdog. Of course, Hollywood could never condone the open taunts and bull-baiting tactics of Grosz or Hausmann.

Grosz liked hanging out with Hecht because he was that rare specimen, a real American. Still, Hecht didn't recognize his new German friend when he stepped out onstage in blackface, wearing a frock coat and straw hat and dancing a jig. Grosz was master of ceremonies for "Pan-Germanic Poetry

Contest," in which a dozen scruffy contestants shuffled onstage. When he fired a starting pistol, all recited their poems simultaneously with histrionic gestures. At the concluding shot, he declared the contest a draw. "Recital for the Eye of Modern Music" was another venture, advertised in advance with a proclamation designed to get the goat of any good German: "Beethoven, Bach Are Dead—but Music Marches On." Three damsels in tights came onstage, each placing a canvas on an easel, each canvas bearing a single musical note. Hecht reports the military brass in the crowd grew so agitated shots were fired, followed by demands for the arrest of the Dada hooligans who, in the meantime, had "melted into the spring night." (This sounds like a fanciful report; the Dadaists themselves mention plenty of fisticuffs in their memories of such occasions, but no gunshots.)

Whether or not they led to violence, Dada performances provided a steady diet of antics. Grosz might pantomime a boxing match with a phantom adversary, or go through the motions of painting an imaginary picture. Sometimes, when the audience grew restless, the performers would line up, backs to the spectators, coolly remove their jackets and fold them up, light cigarettes, and stand, smoking and listening to the growing unrest behind them.

On the same evening he had interviewed Baader, the Oberdada, for "Stands on His Head to Conduct Meeting," Hecht had witnessed the famous race between a woman operating a sewing machine and another, a typewriter—a send-up of Taylorist efficiency standards in the workplace. In this as in the other skits he reports, Hecht adds, "no applause." In fact, the Dadaists would've been horrified by polite clapping. They sought catcalls, insults, and groans of dismay and welcomed even the flight of patrons from the venue. All the while, they insisted that the real nonsense was not theirs, but posing as political authority in the fraught world of German politics. That same night, Baader urged Hecht to consider "what compelling examples of sanity were our two friends who participated in the race between the sewing machine and the typewriter," pointedly comparing the machines with the most prominent political figures of the moment: Friedrich Ebert of the Social Democratic Party and first president of the new German republic, and Philipp Scheidemann, provisional president and chancellor of the republic.

These occasions were undertaken in the spirit of a free-for-all. One reporter captured the mood: "The 'artists' appear with rolled up sleeves among the furious audience, screaming, threatening, egging on, sneering. They have

had the success they wanted: they want turmoil; they want nothing but derision, dissolution, smashing up." Because the Dadaists had no consensus among themselves as to what Dada was or what to do with it, they came onstage seething with rivalry and contention. "There's no cooperative planning, no talk of companionship, at most each of us has the same right to raid the till," Hausmann reported to Tzara in Zurich. They turned their mutual antagonisms on the audience like a fire hose. "Since we usually did a bit of drinking beforehand, we were always belligerent," Grosz recalled. "The battles that started behind the scenes were merely continued in public, that was all." All this was a far cry from the festivities of Cabaret Voltaire, where even the contrite Swiss were invited to read their sentimental poems onstage. Any discomfort the performers experienced at the cabaret came mainly from the manic pace of producing shows nightly. Berlin Dada performances were in galleries and concert halls, at a price point where the audience consisted of the bourgeoisie: those "respectable folks and coupon cutters" ruled by "the spirit of constant profit," not really people at all but "libretto machines with an exchangeable moral disk." The audience was a despised but handy target for these aspiring Communists and hectoring Dada impresarios.

Expert though he was at riling an audience, Raoul Hausmann embarked on a creative venture of his own, one that was more in the tradition of Cabaret Voltaire than Club Dada. His forte was sound poetry, which he likely heard about from Huelsenbeck's account of wordless poems in Zurich. His exploration of "optophonetics," as he called it, persisted beyond Dada. Hausmann had no interest in the singsong sonorities favored by Ball or the faux Africanisms of Tzara. He wanted to reach a primal place, where language had yet to evolve and the human animal vocalized without words. He pioneered a method of making sound effects by enunciating each letter, vocalizing type samples from a print shop or random letters strung together. These resources were the launchpad for producing all manner of sounds from what he called the "chaotic oral cavity."

In this as in all his creative outlets, Hausmann's approach reflects the influence of his friend Salomo Friedländer who, under the nom de plume Mynona (*anonymous* [*anonym* in French] spelled backward), published his philosophical treatise *Creative Indifference*, extolling the indifferent precondition of being. It's the culture that conditions us to make distinctions like that

between good and evil, whereas, Mynona postulates, our essential animal sapience is ready for anything. As Hausmann understood it, there was no reason for a poem with words to be inherently superior to a poem of growls and moans.

How could the saints of the Middle Ages compare, Hausmann wondered skeptically, with "the art of hairdressers, tailor's dummies, and the pictures in fashion magazines"—anything that could inspire and nourish a new approach to life. "We must realize that our customary way of living, with its numb and lifeless impressions, encases us in clichés of reality created by habit and thoughtlessness." Conditioned, conventional perceptions were an impediment to apprehending the new art. Yet "trains, airplanes, photography, and X-rays have pragmatically enhanced visual consciousness today with such powers of discrimination that, through the mechanical enrichment of natural potential, we have been liberated for a new optical cognition and the expansion of visual knowledge in a creative mode of life."

While Hausmann was exploring the frontiers of modern art, and imagined himself adhering to the freethinking standards of his bohemian set, he was conducting a relationship with a fellow artist who was no less revolutionary in her outlook. Hausmann's affair with Hannah Höch lasted the duration of Dada in Berlin. In that strident and aggressive milieu, Höch was tolerated by the others only because she was Hausmann's girlfriend. Yet as Heartfield and Grosz bickered with Hausmann over who pioneered photomontage, they were oblivious to the fact that Höch trumped them all. Would they be chagrined to learn that a century later she would be widely regarded as one of the great twentieth-century artists, master of the technique over which they squabbled? At least Hausmann acknowledged her participation.

When they first got wind of Dada, Hausmann had prompted Höch with the idea that this was just the ticket for the two of them, something they could work on together. But it was a panacea, for their relationship was rocky from the start. Hausmann was married and even had a daughter (born in 1907 when he was just twenty). Not that Höch knew that when their relationship started; after their first sexual encounter on July 3, 1915, Hausmann wrote several poems commemorating them as "husband and wife in touch with the clearest understanding and the purest chastity"—indulging in bourgeois platitudes Dada reviled. The sacred occasion had been out at Wannsee, a popular resort west of Berlin, after they'd read Whitman together—the

American bard being the great literary aphrodisiac for educated Europeans at the time. Yet Höch intuited something was off and a month later reproached Hausmann after he confessed his family secret. "Right from the beginning," she said, "I sensed there was some sort of wall between us."

And so the shuttlecock game between Höch and Hausmann commenced, persisting from 1915 to 1921. It was a classic farrago. Neither could imagine life without the other. Höch hated the fact of Hausmann's marriage, and Hausmann resented the abiding bond Höch had with her family. The couple's relationship could be abusive, judging from Höch's references to Hausmann's brutality. There were abortions in 1916 and 1918, driving them further apart. But other forces drew them together. For Hausmann it was the fertilizing boost of a soul mate. At heart he was lonely, alienated, his creative imagination fired not by a muse in the traditional sense but by real collaboration. In an early letter to Höch he lamented, "Which of my friends does not hate me?" Launched into the adventure of their new cut-and-paste practices, Hausmann clearly found in Höch a source of inspiration, not only because she was a genuine artist, but because she raised the level of his own game.

Hausmann did his best to have his cake and eat it, too. After his marriage was out in the open, he wanted Höch and his wife, Elfriede, to become friends. They did eventually meet, and in the ensuing row, Elfriede ended up siding with Höch. In the end, Hausmann left his wife in May 1918, though it wasn't until 1920 that Höch consented to share an apartment with him, and even then their cohabitation was interrupted by the "flights" Höch took regularly from their relationship, often for months at a time.

The oldest of five children, Höch was artistically inclined from childhood, though for family reasons kept from formal instruction until she was twenty-three, when she entered the School of Applied Arts in Berlin. She was on a field trip with other students to Cologne when the war broke out, after which she worked for the Red Cross before returning to school, this time at the School of the Royal Museum of Applied Arts, where one of her fellow students was George Grosz. In 1916 she started working for Ullstein publishers, a position she held for a decade. This provided her with a steady supply of periodicals like *BIZ* (Berlin Illustrated News) from which she zealously snipped a cache of images for collages.

While Höch was one of the pioneers of the Dada art of photomontage, her official alliance with Dada was through Hausmann and her involvement

was minimal: the Dadaists acknowledged female emancipation but did not welcome women in their ranks. In April 1919 she played pot lids and a toy rattle in Jefim Golyscheff's antisymphony, and at the end of the year she participated in a "simultaneous poem" by Huelsenbeck.

Her most notable contribution to Dada was the collection of photomontages she exhibited in the First International Dada Fair, June–August 1920—and that was only because Hausmann insisted on it. The other organizers, Grosz and Heartfield, resisted, but Hausmann threatened to withdraw his own works if hers weren't included. In this regard, at least, he seems to have been capable of being a supportive mate.

The First International Dada Fair turned out to be the only one of its kind. Though held in Otto Burchard's art gallery, it was not billed as an exhibition but as a "Dada-Messe" (Dada fair), like a trade fair, befitting artists who called themselves mechanics. It was a stretch to call it international, since most of the nearly two hundred works on display were by Germans, mainly Berliners. Ben Hecht and Francis Picabia were token foreigners, with a Dada supplement by way of Max Ernst (Cologne) and Hans Arp (Zurich) to spice the stew. Apart from an ad for an athlete as doorman (read: bouncer), the occasion was devoid of that performance dimension for which Dada had become notorious in Berlin.

The Dada fair was relatively staid, judging from photos of what's likely a preview, since the only people on view were Dadaists and a few of their friends, including architect and future Bauhaus director Mies van der Rohe. In the photos, they are dressed for an occasion, though the occasion might as well be an embassy affair, judging from their attire. For an exhibit plastered with slogans throughout, like "No more Philistine Spirituality" (though *soul-mongering* better expresses the attitude) and "Dada stands on the side of the revolutionary proletariat," the artists in the photos look far removed from the working class.

But if the atmosphere in the photograph was composed, the artwork on display was anything but. Though an exhibition is not a performance in the conventional sense, here in Burchard's gallery the walls were teeming with animation. The catalogue listed 174 works, but references from visitors and journalists make it clear there were quite a few more, all jammed into two

rooms. Framed oil paintings jostled with unframed posters, collages on ea-
sels, overlapping prints on the walls, items hanging literally by a string if not
a thread—all designed to make the eyes spin like propellers on a plane doing
the loop de loop. To top it off, in the smaller room, Baader's *The Great Plasto-
Dio-Dada-Drama: Germany's Greatness and Demise or The Fantastic Life of the
Oberdada* was a veritable gusher of urban refuse.

At first glance a mangy heap, on closer inspection Baader's collection of
objects was a meticulous construction arranged by the architect of funer-
ary monuments. It consisted largely of Dada publications, intact and cut up,
mounted on a pyramid festooned with various objects, including a life-size,
mustachioed mannequin, and topped by a mousetrap. A brochure elaborated
on the structure of the heap, which consisted of "5 stories, 3 parks, 1 tun-
nel, 2 elevators and 1 cylindrical top. The ground level or floor, representing
the fate determined before birth, has no further relevance. First floor: The
Preparation of the Superdada. Second floor: The Metaphysical Exam. Third
floor: The Initiation. Fourth floor: The World War. Fifth floor: World
Revolution. Penthouse: The cylinder spirals into the heavens and proclaims
the resurrection of Germany by way of schoolmaster Hagendorf's lectern.
Eternally." Dada scholar Hanne Bergius calls this the "architecture of the
imponderable"—a phrase even more apt considering Baader's 1906 design for
a Cosmic Temple Pyramid, a colossal structure meant to house universities
(plural), libraries, museums, sports arenas, parks and gardens, pilgrimage
sites, and even "woods and fields and mountains and meadows and brooks
and lakes and rivers and the ocean." Nothing less, Baader admitted, than
a new Tower of Babel. At least *The Great Plasto-Dio-Dada-Drama* visibly
replicated the *babble*, with its profusion of Dada publications from preceding
years.

The sweetest photo of Höch and Hausmann together is at the opening of
the fair. They look almost like teenagers on a first date. He's wearing a plaid
sports cap, shyly holding a piece of paper that she leans over slightly to see.
They stand before a wall of pictures and slogans. One photomontage blurts
out "Dada Advertising"; another reads "Art is dead. What's alive is the new
machine art of Tatlin," a nod to the Russian artist who had sworn off easel
painting and in the wake of the Russian Revolution dedicated himself to
making his *Monument to the Third International*, one of the most iconic art

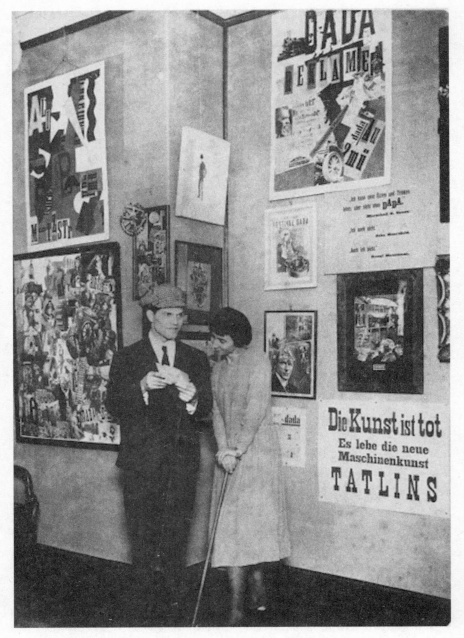

Raoul Hausmann and Hannah Höch at the
International Dada Fair, Berlin, 1920.
Photo by Robert Sennecke.

objects of the twentieth century. Not that the Dadaists were familiar with what Tatlin was up to—they'd just heard about the new turn (soon called Constructivism) under way in the USSR from exiles swarming into Berlin.

Another photo on the wall behind Hausmann and Höch shows a man dressed in a black head-to-toe bodysuit, standing in profile and slightly stooped like he's about to make a jerky move. With a bowler tilted down almost over his eyes, something about his thin angular face makes him a ringer for Fred Astaire. The photo appeared in *Der Dada* 3 as part of a sequence illustrating the Dada-Trott, a variation on the ubiquitous foxtrot, only this one looks like the 1940s comic superhero Plastic Man, squeezed out of a tube and set convulsively in motion on an unsuspecting world.

The Dada fair was a big recycling bin. The organizers gathered together works created in various media and deployed them under the banner of Dada. They called the exhibited works Dada products (*Erzeugnisse*), like commercial goods. The variety prompted one journalist to characterize the show as "an anatomical museum where you can see dissections, not only arm and leg, but head and heart." In fact, the theme of human vivisection was front and center in paintings like *Forty-Five Percent Able-Bodied* by Otto Dix, depicting the war cripples who flooded the streets of Berlin in 1918 and remained all too visible. (When the Nazis included this canvas in their "degenerate art" exhibition in 1937, they branded it a "Painted Sabotage Against the Armed Forces." Then they exterminated the painting itself.) Dismembering the human form was a mainstay of photomontage, in which heads and bodies were cleverly combined with machine parts and industrial products to make hybrid concoctions tacitly announcing the bankruptcy of humanist self-regard.

For some indignant visitors, the fair was a venue that sullied the human form and, worse, insulted the beleaguered military. The most offensive item hung from the ceiling: a dummy dressed in an officer's uniform with a pig snout for a face, titled *Prussian Archangel*. His belt bore an inscription from a Lutheran hymn: "From High Heaven I Descend," and a placard hanging down from the mannequin (reprinted in the catalogue) advised: "To perfectly grasp this artwork, drill twelve hours daily with loaded backpack and combat gear in Tempelhof Field"—a military training ground in Berlin.

This pig-officer was too much for some pious Germans to bear. Prosecutions were brought against the "perpetrators." In the end, Rudolf Schlichter

(who with Heartfield had fabricated the archangel) was acquitted, as was gallery owner Burchard. Grosz was fined 300 marks for the portfolio *God with Us* sold at the fair, and Wieland Herzfelde as publisher fined twice that amount. The plates and remaining copies were seized and destroyed. At the trial, Baader pointed out that Germans might be better respected in the world if they could laugh at themselves. The *New York Times* headline summed it up: "Dadaists on Trial as Army Defamers Charged in Berlin with Insulting the Reichswehr in 'Art' Exhibition Gave Officer Pig's Face Chief of Cult Complains that Germans Lack a Sense of Humor." The alarmist rhetoric of the prosecution proved a self-caricature of official pompousness.

Certainly the year before, when revolution was in the air and combat in the streets, such an exhibition would have seemed an unmistakable act of political agitation, but in the tentative stabilization of the Weimar Republic, it smacked of hoax, not threat. The humorous dimension had in fact been writ large in the press notice written by Hausmann announcing the fair. Composed as a spoof of the pompous official pronouncements to which Germans were accustomed, readers of the June 26 edition of *Berliner Lokal-Anzeiger* were informed: "All Dadaists in the world have delegated their psycho-technical elasticity to the Berlin agents of immortal Dada. Everybody should see the wonder of this psycho-metalogy. Dada overtrumps every occultism." In a dizzying drumroll of words, indulging in the German propensity for compounding nouns with prefixes and suffixes, Hausmann cut loose: "Dada is the clairvoyance of the insight into the viewpoint of any opinion [*die Hellsicht der Einsicht in die Aussicht jeder Ansicht*] about politics and business, art, medicine, sexuality, erotics, perversion, and anaesthetics."

Hausmann's gift for turning the tables on the opposition came to the fore in the exhibition catalogue, printed three weeks after the fair opened. In it, he incorporated the bulk of a negative review: "What you see in this exhibition is of such a low standard you have to wonder how a gallery could get up the courage to show this stuff." Clearly, anyone lured to the fair by such an appraisal could hardly cry wolf when confronted with the Prussian archangel or anything else on display, including a tailor's dummy with a lightbulb for a head, revolver in place of one arm and a doorbell for the other, military decorations pinned to the chest, a prosthetic leg, and a pair of false teeth in the crotch. The title was self-parodying: *The Philistine Heartfield Run Amok.*

Official concerns for the moral well-being of the republic notwithstanding, the Dada fair posed no real threat to German politics or culture. In fact, it may have been the *least* public forum organized by the Dadaists in Berlin. Midway through its two-month run, only 310 admission tickets had been sold. By contrast, the *First Exhibition of Russian Art* at the Van Diemen Gallery in Berlin in 1923 drew 15,000 visitors; the *0.10* exhibit of Futurism in St. Petersburg in 1915 attracted 6,000 in a single month; the legendary 1913 Armory Show drew 88,000 in New York and 188,000 when it went to Chicago; and the Futurist exhibit of 1912 garnered some 40,000 viewers as it toured the Continent after its Paris debut. *Manet and the Post-Impressionists* in London was seen by 25,000, among them Virginia Woolf, emboldened by the experience to declare 1910 the year human nature changed.

None of these attendance figures, however impressive, would be able to rival *Degenerate Art*, the exhibition mounted by the Nazis in Munich in 1937, with over two million, with another million as it went on the road throughout Germany. Certainly far more people saw the work of the Berlin Dadaists vilified there than celebrated at the First International Dada Fair in 1920. Yet there were strange parallels between the two events. The incendiary manner of displaying the art was ironically indebted to Dada, a point not lost on Höch, who attended this infamous exhibit. She was moved to note the almost reverential looks with which the silently attentive crowds viewed this massive cross-section of all that had been most inventive and vigorous in modern art.

The pieces on display at the 1920 Dada fair were perhaps more inventive and energetic than any works of modern art theretofore. As soon as attendees entered, they confronted three huge posters, on each of which was a large photo of one of the organizers accompanied by a slogan. "Down with art," read the caption over the image of John Heartfield, mouth open with hands framing his shout. Hausmann appears on the verge of growling, under the slogan "Finally open up your mind!" Grosz, in profile, looks like a Roman dignitary on a coin, framed by two proclamations: "Dada is the deliberate subversion of bourgeois ideology" and "Dada is on the side of the revolutionary proletariat." Below these images was stationed a young woman at a table selling copies of Malik publications. Nearby were Höch's two Dada dolls and, proudly displayed above, the colorful issue of *Neue Jugend* with the Flatiron Building.

In one way or another, visitors to the fair were exposed to most of the Dada publications, some intact, others cut up in the numerous collages on display. There were a couple of portraits Hausmann had made of friends consisting entirely of snipped publications, and in keeping with the posters at the entrance, the art of self-portraiture was abundant. In Hausmann's *Self-Portrait of the Dadasoph* a pressure gauge and other mechanical parts stand in for the head, the torso consisting of a colored anatomical illustration of a human lung. Grosz's watercolor *The Mechanic John Heartfield, after Franz Jung's Attempt to Put Him Back on His Feet* depicts the artist as a military thug. Grosz portrayed himself as a mechanical compilation along with an unflattering likeness of his new wife in *'Daum' marries her pedantic automaton 'George' in May 1920, John Heartfield is very glad of it*. The original title was in English. Grosz affectionately called his wife, Eve, Maud—the spelling reversed here. Grosz and Heartfield collaborated on a portrait of Huelsenbeck, otherwise missing from the exhibit except for a copy of *Fantastic Prayers*, included more for Grosz's illustrations than for the poems. In a Grosz photomontage, Huelsenbeck's nattily dressed figure floats in a circle framed by a triangle (a variation on Leonardo's Vitruvian man); lacking feet and head, the body is extended by a printed sputter of letters: "dad a dada dadadadadada."

Portraiture extended to other works as well, as in a touched-up death mask of Beethoven, used for the cover of *Dada Almanac*, by Dada-Oz (Otto Schmalhausen). Also on view was an issue of Picabia's magazine *391* with Marcel Duchamp's mustachioed Mona Lisa. In *Disdain for a Masterpiece by Botticelli*, Grosz effaced the famous *Primavera* of the Italian master with an aggressive X. Belligerence abounded, but lighter touches could be found as well. Baader's *Honorary Portrait of Charlie Chaplin* made no effort to depict the endearing film star; instead, the "portrait" was a dense patchwork of cutouts of newspaper headlines and letters glued together like a bird's nest. In Höch's *Da Dandy*, the silhouette of a man swarms with faces of models clipped from fashion magazines.

Höch could be as wittily aggressive as the guys. *Dada Panorama* made use of an infamous photograph of President Ebert and army minister Noske (notorious for his brutality during the Spartacist uprising) bathing at Wannsee, both of them dumpy and unfit. Höch's triumph, and the highlight of the show, was the immense photomontage, cinematically titled *Cut with the Kitchen Knife Dada Through the Last Epoch of Weimar Beer-Belly Culture in*

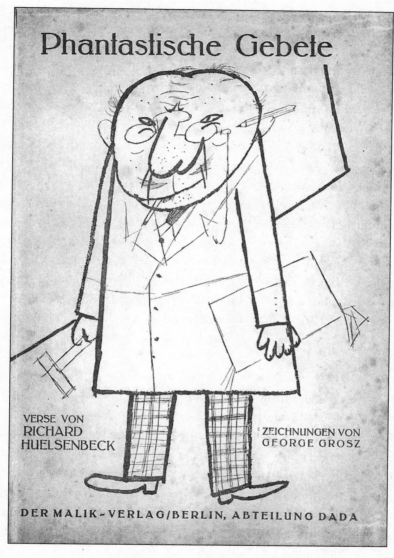

Cover of the second edition of Fantastic Prayers by
Richard Huelsenbeck, illustrated by George Grosz, 1920.

Germany. It's tempting to say it has a cast of thousands. There are crowd scenes, including dozens of recognizable people ranging from Karl Marx and Albert Einstein to most of the Dadaists themselves. Höch's teeming vision merits all the attention it's gotten over the years, making it possibly the most celebrated single work that was on view at the Dada fair.

One of the most iconic productions of Berlin Dada, however, was not at the fair. This was Hausmann's *Mechanical Head: The Spirit of Our Times*, which he said was meant "to indicate that human consciousness was nothing but negligible accessories, pasted on the surface, nothing but a hairdresser's mannequin with a pretty wig." To make it, Hausmann had sanded a wooden bust down to a fine polish, mounted a tin cup on top (a hunting accessory from Höch's father), and run a tape measure down from the cup to the eyebrows. Also on the forehead was a piece of cardboard with the number 22, "because, obviously, the spirit of our time has but a numerical signification." In place of the right ear, Hausmann affixed a jewel box, hanging open so you can see a pipe stem attached to a typographic cylinder. On the left ear, part of the mechanism of a tripod protrudes, onto which is mounted a ruler that rises up like an antenna. Finally, he glued a wallet on the back (looking somewhat like a mullet).

In *Mechanical Head*, the "new man"—heralded by Huelsenbeck and fast becoming a slogan of the German avant-garde—has been trumped by an automaton. Hausmann dated this assemblage from 1919, but it's inconceivable he would have withheld it from the fair, suggesting he made it closer to the date of its first public appearance in 1921 at the Great Berlin Art Exhibition. The Dada fair did include a few of his collages in which mechanical parts were incorporated into human bodies: *Self-Portrait of the Dadasoph* and *Tatlin at Home*, as well as a few "grotesques"—sketches of robotic creatures from his 1920 book *Hurra, Hurra, Hurra!* Most of the Chirico-inspired zombies—like Hausmann's *Engineers, Kutschenbauch Composes*, and, of course, the *Mechanical Head*, along with Schlichter's *Dada Roof Atelier*—clearly postdated the fair.

Grosz, too, was swept up in the enthusiasm for Chirico, and at the end of the year he summed up his position in "On My New Paintings," an article published in 1921 in *Das Kunstblatt*: "Man is no longer shown as an individual, with psychological subtleties, but as a collectivistic, almost mechanistic concept. The fate of the individual no longer counts." In works like

Republican Automatons and *The New Man* he abandoned his skittery graffiti lines in favor of humanoid templates, artists' dummies on which details might be subsequently applied, if at all. "A time will come when the artist will no longer be a soggy bohemian anarchist," he hoped, "but a bright, healthy worker within the collective community." Such visions would soon be dispelled, for various reasons, but it was the last gasp of solidarity that had bound together a few individuals in Berlin as they clung to the juggernaut of Dada.

After the fair closed at the end of August 1920, Dada in Berlin dissipated as quickly as a blown dandelion. Whatever it had been was a mystery wrapped in an enigma, shrouded by provocations and taunts. Lest anybody think of rekindling the spark, in 1921 Hausmann announced the suspension of Dada activities until humankind had evolved enough to embrace its spiritual elasticity.

Not long after the fair ended, a final publication appeared, *Dada Almanac* edited by Richard Huelsenbeck. Like *The Blue Rider Almanac* in 1912, it was the only one of its kind. *Dada Almanac* remains the only comprehensive portfolio assembled by a Dadaist during its heyday, although surviving proof sheets of the aborted *Dadaco*, on which Huelsenbeck had worked since returning to the city in 1917, suggest it would have been more colorful, flamboyant, and lavishly produced.

Published in a compact format with 160 pages and eight photographs, *Dada Almanac* drew the lion's share of its contents from the Berlin scene but also reprinted items from several other countries to promote Dada's international character. Huelsenbeck's introduction is a fairly straightforward exposition of the Dadaist as someone "free to adopt any mask; he can represent any 'art movement' since he belongs to no movement." Elsewhere in the volume Huelsenbeck included his introductory remarks about Dada from the Neumann Gallery reading in January 1918 and his manifesto from the first official Dada evening three months later.

Following *Dada Almanac*'s introduction was Tzara's typographically lively chronology of Dada in Zurich, detailing events through 1919. He concluded with the claim that "8,590 articles on dada have appeared in the newspapers" from fifty-six cities around the world, listed in no particular order. Because Tzara was an indefatigable archivist of all things Dada, it's plausible that

press coverage actually penetrated these locales, but the thousandfold total sounds like a Dada dream too good to be true. Huelsenbeck included ten pages of excerpts from this cache in the almanac, not all accolades. Some were characteristically obtuse, but several included sensible observations. It was noted that while visiting a Dada exhibition "you discover that it is possible to laugh again." From another: "Dadaism is thus not an art movement: it is the confirmation of a feeling of independence." Even a naysayer was moved to acknowledge, "In the fine art of advertising their genius should be admitted even by their enemies."

Dada Almanac was liberally sprinkled with disinformation, like the "Dadaist aperçus" at the end of the volume. The subterfuge begins right after Tzara's chronicle, when one Max Baumann (surely Huelsenbeck himself) lights into the Oberdada for five pages, accusing Baader of money grubbing, in his use of Dada to fund his private mania, and dubbing him "a Kurt Schwitters dressed up as a messiah, a dilettante's mind in cosmic underpants." Hanover artist Schwitters (subject of the next chapter) had been spurned by Huelsenbeck when he tried to join Club Dada. Huelsenbeck was so incensed by the success of Schwitters' book *Anna Blume*—generally received as a Dada publication—that he made a point of repudiating it in his introduction to *Dada Almanac*. So in a single sentence "Max Baumann" dispatched Huelsenbeck's two bugbears.

The biases of the almanac's editor is further revealed in the absence of political writings, though this omission might be justified as the book was strictly literary. Dada was profiled in the almanac as an international literary movement, with poems largely from the Parisian scene, plus one by Arp and another by Walter Mehring that expressed the razor-sharp wit he was honing in Berlin cabarets ("Jews out, stomachs in"). Hausmann's article comparing tendencies in art with national cuisines ("Expressionism," he proposes, "could only have arisen in the land of dumplings"), along with elements of pastiche and satire throughout *Dada Almanac*, conveys the sense of Dada as apolitical and not all that serious. Mehring's fanciful assertion that "the world is only a branch of Dada," like Baader's claim that the Great War was strictly a phantasm created by the press, reinforces this sense. Above all, and in spite of Huelsenbeck's disdain for him, the almanac affirms a sentiment best expressed by none other than Baader: "Whatever *dada* is, none of the Dadaists knows, only the Oberdada, and he's not telling."

5

MERZ

When the First International Dada Fair was held in Berlin, the provocative term was *international*, not Dada, which had largely run its course in the capital.

As far back as the late nineteenth century, international trends in art had sparked xenophobic reactions in Germany, and German artists beholden to Fauvism, Futurism, or Cubism could be branded as turncoats, agents provocateurs of unwholesome foreign tendencies. Still, the 1920 exhibit struck some observers as insufficiently international, a valid point. Others noticed the exclusion of one artist associated with Dada by the general public, though he was rebuffed by the Dadaists and opted to avoid the Dada label himself. He was German and provincial, but he would become one of the major figures associated with Dada, wielding a huge influence around the world.

Kurt Schwitters emerged at the end of the war thanks to the support of art dealer and publisher Herwarth Walden. Walden had supported a range of international modern art before and during the war. Incensed by the pose of neutrality he adopted during the conflict, however, the Dadaists had turned against him, even though many had benefited from his patronage. One of these beneficiaries was Schwitters, who, living in Hanover, had no idea that Walden's patronage would render him anathema to the Dadaists.

As things transpired, he would carry the Dada spirit further than anyone, even if under the rubric of anti-Dada.

Schwitters practiced an assembly technique comparable to the Dadaists' photomontage, which drew on the proliferation of photographic reproductions in popular publications. Schwitters, for his part, privileged no particular source and could be said to have outdone the Dadaists at their own game, embracing the whole spectrum of rubbish as a kind of material proletariat, reclaiming refuse from its lowly state for the most exalted application—one that Schwitters insisted was *art* after all, and not some mechanistic by-product like those the Dadaists produced. He called this art Merz.

Understandably, Grosz and the Herzfeld brothers weren't interested in Schwitters, since he was apolitical through and through. Richard Huelsenbeck, on the other hand, was never very clear about what ticked him off about the Hanoverian. He told his Berlin partners in Dada that Schwitters was simply "middle class," and later in a memoir grouched that he was the sort of person who reeked of "home cooking." Huelsenbeck wasn't wrong to regard Schwitters as middle class, but that was true of nearly all the Dadaists; Schwitters' difference was that he lived in his parental home until he was nearly fifty, leaving only to flee the Nazis. The parents lived on the first floor, and he lived with his wife and son above them, though a significant portion of the space was gradually transformed into one of the most astonishing artworks of the twentieth century.

Two Dadaists felt differently about Schwitters. Raoul Hausmann and Hannah Höch, who had become friendly with the man by the time *Dada Almanac* appeared in fall 1920, discovered, as did many other avant-garde figures, that his lifestyle might look cozily normal from the outside, but that appearances could be deceiving—even, in his case, dead wrong.

Kurt Schwitters was a natural-born Dadaist. But he was also an accidental Dadaist, and even anti-Dada, on the principle already announced in the 1918 manifestos by Tzara and by Huelsenbeck—the latter of whom avowed that "to be against this manifesto is to be a Dadaist!" What others adopted as a vocation, Schwitters came to through spontaneous curiosity. He began his artistic career as a conventional painter, trained at the Royal Academy of Arts in Dresden, but his work showed little promise (he was dismissed from the Berlin Academy—which he briefly attended during his sojourn

in Dresden—as hopelessly untalented). Then, in a brief span, he went from being an undistinguished landscape painter to a maker of assemblages and collages, a man who could introduce himself to Hausmann in Café des Westens, that bohemian watering hole in Berlin, with the startling disclosure, "I am a painter and I nail my pictures together." Hausmann recalled this as being in 1918—maybe because Hans Arp also met Schwitters in the same café that year—but it was probably 1919, since that's when hammer and scissors started edging out the paintbrush in Schwitters' creative process.

Schwitters, born in 1887 in the straitlaced city of Hanover, was a late bloomer. The Berlin Dadaists held his provincial background against him—not that he attempted to conceal his origins, and in any case his regional accent made it obvious. He also lacked the sartorial grace that Grosz and Hausmann prided themselves on. Schwitters' idea of clothing was to wrap a couple scarves around his neck at all times and to hell with the rest of it. What's more, he cut a large figure, being over six feet tall (like Hugo Ball in Zurich, Schwitters is invariably the tallest person in any group photo). When Cologne Dadaist Max Ernst visited him in Hanover, he was unnerved by Schwitters' proud disclosure, concerning his wife Helma's old-fashioned wardrobe, "I have never spent a penny on her clothes; they were all passed down in the family" (probably overstock from the ladies' clothing shop his parents owned when he was a child).

Everything about Schwitters, it seemed, screamed provincial and petit bourgeois. He not only lived in his parents' house, but his wife was also his second cousin, and her family lived nearby, providing an allowance until his mother-in-law drew the line at Schwitters' indolence (which is how she perceived his creativity), cutting the young couple off around the time their son Ernst was born in November 1918. A previous son had died a week after his birth in 1916, and a plaster cast of the infant's head eventually crowned a motley sculptural assemblage to which Schwitters gave the ominous title *Cathedral of Erotic Misery*.

Although Hanover had all the earmarks of a small provincial city, it was rapidly becoming a mecca of modern art. This unexpected turn was due to two uniquely open-minded individuals, Paul Küppers and Alexander Dorner. Küppers, author of one of the earliest books on Cubism, was the first director of the Kestner Gesellschaft, founded in 1916 to promote the most modern and provocative tendencies in contemporary art. After his

untimely death, he was succeeded by Dorner. Previously Dorner had assembled a fabulous collection of contemporary art at the Hanover Provincial Museum. Despite its provinciality, Hanover, through its museum and the Kestner collection, provided Schwitters with an unusually supportive environment, exposing him to the most advanced contemporary art—Berliner snobbery notwithstanding.

For the Berlin Dadaists, the main strike against Schwitters was his affiliation with Herwarth Walden's Sturm Gallery—prior to the war, a preeminent international clearinghouse for modern art—and its journal *Der Sturm*. These enterprises succeeded largely on the strength of Walden's forceful personality. A man of many talents, Walden was a poet, pianist, composer, and, above all, a patron of the arts and tireless proselytizer for the avant-garde. He inspired either love or hate, nothing in between (Hausmann peevishly disfigured Walden's face in a Sturm postcard, writing "shit" across his forehead). Born Georg Levin, Walden was given his very Teutonic pseudonym by his wife, the colorful poet Elsa Lasker-Schüler, who also provided Sturm as the name for their enterprise. She contributed something to Dada too, adding the terminal *e* to Wieland Herzfelde's name and her novel *Der Malik* provided him with a name for his publishing operation. In 1903, a few years after their marriage, Walden founded the Verein für Kunst, an organization sponsoring readings and lectures for advanced artists in different media. It grew over time and eventually led to the founding of *Der Sturm* in 1910. Sturm Gallery became a major destination for the international avant-garde after its 1912 Blue Rider exhibition.

In 1913 Walden organized the enormous Autumn Salon, an international exhibition rivaling anything in Paris. Walden also set a precedent for Dada when he compiled a litany of abuse from the press to make a poster advertising the salon: *good-for-nothings, Hottentots in dress shirts, hordes of color-spraying howler monkeys, sickly apparitions, yellow clown-leaps, lunatic forms, bluffing, idiotic scribblings, new uniforms of insanity, sensationalism of aesthetic hedonists*—these are a few of the cries of indignation Walden shrewdly boiled down into an advertising coup. Thanks to his unfailing eye for artistic innovation, the list of artists who exhibited at Sturm Gallery reads like a who's who of modern art, but the German public regarded the show as a public nuisance—or worse, "a cold-blooded, deliberate rape of nature and humanity."

In an ominous portent of things to come, the German parliament unanimously declared Sturm a bastion of "degenerate art."

During the war years Sturm was even more reviled for its international affiliations with artists from combatant nations, especially Fauves and Cubists in France and Italian Futurists. Hausmann's invective, "The German Philistine Is Getting Worked Up," could just as easily have applied to the effect of Sturm as to Dada. Yet while Walden earned himself the enmity of the state, he did not respond in kind; indeed, part of what turned future Dadaists against Walden during the war was the apolitical stance he maintained in his journal. (After the November Revolution, in a tragic coda, Walden experienced a political awakening, eventually emigrating to the USSR where he was swallowed up in the Gulag in 1941.)

By the time Kurt and Helma Schwitters signed Walden's guest book on June 27, 1918, he not only ran the gallery, published the journal, and hosted Sturm evenings for poetry readings and lectures on art, he also managed a Sturm school, a publishing house, and a theater company. Sturm, then, was possibly the grandest avant-garde industry ever set in motion. To take a stand against it, as the Berlin Dadaists did, amounted to professional suicide; however, by 1918 the times were so out of joint that professional expediency was pointless.

Schwitters, meanwhile, coming up to the big city from cozy Hanover, was clueless about all these political shenanigans, happy to take his place in the star-studded roster of Sturm artists. He naively assumed that Dada was just another of Walden's portfolios. After all, Galerie Dada in Zurich in 1917 had relied heavily on Walden's support, even to the extent of hosting a Sturm evening at which he'd made a personal appearance. This was a natural enough arrangement, since Hugo Ball was in the thick of Sturm activities in Berlin before the war, and Arp's art was exhibited in the gallery and his writings published in the journal.

Schwitters soon learned the hard way that Dada was not just any type of art; it was wrapped up in the revolutionary atmosphere unfolding across Berlin. By the time he shared the Sturm exhibition space with Paul Klee's whimsical paintings in January 1919, art of any sort was bound to pale before the convulsive political events under way since the previous November. Karl Liebknecht and Rosa Luxemburg were murdered on January 15, and the new

National Assembly convened in Weimar a month later (at which Johannes Baader showered the delegates with his Dada propaganda). On February 15 the Dadaists paraded the streets of Berlin hawking *Jedermann sein eigenes Fussball*, and in March over a thousand people were killed in armed combat on the streets of the city. In the peculiar ambience of that time, bloody street battles alternated with life as normal (if you could call it normal to attend an art opening where just a day or two before the street was littered with bodies).

Still, with his first Sturm exhibit the previous summer, and the birth of his son in November, Schwitters felt everything was going his way. He was becoming a staple in Walden's journal, which not only offered reproductions of his art but also published his poems and essays. Soon, it would provide a stage for the debut of Schwitters' Merz, his idiosyncratic form of art.

In the July 1919 issue of *Der Sturm* (with one of his "abstractions" on the cover), Schwitters introduced Merz painting. He began by assuring readers that this new moniker, Merz, was a kind of abstract art, though anyone who followed his work in the Sturm Gallery would've noticed a huge difference between his abstract oil paintings and the multimedia breakthrough of Merz. "Essentially," he went on, "the word Merz denotes the combination of all conceivable materials for artistic purposes, and technically the principle of equal evaluation of the individual materials."

Everything was up for grabs, in other words. As rock star David Bowie would later say, talking about the impact of Dada, "everything is rubbish and all rubbish is wonderful." That was certainly Schwitters' view, signified by Merz, in which "it is unimportant whether or not the material was already used for some purpose or other. A perambulator wheel, wire-netting, string and cotton wool are factors having equal rights with paint. The artist creates through the choice, distribution and metamorphosis of the materials." By *choosing* rather than painting, Merz "aims at direct expression by shortening the interval between the intuition and realization of the work of art."

With Merz, Schwitters was moving closer to the spirit of improvisation, a spirit tentatively explored elsewhere at the time by jazz musicians, and like jazz Merz was sparked by the war. Schwitters was about as apolitical as one could be, but he sensed that patriotism was basically fraudulent, "world patriotism" being his preferred allegiance. Looking back in 1930, he called Merz "a prayer about the victorious end of the war, victorious as once again peace

had won in the end; everything had broken down in any case and new things had to be made out of fragments: and this is Merz. It was like an image of the revolution within me, not as it was, but as it should have been."

The Zurich Dadaists exulted in a name found by accident that meant different things in several different languages. Merz, on the other hand, meant nothing. That was the beauty of it, a blank slate, ready for anything. Schwitters fiddled with possible meanings, noticing Merz might be linked to the verb *ausmerzen*, meaning "to reject." But he kept such associations to himself. He came up with the term from an assemblage called *Merzbild* in which those four letters were visible amidst a mash-up of raw materials. The word remnant *merz* was all that remained of a printed advertisement for a Kommerz-und Privatbank (commercial and private bank).

Schwitters had a habit of giving titles to his works from alphabetic remnants, like *Das Undbild* (1919, The And-Picture), named for the letters *u-n-d* that hover at the top of the assemblage. Another, *Oskar* (1920), has nothing to do with anyone by that name, any more than *Rossfett* (c. 1919), *Ebing* (1920), *Otto* (1921), or *Der Weihnachtsmann* (1922, Santa Claus) mean something beyond the orphaned letters that provide their titles. A collage named *okola* preserves part of the German word for chocolate. Another work, *Rosa*, was renamed when an exhibition jury objected to his original title *Bone from Arosa*. Is *Das große Ichbild* (1919, The Great I-Picture) a self-portrait? No more than any other. This one probably got its name from the little number 87 that appears in the artwork, Schwitters' birth year.

Schwitters lost no time in making Merz the slogan or brand name for everything he did, and since it was about *doing*, it became a verb as well. He didn't compose a picture, he *merzed* it. He wrote "Kurt Merz Schwitters" in guest books. He altered his name in other ways, signing his letters with "Kuwitter" and other variants like "Kuh Witter," suggesting the scent of a cow. He wasn't particular about his birth name, in any case. Like so many men of that era his was cumbersome: Kurt Hermann Edward Karl Julius Schwitters.

With Merz, Schwitters launched himself as a one-man avant-garde, which is not quite as unprecedented as it sounds. Jean Crotti, briefly associated with Dada in New York and Paris, formed a solo movement he named Tabu. Fernando Pessoa in Lisbon was motivated by the impact of Futurism to dream up a movement called Sensationism. Another one-man ism belongs to

Berlin Dadaist Jefim Golyscheff, Ukrainian composer and child prodigy on violin. He pioneered dodecaphonic composition several years before Arnold Schoenberg and was among the first Europeans to incorporate jazz elements in public performances. Golyscheff later said he felt himself to be a Dadaist all along, officially or not, which puts him in the same boat as Schwitters. Certainly Golyscheff was making Merz-like objects. One exhibited in 1920 in Berlin consisted of "a herring skeleton and a dried-up slice of bread laid down on brown wrapping paper with a dark spot resembling nothing so much as a squashed bedbug." Unfortunately, none of these things survive, because an ill-timed retrospective in 1933 was seized and destroyed by the Nazis.

But Merz trumped all of these other micromovements, simply through the effervescence of Schwitters' personality, which started bubbling over with Merz as soon as he named it. Not that Schwitters' contemporaries were appreciative. Walter Mehring, at the time closely affiliated with Berlin Dada, reviewed the July 1919 Sturm exhibition and called Schwitters' pieces "trash-romantic" and "expressionist genre-art." In other words, of no real concern to Dada. It was weird that this emerging artist wanted to join Club Dada; anybody else associated with Sturm would've known to keep clear, even if all the artists did rub shoulders in the same cafés.

Dada's prominence as the height of absurdity was, however, about to be sideswiped by this unassuming Hanoverian. The seed was planted in the August 1919 issue of *Der Sturm*, in which an odd poem by Schwitters appeared, with Marc Chagall's painting *Village* reproduced on the facing page—a cunning juxtaposition, suggesting that Walden grasped the way both artists dealt with worlds on the verge of floating off into some whimsical hyperspace.

Schwitters' poem, "To Anna Blume," was full of anachronistic whimpering and poetic "touches," with bits of seemingly unrelated stuff sticking out just like the rubbish Schwitters was gluing onto his collages. He was also making pictures with rubber stamps of words and images, and "To Anna Blume" shared this sort of approach in the medium of language. "O thou, beloved of my twenty-seven senses," the poem begins, "I love thine!" But it promptly goes off the rails: "Thou thee thee thine, I thine, thou mine, we?" Then, like a punch in the ribs with a wink and a chuckle, "That (by the way) is beside the point!" It goes on in this vein for more than forty lines. Along the way the fabled Anna gets a red dress "sawn into white folds"; she's endearingly called a "drippy animal"; and her name is celebrated as being like that

of the biblical Eve in that it reads the same forward and back. In the middle of the poem a "PRIZE QUESTION" (as the poem presents it) is abruptly posed in the form of a syllogism:

> 1. eve Blossom is red,
> 2. eve Blossom has wheels,
> 3. what color are the wheels?

The answer is as confounding as the poem itself:

> Blue is the color of your yellow hair,
> Red is the whirl of your green wheels,
> Thou simple maiden in everyday dress,
> Thou small green animal,
> I love thine!

A devoted *Der Sturm* reader might wonder what this strange item was doing in the journal, as Walden generally favored a world-resounding, soul-plumbing poetry known as *Wortkunst* (word art), modeled on the drastically condensed lyrics of August Stramm—"phonetic orgasms," Mehring called them. Stramm's work had blazed like a comet through the pages of *Der Sturm* from 1914 until his death in combat in September 1915, and in short order all the poetry Walden published was in this vein.

The irreverent whimsy of "To Anna Blume" would have struck readers of the journal as highly incongruous with this house style. Instead of the usual *Der Sturm* poems full of intergalactic yearning, here "the humdrum is confronted with the humdrum," observed Schwitters' friend Carola Giedion-Welcker. "Stupidities and hackneyed phrases preen themselves willfully and prance about in verbal space as though they were important personages."

How did "To Anna Blume" become famous? Surely not by being in *Der Sturm*, though Walden was a tireless promoter of his artists and managed to get Schwitters' Merz manifesto placed in a major newspaper, the *Berliner Börsen-Courier*, in September 1919. In November an excerpt from the poem appeared there, credited to one Kurt Schwitzter. By that point, it was also about to make a grand debut in book form, thanks to Hanover publisher Paul Steegemann.

Born and raised in the circus and with a carnival barker's instinct for getting the attention of a crowd, Steegemann had only started up his publishing concern in April, and *Anna Blume* turned out to be his first big hit. Along with the titular poem, the book contained a variety of poems and absurdist tales by Schwitters. It flew off the shelves, as did a second printing, making it a bestseller and a national phenomenon. The title poem was reprinted in newspapers throughout Germany and often excerpted in reviews by critics who couldn't resist sampling its peculiarities. Some pundits purported to find symptoms of "schizophrenic rambling" in the book. One reader, who suggested Schwitters be confined to a clinic, was astonished to receive a courteous letter from the author himself. "I am moved by your sympathy," Schwitters began, before calling the gentleman's bluff. "I find your idea to start a collection to heal my nervous condition so admirable that I Myself (sorry) myself have decided to deal with the supervision of the whole sum of money. I am thinking of a substantial undertaking, a year's rehabilitation in an exclusive health resort." Schwitters mobilized this sort of clever comeback in a series of retorts to critics he published over the years under the general title "Tran," reaching number 50 by 1924.

When *Der Sturm* published Schwitters' amusing "General Pardon" addressing his hometown critics, its author was parenthetically identified as the "Captain of Köpenik of Art." This German folk hero was an ex-convict who in 1906 donned an officer's uniform. Wearing that recognizable signifier of authority, he easily garnered the obedience of the kaiser's citizens and commandeered ten soldiers, who dutifully followed his orders, occupying the town hall of Köpenick. There he "confiscated" four thousand marks, and then made his getaway, while the soldiers guarded the premises under his orders. The parenthetical notice in *Der Sturm* was possibly Schwitters' own joke. The Captain of Köpenick is an archetypal figure, perpetrator of a topsy-turvy world, a staple of American screwball comedy and the Marx Brothers.

Even if not symptomatic of its author's derangement, *Anna Blume* roused the critics. *Deutsche Volkszeitung* branded it "the most revolting piece of writing in our time." The fanciful character of the title poem is hardly likely to have inspired such invective, but there was more to the book than simple whimsy. This comes across forcibly in the book's longest piece, "The Onion: Merzpoem 8," a first-person tale about being systematically butchered and

then reassembled, Frankenstein-style. It's grim and gory, but also jolly, a combination sure to get a reader's dander up: "All my parts were back together again, and there were only a few small gouges where bits of flesh still clung to the blade"; "with a slight pressure they popped my eyes back in the sockets"; "the bits and pieces of my skull flew back together, I was almost done." A translation by poets Jerome Rothenberg and Pierre Joris catches the quick wit rippling through Schwitters' lines: "I was dying to know how they would bring me back to life."

The subject was objectionable enough, but "The Onion" is also a genuine Merz product, shot through with contemporary advertisements and colloquial platitudes, usually in parentheses. In the midst of all the anatomical mayhem, these parenthetic remarks drift by: "Latest Mocha Bonbons, A Novelty." "That's how one cleans, dusts, washes, steams, and dries bedfeathers." "Wet paint!" Readers in 1919 were being confronted here with the bloodletting from the previous five years, when men were sent to slaughter as assiduously as in Schwitters' parable, in which ceremonial dismemberment is played out at the behest of a king. When millions expired "for King and Country," as the saying has it, during the war, their sacrifices were attended by the commingling of patriotic slogans and commercial jingles. "The Onion" is a worthy companion to Franz Kafka's famous "In the Penal Colony," published the same year, in which a grisly execution is administered by a machine designed to tattoo the legal verdict on the skin of the accused, but like the management of the Great War, the machine fails to work properly, becoming an instrument of runaway brutality.

Steegemann printed advertising posters for the book, adding to *Anna Blume*'s notoriety. The design cleverly replicated an election campaign poster ubiquitous at the time that printed the Ten Commandments, but Steegemann substituted "To Anna Blume" for the Biblical strictures. Schwitters himself had little stickers made, red circles with her name bracketed by an exclamation mark above and a question mark below, which he maniacally pasted everywhere he went, in shop windows, streetcars, trains, café tables, even in the homes of friends (Hans Richter claimed he had to forfeit his Berlin flat because of all these anarchic deposits).

Thanks to efforts like these *Anna Blume* went viral, overtaking Dada in the process. In fact, the book used Dada as a marketing tool: emblazoned slantwise across the cover of the book, which mainly consisted of a drawing

by Schwitters, the lowercase letters d-a-d-a beamed bright red. In fact, glanc-
ing at the cover, you could easily mistake that for the title. Steegemann was
behind this bit of trickery, though Schwitters didn't object. The publisher
knew a selling point when he saw one, and knew that Berlin was getting a
thorough dose of something called Dada, which was in the press all the time
(thanks especially to Baader the Oberdada). "Schwitters is the Dadaistic
genius of Europe!" Steegemann exclaimed in ads for the book, mounting a
national pitch for Dada on the wheels of *Anna Blume*.

Kurt Schwitters, cover of Anna Blume, *1919.*

Topping off the publication's omnipresence was another small book called *Reality According to Anna Blume* (1920), by Schwitters' friend Christoph Spengemann. The book was intended to quell accusations and rumors that the author of *Anna Blume* was out of his mind, a Dadaist, or both. Dada, Spengemann maintained, was an act of desperation, but it had nothing to do with art. Taking his cue from Schwitters himself, Spengemann reiterated that Merz was devoted to art.

Herwarth Walden and Sturm stood to gain from Schwitters' sudden pre-eminence. Schwitters was a double threat, supplying art for the gallery and writing for the journal. The afterword to *Anna Blume* was reprinted under the title "The Artist's Right to Self-Determination" in the January 1920 issue of *Der Sturm*. In it Schwitters explains that Merz poetry, like Merz art, avails itself of anything that comes to hand:

It uses as given parts complete sentences from newspapers, billboards, catalogues, conversations, etcetera, with or without changes. (That is terrible.) These parts do not have to fit in with the meaning, because there is no more meaning. (That is also terrible.) There are no more elephants either, there are only parts of the poem. (That is terrible.) And you? (Design war loans!) Determine for yourselves what is poem, what is frame.

Apart from this, the piece is a grateful plug for *Der Sturm*, "the first to publish my best poems and to show a collection of my Merz paintings."

As far as most people knew *Anna Blume* and Dada were ladled out of the same pot. It's not clear how the Berlin Dadaists felt about all this, though *Anna Blume*'s fame meant they couldn't help but be aware of it. They were busy enough with their own performances, magazines, and art and preparing for the big international Dada fair scheduled for the summer (one reviewer pointedly suggested the fair would've made a greater impact had it included work by Schwitters and Golyscheff).

But the Dadaists kept their distance from Schwitters. He paid a visit to George Grosz, who turned him away from his studio, insisting "I'm not Grosz." (Schwitters left, but came back a few minutes later, informing Grosz "I'm not Schwitters either.") Richard Huelsenbeck took the *Anna Blume* affair personally. He concluded the introduction to *Dada Almanac* with an explicit disavowal: "Dada fundamentally and emphatically rejects such

works as the famous 'Anna Blume' by Mr. Kurt Schwitters." Ironically, Huelsenbeck's book *En Avant Dada* was issued by Schwitters' publisher Steegemann, who had the temerity to include the name *Anna Blume* in the cover design. Huelsenbeck went on carping about his Merz adversary till the end of his life. For his part, with the success of Merz, Schwitters could afford to take a bemused look at Dada, which he'd only recently sought to be part of. Steegemann published a collection of his lithographs with the title *Die Kathedrale* in 1920, but this time the word *anti-Dada* was splashed across the cover.

Soaring on the wings of Merz, Schwitters clarified his relation to Dada in a long autobiographical article published in *Der Ararat* in January 1921, a journal championing Grosz's work in previous issues. Here, Schwitters settled one account by distancing himself from Expressionism—and, by implication, Sturm: "Today the striving for expression in a work of art also seems to me injurious to art." He made Merz out to be essentially antiprogrammatic. "Merz stands for freedom from all fetters, for the sake of artistic creation. Freedom is not lack of restraint, but the product of strict artistic discipline." Dada, it could be inferred, lacked discipline in its lack of restraint. Schwitters addressed the use of the word *dada* on the cover of *Anna Blume*, pointing out that the illustration also included "a windmill, a head, a locomotive running backwards and a man hanging in the air. This only means that in the world in which Anna Blume lives, in which people walk on their heads, windmills turn and locomotives run backwards, Dada also exists. In order to avoid misunderstandings, I have inscribed 'Antidada' on the outside of my Cathedral. This does not mean that I am against Dada, but that there also exists in this world a current opposed to Dada."

Schwitters' geniality comes to the fore in this article. He knew Huelsenbeck had taken that potshot against him in *Dada Almanac*, but rather than getting huffy about it, he makes a pun, distinguishing between kernel-Dadas (*Kerndadaisten*) and husk-Dadas (*Huelsendadaisten*). The husk-Dadas (making an obvious play on Huelsenbeck) followed the political line. The other Dadas were artists, like Hausmann and Höch, and therefore friends of Merz, which "aims only at art, because no man can serve two masters."

Schwitters acknowledged sharing Dada's love of nonsense. "I play off sense against nonsense. I prefer nonsense, but that is a purely personal matter. I feel sorry for nonsense because up to now it has so rarely been artistically

molded; that is why I love nonsense. Here I must mention Dadaism, which like myself cultivates nonsense." His explanation of nonsense, it must be said, agreeably makes sense. As his poems and collages and assemblages demonstrated, "sense" in the domain of artifacts involves concrete procedures of making, fabrication, arranging materials. Anything could enter into artistic relation in the great *Merzbühne* (Merz stage) outlined in the culminating text in *Anna Blume.* "For example, you marry the oilcloth table cover to the home owner's loan association, you bring the lamp cleaner into a relationship with the marriage between Anna Blume and A-natural, concert pitch."

He might have been describing the stark juxtapositions of his own life. A friend evoked a dismaying mélange of odors encountered in the Schwitters household, a combination of the hot glue, homemade starch, plaster of paris, and clay Schwitters had onsite for his collages, reliefs, and sculptures, mingled with the aroma of cooking and "the just plain baby smell." Animal odors added to the mix, as Schwitters was fond of guinea pigs and always had a steady supply on hand. They can be seen discretely in photographs, on the furniture or peeking out of Schwitters' pockets. Schwitters even traded some toy soldiers for his beloved guinea pigs, ruefully observing: "That's what becomes of the great war heroes of the history books. They're stamped out flat, and one can trade a whole bunch of them for five guinea pigs." Mice also factored into the equation of his household pets, along with newts, salamanders, lizards, turtles, and the occasional dog. Composer Stefan Wolpe (who set Schwitters' poem "To Anna Blume" to music for a theatrical scene of a singer in a clown costume on a bicycle) recalled a public performance at which Schwitters disbursed twenty mice onto the lectern, before setting them free in the lecture hall.

The superficial appearance of a bourgeois household evaporated once visitors entered the place. A journalist visiting the studio in 1920 left this account:

The interior does not give the impression of being a studio but a carpentry shop. Planks, cigar chests, wheels from a perambulator for Merz-sculptures, various carpentry tools for the 'nailed-together' pictures, are lying between bundles of newspapers, as are the necessary materials for the 'pasted' pictures and for the Anna Blume poems. With loving care, broken light-switches, damaged neckties, colored lids from Camembert

cheese boxes, colored buttons torn off clothes, and tram-tickets are all stored up to find a grateful use in future creations.

This seething mass reveals that nothing was ineligible for Merz: "My ultimate aspiration is the union of art and non-art in the Merz total world-view." The term he used, *Merz-Gesamtweltbild*, played on the famous concept associated with Richard Wagner—the *Gesamtkunstwerk* or total artwork. But where Wagner led a Herculean endeavor, characteristic of the nineteenth century, to amass and synthesize multiple art forms, Schwitters went in the other direction, finding the whole immanent in the world itself. For him, it was just a matter of putting the parts into play in a kind of artistic mating ritual. "The imitative picture formerly differed considerably from the surrounding world: it was essentially a pale imitation," he wrote, "whereas the new naturalistic work of art grows as nature itself, that is to say, is more internally related to nature than an imitation possibly could be." In this initiative, he couldn't help but find common ground with Dada—or at least one particular Dadaist more receptive to his work than the others: Raoul Hausmann.

On the gala Dada evening in April 1918, Hausmann was reading his manifesto "New Materials in Painting" when the house lights were abruptly switched off. He thought it due to his incendiary text, but it had nothing to do with him. By that point the audience had been whipped up into a frenzy by cumulative provocations throughout the evening, including Grosz doing a blackface number and bouncing soccer balls off heads in the audience, so the management prudently terminated the show in the middle of Hausmann's talk. But he was justified in thinking he had something radical to say. He took a swipe at artists caught up in dreams of synaesthetic interplay (like Kandinsky's *The Yellow Sound*), citing the "astral imbecility of using colors and lines to interpret so-called spiritual sounds." In Dada, on the other hand, "you will recognize your real state of mind," he advised, "miraculous constellations in real material, wire, glass, cardboard, fabric, corresponding organically to your own equally brittle bulging fragility." It was Schwitters who turned out to be the master of such revelations, and Hausmann recognized as much. The two men set off on the road together to unleash this material onslaught.

Earlier, energized by the success of Dada performances throughout 1919, Hausmann, Baader, and Huelsenbeck decided to take their show on the road after the New Year. For the first several months of 1920, they performed in Dresden, Hamburg, Leipzig, Karlsbad, and Prague. Huelsenbeck reprised his "Fantastic Prayers," while Hausmann kept refining his "chaotic oral cavity" with sound poems, which departed radically from the Zurich model. As he saw it, "the poem makes itself with sounds coming from the larynx and the vocal chords, and knows no syntax, only start and stop." Baader got along just by being the Oberdada. After the First International Dada Fair closed at the end of the summer, it was as though all the air went out of the tires, so Hausmann started seeing Schwitters during his frequent trips up to Berlin and even found himself making visits to Hanover.

Schwitters' first public recital of his poetry was at Sturm Gallery in May 1920, where he performed alongside Rudolf Blümner, Walden's right-hand man and a specialist in recitals. Blümner's lengthy phonetic composition "Ango Laïna" likely had an impact on Schwitters as well. Blümner provided an excellent model for a novice like Schwitters to venture into the untested waters of public enunciation. The following February, he contributed to an anti-Dada soirée in Dresden, but press notices suggest he was still no match for the Dadaists. He must have practiced a lot for Hausmann to consent to perform with him in Prague in September 1921. Posters for the event invited the public to "listen to the truth about Merz and Presentism." By all accounts it was a smashing success. And, Hausmann emphasized, a *success* in the conventional sense: applause was loud and heartfelt, not a scandal like that perpetrated by the Dadaists a year earlier.

The duo had carefully planned out a program billed as "Anti-Dada-Merz," with Schwitters reprising the famous "To Anna Blume" and a lively recitation of the alphabet backward. Hausmann growled, roared, seethed, and hissed his sound poems—as he would continue to do, to the astonishment of dinner guests, to the end of his life. But much of the program involved the two of them going at it in tandem, egging each other on, as they performed Schwitters' one-word poem "Cigar" and his story "Revolution in Revon." Hannah Höch, along on the trip with Helma Schwitters, was spellbound but fearful of the consequences, so worked up did the two men get trying to outdo one another with their thunder.

Theirs was a productive antithesis of personality and style. "Hausmann always gave the impression that he harbored a dark menacing hostility to the world," Hans Richter recalled. "His extremely interesting phonetic poems resembled, as he spoke them, imprecations distorted by rage, cries of anguish, bathed in the cold sweat of tormented demons." By contrast, "Schwitters was a totally free spirit; he was ruled by Nature. No stored-up grudges, no repressed impulses." "A play with serious problems. That is art," Schwitters wrote Hausmann when they resumed contact in 1946, summing up the spirit of Merz he sustained to the end of his life. It was a quixotic adventure, made poignant when Schwitters barely escaped the Nazis, went into exile in Norway, then once again had to flee to England. Respectful of his ordeals, Hausmann wrote his old friend, "You are a type as important as Don Quixote."

The Prague tour was a revelation for Hausmann and Höch, because Schwitters insisted on going fourth class, on cheap local trains that stopped at every Podunk town along the way. They switched to a regular line only at the end so their arrival in Prague would seem commensurate with the publicity. Hausmann was amazed at Schwitters' ability to plug away at his writing, indifferent to the squalor: "There was a woman with her new-born baby in a pram reeking of piss. Schwitters sat quite unmoved before me, writing shorthand in a notebook. From time to time during the eight-hour trip he read me what he'd written." On the return trip it was dark by the time they disembarked for the night, so Höch and Hausmann went off looking for lodging. When they got back to the station they found Schwitters crouched under a streetlight, finishing up a collage, no doubt with scraps gathered from the railway platform. Hausmann was constantly struck by Schwitters' ability to discern color values under the film of grime covering his prized rubbish.

Everyone who spent time with him soon found Schwitters was always on the prowl, filling his pockets—and even those of companions—with his finds. It didn't stop at that, either; visiting friends in other cities, he'd find ways to stockpile refuse under their furniture or in any vacant space. In Höch's flat in Berlin, he discovered a crawl space under the roof and cut out a little doorway so he could keep a stash up there. Höch complained that ever afterward a cold draft penetrated from outside. Much about Schwitters' character comes across in a letter a friend wrote to someone he'd suggested might host Schwitters on his travels: "I hope he will be undadaistic enough to let you know of his visit beforehand. He is a complicated clown;

good-naturedness itself, with bright eyes like a child's. But don't let him refashion your delightful rooms in the style of Merz." And, he added, "If he isn't wearing socks, don't blame me."

Traveling with Schwitters could be challenging, not only because of the lowly accommodations and slow trains, but also because of his luggage. Ever thrifty, he took his own meager food ration along with a portable cook stove and even his own bedding so as not to impose on his hosts. "I'm good company. 1.87 meters tall, live very simply, love Dada and am pretty good at fishing," he wrote to one host, adding, "I'll sleep on the floor." He didn't mention the luggage, which naturally included as portable workshop the scissors, paste, and raw materials for Merz. A Bauhaus student accompanying him to the station saw one of his suitcases burst open, and like everyone else on the platform was mesmerized by the novel profusion.

Höch endearingly tells of a trip from Berlin to Hanover in which Schwitters was carrying his own suitcases along with several parcels from Herwarth Walden for a gallery in Hanover. It took a few trips to haul this stuff in and out of trams on the way to the train station, but then it turned out there was sightseeing to be done en route, so they trundled the load off and on again to take in the sights, finally ending up in a city where friends of Schwitters were throwing a party. Off to that, with dancing and drinking for several hours until he abruptly announced, "We've got fifteen minutes to make it to the station for the last train." Recounting stories like this late in life, Höch knew some would wonder why she endured it, and the answer was simple: Schwitters always made for an adventure. Life was just more vivid in his company.

Schwitters' joie de vivre unfailingly comes across in his Merz pictures, so lively despite their unpromising means. The tattered discards of the world get a facelift, peeking out from the pictures as if winking at the viewer to come on in and join the fun. Which isn't to say they aren't great works of art in the conventional sense. *Das Kreisen* (Revolving, 1919) consists largely of circular pieces of metal traversed by a cone made out of string, against a smudgy blue and brown background. Though the color and materials cry "dirty refuse," they manage to suggest everything from a snowman to the rotation of the heavenly spheres. A shard of anything in his work seems not just deployed there but rescued. Each Merz work is a sanctuary, or "a Song of Songs celebrating the reality of life," as Werner Schmalenbach put it. A chunk of driftwood, part of a feather, a bit of bent wire, a hat check ticket,

and a button each seems to cry out "See, *I too* matter"—as if mindful of the pun on *matter*. Despite the large scale of many works, they can seem as intimate and intricate as a Fabergé egg,.

Although it started with visual art, Merz blurred generic boundaries and distinctions *between* the arts. Schwitters took a cue from Dada, weaning himself from servitude to art in the institutional sense. He'd also benefitted from the milieu of *Der Sturm*, where his pictures and his poems were on equal footing. The elocutionary tutelage of Rudolf Blümner helped. In his 1921 book *The Spirit of Cubism and the Arts*, Blümner wrote, "The poet is not a writer but a word-composer [*nicht Schrift-steller, sondern Wort-Steller*]." Accordingly, "poetry is the art of combining words that are in artistic relation to one another. Poetry is word-composition. It may, but need not, be in accord with logic and grammar. What is indispensable is only the rhythm-creating artistic relation." Blümner was basically elaborating upon Schwitters' own dictum, published in the afterword to *Anna Blume*: "Abstract poetry evaluates values against values. One can also say 'words against words.'" A word in a poem is not obliged to be syntactically subservient, any more than a spot of color in a painting need conform to a color chart.

Schwitters was expanding on what the Dadaists had done, producing art that didn't "work" within the conventional paradigm or system. That system imposed on painting or poetry a preordained message or emotional stimulus, to which ready-made responses clung like flies to flypaper: "How beautiful," "Clever stuff," and so forth. Someone viewing a Grosz drawing that expressed the politically aggressive side of Berlin Dada might respond in predictable ways as well: "That's terrible" or "Something has to be done!" Dada aggression was recognizable, if not as art then as political agitation. But by regarding himself as an artist, Schwitters operated in a domain of sensory experiment, beyond both conventional artists and the Dadaists. That's what had drawn Raoul Hausmann to him, for he too was preoccupied with the notion that human awareness is generally confined to a narrow repertoire of routine perceptions, and the arts in general were guilty of reinforcing cultural platitudes.

An essay published in 1917 by Russian theorist Viktor Shklovsky introduced the influential concept of estrangement (*ostronenie*). The convenience of familiarity has a cost, he argued. Perceptions become habituated. The purpose of art, Shklovsky proposes, is to slow down or impede perception

and reawaken the senses to their full perceptual potential. The language of poetry should be "a difficult, roughened, impeded language." A painting, by the same token, ought not offer the sop of a digestible image but, instead, arouse and agitate the visual faculty. Better to squint and wonder than recognize and make a mental checkmark on a bucket list: been there, done that.

Schwitters made much the same point when he said that conventional art imitated the world, while Merz gives you chunks of the world itself. When Schwitters said he aspired to create the total Merz-world he was hoisting a Dada pennant, convening a nation of one, a nation in which everyone was welcome. He *welcomed* the world—with all its raggedy refuse and all its rough edges.

Schwitters' ability to make much out of little came to the fore during the return trip from Prague. Hausmann had performed his pièce de resistance, a vocalization derived from a print-shop type sample: "fmsbwtözäu." Fascinated, Schwitters began toying with these sounds all the way back to Hanover, at first to Hausmann's amusement, then dismay, as his friend simply wouldn't let go of it. Stopping to see a famous waterfall, Schwitters began rehearsing the letters, and "he did not stop all day until we saw that hydraulic miracle," and he then recommenced afterward. "It became a bit much."

What Hausmann heard on that day in 1921 was the first stirrings of *Sonata in Primal Sounds* that Schwitters spent much of the decade perfecting. It takes about forty minutes to perform. It's truly an elixir for the voice, since Schwitters scored it with such precision it's hard to go wrong, provided you know how to pronounce the letters of the alphabet in German (and have a knack for rolling your r's). There's a recording of him reciting it, and others have recorded or performed it in recent years, including Canadian poet Christian Bök, who prides himself on reducing the recital time to ten minutes. Arp, who became a fast friend of Schwitters, recalled him rehearsing the sonata on vacation. "I heard Schwitters every morning, sitting in the crown of an old pine on the beach, practicing his sound sonata. He hissed, whistled, chirped, warbled, cooed, spelt out letters." But this was more than a man in a tree competing with birds. "The sounds he made were superhuman, seductive, siren-like; they might have sparked a new theory, like the twelve-tone system." Regardless of his originality, one's patience could be tried, as Hannah Höch discovered on a hike in the woods when, instead of the conversation on art she'd anticipated, Schwitters kept reciting his odd

little "novel" *Auguste Bolte*, starting all over again when he came to the end for three hours straight.

Schwitters' first public performance of the *Ursonate* (as his *Sonata in Primal Sounds* was known in German) was in February 1925 in Potsdam at a private home to a very unlikely high-society crowd. Hans Richter was there and fondly recalled the occasion:

> Schwitters stood on the podium, drew himself up to his full six feet plus, and began to perform the *Ursonate*, complete with hisses, roars and crowings, before an audience who had no experience whatever of anything modern. At first they were completely baffled, but after a couple minutes the shock began to wear off. For another five minutes, protest was held in check by the respect due to Frau Kiepenhauer's house. But this restrain served only to increase the inner tension. I watched delightedly as two generals in front of me pursed their lips as hard as they could to stop themselves laughing. Their faces, above their upright collars, turned first red, then slightly bluish. And then they lost control. They burst out laughing, and the whole audience, freed from the pressure that had been building up inside them, exploded in an orgy of laughter. The dignified old ladies, the stiff generals, shrieked with laughter, gasped for breath, slapped their thighs, choked themselves.

Afterward, Richter reports, "the same generals, the same rich ladies, who had previously laughed until they cried, now came to Schwitters, again with tears in their eyes, almost stuttering with admiration and gratitude. Something had been opened up within them, something they had never expected to feel: a great joy."

As his *Ursonate* proved, anyone could feel the buoyancy of a temperament exploring the most rudimentary stuff, whether vowels in the mouth or urban flotsam fixed to a surface. Schwitters' uninhibited creative drive was irresistible. His art made no distinction between parts and wholes, precious and worthless. Merz encompassed the world and opened it to viewers, inviting them to acknowledge the sheer wonder of it. He embodied the condition described by Walt Whitman in "Song of Myself": "I find I incorporate gneiss, coal, long-threaded moss, fruits, grains, esculent roots, / And am stucco'd

with quadrupeds and birds all over." What the world-weary generals experienced in Potsdam, courtesy of Schwitters, was nothing less than a comparable Whitmanian exultation: "Unscrew the locks from the doors! / Unscrew the doors themselves from their jambs!"

Schwitters' Merz had an advantage over Dada, in that it was all his: no movement, no coconspirators to wrangle with over ends and means, no contentious debates about the future of Dada.

The Dadaists in Berlin, on the other hand, were not so lucky. Forced to collaborate on publications and public presentations, they increasingly found themselves at odds. In fact, after the International Dada Fair closed in July 1920 there were no further organized Dada activities in Berlin.

After the fair it momentarily seemed like Dada might have a future in America. In fact, it already had a past there, which American art patron Katherine Dreier knew firsthand as she toured the fair. She arranged for a substantial portion of the display to be shipped to New York for a follow-up show at Societé Anonyme, an organization she'd recently cofounded with Marcel Duchamp.

The Dada exhibit never came off, supposedly because the shipment went down with an oceanliner (or so claimed Wieland Herzfelde late in life). But Anonyme did arrange an exhibition of Schwitters' work. Having seen Duchamp and Francis Picabia in action in New York, Dreier recognized the Hanoverian maestro of Merz as a comparable spirit when she saw his work in Hanover.

Yet the Schwitters exhibit put on by Anonyme was not the first incursion of Dada into the Big Apple. In its own way, New York had a Dada season simultaneous with Dada in Zurich, though it took years for the news to cross the Atlantic.

In 1910, as the iconic Manhattan skyline came into view, Sigmund Freud had confided to his shipmate and professional ally, Carl Jung, "They don't realize that we're bringing them the plague." The plague was psychoanalysis, and the arrival of that virus was followed a few years later by the "virgin microbe" of Dada. In between the two landfalls, however, a more homegrown virus appeared in the streets of Manhattan.

The story of Dada in New York is largely the tale of a phantom parallel, Dada before Dada, in a series of arrivals and departures by two French

artists, Francis Picabia and Marcel Duchamp, who would only later hear of Dada. After all, they had to wait for it to be invented. Meanwhile, they abandoned themselves to a newly awakened cultural combustion in which, like spark plugs, they transmitted the vital jolt.

6

SPARK PLUGS

The handsome young Frenchman arriving in New York on the SS *Rochambeau* on June 15, 1915, was in every respect the opposite of immigrants from previous decades. While earlier immigrants had passed through Ellis Island ready to throw themselves into a new life of hard work, this young man could be described as indolent. Although he had abilities and accomplishments, there was something in his nature that resisted making a career of it—the *it* in question being art. He was an artist and, given his family background, maybe that was part of the problem. He had two older brothers whom he idolized, already established in their own careers as artists. What's more, they'd gathered around them a group of like-minded colleagues defiantly committed to the new aesthetic associated with Cubism.

Young Marcel Duchamp attended these early Cubist meetings, marveling at the assurance with which his brothers Raymond Duchamp-Villon and Jacques Villon (both had changed their names when taking up art) pursued their goals. At a deeper level, Duchamp must have felt that one more artist from the family was a bit much (and this was even before his younger sister Suzanne joined the ranks). Whatever inclination he had to confront the revolving wheel of fashion and upstart causes was rapidly dissipating.

When the Great War broke out, Duchamp proved indifferent to the patriotic euphoria. And almost as a physical symptom of his ennui, he was deemed

medically unfit for service. As war fever assumed a steady state in the months after the initial waves of mobilization, Duchamp found himself repeatedly chastised in the streets of Paris as a presumed slacker. After all, he was young, lean, and looked fit. By 1915, tired of dirty looks and with so many from his circle of artists called up for service, he decided to get away from it all and thought New York might be a good haven. As he insisted to a friend, he wasn't going *to* New York, he was leaving Paris behind. That sort of scrupulous distinction would become a hallmark of his new life in America.

As he sailed into the harbor, unsettled by a heat so intense he thought there must be a fire nearby, Duchamp had no idea he was arriving in a city where he had already achieved celebrity status two years earlier. When he set foot on shore, then, he was gratified to find himself welcomed in style by his old American friend Walter Pach, who had arranged for Duchamp to stay with Walter and Louise Arensberg. He was whisked off straight from the dock to the apartment of the Arensbergs, wealthy art patrons who had moved to New York from Boston shortly before he arrived. Soon after his arrival, their apartment would become the center of a growing international avant-garde, with the newly arrived Frenchman as centerpiece.

From our vantage of instantaneous and ubiquitous messaging, it's hard to grasp a time when a seismic cultural event in the United States wouldn't even register as a back-page item in the European press. But that's how it was when the legendary 1913 Armory Show ruffled the feathers (*plundered the coop* might be more like it) of American culture.

Headlining the bewildered response as the show went from New York to Boston and Chicago was *Nude Descending a Staircase* by an obscure French artist named Duchamp, drawing more than its share of lampoons in the press. "Food Descending a Staircase," "The Rude Descending a Staircase (Rush Hour at the Subway)," "Huntsman Descending a Staircase With His Dog," "Aviator Descending from an Airplane," and "Portrait of a Lady Going Up Stairs Not Down Stairs" were variant spoofs on Duchamp's theme, though a characterization of it as an explosion in a shingle factory proved most durable (spawning its own variant: "Sunrise in a Lumber Yard"). A *Life* magazine illustrator adapted the principle to baseball in "A Futurist Home Run." *Nude Descending a Staircase* even influenced L. Frank Baum to create the character Woozy in *The Patchwork Girl of Oz* (1913). Her motto: "I always keep my

word, for I pride myself on being square." The painting's repute was extended by a postcard reproduction sold by the exhibitors.

The *Nude*, along with three more of Duchamp's paintings, had been chosen by the organizers as they scurried about Europe, scooping up whatever was available for their planned exhibition. Americans attending the Armory Show had no idea what they were in for, and the same could be said of the organizers. When Walt Kuhn caught the Sonderbund exhibition in Cologne on its last day on 1912 (with 125 works by Van Gogh, 25 by Gauguin, 26 by Cézanne, and 16 by Picasso), it was his first exposure to the radical direction European painting had taken in recent years. His frantic visits to Munich, Berlin, The Hague, and finally Paris in the next few weeks revealed how widespread these tendencies were. If the organizers were really going to present modern art to modern America, these Expressionist, Futurist, Fauvist, and Cubist pictures had to be included. The Armory Show was intended as a showcase for American artists, but their work was overshadowed by the Europeans, a plague of modernism every bit as potent as Freud's and far more immediate in its impact.

The Armory Show was massive, with over a thousand works by three hundred artists jammed into eighteen galleries partitioned by burlap in the cavernous 69th Infantry Regiment Armory on Lexington Avenue in midtown Manhattan, February–March 1913. Given the glut, it's not surprising that word-of-mouth and press notices excited visitors' anticipation of the "chamber of horrors" awaiting them at the end—ample fodder for cartoonists who zestily assimilated the pictorial innovations of these "nuttists," "dope-ists," "topsy-turvists," and "toodle-doodle-ists" satirized in *New York American*. The throng of visitors proved typically American in their appetite for shock, and overflow crowds continued when the exhibit moved to Chicago, where the American contributions were much reduced. By the time it ended up in Boston, the Americans were eliminated altogether, ostensibly owing to the smaller exhibition space but in effect verifying that it was the modernist onslaught from Europe that merited attention. In the multitude of cartoons, the work of the Europeans—Duchamp, Picabia, Matisse, Brancusi, and others—invariably drew ridicule.

A mock counterexhibition was held under the delectably named Academy of Misapplied Arts (sponsored by Lighthouse for the Blind), in which

a Picabia Neurasthenic Transformer was on view. The schemer behind this was humorist Gelett Burgess, famous for his purple cow and for coining the word *blurb*. Burgess appended Picabia's name to a device he'd been tinkering on, profiled in 1912 in *The Bookman*, where it was purportedly intended "for the elimination of thought in all forms" and prompting "nonsense in three dimensions." (Although Picabia was not yet manifesting symptoms, on his 1915 sojourn in New York he did undergo treatment for neurasthenia.) In his faux dictionary, *Burgess Unabridged*, Burgess coined *diabob* as the term for "an object of amateur art" with the adjectival form *diabobical* meaning "ugly, while pretending to be beautiful." In a dig at the Armory Show, Burgess writes:

> And yet, these diabobs, perhaps
> Are scarcely more outré
> Than pictures made by Cubist chaps,
> Or Futurists, today!

In hindsight, it's easy to pity the poor saps of yesteryear who confidently leveled such stinging ridicule against works of art that would, in short order, revolutionize modern culture. Take Kenyon Cox, a now-forgotten artist who in 1913 was a widely cited figure of authority. Asked by a reporter from the *New York Times* to comment on the new art, Cox solemnly declared—on the basis of "a lifetime given to the study of art and criticism, in the belief that painting means something"—that Postimpressionism was merely "the deification of Whim" perpetrated by men who were either "victims of autosuggestion" or "charlatans fooling the public." Cox, like other pundits who sought to enlighten the public, thought Henri Matisse was the archcharlatan. He claimed that for Matisse and the Cubists and Futurists (notwithstanding that the latter refused as a group to contribute to the Armory Show) plying their trade as artists was "no longer a matter of sincere fanaticism. These men have seized upon the modern engine of publicity and are making insanity pay." Ironically, it was precisely by this engine of publicity that Cox's views were circulated—in a pamphlet sold at the Armory Show's Chicago venue, no less. The sponsoring organization, the Association of American Painters and Sculptors, issued various pamphlets and postcards to be sold on premises, and one called *For and Against* was prepared in the wake of the New York show. True to its title, it gives equal weight to both sides of the debate.

Cox's position comes across as relatively tame next to that of Frank Jewett Mather Jr., whose "Old and New Art" was reprinted from *The Nation*. Mather shared the general alarm over the "irresponsible nightmares of Matisse" and found new art "essentially epileptic." Taking in the exhibit, he suggested, resembled "one's feeling on first visiting a lunatic asylum," acknowledging that its "inmates might well seem more vivid and fascinating than the everyday companions of home and office," just as "a vitriol-throwing suffragette [is] more exciting than a lady." Confronting the work of Picasso, Picabia, and Duchamp, Mather equivocated as to whether it was "a clever hoax or a negligible pedantry."

One thing that all the commentators agreed upon, even the most vituperative, was that the organizers had done a real service in assembling such irrefutable evidence of the modern movement in art, presenting it in a spirit of neutrality in order to let the public decide for itself. And decide it did, generally along the lines spelled out by an anonymous reviewer for the *Chicago Evening Post*: "Everyman Jack of them had nailed his own flag to the masthead, issued to himself his own sailing orders and was out on the high seas, doing precisely as he pleased." In the aisles of the Armory Show, the public discovered the aesthetic equivalent of the iconic American gunslinging outlaw and was equally fascinated. They might find it as alarming as did the reviewer for the *Chicago Evening Post*, but they were mesmerized by such artistic audacity.

Visitors who weathered the visual assault and didn't dismiss the new art outright tended to take the experience as a lesson or a necessary medicine hard to swallow. "We are in an anaemic condition which requires strong medicine, and it will do us good to take it without kicks and wry faces," wrote Harriet Monroe, editor of *Poetry* magazine. Hutchins Hapgood, Greenwich Village bohemian, told readers of the *New York Globe*, "It makes us live more abundantly." That was certainly the experience of lawyer and art collector John Quinn: "When one leaves this exhibition one goes outside and sees the lights streaking up and down the tall buildings and watches their shadows, and feels that the pictures that one has seen inside after all have some relations to the life and color and rhythm and movement that one sees outside." What Quinn found salutary was what the genteel public—with its belief that art was a hothouse flower far removed from the rough and tumble of the street—held most objectionable. A setting more ripe for the assault of Dada could not be imagined.

Piqued by the influx of modern art from Europe, the press thronged to greet one of the artistic buccaneers as he disembarked at the port of New York on January 20, 1913. The artist—a Frenchman, arriving two years before Duchamp—was featured on the front page of the *New York Times* on February 16, 1913, as "Picabia, Art Rebel" and hyperbolically identified as "the chief of those pirates of art." But this was a courteous and solicitous buccaneer: "It is in America that I believe that the theories of The New Art will hold most tenaciously," Picabia said. "I have come here to appeal to the American people to accept the New Movement in Art in the same spirit with which they have accepted political movements to which they at first have felt antagonistic, but which, in their firm love of liberty of expression in speech, in almost any field, they have always dealt with an open mind." Speaking just a day after the Armory Show opened, which the public at large had yet to view, Picabia assured people they were bound to embrace the new art.

What Picabia soon discovered, as virtually all the European exiles in the coming war would reaffirm, was that the sheer force of modernity concentrated in the city of New York outstripped anything in the sphere of art. Amy Lowell, who considered herself a beacon of the advanced cause of Imagism, decided that "the most national things we have are skyscrapers, ice water, and the New Poetry." Lowell had a sentimental attachment to poetry, but from the perspective of Picabia, a skyscraper like the Woolworth Building was a standing reprimand to artistic timidity; and soon Marcel Duchamp would come up with the zany notion of signing his name to the building (then the world's tallest) and declaring it one of his "ready-made" artworks. But he couldn't think of a fitting title, so the Woolworth Building never became the world's largest ready-made.

Picabia was born into wealth and privilege and generally behaved with a presumption of immunity from social norms, however debonair his manners and tailored his wardrobe. A case in point is his second visit to New York when he was supposed to be carrying out a military mission in Cuba. Taking advantage of the ship's itinerary, he disembarked at New York to rejoin his old friends and found an agreeable milieu awaiting him, from which he found it impossible to withdraw.

During the Armory Show, Picabia was instantly if warily lionized as a bona fide French artist willing and eager to put himself on the line for a cause,

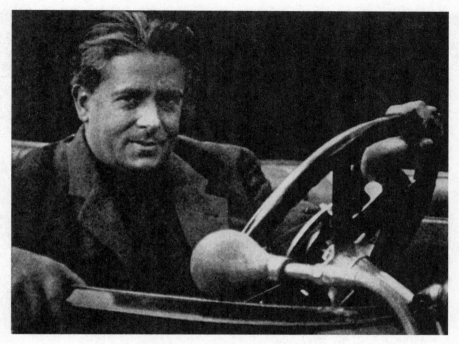

Francis Picabia, photographed by Man Ray, 1922.

the cause of modern art. He struck up a fast friendship with Alfred Stieglitz, champion of photography as a legitimate art, editor of *Camera Work*, and proprietor of 291 Gallery, where he mounted an exhibition of Picabia's works in the wake of the Armory Show. Picabia's statement for the catalogue (reprinted in the "For and Against" pamphlet) isn't particularly incendiary. He helpfully suggested that the public not seek any "photographic" material in his paintings, because he was working in the spirit of a "qualitative conception of reality" to which optical phenomena were subordinated. The result, he admitted, approached abstraction, a term then barely broached in art.

Picabia, along with Wassily Kandinsky and Czech painter František Kupka, were among the first to take the leap into abstraction, and for all three the operative analogy was with music, a theme Kandinsky had taken up the year before in his book *Concerning the Spiritual in Art*. One rejoinder to those who professed to see no nude in Duchamp's *Nude Descending a Staircase* was

to ask, Where is the moon in the Moonlight Sonata? Even before he ventured down the rabbit hole of abstraction, critics had found in Picabia's work a "musical emotion." Charles Caffin, reviewing his contributions to the Armory Show, found him "emulating the musicians as he manipulates the notes of the octave, starts with a few forms, colored according to the key of the impression he wishes to create and combines and recombines these in a variety of relations until he has produced a harmonic composition." Caffin was following a well-worn path identified in 1877 by English aesthete Walter Pater, when he observed that all the arts were aspiring to the condition of music.

In 1905 Kupka wrote to a friend, "I paint only the conception, the synthesis; if you like, the chords." He was prone to signing his letters "color symphonist," but it wasn't until 1913 that his quest for visual music plunged through to abstraction. "I am still groping in the dark," he wrote, "but I believe I can find something between sight and hearing and I can produce a fugue in colors." By that point, Roger Fry was referring to Kandinsky's work as "pure visual music." "This new expression in painting is 'the objectivity of a subjectivity,'" Picabia declared in his statement for 291 Gallery, adding: "We can make ourselves better understood by comparing it to music."

Picabia drew on this comparison when interviewed by the New York press. He spoke of "a song of colors" to a reporter from World Magazine. "I simply equilibrize in color or shadow tones the sensations which those things give me. They are like the motifs of symphonic music." He pressed the point a bit further in The New York American: "I improvise my painting just as a musician improvises his music." Most of the newspaper profiles quoted Picabia at length as if he stepped off the boat chattering away in English, a language he never learned. The journalist for the New York Tribune didn't quote Picabia but assimilated his lesson, reiterating the point that "just as music is only a matter of sounds, so painting is a matter of form and color." And, adding the spice of analogy: "It was Bill Nye who, in one of his wittiest remarks, said that the funniest thing about classical music is that it is so much better than it sounds. In the same way the uninitiated may say of M. Picabia's Post-Cubism that it 'listens' so much better than it looks."

Picabia completed two large canvases in New York in 1913 and characterized them as "memories of America, evocations from there which, subtly opposed like musical harmonies, become representative of an idea, of a nostalgia, of a fugitive impression." Picabia's efforts to pictorialize music were

augmented by his marriage to Gabrielle Buffet, a trained musician who had studied with such luminaries as French composers Gabriel Fauré and Vincent D'Indy and Italian composer Ferrucio Busoni. As the *Tribune* reporter noted, she brought to the cause of her husband's career and modern art generally a "remarkably large" technical vocabulary in "exceptionally fluent English and German."

The consistency of the reportage in 1913 suggests that Picabia was patient and accommodating when dealing with members of the press. Apart from the musical analogy, he routinely explained how photography, with its accurate recording of objects, had freed art from its old mimetic obligations. The art of the past belongs in the museums as a reference point; according to Picabia, such work is "for us what the alphabet is for a child." To advance beyond mere spelling to the complexities of expression—grammar and syntax—is the goal. So the viewer should not search the surface of the painting looking for recognizable forms. "Did I paint the Flatiron Building or the Woolworth Building, when I painted my impressions of the fabulous skyscrapers of your great city?" he asked. "No, I gave you the rush of upward movement, the feeling of those who attempted to build the Tower of Babel." Picabia was in pursuit of "the mental fact" or "emotive fact," identified as precisely that which photography cannot reveal. "Creating a painting without a model of any kind: that is what I call art."

Reporters were eager to learn how their city was affecting Picabia's painting, and he encouraged their interest by pointing out they already inhabited a sort of Postimpressionist urban milieu. "You New Yorkers can readily understand me, just as you can those other painters who are my colleagues. Your New York is the Cubist, Futurist city; with its architecture, its life, its spirit, it expresses modern thought. You have skipped all the old schools and are Futurists in word, action and thought." The *New York Herald* reported, under the racist headline, "Mr. Picabia Paints 'Coon Songs,'" that Picabia had found inspiration in two "coon songs" he heard performed at a restaurant. The following day he produced two paintings called *Negro Song*. American artist Jo Davidson was asked, in the debased idiom of the day, "Do you think he shows us the coons?" Not at all, he replied, "he shows us a grand shuffle of deep purple and brown curved globs of color."

When the Picabias departed after the Armory Show in April 1913, Stieglitz wrote a friend that they "were about the cleanest propositions I ever

met in my whole career. They were one hundred percent purity. This fact added to their wonderful intelligence made both of them a constant source of pleasure." They left a glow still luminous when Picabia returned in 1915, abandoning his military mission and hurling himself into a life of debauchery only someone with his means and temperament could command. The Stieglitz circle was naturally gratified to see him back in town. Because 291 Gallery was not so much a commercial enterprise as it was Stieglitz's private auditorium, his associate Marius de Zayas was in the midst of establishing another gallery as a more commercial alternative, and the first exhibit at his Modern Gallery showcased Picasso, Braque, and Picabia.

Picabia was featured in a succinct profile in *Vanity Fair* that December, as a follow-up to its profile of Duchamp in September. "Marcel Duchamp has arrived in New York!" the unattributed author breathlessly reported, while the accompanying photo of the artist (in polka-dot bow tie) made him look a decade younger than his twenty-eight years. Picabia, by contrast, looks utterly relaxed for Stieglitz, gazing into the camera as if taking precisely thirty seconds out of his busy life; but instead of his dissipations, the text covers his self-serving lead, reporting that he may be called back into combat at any moment. (His closest bout with combat would come a few years later when the husband of a woman with whom he was having affair went after him with a pistol.) The article more accurately tracked the twists and turns of his art, from his salon background ("An Extremely Modernized Academician," reads the subtitle), to the phase in which "I tried to make a painting that would live by its own resources, like music," and the mechanomorphic concoctions he was then developing: "Picabia likes to make a picture of the interior of a motor-car and call it a portrait." On October 24 he was quoted in the *New York Tribune* on this new turn. "Almost immediately upon coming to America," he said, "it flashed on me that the genius of the modern world is in machinery, and that through machinery art ought to find a most vivid expression."

With his proposal to the *Tribune* reporter that painting might profitably address the teeming new world of machines, so conspicuous in America, Picabia unwittingly embarked on a path that would directly impact Dada. In the meantime, though, his concerns and stimuli were strictly local, and increasingly absorbing, especially once Picabia was plunged into a vertiginous reunion with his old Paris friend, Duchamp.

A familiar notion of Duchamp as a grand wizard who purportedly abandoned art for chess was established as early as 1924, when he was depicted playing chess with Man Ray on a Parisian rooftop in René Clair's film *Entr'acte*. But by the time he arrived in New York he already had a tenuous relation to art. Instead, he became fully immersed, as Dada itself was, in the unplanned and the unforeseeable, lighting matches to those moments as they came. There were plenty of moments, and plenty of matches.

And there was Picabia, a cultural arsonist if ever there was one. The two men shared a deep, unremitting, and resourceful nihilism. Where others might politely disagree by beginning a sentence with "Yes, but . . . ," Picabia's rejoinder would be "No, because" Duchamp was mesmerized: it must have seemed like looking in a mirror—and seeing another face. He credited the older artist with introducing him to a spectrum of new experiences in 1911–1912, at a time when Picabia was smoking opium every night—though Duchamp refrained. "A dangerous and enticing wind of sublime nihilism / pursued us with incredible exhilaration," Picabia wrote in a poem called "Magic City," which commemorates those "Years of genius" marked by "sterile passions" like opium, whiskey, and that new dance craze, the tango.

The bond between Picabia and Duchamp had been sealed before the war, during a long car trip with poet Guillaume Apollinaire (Picabia owned scores of cars during his lifetime). "Apollinaire often took part in these forays of demoralization, which were also forays of witticism and clownery," Buffet-Picabia, Picabia's wife, recounted. Visiting her family home in the Jura near the Swiss border, the travelers indulged in conversational fireworks that Picabia and Apollinaire honed to a fever pitch. The poet first read his long poem "Zone" on this occasion, the resounding capstone to his book *Alcools*. Soon afterward, he removed all the punctuation from the manuscript before it went to press.

Around the time of that car trip, Picabia began painting abstract pictures. Duchamp was moving closer to the anti-retinal position he held for the rest of his life; retinal art being for him that which only pleased the eye, and he would soon cease painting altogether. The friendship between Picabia and Duchamp amounted to a kind of cabal, in which they sharpened their native intelligence into complementary sets of surgical tools. Duchamp later called Picabia his copilot. They shared above all a "mania for change," as Duchamp put it. "One does something for six months, a year, and one goes on to something else. That's what Picabia did all his life."

Possibly the most important factor for Duchamp in New York is that in this milieu he was not the little brother. Jacques and Raymond were eleven and twelve years older, respectively, and Duchamp revered them, having followed in their footsteps as an aspiring artist himself. The eminence of his brothers in the Parisian art world had not been an asset to Duchamp, however. Despite winning a medal from the Rouen Société des Amis des Arts around the time he graduated from the lycée in 1904, he failed the entrance exam to Paris' École des Beaux-Arts. Undiscouraged and taken under the wing of his siblings who established an arts colony in Puteaux on the outskirts of Paris, his paintings were accepted annually to the Salon d'Automne from 1908. But his steady if unexceptional rise in the art world came to a sudden halt in 1912, when he decided to remove *Nude Descending a Staircase* from consideration for the Salon des Indépendants, after the organizers expressed doubts, suggesting he delete the title. His own brothers conveyed the grim request. "It was a real turning point in my life," Duchamp recalled. "I saw that I would never be much interested in groups after that." He went to Munich for a while, intentionally isolated and adrift but convinced of one thing: "Everyone for himself, as in a shipwreck."

Another factor contributing to Duchamp's European shipwreck was a growing attraction to Picabia's wife, Gabrielle, to whom he professed his love in 1912. Although he arranged a clandestine meeting, there would be no consummation until a decade later, after she was divorced. Looking back, Buffet-Picabia marveled that "even now I find it really astonishing and very moving. It was utterly inhumane to sit next to a being whom you sense desires you so much and not even to have been touched."

Something of this ardently romantic spirit was evident to the New Yorkers who met the newcomer, an effect doubled by his being a Frenchman. When Beatrice Wood met him late in 1916, she recalled: "We immediately fell for each other. Which doesn't mean a thing because I think anybody who met Duchamp fell for him." He had that effect on men as well, radiating an intellectual magnetism like some fourth dimension of the erotic. A photo by Edward Steichen conveys it best. Duchamp went so far, in fact, as to characterize that period of his life—when he was working on his most famous work, *The Large Glass*—in just such terms. "Eroticism was a theme, even an 'ism,' which was the basis of everything I was doing." And much of it was being done with young women, who, it appears, he needed to make no effort to entice.

Marcel Duchamp, photographed by Edward Steichen, 1917.

Duchamp had an aura of taking everything for granted, including his own unplanned exaltation in the eyes of these Americans. Toward the end of his life, when asked what had satisfied him most, he replied: "Having been lucky." He was not a schemer, and what little ambition he had for a career had been discarded back in France, supplanted by what looks like indolence but was probably patience. He was like a golden child who wanders untouched through the most fraught zones, impervious to the dangers, radiating a glow of immunity. He wasn't a golden child, of course; Beatrice Wood, for one, noted the dark chill he carried within, faintly evident from time to time. He characterized himself much later as "enormously lazy. I like living, breathing, better than working." It's not surprising he's been touted as the antithesis of the hyperproductive Picasso.

But it wasn't sloth or indolence that brought Duchamp to New York. After all, crossing the Atlantic after the sinking of the *Lusitania* by a German torpedo took pluck; and shortly before he left he told a friend that staying in Paris would mean persisting in the usual career aspirations of an artist, seeking fame and fortune while at the mercy of wealthy patrons. Above all he loathed having to become a "society painter," as he put it.

Duchamp stayed with the Arensbergs for his first month in New York. Like Buffet-Picabia, Louise Arensberg was a musician, and she'd already mastered the thorny piano pieces of Arnold Schoenberg (at a concert of Schoenberg's music Kandinsky was emboldened to pursue the "emancipation of dissonance," as the composer put it, in his painting). Louise didn't drink, but her husband, Walter, obliged by drinking for two.

By the time Duchamp found his own place, a salon had blossomed around him. He quickly became the living god in the Arensberg shrine and, just as important, the social lubricant of a burgeoning avant-garde. With Duchamp at the helm—an "angel who spoke slang," as Beatrice Wood put it, and a "missionary of insolence" someone else said—there developed a raucous spirit that was, to all intents and purposes, Dada without anyone being aware of Dada, because it didn't exist yet, even in Zurich.

The intellectual ebullience of the Arensberg circle was most conducive to the conceptual wit Duchamp brought to the objects he called ready-mades. Back in Paris he had mounted a bicycle wheel on a stool, simply for the pleasure it gave him as it spun, like having a fire in a fireplace, he said. He'd also kept a bottle-drying rack at hand, just for the look. The first

declared ready-made, though, was a snow shovel bought in a hardware store on Broadway in late 1915. In January he wrote his sister Suzanne in Paris, informing her of the purchase and the inscription he applied to the shovel, "In advance of the broken arm." Recalling the items left in his Paris studio, he asked her to sign the bottle rack ("I'm making it a 'readymade' remotely"). He cautioned her on attributing any significance to this sort of thing. "Don't try too hard to understand it in the Romantic or Impressionist or Cubist sense—that has nothing to do with it." To the end of his life he insisted that ready-mades were chosen with indifference to any aesthetic qualities or question of taste.

Taste, whether good or bad, Duchamp thought merely a habit, rather like art itself. The mindless perpetuation of habits made him bristle, an opinion he shared with the Dadaists. Anyone now visiting the portion of the Philadelphia Museum of Art given over to the Arensberg collection, which houses the largest body of Duchamp's work in the world, is likely to be impressed with something like the taste evident in the overall selection. Irony? Contradiction? Regardless, Duchamp's greatest luck was escaping the dreaded role of society painter. Instead, he ended up with the Arensbergs—ready, willing, and able to be his personal patrons. Duchamp did almost anything to ensure the consistency of the relationship, even touching up a reproduction of the *Nude*, as consolation for the fact that Walter had been unable to lure it away from its original owner in San Francisco.

When Duchamp arrived in New York, he was as ignorant of English as Picabia. Picabia made no effort to learn the language, but Duchamp (being poor and practical) plunged right in, even though the Arensberg circle took French for granted. The poet Wallace Stevens reported to his wife how delightful it was to converse "like sparrows around a pool of water" in the Latin tongue during a long dinner with his former Harvard classmate Walter and the newly arrived artist. Some of the Americans who frequented the salon were less at ease, like William Carlos Williams, who felt himself chastened when he professed a fondness for one of Duchamp's works hanging on the well, only to find the artist responding, "Do you?" with what the poet thought to be a superior air.

Duchamp's relationship with Man Ray proved the most durable—and one that encouraged them both to bridge the linguistic gap, as neither knew the other's language. Man Ray was a young artist living in what Duchamp

perceived as wild and woolly New Jersey. He was married at the time to Belgian artist Adon Lacroix, but she was less interested in translating for his benefit than in her own conversations with Duchamp on the subject of favored poets, like Laforgue and Mallarmé. The two men had to content themselves with playing a game of tennis, with Man Ray giving a name to each pass and Duchamp repeating his new word *yes*. Their partnership, from there on out, would prolong that welcoming affirmation. For Duchamp, it was as though he'd found a vital balance to the sacred *no* he shared with Picabia.

Man Ray, a native New Yorker, was from an immigrant Ukrainian family named Radnitsky. By the time he met Duchamp, he'd shed the ethnic name and convinced the rest of his family to do so as well. (*Man* was short for Emmanuel.) Trained in technical aspects of art and design, he was lucky enough to discover Stieglitz's 291 Gallery in 1911, when he was twenty-one. But nothing quite prepared him for the impact of the Armory Show, which stopped him in his tracks for half a year. He matured quickly after that, so that by the time he met Duchamp he was preparing his first solo exhibit at the Daniel Gallery in New York, resulting in a liberating windfall when the lawyer and art collector Arthur Jerome Eddy bought $2,000 worth of his paintings. With his eye for venturesome art, Eddy had previously bought two of the four Duchamp paintings exhibited at the Armory Show.

By the time of this eventful solo show, Man Ray had embarked on the path he'd become best known for, photography. He had a mentor in Stieglitz, but characteristically pragmatic, he took up the medium not for its creative potential but to document his paintings before they sold.

Man Ray's propensity for mastering technical challenges reflects his temperament as well as his practical training in industrial art. Some of his paintings resemble stencils in the way they section off body parts into lozenges. Others, like the massive and vibrantly colored *The Rope Dancer Accompanies Herself with Her Shadows*, bring to mind dressmaking patterns, and Man Ray would soon be cutting out various supporting materials to add to the canvas. He also took up the airbrush, an industrial tool that proved just the ticket for the clean, quasi-photographic look he achieves in *Admiration of the Orchestrelle for the Cinematograph*, on which he used ink, gouache, and pencil to produce alphanumeric effects. Spending time with Duchamp, who around this time started laboring over his assemblage piece *The Large Glass*, affirmed Man Ray's multimedia tendencies.

By this point Man Ray was making assemblages as well, like the disarming *Self-Portrait* consisting of a handprint centered between a bell button and a pair of ringers, which prompted critic Henry McBride to salute the artist's enlistment of tactile sensation. Noticing that many visitors to the gallery were inclined to press the buzzer, McBride admitted to his own struggle to refrain.

Self-Portrait may be the clearest harbinger of the contributions Man Ray would make to Dada when he moved to Paris in July 1921, but other works were already treading into Dada waters. Some paintings looked almost as if he were copying the chance generated paper patterns of Hans Arp, though Arp wasn't yet known in New York. And he anticipated by a few years the Berlin Dada vogue for automata, in yet another technical foray into the medium of the *cliché verre*, in which a drawing is incised onto a coated glass, which then acts like a photographic negative to produce a paper print. He was inching closer to the vistas photography would open up, but for the time being it served mainly as the medium in which he and Duchamp could perpetrate, document, and sanctify the antics that would eventually be recognized as Dada.

Ezra Pound, who knew both men later in Paris, admired their audacity. They have pushed art, he said, "to a point where it demands constant invention, and where they can't simply loll 'round basking in virtuosity." Pound makes no reference to Dada, but this passage nicely evokes the spirit of creative adventure characteristic of nearly all the Dadaists.

Dada was still on the other side of the horizon from the New York skyline. Arturo Schwarz, Milanese gallery owner and lifelong curator of Dada, asked Man Ray in his later years if he thought there had ever been Dada in America. "There was no such thing," he emphatically replied. "You can put me down as having said that. I don't think the Americans could appreciate or enter into the spirit of Dada."

It's true that most of what's been identified as New York Dada was accomplished (or indulged in) by expats in the city during the war. Man Ray was the major exception. So bountiful were his artistic activities it's easy to overlook his experiments with sound poems, nearly contemporaneous with Cabaret Voltaire. His denial of an American Dada makes sense in light of his move to Paris, where he was immersed in an avowed Dada movement, with Tristan Tzara at the helm. Man Ray quickly became a central figure

in the cause (even before he arrived his photographs were on display at the Salon Dada Exposition International exhibition at Galerie Montaigne). So it was easy for him, decades later, to insist America had no Dada. At the time, shortly before leaving his homeland, Man Ray had written to Tzara, "Dada cannot live in New York. All New York is dada, and will not tolerate a rival." Apparently he was coming around to the attitude of Picabia, who in 1920 had confided to Parisians that "in America everything is DADA."

This was a theme that would shortly be taken up in the glossy pages of *Vanity Fair* (to which Tzara contributed accounts of Dada). In the February 1922 issue, Edmund Wilson observed that Parisians were worked up about the latest American folderol, and "young Americans going lately to Paris in the hope of drinking culture at its source have been startled to find young Frenchmen looking longingly toward America." As for what Wilson took to be the latest fad, "the electric signs in Times Square make the Dadaists look timid," sounding a theme also taken up by another American, Matthew Josephson, who was not only living in Paris but immersed in the inner sanctum of Dada. In July 1922, in the expatriate arts journal *Broom*, Josephson's "After and Beyond Dada" surveyed the latest publications of Dada poets and found them caught up in a "search for fresh booty." He observed, "The contemporary American flora and fauna are collected, in an arbitrary fashion, out of the inimitable films, the newspaper accounts, the jazz band, on the hunch that the world is on its way to being Americanized."

But that was later, after the war reached its ignominious conclusion, and the survivors were glad to have it behind them. As these European pre-Dadaists romped around the United States, the fight was still raging—both in their homeland, and in the salons of New York, where the future of modern art in America was being decided.

In the summer of 1915, Picabia and Duchamp had just arrived in New York, and Man Ray was still living in an artist's colony in Ridgefield, New Jersey. The scene was profiled in the Special Feature Section of the *New York Tribune* for Sunday, July 25, 1915, under the headline: "Free-Footed Verse Is Danced in Ridgefield, New Jersey." The subhead went on at some length: "Get What Meaning You Can Out of the Futuristic Verse—Efficiency Is Its Byword and Base—It's As Esoteric as Gertrude Stein Herself or a Loyd Puzzle—'Others' Is the Name of the Field Through Which You Must Wander to Grasp It." The

perpetrators of this new cult are described as dressing in "strange garb" of a "Chinese" sort, and wearing sandals. The reporter also lists the residents of the community, erroneously including William Carlos Williams (who lived nearby in Rutherford) and omitting Man Ray, a resident who was himself writing poems.

The author of the *New York Tribune* article made a point of mentioning Mina Loy, a regular of the Arensberg salon. Loy pushed all sorts of boundaries. Her frank "Love Songs" were brandished in the inaugural issue of the free verse journal *Others*, profiling "Pig Cupid," his "rosy snout / Rooting erotic garbage." The journal's editor, Alfred Kreymborg, ran a slogan in every issue: "The old expressions are with us always, and then there are others." It was a sentiment that could be applied to the whole milieu of Dada in New York. Besides Mina Loy, another of the poets who contributed such novel "expressions" to Kreymborg's journal was Man Ray.

Man Ray and Francis Picabia were both prodigiously productive during this time, while Marcel Duchamp labored away fitfully at *The Large Glass*, baptizing a ready-made now and then. He was delighted when the Bourgeois Gallery included two ready-mades in its *Exhibition of Modern Art*. One, called *Trébuchet* (Trap), was a board with four metal coat or hat hooks and would have been inconspicuous were it mounted on a wall, near an umbrella stand, reverting, as it were, to its normative use. But Duchamp nailed *Trébuchet* to the floor near the entryway to the gallery, where it, nonetheless, went entirely unnoticed as "art" by most.

In any case, nobody viewing modern art at the Bourgeois Gallery in April 1916 was prepared to shift his or her gaze away from objects in frames or on pedestals. It would take a more dramatic intervention to press the point home. The opportunity, in fact, would come almost exactly a year later.

Shortly after the United States declared war on Germany on April 4, 1917, the Society of Independent Artists—an organization formed by Arensberg, Duchamp, Man Ray, and a few others—was preparing its first major exhibition. There was no jury, and anyone could exhibit work for a small fee.

Duchamp evidently decided to test the limits of this organization in which he was a presiding member. A week before the opening, after lunching with fellow artist Joseph Stella, Duchamp and Arensberg passed by the J. L. Mott Iron Works showroom at 118 Fifth Avenue, where Duchamp bought a flat-back Bedfordshire model urinal. Back in his studio he signed

the name R. Mutt on the upper rim. Placed so, the signature meant the object had to be seen at an unfamiliar angle. He then arranged for *Fountain*, as he named it, to be delivered to the hanging committee, of which he was a member.

Artistically speaking, this was a shot heard round the world, its sonic boom still resounding. *Fountain* would become one of the most famous artworks of the twentieth century, a fact that would have outraged and depressed most of the artists in the Independents exhibition, to say nothing of the more conservative factions who were still ridiculing the Armory Show years later. Beatrice Wood witnessed a painter (George Bellows or Rockwell Kent, she couldn't recall which) at his wit's end, insisting to Arensberg that the obscene thing could never be shown. Walter pointed out that the fee had been paid, adding that, regardless, "a lovely form has been revealed" in an unsuspected place.

As it turned out, the more than twenty thousand visitors who roamed through the enormous exhibit—its 2,125 works arranged alphabetically by artist, beginning with the letter *R*—were spared an encounter with *Fountain*, which was denied entry in the end. Its rejection precipitated the resignation of Arensberg and Duchamp from the board of directors. The piece was last sighted in 291 Gallery, where Stieglitz photographed it in front of a painting by Marsden Hartley.

The original piece was gone, but it was certainly not forgotten. Duchamp began authorizing replacements in 1950, and by the time he died in 1968 more than a dozen were in circulation. Before then, *Fountain* was known strictly through Stieglitz's photograph, printed in the second issue of *The Blind Man*, a short-lived journal edited by Duchamp with Beatrice Wood and Henri-Pierre Roché. The title affirms Duchamp's "anti-retinal" approach to art. The photograph bore the caption, "The exhibit refused by the independents." It was followed by a short article in variable type, "The Richard Mutt Case," unsigned but probably by Duchamp. The article certainly reflects the aesthetic pioneered by his ready-mades: "Whether Mr. Mutt with his own hands made the fountain or not has no importance. He CHOSE it. He took an ordinary article of life, placed it so that its useful significance disappeared under the new title and point of view—created a new thought for that object." In the word *object* lurks the verb, *to object*, which is precisely what *that* object provoked.

Such homonyms and puns were endlessly fascinating to Duchamp, albeit generally in French. One of his favorite authors was Jean-Pierre Brisset (1837–1923), whose speculative etymologies led him to conclude that humans had evolved from frogs. His abiding principle was that "all the ideas expressed with similar sounds have the same origin and all refer, initially, to the same subject." Given the riotous homophonic propensity of French, Brisset fancied a necessary connection between expressions like *laid en la bouche* (ugly in the mouth) and *lait dans la bouche* (milk in the mouth). Duchamp's inclination to think of the erotic as an *ism* may have been inspired by Brisset's theory that "sexual force alone creates all human speech, as it does all humans." Accordingly, "all words were suckled, aspirated, licked, and there is not one that did not enter the mouth through one of these actions." If that isn't explicit enough, try this: "The pronoun *I* designates the sexual member, and when I speak, it is a sexual organ, a virile member of the eternal-God which acts through his will or his permission." Duchamp made no pretense to speak or act on behalf of a higher authority, but he was consistently clear about his determination to shake off the hidebound habits of personal taste, a position that led him to take up mechanical drawing to, as he put it, "forget with my hand."

At the heart of Duchamp's enterprises and escapades is his mental agility, his ability to think and act not with ideals and principles in mind, but as an exercise of athletic prowess. If you can think it, you can express it; or, more often in Duchamp's case, if you can say it you might then begin to think it (Picabia later came up with the slogan "Thought is made in the mouth," happily reiterated by Tzara). Its principle of forward motion was expressed in another item from *The Blind Man*, a poem called "For Richard Mutt" by the painter Charles Demuth, which concludes:

> For some there is no stopping.
> Most stop or get a style.
> When they stop they make
> a convention.
> That is their end.
> For the going every thing
> has an idea.
> The going run right along.
> The going just keep going.

Among the other contributions to the Mutt issue of *The Blind Man* is Stieglitz's radical proposal that future exhibitions should present the art anonymously, a prospect that some Dadaists might have acclaimed. "Thus each bit of work would stand on its own merits. As a reality. The public would be purchasing its own reality and not a commercialized and inflated name." *Vanity Fair* editor Frank Crowninshield's laudatory letter takes up the theme of the journal's editorial ("The only works of art America has given are her plumbing and her bridges"): "If you can help to stimulate and develop an American art which shall truly represent our age, even if the age is one of telephones, submarines, aeroplanes, cabarets, cocktails, taxicabs, divorce courts, wars, tangos, dollar signs; or one of desperate strivings after new sensations and experiences, you will have done well." A similar note was struck in *The Little Review* by Jane Heap, who lamented the timidity of American artists "terrorized by the power of plumbing systems and engines," urging them instead to seek out alliances with scientists and engineers.

If the infamous *Fountain* quickly attained the replenishing aura of a *fons mirabilis*, a similar object from the same year escalates the gambit. This was a plumbing trap mounted on a miter box, named *God*. This sculpture implied that the alimentary function of the inner organs bore their divine mission as gravitational destiny, as if the famous biblical text read "Let there be digestion" instead of "Let there be light."

The painter Morton Schamberg photographed *God* in front of one of the many machine paintings he executed under the influence of Picabia. The idea behind the piece has been traced to the Baroness Elsa von Freytag-Loringhoven, routinely if inadequately characterized as "colorful" in the bohemian sense. This German poet and artist arrived in New York in the year of the Armory Show, where she met and promptly married a German baron who abandoned her the next year when the war broke out, hoping to enlist but ending up interned in a French prisoner-of-war camp for the duration. Meanwhile, the baroness twisted like a corkscrew through the New York avant-garde until her return to Europe in 1923.

When Duchamp arrived in New York the baroness quickly fixated on him and they became as close as he'd allow. She would trumpet her attraction to him with the refrain "Marcel, Marcel, I love you like hell, Marcel," impetuously declaiming it at the Arensbergs and elsewhere. While some could be cowed by her sexual voracity, Duchamp remained poised in his resistance and

earned her respect for it. Duchamp's preoccupation with bride and bachelors in his *Large Glass* inspired her to write, a tad reproachfully, "thou becamest like glass," and "now livest motionless in a mirror!"—as if *he* were the "unravished bride" of Keats' famous Grecian urn. Joyously responsive to the theme of the female machine introduced by Picabia in works like his detailed drawing of a spark plug with the title *Portrait of an American Girl*, the baroness promoted herself as "proud engineer" unashamed of her "machinery." With scatological clarity, she reasoned, "If I can eat I can eliminate—it is logic—it is why I eat!" It was only natural, she insisted, that to lavishly extol the pleasures of the palate extended to reports of "my ecstasies in toilet room!"

These ruminations appeared in the July 1920 issue of *The Little Review*, pointedly preceding the chapter of Joyce's *Ulysses* in which Leopold Bloom masturbates on the beach, aroused by the undergarments of a coy maiden nearby. *The Little Review*, which proudly bore on its cover the slogan "Making No Compromise with the Public Taste," had been serializing *Ulysses*, beginning in 1918. This ended when the postmaster general seized four issues, refusing to distribute them, one of them the July issue with the baroness' cheeky prelude to Bloom's self-administered "relief." As a consequence, the review and its editor, Margaret Anderson, went to trial in 1921 over this reputedly obscene material. During the trial—which led to the discontinuation of *Ulysses* in serial form—the judge refused to permit passages from Joyce's work to be read aloud in the courtroom on the grounds that this would somehow besmirch the virginal ears of Anderson, who had (so the judge must have presumed) somehow published the offending text without reading or comprehending it.

Jane Heap, coeditor of *The Little Review*, was a tireless supporter of the baroness, responding to the suppressed issue by opening the next with a portrait of the flamboyant German. But this was a fairly docile photographic silhouette, revealing nothing of her ostentatious couture. She was a performance artist of everyday life, though there was nothing "everyday" about her costumes. Djuna Barnes characterized her in the *New York Morning Telegraph Sunday Magazine* as "an ancient human notebook," adorned with "seventy black and purple anklets clanking about her secular feet." She appeared at a fancy dress benefit concert in a "trailing blue-green dress and a peacock fan. One side of her face was decorated with a canceled postage stamp (two-cent American, pink). Her lips were painted black, her face powder was

yellow. She wore the top of a coal scuttle for a hat, strapped under her chin like a helmet. Two mustard spoons at the side gave the effect of feathers." On another occasion she wore a dress clattering with seventy or eighty toy soldiers, locomotives, and similar items, also "a scrapbasket in lieu of a hat, with a simple but effective garnishing of parsley," while dragging along on a single leash half a dozen mangy little dogs. (She was a collector of animal life, even feeding and sheltering rats.)

Baroness Elsa von Freytag-Loringhoven made a fitful living as an artist's model, though by this time she was in her forties and her somewhat unconventional looks were going. The artist George Biddle recorded his astonishment when she appeared in his studio one day seeking work. Sweeping open her scarlet raincoat with a "royal gesture," Biddle beheld: "Over the nipples of her breasts were two tin tomato cans, fastened with a green string about her back. Between the tomato cans hung a small bird-cage and within it a crestfallen canary. One arm was covered from wrist to shoulder with celluloid curtain rings, which later she admitted to have pilfered from a furniture display in Wannamaker's. She removed her hat, which had been tastefully but incongruously trimmed with gilded carrots, beets and other vegetables. Her hair was close cropped and dyed vermilion." She was endlessly inventive in fabricating ornaments, like *Limbswish*, a metal spring conjoined to a curtain tassel, named for the motion it displayed when worn on the hip. The baroness' sartorial flair was a perpetual advertisement for a personality best described as *far out* in an almost galactic sense. Poet-doctor William Carlos Williams, chastened by her ardent advances, allowed that she was "courageous to an insane degree."

Jane Heap celebrated Baroness Elsa as "the first American Dada"—overlooking her origins, conspicuously retained in her thick accent and unorthodox written English. In the baroness, "Dada is making a contribution to nonsense." This estimate appeared in a special Picabia issue of *The Little Review*, when the journal was caught up in the Dada "season" unfolding in Paris, and it reveals by omission that the earlier activities of Duchamp, Man Ray, and Picabia himself were not yet linked to Dada. When Duchamp and Man Ray made a film of the baroness shaving her pubic hair in 1921, did they regard it as a Dada event? There is evidence they did not: Man Ray pasted a still from this film into the letter he wrote Tzara in Paris, informing him "dada cannot live in New York."

Yet other signs point to a steady assimilation of Dada by these New York artists. Man Ray's letter to Tzara coincides exactly with his and Duchamp's production of the journal *New York Dada*. What's more, an entire page (of four overall) in this singular production was given over to Tzara's "authorization" of the use of the word *Dada*. "Dada belongs to everybody. Like the idea of God or of the toothbrush," he wrote, approving this American embrace of Dada. After all, it was "not a dogma nor a school, but rather a constellation of individuals and of free facets." Intriguingly, Tzara addresses his response to "Madame." Perhaps to emphasize the gender, a photo by Man Ray appears sideways at the top of the page, in which a naked woman stands partially obscured behind a hat rack. The madame in question may also be the one seen peering out through a shapely female calf, in a double exposure by Alfred Stieglitz on the previous page, with the slogans "WATCH YOUR STEP!" and "CUT OUT DADYNAMIC STUFF!"

Most signally, though, *New York Dada* features Duchamp on the cover and two photos of the baroness on the last page. Amidst a grid of letters printed upside down, reading "new york dada april 1921," and running the full fourteen inch length of the cover, is a photograph of a perfume bottle labeled Belle Haleine (sweet breath), with an oval portrait of Duchamp in drag in his role as Rrose Sélavy. In another instance of cross-gender appointments, the photos of the (nude) Baroness are accompanied by an ad for the upcoming Société Anonyme exhibit of "Kurt Schwitters and other Anonymphs"—Schwitters' fame having reached America with *Anna Blume*, courtesy of Katherine Dreier.

Duchamp's newfound alter ego as Rrose Sélavy presaged the role that portraiture would play for the rest of his life. At a point when he'd abandoned painting altogether (his last canvas was *Tu'um*, executed in 1918 at the request of Dreier, to fill a long thin space above a bookshelf), the question of what an artist would produce instead of art was intriguing. There were the ready-mades, but Duchamp decided that there had to be strict limits on the number of objects that could be so designated. There was *The Large Glass*, which kept precipitating a sprawl of enigmatic notations, most of which suggested a much grander outcome than anything that could be rendered visible. In a few years he would begin producing "rotoreliefs," discs that when spun added vertigo to the puns inscribed on them. And from time to time he would idly pursue a commercial enterprise, as when he proposed to Tzara

that they produce a line of bracelets with the four letters *d-a-d-a* attached. But the Belle Haleine perfume bottle opened the door to a creative prospect already unintentionally under way.

The press coverage of Duchamp's sojourn in New York had already created a persona that fluctuated wildly. The choirboy countenance in *Vanity Fair* was hard to reconcile with a photo in the *New York Tribune* under the headline "The Nude-Descending-a-Staircase Man Surveys Us." Far from gazing into the camera, the artist sprawls on a recliner with eyes closed. Whether or not Duchamp himself suggested this pose, it conveniently emphasizes the anti-retinal orientation of an artist no longer disposed to paint. And yet, Belle Haleine is a genuine *fabrication* in another domain, taking art into the realm of advertising, where "image" is all. Artists have sometimes found employment in the "artistic illustration" side of advertising—Andy Warhol, most famously—but Duchamp's perfume bottle was linked to no product other than the persona he adopted for the pose as Rrose. It was also a collaborative gesture, one of many undertaken with Man Ray over the years.

As the title of a 2009 exhibition at the National Portrait Gallery made clear, "Inventing Marcel Duchamp" may have been his most consistent creative indulgence in the realm of image making. Duchamp had always been rankled by the French expression *bête comme une peinture* (stupid as a painter), and while he tried to add as much cognitive complexity to his canvases as possible, there was a limit to mere appearance. But people can't help being seen, and Duchamp was no recluse. After the Armory Show he was a celebrity. In the wake of the press coverage, he realized he was bound to make an appearance, one way or another, so *making* that appearance became an artistic prerogative. He was surely inspired to take it up a notch by the uninhibited baroness and the flamboyant Mina Loy, who once was photographed in profile to show off an earring she'd made from a thermometer.

Duchamp, Picasso, and their generation lived out their lives in the Kodak century, so there are countless photos of them. But whereas Picasso was more frequently caught in snapshots, spontaneously cavorting on a Riviera beach, Duchamp posed right up to the end of his life. He posed for famous fashion photographers like Edward Steichen and Arthur Penn, but they themselves were operating with full knowledge of Duchamp's legacy of self-production for the camera. He obligingly went down a flight of steps for a photographer illustrating the *Life* magazine article "Dada's Daddy" in 1952. He even

suggested posing in the nude for the session (fat chance, given that this was *Life* and not *The Little Review*). Despite the lavishly illustrated article, Duchamp was predictably pegged "pioneer of nonsense and nihilism" for the middlebrow American readership.

Man Ray documented Duchamp with a star shaved into the back of his head and, on another occasion, with his hair lathered up into devil's horns for the "Monte Carlo Bond" certificate (1924)—in addition to several sittings with Duchamp posing as Rrose Sélavy. The most feminine version involved a woman's hands reaching around from behind to primp Rrose's fur. Then there was the "Wanted $2,000.00 Reward" poster, based on a joke souvenir into which Duchamp inserted his own mug shots. Duchamp made several return trips to Paris as its own Dada scene was heating up, and his unflappable demeanor and uncanny ability to get the most out of the least effort proved spellbinding to his French peers. Soon there would be no peers, only Duchamp himself, professionally inscrutable—and, for that matter, devoted no longer to art, it seemed, but to chess.

What a strange sojourn his time in America had been—and what a strange artistic borderland Dada inhabited there. Dada in New York wasn't even regarded as Dada until the news of its Swiss eruption trickled in, and *New York Dada* was published as a late saluting shot across the bow. The high spirits of Duchamp and Picabia lingered in the air, though. The war was still raging, but it would be Picabia, with his itinerant lifestyle, who ended up transmitting these high spirits back across the Atlantic to Dada's original homeland in the Alps. Exchanging issues of Dada publications through the mail was one thing, but Picabia's personal appearances in New York, Zurich, and Paris would make Dada seem destined for a global triumph.

7

LAST LOOSENING

By serendipitous coincidence, the term *Dada* was conceived in Zurich in April 1916, the same month Duchamp mentioned his ready-mades to a reporter for the *Evening World* in New York. The link between the two words would not become evident for a while, and then only circuitously.

Later in 1916 the Mexican-born artist Marius de Zayas, whose Modern Gallery had featured Picabia in its first show, published *African Negro Art: Its Influence on Modern Art*, a subject that preoccupied Tristan Tzara. The two men struck up a correspondence, and by the end of the year, *The First Celestial Adventure of Mr. Antipyrine*—with its manifesto-speech declaring Dada "our intensity"—was circulating in the Arensberg circle, courtesy of de Zayas. By then, the Arensbergs' salon had reached a state of near incandescence with its combination of artistic brilliance and intellectual momentum, fueled by excellent food and intoxicants. This Dada, from Switzerland of all places, had found the perfect nesting ground.

As it migrated around the earth, Dada resisted the usual properties of time and space. It appeared in different places at different times, rarely following a linear chronology or causal sequence. To go forward with the story, then, requires a leap back in time, in order to arrive at the consequential meeting of Tzara and Picabia—the two men whose combined efforts would conjoin the Old and New Worlds under the banner of Dada.

Shortly after Picabia returned to New York in June 1915, while ostensibly on his military mission, he ended up sharing a house with the Cubist painter Albert Gleizes and his wife, Juliette Roche, who wrote much of her sole book of poetry, *Demi Circle*, while there. She found Picabia's lifestyle challenging. "Picabia could not live without being surrounded morning and night by a troop of uprooted, floating, bizarre people whom he supported more or less," she recalled. "The whole artistic Bohemia of New York plus several derelicts of the war." With this ragtag band in residence, and Picabia's unrestrained and uninhibited appetites, there were incessant appeals to join the frolic: "Noise at any time or knocks on the door, 'We are having a party. Come down.'" Although Roche and her husband would soon tire of the frenetic pace they found in the New World, it was initially captivating, a place, as Roche wrote in a poem, in which:

> the woodwinds of the Jazz-Bands
> the gin-fizzes
> the ragtimes
> the conversations
> embrace every possibility

Roche, Picabia and other wartime exiles like Duchamp, Jean Crotti, and Mina Loy were habitués of de Zayas' Modern Gallery, where a new oversized journal named *291* (honoring Alfred Stieglitz's gallery) was under way. Among its notable innovations were pictorial word compositions called psychographs, fielding bits of conversation and psychological introspection amidst great black lozenges threatening to blot out the page altogether. In "Mental Reactions," Agnes Ernst Meyer drew on the experiences of women everywhere to chronicle the fits and starts of self-recognition in a patriarchal world. "At best her life, her whole life, was nothing but his introduction to himself." Meyer is left wondering, at the end, about women's plight: "Why do we all object to being the common human denominator?" Juliette Roche adopted the format of the psychograph for several poetic portraits in *Demi Circle*, including one depicting the expats' favorite haunt, the Breevort Hotel on Fifth Avenue a few blocks north of Greenwich Village.

Meanwhile Gabrielle Buffet-Picabia was growing concerned about her husband's prolonged stay in New York, so she made the transatlantic

crossing only to find Picabia caught up in a neurasthenic whirlwind—sleepless, overstimulated, firing on all cylinders. His wife had walked in on a creative orgy.

To say that Picabia was spewing out artworks is misleading, because what he was doing required the precision of a watchmaker. He had to be on top of his game when it came to producing art, even if everything else in his life slid into dissipation. The fifth issue of 291 consisted of portraits (de Zayas, Stieglitz, and Paul Haviland among them) modeled entirely on mechanical parts. On the last page, in both French and English, de Zayas acclaimed Picabia the natural successor to Stieglitz. "Of all those who have come to conquer America, Picabia is the only one who has done as did Cortez. He has burned his ship behind him," he wrote. "He has married America like a man who is not afraid of consequences. He has obtained results." A self-portrait accompanied portraits of Stieglitz, de Zayas, and Haviland, along with the provocatively titled spark plug, "jeune fille Americaine dans l'état de nudité" (who, it's been suggested, may have been Agnes Meyer, a beauty apparently immune to the artist's customary allure).

Picabia was given the last word in the final issue of 291 in February 1916, in which he reiterated the stance he'd developed around the time of his first American trip—that is, painting needed to absorb the visible world into a complex of mental and emotional responses in its quest to be "the most truthful and the purest expression of our modern life." The mind's eye, not the retina, was the agent of vision. Picabia never adopted the resolutely anti-retinal position of his friend Marcel Duchamp, but painstakingly drawing a spark plug and calling it a young American woman in a state of nudity was his way of giving a high five to that other nude descending a staircase—and a wink and a nod to the "bride" Duchamp was busy courting in his never-completed *The Large Glass.*

Buffet-Picabia prevailed upon her husband to go to Cuba and fulfill his military mission by procuring sugar reserves for France, thereby avoiding court-martial or worse. His mission completed, the pair went on to Barcelona, where they found Gleizes and Roche along with other friends from prewar Paris days.

Apart from indulging in an affair with Marie Laurencin, a painter who'd been the mistress of his friend, poet Apollinaire, Picabia found the Catalan

port depressing. Desperate to spark his life, he decided to launch his own magazine, naming it 391, as a numerical successor to the recently folded 291. Writing to Stieglitz, he allowed that "391 is not as well done, but it is better than nothing, for truly here there is nothing, nothing, nothing." The refrain—nothing, nothing, nothing—would be tellingly repeated several years later in Picabia's "Dada Cannibal Manifesto." In the inaugural issue of 391, he declared that his artistic platform, honed to a fine pitch in America, would "only use symbols drawn from the repertoire of purely modern forms," namely machines.

It was a curious enterprise. Picabia had the means to bankroll a handsomely produced publication but hardly the temperament to adhere to a production schedule. Or maybe 391 was a genuine *periodical* in that it came out periodically—that is, from time to time, with nineteen issues between January 1917 and October 1924. The format varied over the years. The first seven issues were roughly fifteen by ten inches, then swelled into various larger formats, sometimes up to twenty-three inches tall. Whatever its dimensions, it was always exquisitely designed and generously filled with Picabia's wit and wickedness.

If it seemed his private forum for thumbing his nose at the world, more discerning readers recognized his gift for sizing up (and squashing) artistic and intellectual pretensions. In the first issue, after opening with a poem in which, with mock patience, Picabia took swipes at rival artists Robert Delaunay (mischievously suggesting that he was going to Lisbon to decorate the façades of all the buildings in the city) and Picasso ("Picasso repents" read another item, reporting that the Cubist master had enrolled as a student in the École des Beaux Arts).

In the midst of these shenanigans, Picabia related a curious incident in which a painting he'd shipped to Paris was confiscated at the border and sent to the Minister of Inventions because it was suspected of depicting a compressed air brake. During wartime something resembling a technical drawing was bound to raise suspicions, but this episode points to a lingering problem that would play out for years to come, as in the confiscation of a Brancusi sculpture by American customs agents who decided it was not art but industrial material subject to duty. Defiantly, the covers of all but one of the first nine issues of 391 featured Picabia's mechanomorphic

drawings, including the exquisite depiction of a flamenco dancer (no. 3), a ship's propeller wittily labeled "ass" (no. 5), and a lightbulb labeled "Américaine" through which can be seen the words *flirt* and *divorce* (no. 6).

Picabia churned out four issues of 391 in the three months he spent in Barcelona and three more in the summer back in New York. In addition to containing artwork and occasional contributions by others, the magazine served as a forum for his poetry. He'd started writing around the beginning of the war, and the trickle became a torrent, especially during neurasthenic episodes when he was medically advised to refrain from painting. (His second collection, *Poems and Drawings of the Daughter Born Without a Mother*, was dedicated to his doctors in New York, Paris, and Lausanne.) The poems could hardly be read as evidence of a cure. Quite the contrary, they're a farrago of agony, intemperance, and obscurity. The abstraction he'd pioneered as a painter seems to have flowed freely into his word compositions.

A third of the poems in his first book, *Fifty Two Mirrors*, are from issues of 391. If they generally fall under the heading "Frivolous Convulsions," the title of a poem published in the second issue, aspects of his life and temperament are faintly visible through the haze. He may portray himself as a "freeloading angel" and refer to "my indecent gibberish"—or in a wry self-assessment, "I have but one tongue / With bad manners"—yet he'd suddenly arrive at the most lucid pledges: "I want my life for myself," "one must be many things," and "I demand the ravishing." Inveterate womanizer that he was, Picabia made no attempt to conceal his extramarital escapades:

> Won't I go
> The full distance
> For a single pleasant hour
> Of vertiginous passion.

Frequent references to opium disclose another weakness:

> Near the table the obese pipe
> Smokes
> Like a crack in the
> Superterrestrial brain

The full register of his neurasthenic travails is on display in these poems, chronicling the heights of creative, erotic, and drug-induced euphoria and plumbing the depths of fatigue and depression down to that realm where an idea is nothing but an "animal squeal." Although he may not intend it, surely Picabia is among those "Artists of speech / Who have only one hole for mouth and anus" (from the very first poem he ever published, in English translation, in Man Ray and Duchamp's magazine *The Blind Man* in May 1917).

Besides sex and drugs, Picabia's poetry bore signs of another telltale American influence. This was pointed out in the single issue of another little magazine *Rongwrong*, which Duchamp published in May 1919. There, Duchamp printed a letter by his near namesake Marcel Douxami (leading many to assume he'd penned the epistle himself). Douxami, an engineer from New Jersey, thought Picabia's poems mere trickery, but made an interesting topical observation. "Picabia's poetry seems to me to spring from American music—a syncopated beat with a melody that the composer either wasn't able or didn't know how to get down."

Douxami was on to something, though he clearly hadn't yet heard or processed the new word *jazz*, a term beginning to circulate in tandem with that other four-letter word *dada*. Indeed, Man Ray's aerograph painting *Jazz* dates from the same year as *Rongwrong* and might just as plausibly have been named *Dada*, given the nearly synonymous implications of these two new words.

For many, jazz and Dada seemed interchangeable. "Dada Putting the Jazz into Modern Verse," ran a headline in the *Boston Evening Transcript* in 1921, characterizing the new phenomenon in subsections titled "An Intellectual War-Baby" and "Shell-Shocked Literature." In Europe, posters for Dada activities sometimes included the word *jazz* as part of the overall typographic soup. In 1922 there was a journal named *Dada-Jazz* in Yugoslavia, far from the circuits in which jazz musicians were performing.

Given these early uses of the term, it's likely *jazz* arrived piggyback on Dada. But Dada itself was in some sense beholden to American initiatives like jazz. Hugo Ball reflected on this shortly before he started up Cabaret Voltaire, when he wrote a note in his diary chastising himself and his cronies for their supercilious Eurocentrism. "Art must not scorn the things that it can take from Americanism and assimilate into its principles; otherwise it will be left behind in sentimental romanticism." Americans themselves, with

their innovations like jazz, were harbingers of radical change and personified cultural chic, with which the artistic avant-garde struggled to keep pace.

One American student studying abroad made an early impression in England as a proponent of Americanism. During a college debate at Oxford in 1914, "I pointed out," the student T. S. Eliot wrote to the folks back home, "how much they owed to Amurrican culcher in the drayma (including the movies) in music, in the cocktail, and in the dance. And see, said I, what we the few Americans here are losing while we are bending out energies toward your uplift . . . we the outposts of progress are compelled to remain in ignorance of the fox trot." He assimilated jazz as a flourish of his verbal calling card, assuring an English friend in 1920 that, in future visits, "it is a jazz-banjorine that I should bring [to a soirée], not a lute." By that point, Eliot was a celebrated poet, associated with the vanguard movement Vorticism.

At the Cabaret Theatre Club in London, the turkey trot and bunny hug were thought of as "Vorticist dances," in a milieu described by one participant as "a super-heated vorticist garden of gesticulating figures, dancing and talking, while the rhythm of the primitive forms of ragtime throbbed through the wide room." Reviewing Diaghilev's ballet *Parade* with music by Eric Satie in a 1919 London performance, F. S. Flint wondered what to call it: "Cubo-futurist? Physical *vers-libre*? Plastic jazz? The decorative grotesque?"

Such terminological indecision was rampant among those documenting current events, so it's not surprising that the impact of avant-garde performances contemporaneous with the spread of Dada carried this loose association with jazz. A few years later there was also the novelty element of jazz in which Dada performances also seemed to specialize. So when entertainer Madame Power in London was advertised with her "jazz-dancing elephants," how could it not sound like Dada had come to town?

On the Continent, jazz arrived as accessory to the new dances—an extension, in effect, of the animation with which the musicians performed. "They enjoy themselves with their faces, with their legs, with their shoulders; everything shakes and plays its part," exclaimed the enthralled Yvan Goll. Goll had witnessed similar high spirits at Cabaret Voltaire, which Hans Richter characterized as "a six-piece band. Each played his instrument, i.e. himself, passionately and with all his soul." Huelsenbeck's passion for the big drum and "Negro rhythm" presages Marcel Janco's 1918 painting, *Jazz 333*. Arp, Hausmann, Schwitters, and other Dadaists were keen on the latest jazz

dances long after Dada subsided. Insofar as Dada was perceived as part of a modernistic complex that included Cubism and Futurism, the visual contortions common to all three movements could be seen as infused with the spirit of jazz. "Like a Cubist painting by Picasso, a watercolor by Klee," wrote bon vivant and fashion guru F. W. Koebner in Berlin in 1921, "seemingly senseless and discordant, jazz is in fact thoroughly harmonious by means of its discord."

Koebner's numerous books on popular dance may have reached George Grosz and Raoul Hausmann, who were dedicated to the latest dances, and Arp, too, was an enthusiastic dancer. With his penchant for all things American, Grosz was a devotee of jazz. After Czech composer Erwin Schulhoff was exposed to jazz by Grosz in 1919, he set Hans Arp's *Cloud Pump* to music and composed a five-minute, scrupulously notated "orgasm" for a female soloist called *Sonata Erotica*. Schulhoff hailed from Prague, where a general initiative called Poetism absorbed Dada as part of the cultural tendency of the age, in which jazz, Charlie Chaplin, sports, dancing, music hall, and the circus were extolled as "places of perpetual improvisation," valued precisely for the fact that they were unpretentious and, above all, *not* art. "Clowns and Dadaists taught us this aesthetic skepticism," wrote Karel Teige, one of the ringleaders of Poetism.

Aesthetic skepticism is what Gilbert Seldes recommended in his influential 1924 book *The Seven Lively Arts*, disparaging the "vast snobbery of the intellect which repays the deadly hours of boredom we spend in the pursuit of art." By "we" he meant Americans, "inheritors of a tradition that what is worthwhile must be dull; and as often as not we invert the maxim and pretend that what is dull is higher in quality, more serious, 'greater art.'" This was a view shared by Dadaists, not that Seldes knew anything about Dada. But his advocacy of "lively arts" like cinema, jazz, variety shows, and other purportedly lowbrow entertainments would have been welcomed in Dada circles. The national qualities he enumerates—"our independence, our carelessness, our frankness, and gaiety"—characterize the way Duchamp and Picabia experienced America, finding it a quintessential and entirely unconscious manifestation of the Dada spirit.

When the Picabias made their way back to New York from Barcelona in March 1917, they promptly "became part of a motley international band which turned night into day," Picabia's wife Gabrielle recalled. Their group

was composed of "conscientious objectors of all nationalities and walks of life living an inconceivable orgy of sexuality, jazz and alcohol." Perhaps unsurprisingly, she soon returned to Europe to be with their children.

After Gabrielle's departure, Picabia rented an apartment with composer Edgard Varèse, where the two quickly established a norm—in the pre-air-conditioned New York summer—of forfeiting clothes, even receiving visitors in the buff. Among them was Isadora Duncan, herself no prude, and she promptly claimed Picabia as the next in her long retinue of lovers. One day she phoned Duchamp, asking him to pay a visit precisely at noon. When the young artist arrived, not knowing what to expect but probably anticipating some erotic turn of events, she marched him straight to her bedroom—to the closet, actually, which she opened with a flourish to reveal Picabia perched on a stool, having a cup of tea. "Isadora hid me here without telling me why," he said.

Soon after this titillating exchange, an oft-cited scandal imputed to Dada occurred, although its protagonist had little to do with Dada. Arthur Cravan—who, as a point of personal pride, was distantly related to Oscar Wilde—had made a name for himself issuing a solo magazine called *Maintenent* (Today), a no-holds-barred enterprise that likely inspired Picabia when he began his own *391*. Cravan's specialty was insulting artists. "I feel nothing but disgust for a painting by a Chagall," he would write, or "Metzinger, a failure who has snatched at the coat-tails of cubism." "A bit of good advice," Cravan extended to these unfortunates, "take a few pills and purge your spirit; do a lot of fucking or better still go into rigorous training"—like Cravan himself, in fact, who had some success as a boxer. "Genius is nothing but an extraordinary manifestation of the body," he wrote.

Cravan spent some time in Barcelona, where he was knocked out in a legendary fight with heavyweight champion Jack Johnson and came to the attention of that city's temporary resident, Picabia. In the inaugural issue of *391*, Picabia inserted a fanciful item about this colorful athlete: "Arthur Cravan is another who's on the transatlantic. He'll be giving some lectures. Will he be dressed as a man of the world or a cowboy? For his departure he opted for the latter, making an impressive appearance on horseback, with three shots from his revolver."

Once in New York, Cravan began mingling with the Arensberg circle, making unwelcome advances to Mina Loy, who would nevertheless come

around—the couple wed and had a daughter, born after Cravan disappeared mysteriously in the Gulf of Mexico and was never heard from again.

In June 1917, though, while Cravan was alive and kicking, Duchamp arranged for him to give a lecture at the Independents at Grand Central Palace, the Premier Exhibition of the Society of Independent Artists, where of course *Fountain* was not on display. Cravan was so drunk when he arrived, an hour late, that he could barely stand at the podium, where he delivered a resounding blow before starting to disrobe while shouting obscenities. The audience began streaming for the exit as the police arrived and shut down the proceedings. "What a wonderful lecture," Duchamp later remarked. This occasion has been routinely recounted in books about Dada, becoming in effect a canonized scandal for those content to associate Dada with scandals and nothing but.

The Cravan "lecture," which fueled the superficial perception that Dada frequently engaged in juvenile misbehavior, is a bit of urban folklore that's no more part of Dada than the parties attended by Scott and Zelda Fitzgerald in the roaring decade of Prohibition. But it does have the virtue, in the present context, of indicating the desperate alcoholic torpor afflicting the whole community of exiles as the war dragged on. What began for many of them as a stimulating interlude in New York was beginning to look like a tawdry lifestyle.

After his indulgent summer, Picabia finally had enough, rejoining his family in Europe in October. But his travails and exploits continued. A month after returning to Paris, he met Germaine Everling, whose marriage was on the rocks. With his customary erotic alacrity, he managed to sweep her off her feet, and ten days later the couple had an extramarital honeymoon precisely where his honeymoon with Gabrielle had been.

Neither this nor any of his other exploits were hidden from his wife, who was increasingly called upon to nurse him through his bouts of neurasthenia and depression, which had reached such a severe pitch that he consented to a prolonged treatment in Switzerland—but not before cementing the relationship with Everling that would eventually end his marriage. As Everling later recalled, Gabrielle told her outright that Picabia was hers for the taking, but she stressed that his mental health was precarious. Insightful and accommodating as always, she suggested Everling pay daily visits just to keep up Picabia's spirits, assuring her they were above bourgeois conventions.

In February the family went to Lausanne so that Picabia could be treated by the eminent Dr. Brunnschweiller, with Everling following in June. Picabia met her at the station, admitting his condition had taken a turn for the worse because he'd been shot at several times by a fellow artist outraged to find Picabia sleeping with his wife. There's a certain picaresque aspect to Picabia's womanizing, but this episode is a reminder of just how reckless he could be. It was this volatility that had driven Gabrielle to leave him in New York the previous year. A biographer puts it well: "Picabia, with or without depressions, allowed himself the life of a true bachelor and did his best to put into practice all sorts of separating ploys and extenuating experiences in order to attain that state of supreme freedom which is the patrimony of the superman." As the Nietzschean reference suggests Picabia was accustomed to living "beyond good and evil." But that was also a no-man's-land in almost a military sense.

Maybe Picabia should be counted among the war casualties suffering not from shell shock but from the accelerated churn of his own unchecked appetites. To use the machine vocabulary that he deftly assimilated in his art, Picabia was a human drill bit, boring into the future. Serendipitously, the one person most disposed to revel in his spirit was living nearby in Zurich—a dapper Rumanian, anxiously eyeing the horizon to see where, and how, Dada might take on new life.

During the run of Galerie Dada, Tristan Tzara was busy consolidating international contacts, bombarding them with press clippings of Dada exploits, and soliciting contributions to a new Dada publication. His ministrations proved vital because he found the combatant nations only too happy to supply propaganda materials, without postal charge, as a routine expenditure of the war effort. Art somehow passed muster under this category. So the gallery was plentifully stocked with works from Germany, France, and Italy, amicably sharing the exhibition rooms. It was propaganda all right, but "propaganda for us."

Now, with Ball once again out of the picture, Tzara was poised to embark on his biggest propaganda campaign. His calling card was the inaugural issue of *Dada*, published in July 1917. It wasn't all that imposing, running to just seventeen pages, with texts on the left facing artworks on the right-hand pages—little more than a slim profile of what had transpired since *Cabaret*

Voltaire was published a year earlier. Its diminutive size, however, made it cheap to mail—after all, that was its main purpose—and it was commensurate with other journals of the international avant-garde published during the war, like Pierre Albert-Birot's *SIC* and Pierre Reverdy's *Nord-Sud* in Paris, *Neue Jugend* under its new editor Wieland Herzfelde in Berlin, and *De Stijl*, launched by Theo van Doesburg in Leiden in October.

Thanks to his determination to establish contact with vanguard enclaves around the world and promote the Dada cause, Tzara gradually became aware that interesting things were under way in New York and the artist Francis Picabia was involved. In August 1918, hearing that Picabia was in Switzerland, Tzara wrote to introduce himself and ask for a contribution to *Dada*, describing it broadly as a publication "on modern art" (adding later that its goal was to represent "new trends"—albeit "according to a criterion that shall remain secret"). The two men hit it off right away, sending each other publications and manuscripts, and by November Picabia confessed "I live quite isolated from everything, and your letters are a sympathetic contact that does me good." (He was also frank about his neurasthenic problems and ongoing psychiatric care.) They shared an abiding affection for Picabia's old friend Apollinaire, recent victim of the Spanish flu epidemic that swept the world after the war. The sudden loss affected Picabia deeply because his wife had dined with the poet in Paris less than a week before he died, and he'd spoken of visiting them soon in the Alps.

In their correspondence, Picabia and Tzara come across as kindred spirits almost furtively seeking heat and light, each of them depressed and dispirited in their isolation. "May I call you my friend?" Tzara writes in early December, and Picabia responds, warmly if somewhat dutifully, "Dear sir and friend."

At the center of their mutual stimulation is a series of disclosures central to Tzara's view of Dada as a destructive force, a view most congenial to Picabia, the intellectual and artistic swashbuckler. Tzara suggested that their budding friendship drew on a "different, cosmic blood," giving him "strength to reduce, decompose, and then order into a strict unity that is simultaneously chaos and asceticism." Picabia in turn expressed his appreciation for Tzara's manifesto, which he thought "expresses every philosophy seeking truth, when there is no truth, only convention." Tzara responded by applauding his friend's "individual principle of dictatorship, which is simplicity, suffering + order." Few at the time would have been capable of discerning

in Picabia's ravaged and raving poetry anything of the sort, but Tzara's own poems were similar testimonies to his peculiar amalgam of exasperation, personal torment, and free-spirited sense of wonder. Where William Blake distinguished his *Song of Innocence* from *Songs of Experience*, Tzara and Picabia freely mingled them within the same poem, even in the same line. Their meeting by correspondence was a sort of alphabetic mingling, inciting in each man the feeling that the other was capable of finishing his sentences. But this shared sensibility pitched the two headlong into a kind of jubilant despondency—and how many people could really deal with that?

At the root of Tzara's particular negativity was the fortifying genius of Dada itself, for which negation was a positive measure: "I'm telling you," he confided to Picabia, "the only affirmation for destructive work (which all art radiates) is productivity, and that can be found only in strong individuals"— individuals honed on a Nietzschean self-regard, like Picabia. So Tzara could appeal to Picabia with disclosures the older man was uniquely prepared to understand. "I've never passed up an opportunity to compromise myself, and besides devilry, it is an efficient and recreational pleasure to wave magic handkerchiefs before the lanterns of cow eyes"—a rueful reflection of the low regard Tzara had for the local Swiss who comprised the audience for Dada.

By this point Picabia was urging Tzara to pay an extended visit to Paris, to which he was about to return. Tzara relished the prospect: "Perhaps we'll be able to do beautiful things, since I've a stellar, insane desire to assassinate beauty." These confessions caused Picabia to delay his return to Paris in order to pay a personal visit to Tzara in Zurich. Correspondence was one thing, but a personal meeting now seemed paramount for both men. What was intended to be a quick visit of a few days extended to three weeks, weeks that "just flew by" wrote Picabia afterward.

Picabia's visit to Tzara and his dwindling circle of Dadaists in Zurich was like a key fitting into a lock. There was perfect reciprocity all around, a mutual stimulation they all lapped up. "Picabia's first appearance, plying us all with champagne and whisky in the Élite Hotel, impressed us in every possible way," Richter recalled. In addition to his wit and audacity, Picabia was wealthy, unorthodox, a free spirit—and that rara avis, "a globetrotter in the middle of a global war!" But his creativity was inseparable from his unremitting nihilism. He possessed "a radical belief in unbelief" that excited Tzara,

but sent Marcel Janco into a spiral of depression. Richter himself reflected, "I met Picabia only a few times; but every time was like an experience of death." (Richter would eventually end up in New York, where he made films with Duchamp and others associated with Dada late in their lives, and he recognized that Duchamp and Picabia walked a very fine line in which they repudiated art by making it, although what they made of it did not comply with artistic conventions, the ready-made being a prime example.)

Behind Picabia's captivating darkness, there was exuberance—at least for those capable of withstanding it. The dynamic momentum of negation needed a positive counterforce, a beneficent receptivity. This was one of the paradoxes on which Dada was perched, almost like those publicity hounds in the Roaring Twenties who perched atop flagpoles with the nonchalance of someone lounging in an easy chair. Tzara captured a bit of this in his chronicle of the Zurich scene for Huelsenbeck's *Dada Almanac* in 1920, intriguingly identifying Picabia as "the anti-painter just arrived from New York" whose arrival provoked the next step in exuberant negation. "Let us destroy let us be good let us create a new force of gravity NO = YES"—and, without a pause or any distinguishing punctuation, he segues into another subject altogether:

> Dada means nothing life Who? catalogue of insects
> Arp's woodcuts
> each page a resurrection each eye a daredevil-leaping
> down with cubism and futurism every sentence a blast of
> an automobile horn.

Arp and Tzara visited Picabia at his hotel. "We found him busy dissecting an alarm clock," Arp recalled. "Ruthlessly, he slashed away at his alarm clock down to the spring, which he pulled out triumphantly. Interrupting his labor for a moment, he greeted us and soon impressed the wheels, the spring, the hands, and other secret parts of the clock on pieces of paper. He tied these impressions together with lines and accompanied the drawing with comments of a rare wit far removed from the world of mechanical stupidity." Arp added, with an artist's insight, "He was creating antimechanical machines," and in his unbounded creativity Picabia released "a teeming flora of these gratuitous machines." Not surprisingly, one of these decomposed clocks adorned the cover of *Dada 4/5*.

Dada 4/5 (May 1919), cover by Francis Picabia.

Tzara had become absorbed in Picabia's poetry, which could be more easily transmitted through the mail than his artworks. But he had seen some of the paintings, which had been solicited for an exhibit by a Zurich dealer and then peremptorily returned to Picabia without explanation—and with the obligation to pay return post. Meeting the artist in person elevated Tzara's admiration, and he started looking out for opportunities to circulate his friend's work in any medium. In February 1919 he mentioned that "a certain Mr. *Benjamin* (writer-journalist)" of Berne was interested in purchasing *Daughter Born Without a Mother*. The person in question was Walter Benjamin, one of the most brilliant intellectuals of the postwar decades. At that point, doing graduate work in Berne, he found himself living next door to Ball and Hennings, who naturally apprised him of the recent Dada activities in Zurich.

Benjamin did not succeed in acquiring Picabia's fanciful daughter, but he managed to buy a little painting by Paul Klee called *Angelus Novus*. It made its way into the "Theses on the Philosophy of History" he wrote as the shadow of another world war loomed, leading to his untimely death fleeing the Nazis in 1940. In Klee's angel he found this allegory:

> His eyes are staring, his mouth is open, his wings are spread. This is how one pictures the angel of history. His face is turned toward the past. Where we perceive a chain of events, he sees one single catastrophe which keeps piling wreckage upon wreckage and hurls it in front of his feet. The angel would like to stay, awaken the dead, and make whole what has been smashed. But a storm is blowing from Paradise; it has got caught in his wings with such violence that the angel can no longer close them. This storm irresistibly propels him into the future to which his back is turned, while the pile of debris before him grows skyward. This storm is what we call progress.

This chilling passage has been justly celebrated. But has its affinity with—maybe even its source in—Dada ever been recognized? Benjamin's "theses" famously include the aphoristic observation, "There is no document of civilization which is not at the same time a document of barbarism"—a view rehearsed, performed, shouted, and whispered as Dada wended its way from Zurich to Berlin and beyond.

Benjamin recognized the relevance of Dada to his messianic outlook on modern political barbarity. Dada is central to his famous essay "The Work of Art in the Age of Mechanical Reproducibility," where it serves as a model of the shock effects of modern media in general: "The work of art of the Dadaists became an instrument of ballistics. It hit the spectator like a bullet." It was part of an arsenal for ringing the alarm bell. *Wake up,* Benjamin heard Dada call out, *the time is later than you think.* In his theses on history, Benjamin exhorted readers to realize that "the 'state of emergency' in which we live is not the exception but the rule." By the time he wrote this, he'd spent the better part of a decade compiling a vast archive of notes for *The Arcades Project,* a portrait of Paris as capital of the nineteenth century, launchpad of the twentieth.

Benjamin characterized his *Arcades Project* as "an alarm clock that rouses the kitsch of the previous century to 'assembly.'" He conducted much of his research in the fabled City of Light during the heyday of Surrealism. Although not an insider of the movement, he was in touch with Breton, Tzara, and others and wrote a profile of Surrealism in 1929 for a German audience in which he celebrated its "profane illumination." The Surrealists, he concluded, "exchange, to a man, the play of human features for the face of an alarm clock that in each minute rings for sixty seconds." It's not too much to imagine that Picabia's dismembered apparatus on the cover of *Dada* left an imprint on Benjamin's imagination commensurate with the gears Tzara and Arp saw anatomically revealed in a Zurich hotel.

There was a final hullabaloo after Picabia's visit to Zurich in January 1919. It would prove to be the apotheosis of everything cultivated in Cabaret Voltaire, combined with the experiments of Galerie Dada.

On April 9, 1919, in the large Kaufleuten Hall—allegedly seating a thousand—the final event of Zurich Dada was held. Tzara planned out the program with fanatical precision but could not achieve all his intentions. As he wrote Picabia during preparations, "This is the first time I regret not having learned how to ride a bicycle; I wanted to come on stage on a bicycle, get off, read, get back on, leave: curtain. Now I'll have to hire someone who'll walk around on the stage while I read." Tzara also confided to his newfound guru of negation the hidden ennui that motivated him. "I live from one amusing idea to another. But know that this game will also bore me before long."

That underlying spirit of engaged indifference, or animated boredom, was quickly picked up by the Kaufleuten audience, providing the Dadaists with the bull's-eye they'd been seeking all along. The occasion had all the earmarks of former Dada events, with a few additional ingredients applied in just the right measure.

Arp and Richter painted a massive backdrop, mainly black but with abstract lumps that made the whole thing look like a cucumber patch run amok. Some of the Laban ladies danced with African masks. Music by Schoenberg, Satie, and resident composer Hans Heusser was reprised, along with poems by Arp, Huelsenbeck, and Kandinsky. Familiar fare for some, but as this was a full house, the performances were certainly a new experience for most.

The program opened with a dry lecture on abstract art by the Swede Viking Eggeling, who'd recently come to the Dada scene and whose interest in developing a universal vocabulary of abstract forms hit a chord with Hans Richter. The two would soon move to Berlin and take up an entirely new pursuit: making films. The first section of the program concluded with another simultaneous poem by Tzara, this time on a grand scale with twenty performers, their cacophony matched by a chorus of catcalls from the audience. An intermission gave the seething mood of the restive crowd a chance to subside.

The program resumed with a brief excursus in audience baiting by Richter ("elegant and malicious," thought Tzara) before another round of music, poetry, and dance. Then came Walter Serner, a dyed-in-the-wool nihilist, a human curse incarnate. A wartime refugee who'd come to Switzerland from Berlin, Serner voiced skepticism toward Dada in his journal *Sirius*. Nevertheless, he proved willing to grace this grand occasion with a manifesto, "Final Dissolution," also translated as "Last Loosening." Dressed in the most elegant attire, Serner came on stage carrying a headless tailor's dummy, to which he presented a bouquet of flowers where the head would have been. Then, conspicuously sitting in a chair with his back to the audience—now in a deep hush, straining to hear—he began reading his manifesto.

It's hard to convey the tight spiral of Serner's text as it keeps cancelling itself and everything else, combining the scholastic rigor of Kant with a steady drizzle of insolence. In any case, the poison quickly penetrated the normally polite Swiss audience until it exploded when Serner made reference

to Napoleon as a "really clever lad." As Richter comments in his history of Dada, "What Napoleon had to do with it, I don't know. He wasn't Swiss."

At Serner's mention of Napoleon, the audience was instantly transformed into a crowd of thugs, ripping apart the balustrades and chasing Serner from the premises. "This is our curse, to conjure the UNPREDICTABLE," Richter felt at the time. But Tzara thought it the ultimate Dada triumph. "Dada has succeeded in establishing the circuit of absolute unconsciousness in the auditorium." In a note describing the scene for *Dada 4/5*, he suggested Serner incited in the audience nothing less than "a psychosis that explains wars and epidemics."

Amazingly, after the pent-up agitation burst, the show resumed and concluded without further incident. It's as if the audience had been drained and had no strength left to rise up against another round of free dance with African masks, another spirited manifesto by Tzara, and aggressively rhythmic but atonal music by Heusser. The final Dada unguents were lavishly applied to the open sores of the Zurich natives, spent and chastened by their own unleashed aggression. When the show was over, the performers thought Tzara had gone missing, but found him in a restaurant nearby counting the take, the largest windfall Dada had managed in its three years.

After this "last loosening" in Zurich, little remained for Dada in the Swiss capital. The war had ended only months before, and Switzerland was beginning to empty out as refugees made their way home, or elsewhere. Many of the hard core of original Dadaists joined this exodus, transmitting the "virgin microbe" to fresh, unsuspecting populations.

By the end of the year the Janco brothers were in Paris, where Tzara followed early in 1920. Arp, being a German national, couldn't get a visa to return to Paris for another five years, but the life he'd embarked on with Sophie Taeuber more than compensated. The most that he and Tzara could manage in the wake of the Kaufleuten extravaganza was to plant an item in the press to keep Dada before the public eye. Distributed to dozens of papers around the world was a news flash, "Sensational Duel," in which it was reported, "There was a pistol duel yesterday on the Rehalp near Zurich between Tristan Tzara, familiar founder of Dada, and Dada painter Hans Arp. Four rounds were fired, and in the fourth exchange Arp was slightly grazed on his left thigh." Adding mischief to this fanciful report, the item

indicated that Picabia had come all the way from Paris to act as a second for Arp, while Swiss writer J. C. Heer served in that capacity for Tzara. Poor Heer suddenly gained local notoriety and wrote to the newspapers declaring his complete mystification—and innocence. Meanwhile, Tzara and Arp frequented their usual cafés, with no evident acrimony between them. In fact, they issued a disclaimer, stating that the bogus news flash had been planted by one of their enemies.

Circulating false reports of a duel was clearly a step down from the "circuit of absolute unconsciousness" unleashed in the Kaufleuten audience. After that triumph, the remaining Dadists found themselves trapped in the middle-class environment of Zurich, its bourgeois coziness a reminder of how improbable it was that Dada had erupted there at all. In fact, most Dadaists were themselves born middle class, and pursuing a life of art meant a renunciation of that birthright. Rather than conformism, though, something else in that background contributed to Dada's identity. Never before had a dominant class invested so much in perceiving itself as a norm while being fascinated by individuals or lifestyles that deviated from that norm. A familiar, if extreme, example of a beguiling deviant is the American outlaw, who seems to work overtime to attain what others manage by being unexceptional. It's not surprising that George Grosz idolized American gangsters, cultivating an American wardrobe to look the part. The daring and guile of the outlaw crossed over into Dada, which exalted destruction as a virtue.

After the Kaufleuten performance, as Tzara basked in the cynical company of Serner, he adopted destruction as the characteristic expression of Dada. "To be dangerous is the most pointed probe," he wrote in the next Dada journal, *Der Zeltweg*. In the same pages, Serner paraded his sharp wit at length, tossing off pithy sayings with the vigor of someone hammering a nail in a coffin. "The ultimate disappointment? When the illusion that one is free of illusion reveals itself as such," he wrote, and "one becomes malicious out of boredom. Then it becomes boring to be malicious."

Tzara's embrace of destruction alienated him permanently from Janco, who was still fuming nearly forty years later when he distinguished between creative and destructive tendencies in Dada, resenting Tzara's propensity for negation. But Janco was already at odds with Tzara anyway, reproaching him for not disclosing the extent of his international contacts. Tzara, he thought, was promoting Dada far and wide as his personal calling. But if Tzara was

smitten by mayhem—as though obeying Joseph Conrad's exhortation in his novel *Lord Jim*: "in the destructive element immerse"—he knew there was an honorable foreground.

Tzara had honed his poetic sensibility on the French Symbolists, chief among them Stéphane Mallarmé, who said "destruction was my Beatrice"— that is, his inspiration (Beatrice being Dante's muse). But destruction of what? He managed to produce his poems, he said, "only by *elimination*." In an era when poetic rhetoric heaped analogy on analogy, adding fussy decoration to any mood, Mallarmé went in the opposite direction, reducing his verses to such dense, compact shapes they're barely readable. The mind bounces off their diamond surfaces. Such work anticipated the anti-art/anti-literature achievement described by Parisian Dadaist Georges Ribemont-Dessaignes, "destroying the usual effect of language and giving it an effect more certain, but also more perfidious, that of dissolving thought."

Now that Tzara had experienced total immersion in the destructive principle onstage as well as in print, he set his sights on the grandiose prospect of Dada invading the world. For the moment, however, he found himself stuck in Switzerland, a land of cuckoo clocks and lederhosen—all too far from the paroxysm of Berlin, or the Paris of his youthful dreams.

8

A NEED FOR COMPLICATIONS

Tristan Tzara felt the whole adventure of Dada come to a head in the performance at Kaufleuten Hall in Zurich, a performance that drove the audience headlong into "absolute unconsciousness." While biding his time in the aftermath of this triumph, he kept up with the latest exploits of Dada in Berlin, which sounded like the place to be, even as Francis Picabia kept exhorting the young Rumanian to come to Paris.

Both Berlin and Paris were alive with Dada. In April, the recently fashionable Parisian poet Jean Cocteau hailed the latest issue of *Dada* as an amalgam of jazz bands and cocktails. This was *Dada* 4/5, billed as "Anthologie Dada." Printed in different editions for the German and French markets, Tzara also produced a deluxe version to generate revenue. That such a patently commercial motive seemed un-Dada did not escape Hans Richter, who expressed his disapproval and asked that his contribution be withheld from the deluxe edition. Still, *Dada* was turning heads in Paris, stirring keen anticipation among certain young writers that the perpetrator of this extraordinary phenomenon might soon descend from the mountains.

Tzara initiated contact with poet André Breton in January 1919, requesting contributions for *Dada*. Their exchange, like that between Tzara and Picabia, began cordially and deepened into a series of rapturous disclosures. Right at the outset, almost like a personal appeal for attention, Breton

confided his shock at the death of his friend Jacques Vaché by suicide. A few weeks later Tzara in turn related an incident that made him a nervous wreck: "At the station, a woman who had gotten off a train and with whom I was speaking was literally cut into pieces by the train before my eyes a few seconds later." Breton responds by assuring Tzara, "Of living poets, you are the one who touches me the most," then wondered, "Are we friends?" (Breton later admitted, ruefully, that he "projected onto Tzara some of the hopes that Vaché . . . would never have disappointed.")

Breton's and Tzara's exchange of photos and confidentialities proceeded with the air of spellbound adolescents finding their soul mates. Responding to the latest issue of Breton's journal *Littérature*, Tzara writes: "I like your attitude *very much*. I don't know if it's one of your intentions: I see a tactic for gradual and ascendant demoralization in it. For me taking part in the decay of present-day man is an entertaining task and the only one that interests me. Believe me," he adds, "it is not a demoniac plot, my dear friend, but the consequence of the enormous chasm separating us from the bourgeois species."

The bourgeoisie was a familiar target of artistic disdain, but the two young poets formed a pact of solidarity in generational terms as well. "It is only natural if the elderly fail to observe that a new type of man is being created everywhere," Tzara wrote in September. Facing the new was a task for the young, but both men periodically confessed to being enervated by the challenge. Tzara suffered migraines and was prone to bouts of depression. He toyed with the prospect of doing nothing, giving up the game. Even despondency was taxing: "It takes enormous energy," he reflected. "And we have an almost hygienic need for complications." How prophetic this would prove: a *need for complications* is in many ways the story of Paris Dada in a nutshell. But why a *need*?

Dada was Tzara's calling card, but it was also becoming his personal burden. He'd agitated for a publication back in 1916 when Cabaret Voltaire was still going strong and had to keep pressing against Ball's hesitations to get anything under way. So, after complaining that he was worn out handling the consequences ("I have too little energy and patience to look after *Dada*'s administration"), he apparently felt obliged to sketch out the background for his new Parisian friend. "I proposed the word Dada for the title of a journal three years ago. This took place in Zurich with some friends who also felt that they had nothing in common with futurism and cubism"—omitting the

fact that these movements provided much of what he and his friends offered up in their publications and exhibits. "In the course of campaigns against every dogmatism," he goes on, "*Dada* became the 'Dada movement.'"

Given Tzara's unremitting role as chronicler, press agent, and entrepreneur of the Dada movement (the cover of *Anthologie Dada* rendered *Tristan Tzara* and *Mouvement Dada* as, typographically, almost one and the same), his rhetorical distancing of himself from the "movement" in this disclosure is significant. Maybe he really was exhausted, handling all the affairs of a "movement" that was waning. Marcel Janco, Hans Arp, and Sophie Taeuber were increasingly engaged with an artists' collective called The New Life, leaving only the venomous Walter Serner eager to flout the Dada label.

Everything achieved in the name of Dada had been a group effort, and Tzara was beginning to suffer the absence of a group. But Paris beckoned—Picabia in particular, whose weeks in Zurich back in January had reignited the old spark. As he edged closer to the long-awaited trip to Paris, Tzara began nudging Breton and his friends, the poets Philippe Soupault and Louis Aragon, to seek out the older artist.

Francis Picabia was unknown to Breton's circle until the end of 1919—a fact that may seem surprising, given that he had published ten issues of his journal *391* since 1917, along with seven volumes of poetry. But as the title of the journal *Littérature* patently indicates, Breton and his editors, Soupault and Aragon, were "litterateurs," men of letters, minimally cognizant of visual art, indifferent to music. Furthermore, as young men of middle-class background, they were far removed from the lofty social circles in which Picabia moved—circles in which his attendance at society events was duly noted in the press. The milieu to which Picabia had access was also frequented by Pablo Picasso, as a consequence of his newfound eminence as a painter and his collaboration with Diaghilev on his ballet *Parade*, based on a scenario written by Jean Cocteau.

Cocteau, the rising literary star of that world, was already anathema in Breton's circle. The day after Christmas, 1919, he wrote Tzara about Cocteau: "He is the most hateful person of our time. Again, he has done nothing to me and I assure you that hatred is not my strong point." Such frank disclosures, however prejudicial, were drawing Tzara and Breton closer together. In the same letter in which Breton dismisses Cocteau, he takes up the prospect

of Tzara's arrival in Paris in a tone of courtship. "I am waiting for you, I wait for nothing but you." Behind this ardor is a growing proprietary attitude. Breton, longing for Tzara, needs the cachet of Dada to take the next step in a cultural milieu in which Cocteau's star is ascendant. And, as he anxiously reports, Cocteau is promoting his own contact with Tzara as a point of honor.

Meanwhile, Breton had taken the plunge and sought out Picabia. Even though both lived in Paris, they corresponded at first. "You are one of the three or four men whose attitude I entirely approve," Breton somewhat boldly informed Picabia, nearly twenty years his senior. The source of his amazement was Picabia's latest collection of poems, *Thoughts Without Language*, and he in turn assured the younger poet "you are truly the man one must meet once or twice in his life in order to have the courage to continue to live."

Breton and Picabia finally met in person on January 4, 1920, and fell into a conversation about their shared fascination with Nietzsche, Rimbaud, and Tzara, interrupted by the commotion of Picabia's mistress, Germaine Everling, giving birth in the next room. In her memoirs she recounts a family friend repeatedly trying to get Picabia's attention, only to be rudely rebuffed: "Leave us alone—really, it's unbearable that we can't have a quiet conversation!" (His wife, Gabrielle, had borne another son only weeks earlier.)

Breton and Picabia quickly became almost conspiratorial in their new friendship, setting the scene for Tzara's arrival later that month. It was arranged that Tzara would stay in Everling's flat, where Picabia was mainly living by this point. Much was riding on his arrival, especially given the ardent correspondence during the previous year. Breton's circle eagerly anticipated the eruption of Dada in Paris, needing only the putative leader to strike the match.

Breton's group was there to greet the legendary and long-awaited Rumanian when he arrived on January 17, at which point the legend was awkwardly revealed to have been in the imagination of the anticipators. Tzara was small, somewhat meek in appearance, and not nearly as fluent in French as his writing had suggested. What a comedown! On the other hand, his luggage was bursting at the seams with his Dada archive, a veritable treasure chest of cultural loot—more than enough to sustain the group's dream of rekindling Dada in Paris.

Perhaps anticipating Tzara's arrival, certainly mindful of public events sponsored by Dada in Zurich, the *Littérature* group had decided to embark

on a series of public matinees around this time. The first was scheduled for January 23 at the Palais des Fêtes, in a hall sandwiched between two cinemas, so the accompanying music kept seeping through the walls during the soirée. A program was drawn up and printed before it was known that Tzara himself would be on hand. The organizers decided to keep his presence a secret and rethought the evening's events. Certain esteemed cultural figures, having agreed to participate in what looked to be the usual literary forum, were ambushed, along with the audience, by the Dada tactics the organizers imposed at the last minute—foremost of which was the surprise appearance of Tzara, the very incarnation of whatever this Dada was.

Instead of presenting his own work at the Palais des Fêtes event, Tzara read verbatim a speech by right-wing politician Léon Daudet, while a bell was stridently rung, drowning out most of his words. "Back to Zurich! Shoot him!" and similar cries attended the performance of this perverse interloper. Before Tzara took the podium, the audience had already gotten testy with the display of Picabia's painting *The Double World*, which had the letters *L-H-O-O-Q* inscribed from top to bottom—mimicking a pun concocted by Duchamp for his treatment of the *Mona Lisa*. When pronounced in French, the letters sound like the phrase *elle a chaud au cul* (she's got a hot ass). Despite these provocations, there was no riot or fisticuffs. The crowd dispersed into the night, and the exhilarated organizers eagerly looked forward to more such events.

Tzara, reenergized, busied himself preparing another issue of *Dada*, this one named *Bulletin Dada*, a four-page typographic explosion to be distributed at the Salon des Indépendants on February 5. The title was splashed in red across the matinee program consisting of manifestos read by decreasing numbers of people, starting with ten for Picabia's and dwindling to "four persons plus a journalist" for Tzara's. Inside was a long list of presidents of the Dada movement, presented by way of a pun at the expense of Cubism: "Vivent les concubines et les concubistes. Tous les members du Mouvement DADA sont presidents" (Long live the concubines and the con-Cubists. All members of the Dada movement are presidents). The seventy-six dignitaries were listed alphabetically, many by last name only. Much of the list looks like Tzara's personal Rolodex: anyone with whom he corresponded or who even attended Dada events back in Zurich might find himself listed as a Dada president.

Inset on the same page—interrupted by placard-like ads for Dada publications—was a cascade of aphorisms and inanities set in the tiniest possible type. "Anti-dadaism is a disease," read one. "Self-kleptomania is the normal human condition: that's Dada." Breton's contribution: "Workplace injuries, you'll agree, are more beautiful than marriages of convenience." Far from being a helpful guide to the salon, *Bulletin Dada* was a spirited inside joke, noting, for instance, that Arp had been called to London to install a crocodarium at the site of the old Royal aquarium—not that anyone had a clue who Arp was—and Breton's friend Philippe Soupault was reported, falsely, as having committed suicide in Geneva. But all of this was idle stuff compared to the drama Tzara was concocting behind the scenes.

A few days before the Salon des Indépendants, Tzara circulated a press release, obligingly printed in the papers, indicating that Charlie Chaplin had just joined the Dada movement and would be making an appearance on its behalf. The claim that Chaplin had joined Dada was first made in *Dada* 4-5 a year earlier, and the Berlin Dadaists had collectively pledged, in *Der Dada* 3: "The International Dada Company, Berlin, sends Charlie Chaplin world's greatest artist and a good Dadaist, friendly greetings. We protest the ban of Chaplin films in Germany." Even though Tzara went so far as to list the eminent philosopher Henri Bergson and the Prince of Monaco as other converts to Dada, nobody seems to have seen through the bluff (despite its billing as "avant-garde, free, public, and contradictory").

On the day of the event a throng surrounded the Grand Palais, expecting to see "Charlot" himself, transfigured from movie star to Dadaist overnight. Once the crowd squeezed inside the venue, there was no mention of Chaplin; instead, the Dadaists read manifestos laced with the refrains familiar only to those informed of what had preceded this event in Zurich: "No more painters, no more writers, no more musicians . . . *nothing, nothing, nothing.*" It was a template that would resonate through the century, right up to John Lennon's song "God," in which his refrains of disavowal ("I don't believe in magic, Jesus, Buddha, Elvis" and finally "I don't believe in Beatles") yield a domestic pledge, "I just believe in me, Yoko and me."

Despite their initial dismay at his diminutive and unprepossessing figure, Tzara quickly won over his Parisian allies with skills honed onstage in Zurich. For this group of romantically self-absorbed writers, public performance

was novel, and having a taste of it in January and early February, they were primed for more. Tzara had revealed an unsuspected dimension of irreverence, in which everything from public declamation to the printed page could be a freewheeling performance. Back in 1916, Apollinaire had written Tzara, "I've long admired your talent and I now admire it all the more as you have done me the honor of directing it along a path on which I precede you but in no way surpass you." For Breton, Aragon, and Soupault, Apollinaire was the totemic figure who had initially focused their hopes and energies, and now they felt the path he opened would be extended by others, with the dapper if improbable Rumanian leading the way.

These three young poets had found one another near the end of the war, when Breton (born 1896) and Aragon (1897) were medical students doing military service, and Soupault a recruit recovering from a nearly fatal typhoid vaccination. Apollinaire introduced Soupault to Breton in 1917. The "three musketeers," as they've been called, decided to launch their literary careers after the war by starting a journal. At first they thought to call it *Le Nègre*, capitalizing on the vogue for African art. Inspired by Apollinaire's lecture on the new spirit they decided on *Le Nouveau Monde* until they found that title already taken. Pierre Reverdy, editor of *Nord-Sud*—one of the journals in which the young poets had first published during the war—suggested *Carte Blanche*. Finally in a mood of sheer resignation they settled on *Littérature*, as plain and straightforward as its format—consoling themselves at least that it held a veiled reference to the famous line by Paul Verlaine ("And all the rest is literature").

Almost everything about *Littérature* made it the opposite of the Dada publications in Switzerland and Germany. It was literary and nothing but, openly solicitous of the approval of reigning literary lions like André Gide and Paul Valéry and typographically tame. Breton and his friends wrestled with the journal's identity; with their developing awareness of Dada, and correspondence with Tzara, the "three musketeers" soon felt discomfort at being heirs apparent to the literary establishment. In spring 1919, with the journal barely under way, the editors committed themselves to a mild-mannered revolt, defining their task as a clandestine "work of destruction." But they maintained the camouflage of being men of letters, and this destructive germ did not derive solely from Dada. The editors of *Littérature* idolized renegade predecessors Lautréamont, Rimbaud, and Jarry and managed to procure rare

manuscripts of unpublished work by these mavericks. It was also during the spring of 1919 that Soupault and Breton collaborated on *The Magnetic Fields*, an experiment in automatic writing, installments appearing in the journal by the end of the year.

A curious phenomenon: poets who resolve not to write poetry nevertheless persist in publishing a literary journal. Meanwhile, they write a text that dissolves individual authorship and, with its indulgence in free association, knocks rational communication off its pedestal. Breton's medical training had extended to psychiatry, so automatic writing was familiar to him as a therapeutic technique. In its way, *The Magnetic Fields* is an exercise in self-therapy by men keen on diagnosing not themselves but their times: a ravaged world that had sent the past packing, but offered little sense of which way to turn or how to proceed. It's as if they heard the phantom cry of Samuel Beckett fifty years ahead of time—"I can't go on, I'll go on"—and wrote down, instead, "A man comes back to life for the second time."

The Magnetic Fields has long held pride of place as a foundational work of Surrealism, albeit predating that movement by five years. Its translator, English poet David Gascoyne, suggests Surrealism therefore predated Dada, which intriguingly implies that the difficulties soon faced by Dada in Paris were basically the birth pangs of the later movement. To be sure, Surrealism was in the air long before it was formalized, and even the moniker was floating around, having been invented by (who else?) Apollinaire in a preface to Cocteau's 1917 ballet *Parade*, which he took to embody "a kind of surrealism, which I consider to be the point of departure for a whole series of manifestations of the New Spirit that is making itself felt today." In the preface to his play *The Breasts of Tiresias*—a jaunty wartime paean to the national service obligation of motherhood—Apollinaire proposed that Surrealism was born when man invented the wheel, a device achieving locomotion without any resemblance to legs. Céline Arnauld (sole woman among the Paris Dadaists) reprised the dictum with a twist in her "Dada Parasol" manifesto: "Carry on, the wheel turns as it's turned since Adam, nothing changes, except now we've only got two legs instead of four."

The arrival of Dada in Paris, courtesy of Tzara, seemed to sanction the preparatory gestures of *The Magnetic Fields* and the "new spirit" called for by Apollinaire as first inklings of the movement's arrival in Paris. The initial

Dada events from January through the spring of 1920 achieved all the noto-
riety, press coverage, and social chatter that Tzara had been accustomed to
in Zurich—and more, this being Paris, presumptive cultural capital of the
world. The new recruits quickly learned the tricks of the trade, and Breton
in particular exuded a haughty imperturbability. He gravitated to the cen-
ter of the group through innate intelligence and intellectual audacity, with
an affecting mannerism the others unconsciously imitated. He spoke with
slow but precise articulation so that "words fell from his thick lips like drops
of honey," Germaine Everling observed (bookseller Adrienne Monnier was
likewise struck by his "heavy and excessively fleshy mouth"). This affectation,
effective at a café table, was dramatically enlarged onstage. Picabia's contribu-
tions were inflammatory, but his personal reluctance to appear in public for
these occasions often meant Breton would appear in his stead.

On one occasion, Breton read Picabia's "Cannibal Manifesto" at the
Théâtre de l'Oeuvre in March. In a hall plunged into darkness, except for
the spotlight on Breton wearing a sandwich board, he intoned his friend's
incendiary document, which began, "You all stand accused: the defendants
will rise," addressed to the audience as if in the court of Dada. A concise lit-
any of invectives and insults followed ("What are you doing here, packed in
like oysters? . . . you're all chumps"), while the audience pelted the stage with
its routine shower of fruits and vegetables. Tzara, offstage with Picabia, was
beside himself. "Listen to them," he said of the audience's escalating uproar,
"Dada lives! It's magnificent!"

On this same program, after the audience endured a piano piece by
Georges Ribemont-Dessaignes consisting of notes chosen strictly at random,
it was confronted with a canvas by Picabia to which a stuffed monkey was
attached, bearing inscriptions along the sides: Portrait of Cézanne, Portrait
of Rembrandt, Portrait of Renoir. In the ensuing uproar it proved impossible
for an invited opera singer to perform Henri Duparc's lovely song "Clair de
Lune," and she was reduced to tears by hecklers.

Even before the provocations onstage, the audience was confronted with
the incendiary contents of the latest issue of 391, passed out at the door in lieu
of a program. The cover brandished Duchamp's mustachioed Mona Lisa with
its salacious title LHOOQ; the third page featured an ink blot by Picabia with
the provocative title The Virgin Saint and on another page his poem "Chimney

Sperm" confided that "My penis has the shape of my heart" before uttering, as if it were a term of endearment, "I kiss your mouth while vomiting."

Following the animated precedence of 391, *Littérature* finally took the plunge into Dada in May 1920, devoting its thirteenth issue to twenty-three manifestos, breaking with precedent by emblazoning the fact on its cover (*Vingt-trois manifestes du mouvement Dada*), along with an aggressively over-sized number 13. Previous issues had chastely given the number and date in small type, accompanied only by the name of the journal and the address. After that, the kid gloves came off, and subsequent issues were arsenals of Dada fireworks—intellectually speaking of course, since the typography remained conservative except for the occasional contribution by Tzara. The manifestos in number 13 ("the order was drawn by chance," an editorial note indicates) were those performed on three soirées in February. They run the gamut, stylistically and conceptually, even as they dutifully fill out a then-familiar Dada prescription for combining indignation and irreverence in something approaching literary slapstick.

Soupault took up the old refrain, "I am writing a manifesto and I have nothing to say," garnishing it with the assurance, "all my friends, killers or writers, are just as stupid as me." Breton wrote a manifesto with the perky title "Dada Skating" in which he reflected, "it's possible that I'm dreaming, this very moment." Hearing this read in public may have given some in the audience a premonitory whiff of Surrealism. He too had assimilated the primary Dada mission: "DADA attacks you through your own powers of reasoning." Bucking the trend, he managed to make the judicious and sensible observation, "It's ludicrous, a priori, to expect a DADA masterpiece in the domain of literature and painting." The principle in question is the principle of contrariety, whereby "'Peace at any price' was DADA's motto during the war just as 'War at any price' is DADA's slogan in peacetime." Paul Dermée declared Dada to be a "god-swatter" or "omni-swatter," while Ribemont-Dessaignes proposed a medicinal application: "If you exterminate your bugs but keep the lice, Dada will apply its little puff of insecticide."

In another manifesto, "To the Public," Ribemont-Dessaignes rose to a martial pitch reminiscent of Dadaist invective in Berlin. "Before I come down there among you to tear out your rotten teeth, your scab-filled ears, your canker-covered tongue," he began in a litany that just got uglier until hitting its mark on a Dada grace-note:

And we're warning you—
It's us who are the murderers—
Of all your little newborn babes—
And to end here's a song
Ki Ki Ki Ki Ki Ki Ki
And here's God with a nightingale for a horse
He's handsome, he's ugly—
Madam, your gob stinks of pimp's come.
In the morning—
'Cos in the evening it's more like the arse of an angel in love with a lily.
Nice, huh?
Cheerio, mate.

Writing from New York, Walter Arensberg characterized Dada as "the global representative of everything young, lively and athletic" and determined, accordingly, "genuine Dada works should last for six hours"—about the length of a few rounds of cocktails. Compared with the cleverness of the others, Aragon sounds contrite: "My friends are the ones to whom I'm beholden for stupid but strongly heartfelt reasons. It's a flood sweeping me along and I acknowledge it as my master and flatter it with my voice." Jettisoning posture and mask, Aragon here comes as close as possible to identifying the precise character of Dada for himself and his Parisian companions in Dada during the spring of 1920. They would soon be borne along by another torrent, the so-called "wave of dreams" that marked an onset of Surrealist research activities, but for the moment they were intent on preserving, and cradling, the term Dada as if the suckling babe envisioned by Hugo Ball had arrived in a caravan of wise men. Or rather one man, whose wisdom would soon be tested.

Almost as soon as it got under way in Paris, Dada was scrutinized in official quarters—and with the complicity of André Breton, no less. His warm relations with Gide and the editors of the recently resurrected Nouvelle Revue Française led to a profile of Dada in that vaunted publication. In its April 1 issue, several authors weighed in on the new movement, including Breton, who admitted the aptness of an observation he quoted from Jacques-Émile Blanche: "Dada will survive only by ceasing to exist." In its rudimentary

form, this was a semantic flip-flop typical of Dada (yes equals no, etc.). But other contributors to the revue pressed the issue in more literal terms. Gide weighed in by acknowledging the value of Dada even as he signed its death warrant. "The day the word Dada was found, there was nothing more left to do," he wrote. "Nothing equaled: DADA. Those two syllables achieved the goal of 'sonorous vacuity,' an insignificant absolute. With this single word 'Dada' they have expressed in one go everything they had to say, *as a group.*"

It was not quite true that the Dadaists had shot their wad, considering the luxurious sprouting and growth of Surrealism from the spent husk of Dada, but Gide wasn't making predictions. Instead, he was assessing the behavior of a recognizable social type. Jacques Rivière, in the same issue, made the pertinent observation that "Dada, all that is shapeless, negative, and exterior to art, represents, in a consummate way, the implicit dreams of many generations of writers." That must have stung: for rebellious youth, nothing smarts so much as to be told that your rebellion has a genealogy, that it's just part of a series. It was a diagnosis that applied—not necessarily to Dada, but to the young men of letters in Paris who had lately taken up its cause.

Unlike his Parisian friends, Tzara had already sown his literary wild oats in Zurich, and he was increasingly intent on *leading* the Dada movement, an urge that would soon lead to disputes with Picabia and Breton and finally run the Dada vessel aground. His own imperious management of the movement led poet Max Jacob to call him "Tzara Thoustra" in a nice pun on Nietzsche's superman (Arp dubbed him Tzar Tristan). The longer he resided in Paris, the veil of hero worship with which Tzara was greeted began to dissolve, and in its place emerged the figure described by Hans Richter as "sensitive and aggressive, a magician with the alacrity of a weasel, arousing trust and suspicion" in equal measure. In 1923, as Dada sputtered to an ignominious conclusion in Paris, Tzara would defiantly claim, "Dada has been a purely personal adventure, the materialization of my disgust."

By the time Tzara claimed Dada as his own, the whole edifice of the collective enterprise lay in ruins, and neither he nor anyone else was inclined to pick up the pieces. The dismantling that brought Dada to that point was played out over several years, spotlit by press coverage. Published denunciations and recriminations were batted back and forth in the public eye by the erstwhile Dadaists, which earned for them a reputation as "merchants of dementia."

Before the descent, there were still heights of buffoonery that made Dada a fixture of the annual Parisian literary "season." To enhance public awareness, multicolored stickers were pasted up around the city, proclaiming "Dada Ltd" as an enterprise for the "exploitation of vocabulary." "Subscribe to DADA, the only loan that yields nothing," read one, the wording borrowed from Berlin. The 1920 season culminated with a Dada festival in May, held at Salle Gaveau, a large concert hall. A press release detailed a smorgasbord of enticements: "An unprecedented act: all the Dadaists will have their heads shaved in public. There will be other attractions: pugilism without pain, presentation of a Dada magician, a real *rastaquouère*, a vast opera, sodomist music, a symphony for twenty voices, a motionless dance, two plays, manifesto, and poems. Finally, we will discover Dada's sex."

The term *Dada* was ubiquitous at this point, but usage reflected the deliberate ambiguity perpetrated by the Dadaists themselves, amplified by the perplexity and outright credulity of journalists and gossip columnists. What Dada *really* was nobody knew, so when it was announced that the festival would reveal its sex—well, why not? Wonders never cease. And while you're at it, what in the world was musical sodomy? The lure of a "real *rastaquouère*" put the footing squarely in the domain of the music hall and the cabaret, where that was a recognizable type, a kind of rake, rapscallion, parvenu, or conman presumed to be a foreigner, but with a touch of the debonair—like Cary Grant in *To Catch a Thief*.

Picabia's latest book was provocatively titled *Jésus-Christ Rastaquouère*. American poet Ezra Pound, then living in Paris, was close to Picabia and Cocteau. His blurb for the book declared, "Picabia has a pair of remarkably strong intellectual lungs that enable him to breathe and exist in the deserted heights of negation, those regions where the leading English writers and the French literary cliques suffer from vertigo or nose-bleeds." Picabia's well-stocked bag of aphorisms pours out of *Jésus-Christ Rastaquouère*, seasoned with his inimitable acerbic wit, his sights set squarely on modern times. "You look at life with a paint brush and what you need is a gasmask," he writes—to himself? to fellow painters? No matter, it's the thought that counts. Artists generally get a bad rap. He accuses them of abasing themselves with emotional repetition. His wit moves so briskly that his sentences smell of scorched earth. Then when it gets down to plain speaking, he can't be topped—or should that be *stopped*? "Dear artists, fuck off, you're a tribe of

priests who are still out to make us believe in God." Since Picabia completed the book in July, the reference to "a real *rastaquouère*" in the announcement for the Salle Gaveau festival in May may have provided the spark.

By the time they performed in this festival, the Dadaists were thoroughly seasoned by Picabia's wily nihilism and Tzara's agile stagecraft. This is most evident in a sketch by Soupault. Appearing in blackface (as he was wont to do, ardent in his enthusiasm for ragtime, jazz, and American popular culture), dressed in a white robe, he released five balloons from a trunk. On each was written a name (the pope, several politicians, and other noteworthies), and with a long dagger he made a point of brutally slashing the balloon named Cocteau. A performance like this treads a fine line, threatening real violence. Even the choice of Salle Gaveau was a taunt, as this venue, in a swank district, was commonly associated with performances of classical repertoire, like Bach and Mozart.

The Dadaists' theatrics were beginning to wear thin, however. At the same event where Soupault slashed the balloons, he and the other Dadaists, bellicose and impudent, declared they'd have their heads shaved onstage—which they didn't, owing to "a lack of courage in the Dadaists' recklessness," Ribemont-Dessaignes thought. News of this cowardice spread to London, where a *Daily Mail* headline read "Dadaists Disappoint: Still Unshaven." A Czech visitor reviewed the affair for a Brno newspaper under the title "A Pathological Case," noting this act of apparent cowardice and adding: "They were serious, terribly serious in their stupidity. *That's the most striking and sorrowful thing: they are serious.*"

Based on various accounts, it's clear that the theatrical skits made the whole affair come across like amateur night. The performers read their lines, but mumbled and didn't project. They missed their marks and even appeared bewildered by their own inanities. The stagecraft left a lot to be desired as well. What it all amounted to was "some scatological crudities recited like at school, by pallid lads," wrote the critic for *L'Echo de Paris*. For many in the audience—which had come, after all, well supplied with fruits and vegetables (and even slabs of meat) to hurl at the offending performers—Dada evidently meant incompetence, and *proud of it*. Even the heralded "sex of Dada" was nothing more than a pair of balloons attached to a phallic column.

Four months of these adolescent presentations were beginning to exhaust even the patience of the participants themselves, for whom the initially inspiring

scenarios concocted by Tzara were being senselessly reprised with minor modifications. The Dadaists were getting restless, a bit bored with Dada. Thankfully, the annual summer exodus of Parisians, leaving on vacation, loomed, alleviating the group from having to come up with yet another show.

Without further free-for-all, in-your-face public events, the second half of 1920 saw the movement contract and withdraw into exhibition spaces. At the Au Sans Pareil bookshop, a small show of Picabia's works was mounted in the summer, followed by Ribemont-Dessaignes, presented under the confounding title "Course in Electric Alpinism and the Breeding of Microcardiac Cigarettes." But these exhibits were held without fanfare, and the failure of Ribemont-Dessaignes to sell any work resulted in his abandoning art altogether.

By contrast, another show by Picabia opening on December 9, 1920, at Galerie Povolovsky was billed as a star-studded gala event. Dada was part of it, but more like a decorative feather in a hatband. Most of the Dadaists were stung to the quick by the star billing, "Jean Cocteau and His Parisian Jazz-Band." Accompanied by Darius Milhaud (whose ballet *The Ox on the Roof* earlier in the year cemented the vogue for "Negro" music; a famous nightclub was later named after the ballet) and Georges Auric (the composer most consistently involved with Dada in Paris), Cocteau thrashed and rattled along on bass drum, snare, castanets, drinking glasses, flute, and klaxon. His fickle opportunism, which irked Breton, was borne out when, not long afterward, Cocteau repudiated jazz by peremptorily announcing that "the negro crisis has become as boring as the *japonisme* of Mallarmé." Nonetheless, for Picabia's gala opening Cocteau's jazz band had star billing.

Apart from Picabia's paintings, the sole Dada component of the reception at Galerie Povolovsky was Tzara's recitation of his "Dada Manifesto of Feeble and Bitter Love." As described in the press, "Tzara installed himself on the counter. He raised his hand and the music stopped. In the thick silence, the great tongue-in-cheek artist launched, with terms of a maddening incoherence, into a lecture on love." Between each of the manifesto's sixteen numbered sections, Cocteau's jazz band provided musical punctuation, reinforcing the casual assumption that this new musical idiom was a species of Dada. The refrain that ties the whole manifesto together is "I consider myself very likeable, Tristan Tzara." In a veiled reference to Cocteau, Tzara

declaimed: "I prefer the poet who is a fart in a steam-engine—he's gentle but he doesn't cry—polite and semi-homosexual, he floats." Most of the manifesto plays out as conceptual ping-pong between Dada and poetry. Is poetry even necessary? "We have always made mistakes, but the greatest mistakes are the poems we have written"—a sentiment he and Breton had batted back and forth in their correspondence the previous year, in spite of which they both wrote poems. But what of that? After all, in a much-quoted aphorism borrowed from Picabia, Tzara conceded: "Thought is made in the mouth."

Writing poems and being a Dadaist become for Tzara the defining features of Dada's perpetuum mobile of self-contradiction:

> Anti-dadaism is a disease: selfkleptomania, man's normal condition, is DADA.
> But the real dadas are against DADA.

The means by which Dada and anti-Dada are bound together result in a stream of invective-like slogans, all bent on conveying the sense that Dada is a tendency "working with all its might towards the universal installation of the idiot. But consciously." More than anything, it was the *consciously* that punctured Gallic pride in Cartesian rationality. Being *consciously* stupid could only be a foreign aspiration, proof that Dada was *boche* (German)—that is alien.

The most famous moment at the Galerie Povolovsky event was Tzara's instructions on how to make a Dada poem.

> Take a newspaper.
> Take some scissors.
> Choose from this paper an article of the length you want
> to make your poem.
> Cut out the article.
> Next carefully cut out each of the words in the article
> and put them all in a bag.
> Shake gently.
> Next take out each clipping one after the other.
> Copy conscientiously in the order in which they come
> out of the bag.
> The poem will resemble you.

One can only imagine Tzara's revelatory last line accentuated by a rim shot, but was Cocteau at his drum kit capable of such American musical cunning?

For the other Dadaists, who were reduced to small fry in every sense amidst a glittering crowd of the Parisian elite on hand for Picabia's opening fête, it was bound to seem like the painter and his Rumanian ally had usurped their precious movement. It was Dada, and yet it wasn't: the despised Cocteau was given a prominent role, accentuated by the interplay of his jazz band and the indisputably Dadaist manifesto performed by Tzara.

Back in March, Walter Serner capitalized on the association of Dada with jazz when he prominently advertised a jazz band as the main attraction for a Dada ball in Geneva. He was not above putting words in other people's mouths, either, publishing an article in which he made out Igor Stravinsky (widely regarded at the time as a "jazz" composer) to be an avid supporter of Dada. Claiming that Stravinsky had spoken at a Dada soirée, Serner describes the composer expounding "with ceremonious gestures that the dada musician has to assume the posture of a Moravian wet nurse in the pursuit of her trade and modify the resulting notes with the greatest possible use of street noises."

Serner subsequently visited Paris, followed by his ally Christian Schad (whose "schadographs" preceded Man Ray's "rayographs" in the domain of camera-less photography). The two men deftly injected a poison into Paris Dada—sensing that its prominence in the City of Light overshadowed their increasingly futile endeavors back in the Alps—spreading the rumor, and then the outright assertion, that Tzara was not the founder of Dada, nor had he even written the famous 1918 manifesto that had so endeared him to Breton. Dada practice in Zurich and Berlin, of course, sanctioned the circulation of rumors and innuendo and misinformation. Serner himself had collaborated with Tzara to produce the news item about Tzara's purported pistol duel with Hans Arp. So Serner could be said to be doing no more than playing the game of Dada as he'd learned it. But with this difference: other Dada affairs applied the dose externally, through the press, in public events, and through Dada publications. This was a deliberate attempt to spread dissension among the Dadaists themselves, and it was administered at precisely the point when the Picabia vernissage raised red flags about who owned Dada and how it might be cavalierly appended to other interests.

The events of 1920 in Paris brought to a head a certain crisis incipient in Dada. Dada was conceived as a "movement," which implies unanimity of purpose and a consensus about goals, but it was becoming apparent that gusto alone was not a goal, except in the most elementary, animal sense. All along Dada had resolved never to stray from the immediate, the sensory. Dada aspired to mindlessness as a curative for modern rationalism run amok. But those young Frenchmen who had been exhilarated by the roller coaster of upstart emotions they called Dada were beginning to doubt the movement and its direction. On behalf of whom did Dada persist? Where was it going? Whither? Whence? These burning questions leached an acrid smoke.

9

NOTHING, NOTHING, NOTHING

D ada's inaugural year in Paris had both energized and enervated the participants. On one hand, Dada was the creative whirlwind they'd longed for; on the other, it threatened to become routine. A permanent rebellion wasn't a dream come true after all. Later on, André Breton characterized Dada as a state of expectancy, preparation for something else. When the alternative finally appeared late in 1924, he named it Surrealism and spent his remaining forty years leading the movement. But as the Dada "seasons" rolled on, Surrealism was still in the future—and Dada still had more to accomplish in Paris.

As 1921 commenced, the *Littérature* group meeting regularly at Café Certa (already included in guidebooks as a place frequented by the infamous Dadaists) reconsidered how to proceed. The confrontational soirées of the previous year had, in retrospect, all too clearly followed the program pioneered by Tzara. It was time to try something different. Finally, on April 14, the first in a proposed series of Dada "visits" to sites of negligible interest was held. The announcement read: "The transient Dadaists in Paris, wishing to remedy the incompetence of suspect guides and cicerones, have decided to undertake a series of visits to chosen locations, in particular to those which really have no reason to exist." On a rainy day the Dadaists led a small group of sodden spectators to the modest chapel of Saint-Julien-le-Pauvre, where

Ribemont-Dessaignes provided commentary for various architectural features by reading entries at random from a Larousse dictionary.

A few weeks later the Dadaists presented an exhibit of art by Max Ernst at the Au Sans Pareil bookstore. (Sans Pareil, meaning "unparalleled," would become a leading publisher of Dada titles.) This occasion reinforced the still controversial foreignness of the Dada movement, as Ernst was German. What's more, he'd been denied a visa because of his Dada activities in Cologne, so he wasn't on hand for his own show.

Advertised as "beyond painting," the show featured works that, numbered with bus tickets, were described in the exhibit's poster as "mechanoplastic plasto-plastic paintopainting anaplastic anatomic antizymic aerographic antiphonaries and sprayed republican drawings." Certainly the pieces were unlike anything seen in Paris before. Instead of pictures, they seemed like laboratories in which you beheld a parallel universe being smelted before your eyes, or a hothouse where poisonous plants were bred, taking on humanoid characteristics. (Ernst would have been an ideal illustrator for those lugubrious tales by Nathaniel Hawthorne, like "Rappaccini's Daughter.") To Picabia's catalogue of mechanomorphic works, these by Ernst teased mechanism into organism. He was called "a scissors-painter."

An alchemical garden in *always the best man wins* (title in lower-case English) sprouts an array of ambiguous interspecies shapes, combining flowers with firearms. *The Bedroom of Max Ernst* houses a bear and a sheep at the far end of a chamber long enough to be a bowling alley, while the foreground is populated with a bat, a snake, a fish, and a whale. But these creatures were not to scale, as if to suggest that the dimensions of animal life were susceptible to psychotropic adjustment. Ernst's medium was collage, with lots of overpainting. Using this method, he populated his paintings with deviant and unique life-forms. Ernst's creativity extended to the titles, the inscriptions of which were rendered as visible components of the pictures, like *Cuticulus plenaris*, *Sleuths*, *Vegetable Sheaves*, and *Adolescent Female Dadaists Cohabit Far Beyond the Permitted Extent*—a title that could apply to the ensemble as a whole. His resources resembled those of Kurt Schwitters, raiding the heap of print culture, plucking pulp images for deviant repurposing. His goal, said Ernst, was "to transform into a drama revealing my most secret desires, that which had been nothing but banal advertising pages."

During the opening of Ernst's exhibit, the Dadaists in the gallery deliberately engaged in moronic behavior, each enacting an assigned routine with the mechanical regularity of a clock. Two of them repeatedly shook each other's hands; another like an auctioneer called out the number of pearls worn by ladies as they entered. Breton chewed on matchsticks like an old cowhand, and Ribemont-Dessaignes intoned the dull slogan, "It's raining on a skull." As if these antics didn't sufficiently single them out from the crowd, all the Dadaists dressed in black with white gloves.

Their shenanigans provided a contrast to the paintings hanging on the walls, with their ethereal aura. Unbeknownst to the organizers, this exhibit of Ernst's works injected the bacillus of an eventual Surrealism into Dada. More than any other artist, Ernst brought an unrivaled prowess of visual imagination to Dada and then to Surrealism—and his prominence in both movements has caused many historians to collapse the two into one.

A cache of works by Ernst was originally viewed by the Dadaists in a meeting at Picabia's house, after which Breton wrote to André Derain that Picabia was sick with envy, sensing his eminence as the foremost Dada artist in Paris was no longer secure. For Breton, on the other hand, Ernst's impact was definitive, as important to art as Einstein to physics. Although Breton was making his living at this point as a consultant on literary and artistic investments to Jacques Doucet, the couturier whose vast collection is now a primary archive of Paris Dada, he had not yet presented his views about art in public.

For Ernst's exhibition at Au Sans Pareil, Breton provided a short text to accompany the checklist of works. Breton presents Ernst as an artist made possible by cinema, dispelling "the swindling mysticism of the still life" on a trajectory that may even emancipate us, he suggests, "from the principle of identity." The terms in which he spells out this prospect amount to an early draft of Surrealism, here construed under the auspices of Dada:

The belief in an absolute time and space seems to be vanishing. Dada does not pretend to be modern. It regards submission to the laws of any given perspective as useless. Its nature preserves it from attaching itself, even in the slightest degree, to matter, or from letting itself be intoxicated by words. It is the marvelous faculty of attaining two widely separated realities without departing from the realm of our experience, of bringing

them together and drawing a spark from their contact; of gathering within reach of our senses abstract figures endowed with the same intensity, the same relief as other figures; and of disorienting us in our own memory by depriving us of a frame of reference—it is this faculty which for the present sustains Dada.

For the moment, the knack of conjoining discrepant realities seemed most vividly rendered in the art of Max Ernst.

Ernst's impact was rivaled by that of two preeminent New York Dadaists: Man Ray and Marcel Duchamp. Man Ray arrived on July 22, on a sojourn bankrolled by an American benefactor. It was just a few months after the Ernst exhibition. Duchamp met him at the station and took him straight-away to the Dadaists gathered at Café Certa, where the group commenced to make an all-nighter of the occasion.

For the time being, Man Ray, who had yet to learn French, could only communicate through Duchamp, but the art he brought with him spoke more vehemently than anything he could have said. Coming in the wake of Ernst's "being-objects" (a concept coined later for Surrealism), Man Ray offered an equally original world that was all the more marvelous for having no overlap whatsoever with the artist from Cologne.

"Man Ray is the subtle chemist of mysteries who sleeps with the metrical fairies of spirals and steel wool," wrote Ribemont-Dessaignes. "He invents a new world and photographs it to prove that it exists." Hans Richter called Man Ray "the matter-of-fact realist of the irrational," and making reference to the hero of Wagner's epic *Ring* cycle, he elaborated: "Like Siegfried anointed with the dragon's blood, Man Ray, being fried in the hot oil of Dada, hears the mute hissing of suppressed utilitarian objects. An anti-Woolworth's." For this "magician of uselessness," ordinary objects harbored incalculable depths. In-nocent surfaces were repositories of—not guilt, but some oblique shadow that tainted yet retained the innocence. In Man Ray's objects, "the splendor of the commonplace practicality drops its trousers and shows its poetical backside."

It was inevitable, given these accolades, that the Dadaists would exhibit Man Ray's work in December. It was a sensible complement to earlier exhib-its of Picabia, Ribemont-Dessaignes, and Ernst and the Salon Dada exhibit

held in June, which fielded an impressive array of artworks from America, Germany, Italy, and France, making patent the fact that Dada was genuinely international.

Although Man Ray never gave up the medium—painting—that he was supposed to be practicing in Paris, he'd been increasingly absorbed in multimedia explorations in New York, and in Paris he began concentrating on photography. For the Dada-sponsored show at Librairie Six, a new bookshop opened by Soupault, the works consisted mainly of paintings and aerographs.

This show would produce one serendipitous concoction that was not listed in the catalogue, because it was created the day the exhibit opened. While hanging the artwork at Librairie Six, Man Ray struck up a conversation with a man who spoke excellent English. He turned out to be the composer Erik Satie. The two went out for a drink, and on the way back passed a hardware store where, with Satie's help, Man Ray bought a flatiron, some tacks, and glue. He attached the tacks down the middle of the iron and gave the object to Soupault, but not before photographing it. The object, suitably named *Cadeau* (gift), disappeared, periodically replaced through the decades by knockoffs (each dutifully photographed), becoming the artist's signature piece. Years later, in his eighties, he authorized and signed an edition of five thousand, which sold for $300 each.

Befitting a Dada event, the art on display in Librairie Six was obscured by as many balloons as could be crammed into the shop, squeezed together by the incoming crowd. At a predetermined signal, the Dadaists started popping the balloons with their cigarettes. The Dada spirit also was evident in the biographical note composed by Tzara for the catalogue: "Monsieur Ray was born goodness knows where. After being a coal merchant, a millionaire several times over, and chairman of the chewing gum trust, he decided to respond to the Dadaists' invitation and exhibit his latest works in Paris." More than a half-dozen texts in the catalogue suggest that Man Ray's work, like that of Max Ernst, served as a stimulus to the production of writing—a reminder of the literary orientation of Paris Dada. Purportedly swearing off literature—and despite a range of abject responses to a forum in *Littérature* on the question "Why do you write?"—the Dadaists kept falling back on what they did best.

Man Ray, Gift, 1921.
Copyright © 2014 Man Ray Trust / Artists Rights Society (ARS),
New York / ADAGP, Paris.

Before its arrival in Paris, Dada had been consistently presented in the language of inconsistency. Its provocations used language to undermine the semantic authority of language. The sense it made was always precarious, if not outrageous, but in the process the normal hankering for linguistic stability came to seem equally absurd. Jean Paulhan, in the Dada journal *Proverbe*, wrote: "My interest is in demonstrating that words do not translate thoughts (as with telegraphic signals or the signs of writings) but are things in themselves, material to be worked on, and difficult at that."

Whether or not Dadaists elsewhere shared Paulhan's interest in concretizing words and separating them from thoughts, the issue of language was closer to the center of Parisian Dada simply because most of the participants were—in that time-honored bourgeois phrase—men of letters. They might aspire, like Aragon and Breton, to fit the bill while resisting further production of literature, but they couldn't help themselves. Cubist artist Albert Gleizes noticed the discrepancy between their vitriol and their publications, which "rather recall the catalogues of perfume manufacturers. There is nothing in the outward aspect of these productions to offend anyone at all; all is correctness, good form, delicate shading, etc."—the key term being *outward aspect*. Still, they wrote, they published, and eventually saw the question of literature as such dragged into the Dada orbit, where its viability came under unprecedented scrutiny.

No one felt the literary mission more acutely than Breton. A few weeks after the Ernst exhibit opened, he presided as judge at a mock trial of eminent writer and parliamentarian Maurice Barrès, accused of having denied the anarchist-socialist outlook of his youth. The man himself was in the south of France at the time: no matter, a dummy sufficed. But this was no parody. The somber procedure was conducted like a real trial, with the various parties dressed in official robes. Not everyone was as keen on the idea as Breton. Picabia refused to take part, making a dramatic exit from the scene even before the proceedings got under way, when poet Benjamin Péret put in an appearance as an Unknown Soldier. At the time, a public debate was raging over an initiative to deposit the body of an unknown French soldier beneath the Arc de Triomphe, but Péret's appearance put a match to the fuse. Wearing a gasmask and a German uniform, he goose-stepped onstage. Dozens of patriots in the audience responded with a spontaneous chorus of

"La Marseillaise," contributing an ominous prelude. When the actual trial commenced, a pall hung over the proceedings.

Georges Ribemont-Dessaignes proved less than committed to his assigned role as prosecutor. "Love, sensitivity, death, poetry, art, tradition and liberty, individual and society, morals, race, homeland. But what does Dada think of these pretty objects, Dada that judges Barrès?" he asked in his closing speech. "Gentlemen, Dada does not think, Dada thinks nothing. It knows, however, what it doesn't think. Which is to say, everything." How can Dada, he seemed to be saying, judge anyone or anything but itself?

Several of the participants in this performance realized that Dada and not Barrès was on trial. Tzara acted the part, much to Breton's chagrin. "My words are not mine," he insisted. "My words are everybody else's words: I mix them very nicely into a little bouillabaisse—the outcome of chance, or of the wind that I pour over my own pettiness and the tribunal's." Not truth, in short, just "the commodities of conversation." Breton was livid at Tzara's behavior, seething at his refusal to play his designated role as witness for the prosecution. This was clear from the beginning, when he said no to the standard legal question about telling the truth and nothing but. "I don't trust justice, even if it's been conceived by Dada," he countered. "You will agree with me, your Honor, that we're all just a bunch of bastards," dragging Breton by implication down into the muck of pure Dada noncompliance and revealing that the organizer of this fiasco was a dubious Dadaist. As Ribemont-Dessaignes sharply put it, Breton "adopted a bourgeois point of view toward Tzara's conduct."

In early 1922 Breton followed up the Barrès trial with another ill-fated initiative, organizing an event that would seem to fly in the face of every prior Dada manifestation. It was to be called "Congress to Determine the Aims and the Defense of the Modern Spirit." In order to enhance its authority, he managed to interest prominent figures across a spectrum of the avant-garde to serve as organizers: Jean Paulhan of the *Nouvelle Revue Française*, Amédée Ozenfant of *L'Esprit Nouveau*, the painters Robert Delaunay and Fernand Léger, composer Georges Auric, and erstwhile Dadaist Roger Vitrac, who would later go on to found the Alfred Jarry Theatre with Antonin Artaud.

Not surprisingly, the other Dadaists balked at the prospect of such a venture. Unwilling to denounce the Barrès trial outright, Tzara wrote a polite

letter explaining his reluctance to be involved. He summarized his position the next year in an interview: "Modernism is of no interest to me, and I think that it would be a mistake to say that Dadaism, cubism, and futurism rest on a common foundation," he reflected. "These latter two tendencies were based on an idea of intellectual or technical perfection above all, whereas Dada never rested on any theory and has never been anything but a protest."

Breton, overreacting to Tzara's demurral, rallied the organizers of the modernist congress to issue an insulting press release: "At this time the undersigned, members of the organizing committee, wish to warn the public against the machinations of a character known as the promoter of a 'movement' coming from Zurich, which demands no other designation, and *which today no longer corresponds to any reality.*" The italics effectively acknowledged the growing suspicion that Dada was mortally ill if not defunct.

Breton endorsed the notion that Dada shared something with other tendencies in modern art, particularly Cubism and Futurism, and that this general trend merited investigation. He continued these ruminations when he accompanied Picabia to Barcelona for an exhibit of the artist's works at Galerie Dalmau in November 1922. He gave a lecture called "Characteristics of the Modern Evolution and What It Consists Of." He reiterated his view that Cubism, Futurism, and Dada were "part of a more general movement" and made known his alienation from Tzara. "Yes, Tzara did walk for a time with that defiance in his eye," he informed his Catalan audience, "and yet all that wonderful self-assurance could not bring him to stage a veritable coup d'état. It's just that Tzara, who had eyes for no one, one idle day took it into his head to have some for himself." Eager to expunge Tzara from the ranks of inspirational figures, Breton credited Duchamp as having "delivered us from the concept of blackmail-lyricism with its clichés," though it was Tzara who actually led the way where poetry was concerned.

Still under the thrall of Dada's appetite for destruction, Breton envisioned the modern "movement" culminating in some violent rupture and even went so far as to declare: "It would not be a bad idea to reinstitute the laws of the Terror for things of the mind." Internalizing the French Revolution as the standard for cultural significance, Breton was characterizing Dada as if it were a heedless monarch when, in March, he objected to its "omnipotence and tyranny." In September he made the terms even more explicit, consigning Dada to a merely preparatory role in some larger venture: "Never let it

be said that Dadaism served any purpose other than to keep us in a state of perfect readiness, from which we now head clear-mindedly toward that which beckons us." A few months after the Barcelona lecture, he made a veiled reference to "that disquiet whose only flaw was to become systematic," in which his evident reluctance to pin it all on Dada suggests a faint acknowledgement that the sin of being systematic fell more squarely on his own shoulders than on Tzara's.

Nobody was less disposed to being systematic than Picabia (Breton noted, approvingly, that "the man who provides the greatest change from Picabia is Picabia"). The painter cast a wary glance over the plans for the congress as evidence of some inexplicably puerile compulsion. "This *Congress of Paris* would probably be to my liking if my friend André Breton managed to toss all our 'modernist celebrities' into the melting pot and in doing so obtain a superb nugget, which he would drag around behind him on a little cart and sign it André Breton."

Those associated with Dada were not the only ones to balk at the proposed congress; André Gide dismissed it as an attempt "to teach people how to mass-produce works of art." But an outpouring of positive support from the public at large suggested how much latent yearning there was for the creation of a "ministry of the mind," as one person put it.

This was, after all, a moment that has become known as a return to order in France—*retour à l'ordre*—with Cocteau conspicuous among those clamoring for it. It was the moment prophesied by Apollinaire, who not long before his death in 1918 had delivered a lecture called "The New Spirit and the Poets." Advocating an "encyclopedic liberty" as the poet's prerogative, he concluded with a nationalist peroration on France as "guardian of the whole secret of civilization," responsible for keeping the house of poetry in order. The resonant phrase of Apollinaire's title was adopted by Le Corbusier and Amédée Ozenfant for their journal *L'Esprit Nouveau*. (The first few issues were edited by Paul Dermée, a Dadaist, with the names of the Paris Dadaists listed as editorial consultants—no matter that Dermée himself was persona non grata in Breton's circle.) This congress sounded exactly like the sort of forum *L'Esprit Nouveau* might sponsor, especially with Ozenfant himself as one of the organizers.

All these efforts to organize Dada or inject it into some broader schematization were wearing Picabia's patience thin. As he sniped in the pages of *391*,

"Dada—it has become Parisian and Berliner wit." After he stormed out of the Barrès trial, he fired off an article for Dermée to publish in the June 1921 *L'Esprit Nouveau*, venting at the conspiratorial drama consuming the *Littérature* circle. "I was getting terribly bored. I would have liked to live around Nero's circus; it is impossible for me to live around a table at the Certà, the setting for Dadaist conspiracies!" He went on to claim, not altogether erroneously, that he and Duchamp had "personified" Dada as long ago as 1912, that it was subsequently given a name, and that the concept had lately been squandered by taking on the characteristics of a *movement*. He acknowledged leaving Dada out of both boredom and wariness that it was following in the footsteps of Cubism, gathering adherents and insiders: "I had the impression that Dada, like cubism, was going to have disciples who 'understood.'" In *L'Esprit Nouveau*, he confesses, "I separated from Dada because I believe in happiness and I loathe vomiting." Still, vomit Picabia did.

Picabia's estrangement from the movement did not deter the public perception that his contributions to the upcoming Salon d'Automne of 1921 would be anything other than a Dada prank. It was even rumored that one was, literally, explosive, and the head of the salon had to issue a statement assuring the public of their personal safety in its presence. Picabia contributed two paintings, neither of which inflicted bodily harm upon any of the attendees. One was derived from a technical diagram. When commentators in the press objected that it was absurd to present a diagram as a painting, he responded that it was absurd to presume that copying apples was more dignified than copying a blueprint.

Picabia's second painting has since been enshrined in the annals of Dada, even serving as the dust jacket illustration of one history of Paris Dada. Titled *L'Oeil Cacodylate* for the medication Picabia was taking during an attack of ocular shingles he suffered early in the year, this large canvas (fifty-seven by forty-five inches) was little more than a guest book, bearing the signatures of dozens of the artist's friends, with whatever inscriptions they thought to add. He declared it finished when the space was filled, simple as that. He elaborated on its subject with characteristic wit: "The painter makes a choice, then he imitates his choice, the deformation of which constitutes Art; why not simply sign the choice instead of monkeying about in front of it? Enough paintings have accumulated: the approving signature of artists—only those approving—would give a new value to art works destined for

modern mercantilism." You want signatures from artists? Picabia asked, well here they are and *nothing but*. They included those of wife, sister-in-law, and mistress, the composers Auric, Poulenc, Milhaud (who wrote "I've been called Dada since 1894"), and a few of the Dadaists including Tzara, Ribemont-Dessaignes, Dermée, and the Russian Serge Charchoune. Isadora Duncan applied her signature in green above a photo of the artist's head—a halo for the man whose Dada pedigree seemed unimpeachable.

Picabia, argonaut of the Dada sensibility from New York to Switzerland and Paris, was also an argonaut perfectly contemptuous of any golden fleece. He was in a sense a pure distillation of his generation, forged in the aphoristic cauldron of Nietzsche, whose "will to power" he took to heart as a code—not a code of "honor" but of bare life, biological ardor pursuing its moment-by-moment destiny. Much as Picabia was a wizard at scattering nuggets of philosophical contempt across the lively pages of 391, he consistently reaffirmed his Nietzschean outlook, often quoting from the philosopher without attribution. Maybe Picabia was so steeped in *The Gay Science, Beyond Good and Evil*, and *Zarathustra* he'd come to hear Nietzsche's thoughts as his own. The spirit in which he dealt with his alienation from Dada was certainly Nietzschean in its avowal of a life spirit unhindered by the past. Nietzsche's most biting critique was directed at what he called herd mentality, the salient characteristic of which was *ressentiment* (the German sage insisted on the French term). Picabia had none of that. He never felt betrayed by his friends, just bored by their tendency to behave like military officers or, as in the Barrès trial, members of the judiciary.

Although it's hard to find extended expository prose in Picabia's writings—he's too slapdash, irreverent, and spirited to submit to what he'd have called a classroom obligation—he did write a response to one of the few articles in the press that took Dada seriously. Published early in 1920, "Dadaism and Psychology" by Henri-René Lenormand sufficiently engaged his attention that he replied at length in a letter unpublished during his lifetime. To the familiar charge of Dadaist behavior as "mad," Picabia offers a retort: "One thing opposes this assertion: lunacy necessitates the obstruction or at least the alleviation of the will, *and we have willpower*." Then, in a kind of personal credo, he uncharacteristically elucidates "the mechanism of our will: negative at the moment the association of ideas is formed, it becomes positive with

the *choice* that follows." As to Lenormand's attempt to account for Dada in Freudian terms, Picabia does not so much disprove it as brush it aside. Dada, he says, has little to do with psychology, "it is more in physical phenomena than in any other that we must find the explanation." It is a *detoxification*, he contends, and in an analogy comparable to Hugo Ball's vision of Dadaists as babes in arms, Picabia suggests that the quest for knowledge pursued by Dada involves a regression to childhood: "Children are closer to knowledge than we are since they are closer to nothingness, and knowledge is nothing."

This syllogistic explanation was written concurrently with a manifesto Picabia concluded with emphatic exasperation:

> DADA wants nothing, nothing, nothing, it does something so
> that the public can say: "we understand nothing, nothing,
> nothing."
> "The Dadaists are nothing, nothing, nothing, they will most cer-
> tainly amount to nothing, nothing, nothing."
>
> — **Francis Picabia**
> **Who knows nothing, nothing, nothing, nothing.**

Picabia was consistent in his revulsion against art or any enterprise that laid claim to *something*, some tangible product or endgame that superseded the simple daily sentience of the living organism. I sniff the air, he would say, I don't check my stock portfolios. "Life has only one form: forgetting," he wrote in April 1920 in one of many aphorisms in his brief-lived journal *Cannibale*. A variant of the sentiment appeared in *The Little Review*: "I am for incineration, which conserves ideas and individuals in their least cumbersome form."

A year later, after his stormy departure from the Barrès trial, Picabia's withdrawal from Dada was taken up in the newspapers, so he tried to clarify the situation in two accounts. In *Comoedia*, he began by saying "I approve of all ideas, but that's it, they alone interest me, not what hovers around them; speculations made on ideas disgust me." This was a man who had come up with the brilliant one-liner: in order to keep your ideas clean, change them like you change your clothes. "You have to be a nomad," he wrote, "and go through ideas the way you go through countries and cities"—speaking from considerable experience.

Perhaps owing to his painful eye infection, and exacerbated by the claims made by Walter Serner and Christian Schad that Tzara was an imposter, he assembled a special "supplement" to 391 published as *Le Pilhaou-Thibaou* in July 1921, a nonsense title suggesting, if anything, the Tabu Dada movement of his friends Jean Crotti and Suzanne Duchamp (Marcel's sister). In fact, Crotti's contribution on the front page announced himself as Tabu-Dada: "My feet have started to think and want to be taken seriously."

The sixteen pages of *Le Pilhaou-Thibaou* were lavishly designed and drew more on the contributions of others than issues of 391. In addition to Crotti and Picabia himself (with his English nom de plume Funny Guy), the contributors were Paul Dermée, Jean Cocteau, Ezra Pound, Clément Pansaers, Duchamp, Georges Auric, Céline Arnauld, Guillermo de Torre, Gabrièle Buffet, and Pierre de Massot. None of them would have been considered Dadaists at that point. Dermée and Cocteau, in fact, were both on the outs with the Dadaists for their patent careerism in the avant-garde, and Arnauld, being Dermée's wife, was guilty by association.

In the midst of this multifaceted compilation, Picabia had his usual field day. "To those talking behind my back: my ass is looking at you," a reproach clearly aimed at his former comrades in Dada, was actually a quote from Gustave Flaubert. "I don't need to know who I am since all of you know," on the other hand, is closer to his usual flair for the clever barb. Such aphorisms romped in the margins next to the contributions by others. But in a longer piece Picabia squeezed out a bit more diagnostic pus: "Can't you sense that what you call your personality is just a bad digestion that poisons you and conveys your bouts of nausea to your friends?" Is he addressing himself here, one wonders, or others?

Le Pilhaou-Thibaou proclaimed Picabia's release from the grip of Dada. Cocteau's contribution made it explicit:

> After a long convalescence, Picabia has recovered. My congratu-
> lations. I actually saw Dada exit through his eye.
> Picabia hails from the race of the contagious. He shares his ill-
> ness, he doesn't catch it from others.

Another notable contributor to *Le Pilhaou-Thibaou* was Ezra Pound, recently relocated to Paris after a decade in London. Early in 1921, Pound spent

Artists and writers in Paris, 1920.
Kneeling, left to right, are Man Ray, Mina Loy, Tristan Tzara,
and Jean Cocteau. Standing behind Cocteau is Ezra Pound.

Scala / White Images / Art Resource, New York.

several months on the Riviera where he tutored himself in Dada at the book-
store of Georges Herbiet, who, under the name Christian, translated some
of Pound's work into French. A sequence titled "Moeurs Contemporaines"
(in Pound's original) appeared in *Le Pilhaou-Thibaou* and in the Belgian jour-
nal *Ça Ira*, published by Clément Pansaers, the main proponent of Dada
in Belgium; an extract also appeared in the Dutch Dada journal *Mécano*.
It's a fierce and amusing piece of social satire, owing more to Pound's idol
Henry James than to Dada. There were other pieces by Pound written in
French in a more recognizably Dadaist vein, but more important is his per-
sonal association with Picabia, which gave him a lifelong connection with an
unfettered human mind. He never knew Duchamp, but Pound would have
likely concurred with Breton's observation about Picabia and Duchamp that
"they move without losing sight of the major elevation point where one idea
is equal to any other idea, where stupidity encompasses a certain amount of
intelligence, and where emotion takes pleasure in being denied."

In October 1921, in one of his "Paris Letter" contributions to *The Dial*,
Pound informed American readers of Picabia's "hyper-Socratic destructiv-
ity," citing his *Thoughts Without Language*, the book that thrilled Breton.
Pound was transfixed by the "very clear exteriorization of Picabia's men-
tal activity" in everything he undertook. "Picabia's philosophy moves stark
naked," unencumbered by the usual scaffolding of explanation, the poet sug-
gested. In *Guide to Kulchur* (1938), Pound recalled Picabia's conversation on
"a Sunday about 1921 or '22" as "the maximum I have known." He was a man
so "intellectually dangerous," in fact, "that it was exhilarating to talk to him
as it would be exhilarating to be in a cage full of leopards." In short: "There
was never a rubber button on the tip of his foil." Pound sensed that this was
not owing to some obscure need to inflict pain or seek revenge. Picabia's pro-
pensity was nature's gift, the way a greyhound runs because of its breeding,
or as Marianne Moore put it memorably in a poem: "an animal with claws
wants to have to use / them."

The correlation between wit and claws is longstanding, and the pros-
pect that blood might be drawn is what distinguishes wit from just hors-
ing around. The Dadaists gleefully took aim at themselves, but always with
the assumption they were superior to the goggle-eyed bourgeoisie. Picabia,
though, was different. If nobody was immune to his barbs, neither did he
single out a particular group for derision. He jauntily made all sorts of

false claims about people, including his friends, throughout the pages of 391—adding a dash of gossip-column spice to the stew, albeit as a sleight of hand. The closest he came to vengeance was in the folded sheet *The Pine Cone*, half of which was given over to Crotti's Tabu Dada. Picabia pelted Tzara and Ribemont-Dessaignes with various insults, like "Your modesty is so great that your works and inventions will only attract flies."

When *Le Pilhaou-Thibaou* was produced in July 1922, Picabia was tenuously allied with Breton's attempt to convene his Congress on the Modern Spirit, effectively taking sides against Tzara. Eventually that too was water under the bridge; when Breton formed his new movement, Surrealism, Picabia astutely observed that it was "quite simply Dada disguised as an advertising balloon for the house of Breton & Co." Picabia himself was always ready to move on, abiding by the zesty principle: "Our head is round to allow thoughts to change direction."

Picabia's maxim could count as the last word on Paris Dada, but not the final incident. That occurred on the evening of July 6, 1923, at the Théâtre Michel in Paris, when a performance of Tzara's *Le Coeur à gaz* (Gas Heart) was aggressively interrupted by several young men of letters no longer calling themselves Dadaists.

The performance was part of an evening billed as the "Soirée of the Bearded Heart." The convulsive seasons of Dada having made theatrical managers wary of renting their properties for such events, Tzara had been forced to work by subterfuge, enlisting the aid of exiled Russian writer Iliazd (Ilya Zdanevich), who had dabbled in proto-Dada-cum-Futurist performances in his homeland. Iliazd booked the hall, and an elaborate program was drawn up that was in many respects a pinnacle of the avant-garde at that moment—less Dada, perhaps, and closer to whatever the ill-fated Congress of Paris had envisioned.

The evening's program included three films: one of Hans Richter's abstract "rhythm" exercises and Man Ray's *Return to Reason*, produced on the shortest possible notice when Tzara came up with a camera and some film. Like his rayographs coming to life, his film inaugurated yet another turn in his ever-inventive forays through different media. The third film was *Manhatta*, a portrait of New York by Charles Sheeler and Paul Strand. Some piano pieces by Pound's protégé and self-declared "bad boy of music," George

Antheil, were performed, as well as a dance by Lizica Codreano. There was also a repertoire of poems, including several by former Dadaists, from whom Tzara was now utterly estranged.

Getting wind that their poems were to be used by a man—and a movement—for which they no longer felt any allegiance or affinity, the disaffected Dadaists showed up determined to disrupt the proceedings. At an innocuous reference to Picasso by Pierre de Massot, Breton ("a thick-set bully" in one account) stormed the stage and thrashed the poor fellow with his cane, breaking his arm. Police intervened and expelled Breton, but his allies remained, seething and waiting for their next opening. This came during the performance of *Gas Heart*, a play dating from 1920, featuring the characters Eye, Mouth, Nose, Ear, Neck, and Eyebrow. The actors were outfitted with Sonia Delaunay's stiff trapezoidal costumes. Once the curtain rose, Paul Éluard erupted from the audience, making a stink over the expulsion of Breton and demanding that the villainous Tzara show himself. As soon as Tzara appeared, Éluard leaped onstage and punched him in the face. Stagehands and audience members came to his defense, while others joined the fray, busting up the set and leading to further expulsions.

In a sense, Éluard's explusion was the most far flung. Within six months of the fracas at Théâtre Michel, the French poet vanished from Paris without a word to his friends, embarking on a voyage to the Far East as if carrying out literally the assignment Breton had figuratively announced in his piece "Leave Everything," published in *Littérature* in April 1922:

> Leave everything.
> Leave Dada.
> Leave your wife, leave your mistress.
> Leave your hopes and fears.
> Drop your kids in the middle of nowhere.
> Leave the substance for the shadow.
> Leave behind, if need be, your comfortable life
> and promising future.
> Take to the highways.

10

A DOSTOYEVSKY DRAMA

When Paul Éluard abruptly left Paris on March 24, 1924, no one had a clue about his intentions or his whereabouts, although the provocative title of his new collection of poems might have given them pause: *Mourir de ne pas mourir* (Dying of Not Dying). For those in the know, there was an additional twist: the frontispiece was a portrait of the author by Max Ernst. The two men were deeply embroiled in a ménage à trois with Éluard's wife, Gala, when the poet abruptly disappeared.

Éluard surmised at one point that he'd been within a kilometer of Ernst at Verdun, one of the costliest engagements of a miserable war for which neither man had any enthusiasm. Whether or not they'd been that close in the combat zone, the supposition reinforced an abiding bond between them, forged by the realization that each might have killed the other. Ernst had been conscripted three weeks after the war began, serving in an artillery unit. He was injured, although—fortunately for him—only by the recoil of a big gun and the hind leg of a donkey. Relocated to a command post, an officer recognized this young recruit as none other than the artist whose work he'd seen recently at Alfred Flechtheim's gallery in Düsseldorf.

When the war had broken out, the twenty-three-year-old Ernst was beginning to see some success as an artist. A year earlier, in August 1913, he'd funded a monthlong trip to Paris by the sale of a painting. His first exposure

to the full range of modern currents in art was at the 1912 Sonderbund exhibition in his native city, Cologne. This was the same exhibit that inspired organizers of the Armory Show in New York to rethink their plans; like them, Ernst was awestruck by this cornucopia of Fauves and Expressionists and Cubists. His plunge into the latest art was aided by August Macke, the Expressionist who lived in nearby Bonn and whose circle the young artist frequented. Through Macke he was exposed to the Blue Rider group in Munich, meeting Kandinsky during the latter's trip to Cologne in early 1914. Ernst was also present when Robert Delaunay and Guillaume Apollinaire visited Macke on their way back to Paris from Berlin, where the French artist's brilliantly colored paintings, deemed "Orphic" by the poet, were featured at Sturm Gallery. These encounters reinforced Ernst's sense of mission, even as his father (an amateur painter) literally screamed at him for indulging in this grotesque tendency to splash colors all over the canvas without regard for actual appearances.

Another key encounter came in May 1914, when Ernst was strolling through an exhibit of French art in Cologne and came across a young man explaining the work to an outraged elderly gentleman. Rather than being confrontational or intemperate, the younger fellow patiently persisted "with the sweetness of a Franciscan monk and an adroitness worthy of Voltaire," but to no avail. Afterward, Ernst introduced himself and made a lifelong friend of Hans Arp, who had been visiting his father.

That summer, Arp warily observed the escalation of international tensions and warned Ernst that things would soon take a turn for the worse. He was right, but only Arp made it out of the country to neutral Switzerland on one of the last trains before the borders were closed. The two young artists shared a dedication to the latest in modern art, which Arp took with him to Zurich, providing Dada its early profile as a successor to these tendencies.

Meanwhile, Ernst endured the war and kept abreast of what was going on in the art world as best he could. He had a reliable informant in Luise Straus, two years younger, whom he'd met in a drawing class before the war. "What I first noticed about him," she wrote later, was his "astonishingly shining blue eyes, his extravagant colored silk ties, and his constant radiant contentment, that held something very childish at the same time as a superior irony." Lou, as she was known, completed her doctorate in art history in 1917, by which point she and Ernst were engaged. This was not a welcome prospect for

either family, traditionally Jewish on her side, traditionally Catholic on his. After their marriage in October 1918, she worked at the Wallraf-Richartz Museum in Cologne, curating an exhibition on "Depictions of War Through Graphics" in 1919, and maintained an active professional profile until the birth of their son, Jimmy, in June 1920.

Max and Lou Ernst thrived in Cologne's lively postwar arts scene. As Lou put it, "we were the leaders of one of those groups that shot up like mushrooms then, with their lectures, concerts, meetings, but especially a lot of big ideas and little scandals." One scandal, such as it was, involved a prearranged disruption of a vapid monarchist play, which drew the ire of local journalists who denounced the escapade as a symptom of "literary Bolshevism" and "Dadaism." That was in March 1919, when the charge of being a Dadaist meant little to Ernst. It wasn't until that summer, during a trip to visit Paul Klee in Munich, that he was exposed to the latest issues of *Dada* coming out of Zurich. *Dada* revealed, among other things, that his prewar friend Arp was part of the movement, whatever it was.

During this trip Ernst also encountered the haunting dreamlike paintings of Giorgio de Chirico in the Italian journal *Valori Plastici*. As he recalled, "I had the impression of having met something that had always been familiar to me, as when a déjà-vu phenomenon reveals to us an entire domain of our own dream world that, thanks to a sort of censorship, one has refused to see or comprehend." He absorbed the Italian's work not so much as a stylistic or conceptual influence but as an alternate world he could explore only by way of his own art. In years to come, the Surrealists would regard de Chirico's work as exemplary for their movement, but where the Italian artist seemed to have abruptly turned aside from its potential, Ernst soldiered on, becoming one of the abiding standard bearers of whatever Surrealism would be in the visual arts. "As a Dadaist he was already a Surrealist," Richter observed of Ernst, who arrived at that sweet spot even before André Breton baptized it.

But before Surrealism was inaugurated in 1924, there was Dada, and in truth Ernst was among its most stalwart standard bearers. Although he would be barred from entry to France when the Dadaists sponsored his exhibit there in 1921, Ernst finally made it to Paris the next year in clandestine and complex circumstances. And even before that, he had pioneered a Dada season in his native Cologne. His transit offers a glimpse into the wayward

exhilaration Dada could provide, especially for those not living in the major Dada centers—Zurich, Berlin, Paris—but keenly attentive to reports that trickled in from those locales.

By the end of 1919, Ernst was in frequent contact with Tzara in Zurich, Schwitters in Hanover, and, less keenly, the Berlin Dadaists. He was freely adapting their attitudes and jargon, referring to some of his assemblages as "merz paintings" and generally coming around to the sense that he and a few local friends were mining the vein of Dada. These friends included Otto Freundlich, Heinrich and Angelika Hoerle, and Johannes Baargeld. The Hoerles shared an outlook close to that of the Herzfeld brothers in Berlin, for whom art was a weapon in political action. Their journal, *Der Ventilator*, issued in six installments in February and March 1919, was distributed at factory gates.

Ernst and his friends called themselves W/5, short for Weststupidia 5— English having local relevance, since the Rhineland was then occupied by Allied troops. If they thought of Weststupidia as Dada, it was in spirit not in name. The issue was forced in November, when an artists' society to which they belonged held an exhibition and the organizers balked at including the work of Ernst's group. The upshot was a parallel exhibit housed in the same venue, with a clarifying sign:

DADA HAS NOTHING IN COMMON WITH THE SOCIETY OF ARTS

DADA IS NOT INTERESTED IN THIS GROUP'S HOBBIES

SIGNED: JOHANNES THEODORE BAARGELD, MAX ERNST

← TO DADA TO SOCIETY OF ARTS →

This inaugural Dada exhibition in Cologne offered a heterogeneous range of objects, prompting some of the participating artists to withdraw their works before its premiere. It was the opening salvo in what a local journalist decided was a program of "methodical madness," wondering whether to be indignant or amused. The terms of that indecision strike a note familiar from other cities in which Dada made its mark.

One person who laughed at this latest Dada's manifestation without laughing it off was Katherine Dreier, visiting from New York. Familiar with Duchamp, Man Ray, and Picabia, she was keenly appreciative of what Ernst and his cronies were up to and tried to arrange for the exhibition to come to America for Societé Anonyme. Unfortunately the occupying British authorities would not permit it, and as was also the case with the Berliners after the International Dada Fair, Americans never got to experience German Dada as a group effort.

The Dada initiative in Cologne was augmented by the arrival of Hans Arp for ten days in February 1920, shortly after Tzara moved to Paris. The input of Arp's perspective from Zurich probably reinforced Ernst's instinct about keeping his distance from Berlin. Writing to Tzara on February 17, he referred to the Berliners as "counterfeits of Dada." He found them "truly German" in that "German intellectuals can neither shit nor piss without ideologies." (An amusing example of that spirit comes from Vera Broïdo, one of Raoul Hausmann's ladies. "One day as Baader and Hausmann went for a walk with a writer friend," she relates, "the latter stopped near a tree and peed. Seeing that the others continued their walk, he got annoyed and said as he peed that the others should do the same. This is characteristic of the attitude of the Berlin Dadaists towards their art.")

Ernst also sensed the growing ideological outlook of his Cologne colleagues, and the Hoerles would split from Dada by April, forming their own group called Stupid. "We have turned away from all individualistic anarchy," they declared, expressing their wish "to be the voice of the people." As a consequence, they concluded, "We reject the supposed anti-middle-class buffoonery of Dada, which only served to amuse the middle class."

They had a point about Dada's bourgeois roots, although the middle class was hardly amused. Its response to Dada everywhere was summed up in the title of Raoul Hausmann's article in Der Dada 2 in February 1919, "Der deutsche Spiesser ärgert sich," which might be translated as "The German bourgeoisie is getting worked up." As for Ernst, his wrath was existential, not political. "A mad gruesome war had robbed us of five years of our lives," he recalled in 1958. "Everything that had been held out to us as right, true and beautiful fell into an abyss of shame and ludicrousness. My works at the time were not supposed to please anyone; they were supposed to make people howl." And howl they did, not only at the works themselves but at the

attitude expressed in the title of Ernst's lithograph series, *Fiat Modes—Pereat Ars*, or "Let there be fashion—down with art."

"Dada Early Spring Exhibition," Cologne's major Dada event, came about when Ernst and Baargeld were refused access to a show being mounted at the Kunstgewerbe Museum. They countered by organizing their own exhibition. It was held in a pub, with access only through a restroom, beyond which one encountered a young girl in a communion dress reciting obscene lyrics. As reported in the press, "You go through a door in a building behind a Cologne bar and run into an old stove; to your left is a vista of stacked-up bar chairs, and to your right, the art begins." The reporter expressed a preference for the left-hand view. On exiting the exhibition space, viewers "pass a couple of open garbage cans full of eggshells and all kinds of junk, and cannot decide whether these belong to the exhibition or are 'natural originals.'" One of the works exhibited was a fish tank Baargeld filled with red water, a wig floating on top and a mannequin's hand submerged in the murk.

The authorities promptly shut down the exhibit after complaints of pornographic content, but the ban was lifted the next day, when the offending item was revealed to be Albrecht Dürer's revered *Adam and Eve*, which Ernst had glued into an assemblage. A poster exclaimed:

DADA TRIUMPHS!

REOPENING

OF THE EXHIBITION CLOSED BY THE POLICE

DADA IS FOR PEACE AND ORDER

The exhibit struck many as fraudulent. But the organizers rebutted: "We said quite plainly that it is a Dada exhibition. Dada has never claimed to have anything to do with art. If the public confuses the two, that is no fault of ours." This was exactly the sort of rhetoric Ernst's father found offensive, quite apart from his art. "I curse you. You have dishonored us," he scornfully told his wayward son.

With its early spring exhibition in April 1920, Dada had officially arrived in Cologne. Soon, Baargeld was off on other pursuits, and Ernst's hopes for any ongoing involvement with Dada meant setting his sights elsewhere. He'd kept abreast of the inflammatory situation developing in Paris, and in the wake of Picabia's decisive repudiation of Tzara in *Le Pilhaou-Thibaou* (which Arp, too, found distressing), Ernst proposed to Tzara meeting in the Alps to lick their wounds and strategize. He thought of it as an "important conference of the potentates." "Please decide and telegraph me," he wrote, suggesting August 15 as a suitable date. "The immediate future of Dada depends on it."

In the summer of 1921, Dada had little more than an "immediate" future left. It had been a year since the last hurrah at the International Dada Fair in Berlin, and even in Paris, where Dada didn't enter the picture until Tzara's arrival in early 1920, the movement was now spinning its wheels. To be sure, little tentacles of Dada life were slithering their way into far flung locales, from Belgrade to Tokyo, but that was Dada second or third hand—Dada as guess, wish, and innuendo. The initial fire had burned out, and even the sparks were dwindling.

So it was an inspired guess on Ernst's part to take Dada back to its original Alpine heights—and during the traditional vacation season, no less. Dada on vacation? Odd. But this was getting near the end, and even the participants couldn't help but sense it. For Ernst, though, it felt like his true vocation was just coming into focus. He needed to keep Dada going to keep himself going, because the discoveries he was making in his art had no foreseeable life outside the singular incubator of Dada.

Max Ernst's objets d'art, indeed, were the quintessential "objets dad'art" (a punning title he provided). Dadamax, as he called himself, repopulated the visible world with mechanisms and automata gleaned from nineteenth-century illustrated catalogues. The cover illustration Ernst would make for a 1922 collection of poems by Paul Éluard epitomizes his Dada sensibility, insinuating itself through the viewer's eye as an uncanny physical discomfort. As if the image of a needle being threaded through a cornea isn't disturbing enough, the book's title prolongs the distress: *Répetitions*. (Characteristically, even this vivid motif was derived from a prior source, his fellow Dadaist Johannes Baargeld's *The Human Eye and a Fish, the Latter Petrified*, which hung in Ernst's living room.) Despite his obvious and growing affinity for the

movement, however, Ernst was fated to have clambered onboard the Dada raft at the very moment it started to sink—a coincidence that led him to seek refuge in the unlikeliest of places.

Vacation in the Tyrol offered the immediate gratification for Ernst of spending precious time with Arp, as well as the opportunity at long last to meet Tzara. And of course Lou and little Jimmy would thrive in the mountain air. It was a happy occasion all around, overflowing into postcards they sent friends and comrades. As enticement to Paul Éluard: "Max Ernst is giving each Dada who comes to Tarrenz a picture. He is here with his wife and his baby Jimmy, the smallest Dadaist in the world."

Éluard couldn't make it to the Tyrol this time around, but there was a palpable appeal in the idea of a retreat with the German artist. Ernst's show at Au Sans Pareil had been held in May, and with Picabia's apparent defection from Dada, Ernst was the great hope of the movement. (Man Ray had only just arrived in Paris, and his own exhibit wouldn't be until December.)

In any event, it was not Éluard but Breton and his new bride who arrived near the end of the vacation. Ernst immediately felt the aura of grandeur that hung about the man like a cape, an "almost magical presence," it seemed, marked by "presumptuous politeness, and a frank, uninhibited authority." He also discerned the discomfort of Tzara and Breton in each other's company.

By the time the Bretons arrived, the trio of Arp, Tzara, and Ernst had produced a small publication regarded as the final issue of *Dada*. Its title (suggested by Tzara's girlfriend from Zurich, dancer Maja Kruscek) was the slaphappy-sounding *Dada in Tyrol the Singers' War Outdoors* (*Dada Intirol augrandair der Sängerkrieg*), and although it retained the high spirits of the vacation—most of the writing was in a gleefully nonsensical vein—it made a point of responding to the poisonous claim Picabia made in *Le Pilhaou-Thibaou* that Dada was created by himself with Duchamp and that Tzara had, at most, found the word—though even that attribution was in question, with Huelsenbeck listed as cofounder. In *Dada Intirol*, Hans Arp contributed a send-up of this vexing issue of paternity, which has nevertheless influenced the collective memory of how Dada evolved.

I declare that Tristan Tzara found the word DADA on 8 February 1916 at 6 in the evening; I was present with my 12 children when Tzara

pronounced for the first time this word that unleashed in us a legitimate enthusiasm. This occurred at the Café Terasse in Zurich and I bore a brioche in my left nostril. I am convinced that this word has no importance, and that only imbeciles and Spanish professors are interested in dates. What interests us is the dada spirit and we were all dada before the existence of dada.

The prehistory of Dada was mockingly suggested in the date the periodical bore: September 16, 1886–1921. This was in fact Arp's birthday, extended to the present moment, his thirty-fifth year.

The first item in the publication, signed by Tzara: "A friend from New York tells us about a literary pickpocket; his name is Funiguy, celebrated moralist." Funny Guy was the nom de plume with which Picabia signed many of his freewheeling writings in 391. In a separate note, Tzara extended the lampoon, informing the reader that Funny Guy invented Dadaism in 1899, Cubism in 1870, Futurism in 1867, and Impressionism in 1856—the year of Freud's birth, although Tzara may not have known or intended that coincidence.

Dada Intirol included only two visual works, a woodcut by Arp and a collage by Ernst, the latter taking pride of place under the journal's title (printed upside down and backward). It was named *The Preparation of Glue from Bones*, and it is a splendid example of the lugubrious world Ernst could summon almost casually, his finger on the pulse of an otherworldly arterial network pumping dreams instead of blood. Werner Spies characterizes it as a "collage manifesto," inasmuch as the title alludes to the procedure of making collages. Ernst added very little to an image already sufficiently arresting, an illustration from a medical journal depicting diathermy treatment. (A photograph of the treatment can be found in *Foto-Auge* or Photo-Eye, assembled by Franz Roh and Jan Tschichold in 1929, where it's intriguingly juxtaposed with Georg Grosz's collage-painting *The Monteur Heartfield*.) Ernst was so taken with the image he replicated it in a large painting. With its bright colors, it "naturally has a much insaner effect than the little reproduction." It was destroyed during the Second World War, but its impact persists in a photograph of Düsseldorf gallery owner Mutter Ey and a group of enthusiasts posing with the painting like a sacred talisman of some obscure religion.

Max Ernst, Preparation of Glue from Bones,
published in Dada Intirol (September 1921).

Because he couldn't extricate himself from professional obligations in Paris in time to meet Ernst in the mountains, Éluard arranged for a visit to Cologne where he and Gala spent a week in early November. They took in a Man Ray exhibit Ernst arranged, as well as a separate exhibition of Ernst's own work. The stimulating visit resurrected the bright spirits that had animated the Tyrolean vacation. The mood continued when Tzara arrived in December for three weeks. But the Éluards' Cologne visit proved to be stimulating in unexpected ways as well.

During that week, Ernst and Gala Éluard felt the first pangs of a mutual attraction. Gala was Russian, born Helena Dimitrievna Diakonova in 1895, the same year as Éluard. Gala and Éluard met at a sanatorium in Switzerland when they were both seventeen, developing a bond that lasted after they returned to their homelands. Finally, in 1916, Gala came to Paris where she lived with Éluard's parents while he was serving at the front, and the young couple

married during a short leave he'd obtained in February 1917. It was a point of contention between them when, in December, Éluard abandoned his post as a medical orderly and enlisted in an infantry unit, needlessly risking his life in combat. He survived, and the couple had a daughter, Cécile, in 1918.

As soon as they met in Cologne, Ernst and Éluard regarded each other as long lost soul mates, thanks to their recent proximity in combat, and when the Éluards returned to Paris, the two men embarked on a collaboration by post, the fruit of which was published in March under the title *Répétitions*, with poems by Éluard and collages by Ernst. As soon as the book came off the press, Éluard and Gala headed back to Cologne with fresh copies, high spirits—and aroused senses.

The rapport between Ernst and Gala that developed in November precipitously came to a head. In her memoir, written twenty years later, Lou still seethed at the indignity of what transpired and at the woman to blame for it: "This slippery, scintillating creature with cascading black hair, luminous and vaguely oriental black eyes, delicate bones, who, not having succeeded in drawing her husband into an affair with me in order to appropriate Ernst for herself, finally decided to keep both men, with the loving consent of Eluard."

The impetuousness of the affair between Gala and Ernst was even more striking because her daughter and his son were on hand. It made for one big unhappy family. There are several group portraits of the four adults and two children, and it's hard not to register Lou's bewilderment, Gala's intensity, Ernst's fixation. And Éluard? As Tzara divulged, "Eluard liked group sex. He was keen for his friends to make love to Gala—while he watched or joined in." And the friend in this case was more like a second self. During this time, Ernst executed a double portrait in which his head and Éluard's blend into a single entity, exactly like the collages Raoul Hausmann produced in Berlin, merging his head with that of Baader, the Oberdada.

The appeal of Dada in the Alps held over from 1921 into the next year, when the original vacationers were joined by the Éluards, along with American writer Mathew Josephson and his wife, Hannah. Josephson was living in Paris, where he'd met Tzara through Man Ray, and at Man Ray's exhibit at Au Sans Pareil in December, he'd struck up a rapport with Louis Aragon. Soon he was attending all the Dada events, hanging out at Café Certa and the other watering holes frequented by the *Littérature* clan. "While there were certain inconveniences in such a group life," he found, "one felt there was a warm spirit of comradeship

ruling them. Whereas, in contrast, a gathering of avant-garde American writers and painters would have found everyone talking at cross-purposes."

Reunited in the Alpine setting, Tzara and Arp anticipated a reprise of the previous year's Dada publication, but such hopes were dashed by the grim mood surrounding the ménage à trois. Even the participants seemed none too happy about the affair. It was a pressure cooker with Ernst, Éluard, and Gala occupying one room, while Lou and little Jimmy were next door (the Éluard daughter was with her grandparents, back in Paris). "You've got no idea what it's like to be married to a Russian!" Éluard exclaimed to Josephson, who felt that while Ernst "carried himself with much aplomb in a difficult situation," Gala's "changeable moods" and nervous tension poisoned the atmosphere. "Of course we don't give a damn what they do, or who sleeps with whom," lamented Tzara. "But why must that Gala Éluard make it such a *Dostoyevsky drama!* It's boring, it's insufferable, unheard of!"

The only relief, in Josephson's view, came with the arrival of Hans Arp and Sophie Taeuber. The American found Arp to be "one of the most lovable and fantastically comic companions I have ever had," able in a wink to go from monkish sobriety to Mack Sennett movie clown. Arp's oblique way of acknowledging the extra- and intramarital escapade unfolding was to declare, "I could never make love to a woman unless I were married to her"—his own conspicuously intimate, longstanding relationship with Sophie notwithstanding. (The couple would finally marry later that year.)

There would be little point in mentioning the ruckus surrounding the Max-Gala-Paul triangle but for its precipitous outcome. Had it been confined to a week or two here and there, in Cologne and in the Alps, it would have receded to little more than a biographical detail in three lives better known for other things. (Gala, for instance, went on to marry Salvador Dalí.) But the tryst was not fleeting. One day Lou reproached her husband for being verbally abusive toward Gala, wondering why she put up with it, because Lou herself surely wouldn't. Ernst coldly turned to her and said, like a slap in the face, "I never loved you as passionately as I love her."

Ernst resolved to follow the absorbing couple to Paris for a few weeks, but Lou told him not to return. The problem for Ernst was that he had no legal way to enter France. In a solution that added another complication, Éluard let Ernst use his own passport. Consequently, Ernst became an illegal alien, without means. Once in Paris, he took on yet another false name (Jean Paris,

of all things) just to scrape by, doing odd jobs, including being an extra for a film production of *The Three Musketeers*. At first his visit to Paris proved something of a romp—but before long it would contribute irrevocably to the dissolution of the movement he had avidly embraced back in Cologne.

For a time immediately following his arrival in Paris, Ernst lived with the Éluards, which meant living well, since Éluard was the only child of a wealthy real estate developer, and Éluard himself (though not to his liking) worked in the family business. The living arrangement was eyed with suspicion by Éluard's parents—not that they knew of the sexual arrangements, necessarily, but they certainly regarded Ernst as a foreign sponger, benefitting unreasonably from the generosity of their son. As the situation wore on, the son showed signs of stress.

Before long, the spark that had made the vacation trysts so lively was emitting more smoke than fire. As early as August 1922, Dada friends visiting the suburban Éluard domicile were alarmed by the mood. One wrote to Tzara about a dinner where "the drunkenness of Éluard became dreadful." Everyone else was jolly and in high spirits "except Ernst, who had hardly said a word during the evening, and who looked at Éluard, mouth set, eyes like those of marble statues"—exactly as he'd looked at Lou, in fact, just a month earlier in the Alps.

Somehow this eccentric arrangement persisted through the year and into the next, when in April 1923 Éluard bought a sizeable house about twelve miles outside Paris. Over the next six months, Ernst painted decorative murals all over the house. Cécile Éluard later recalled her childhood home in less than fond terms.

The exterior of the house was very banal. But the inside was fantastic and strange. All the rooms were filled with surrealist paintings, even in my room, my parents' bedroom, the salon. Everywhere. Some of these paintings made me frightened. In the dining room, for example, there was a naked woman with her entrails showing in very vivid colors. I was eight at the time, and those images made me very, very afraid.

The innocent reference to the parents' bedroom is striking, because as Gala later confided to a friend, Ernst and Éluard were both sleeping in her bed every night.

The situation unraveled completely soon thereafter, adding its own seismic jolts to an already deteriorating Dada scene. When the other Dadaists (as Dada was sputtering out) finally saw the Éluard place, Breton was aghast, saying it "surpasses in horror anything one could imagine." Less than six months later, Éluard stunned everyone by slipping off suddenly, without warning or explanation. Three days after that, Breton's wife, Simone, observed, "André's so sad, worried, nostalgic and more detached than ever." Two weeks later, Breton conceded that the event confirmed his "gloomiest concerns," to the extent that "I can barely make sense of anything." He felt even more deeply implicated by Éluard's dedication in the book he left behind: "To simplify everything this my last book is dedicated to André Breton." While *dernier livre* (last book) could innocently mean most recent, it was hard not to hear a grim finality in the wake of the man's disappearance.

In fact, the whole group was shaken. It was as if the mock epitaph to Éluard published by Philippe Soupault back in 1920 had been an unwitting forecast of what had now come to pass: "You left without saying goodbye." In his author's note to this collection of "Epitaphs" published in *Littérature*—nine poems bearing the names of nine Dada friends—the poet confides that, feeling his verse becoming lifeless, he'd adopted this strategy, and "in reality each of the characters bearing these famous names are Philippe Soupault." Now in the wake of Éluard's disappearance, the notion of an epitaph loomed as something more than literary stratagem. This was in the wake of the legendary "sleeping fits," those somnambular exercises in automatic writing that captivated but so disturbed the participants that Breton shut them down after a few weeks. The most clairvoyant participant had been Robert Desnos (who even claimed to channel messages from Duchamp's Rrose Sélavy!), who came up with the idea that Éluard was in the Pacific. Éluard never communicated with any of his friends during his absence, but he had sought Desnos' help in procuring a false passport, perhaps tipping his friend to a possible voyage.

So what happened to Éluard? Undoubtedly the domestic triangle proved untenable, but there are no details of what transpired in private. What's available, instead, is a revealing missive Éluard sent his father.

24 March 1924. Dear Father, I've had enough. I'm going travelling. Take back the business you've set up for me. But I'm taking the money I've got,

namely 17.000 francs. Don't call the cops, state or private. I'll see to the first one I spot. And that won't do your reputation any good. Here's what to say; tell *everyone* the same thing; I had a haemorrhage when I got to Paris, that I'm now in hospital and then say I've gone to a clinic in Switzerland. Take great care of Gala and Cécile.

I've had enough says enough. Éluard's letter makes no mention of Ernst, but of course he was persona non grata where Éluard's parents were concerned. And they grew even more concerned to find their granddaughter still housed with Gala and her paramour. There were rows. But it's not as if Éluard himself was off the hook: his cavalier reference to 17,000 francs—close to $30,000 today—glosses over the fact that he'd pilfered it from family business funds.

Éluard needed the money, though, for he was on his way to Indochina, on a passenger ship recently converted from its military mission, having served as a German raider in the South Pacific. He was soon in touch with Gala, arranging for her to auction off his art collection to repay the stolen funds and generate enough extra for her to join him in the Far East. And Ernst? In the end he sailed with Gala, eventually meeting up with Éluard in Saigon, where existing photographs disclose no longer a trio but the original Franco-Russian couple in one picture and the German artist alone in another, dressed in tropical white from head to toe, gleaming so brightly he looks on the verge of being whited out altogether. Éluard and Gala left Ernst behind, and he went on to Cambodia, visiting Angkor Wat and other ruined temples that left a lifelong imprint on his art.

When Éluard returned with Gala to Paris six months after his departure, his reappearance was as chilling to his friends as his original disappearance. He slipped back into his chair at the café as if he'd just gone out for a smoke. The most he allowed was that it was an idiotic trip. "It's him, no doubt about it," Breton wrote despondently to a friend. "On holiday, that's all." The French writer Pierre Naville, on the other hand, realized it was more momentous. Éluard's "disappearing act" he thought more significant than the train trip that brought Tzara to Paris in 1920: "Dada arrived by train and disappeared into Oceania by steamer."

For Naville, too young to have participated in the Dada seasons in Paris, soon to be active in the Surrealist movement, Oceania signified nothing less than the profound depths of the unconscious. Tzara had rejoiced at the way

Dada convulsively released "pure unconsciousness" in its Swiss audience, yet dismissed the Tyrolean ménage à trois as little more than a Slavic emotional tempest boiling over to the inconvenience of fellow vacationers. But given the avidity and desperation with which the Paul-Gala-Max juggernaut went on for years, only some deep unconscious surge could sustain it.

Ernst moved into a flat by himself and left Éluard and Gala on their own, yet he continued collaborating with Éluard. The two men remained collaboratively and personally bound to one another, confirming the double portrait Ernst had sketched soon after they first met.

There would be rocky moments, inevitably. When another of their books, *Au Défaut du Silence*, was published in 1925, Ernst penned this personal dedication:

> Gala, my little Gala
> Please forgive me. I love
> you more than anything and more than ever.
> I can't understand what's happening to me . . .

Ernst eventually divorced Lou and married a Frenchwoman, Marie-Berthe Aurenche. At a dinner at Breton's in 1927 she made an impertinent reference to Gala, then on a trip back to Russia to see her family after many years away. That got Éluard going, and emotions escalated until Ernst punched him, with Éluard flailing back inconsequentially. Éluard wrote to Gala: "He dared what no one else has dared to do, hit me—and with *impunity*," adding definitively "I shall not see Max again. EVER." Within two years, however, they were pals once more, Éluard buying paintings from Ernst.

In the thirties after Gala left him for Dalí and Éluard remarried, the Ernst and Éluard couples were great companions. Not that Éluard could ever shake himself free of Gala. The evening before his wedding in 1934, he wrote her, revealing that he owed all the delights of his life to her: "None of this is possible without the reassurance of seeing you, of your voice. I need your nakedness for the desire to see others." He kept writing to Gala in these terms to the end of his days. She always remained the libidinal spark of his life, poetic and apparently sexual as well.

By all accounts Gala was a sexual and emotional predator. Ernst's later wife, artist Dorothea Tanning, wrote of her "burning cigarette eyes"—a perfect complement to Lou Ernst's evocation of that "slithery, scintillating creature." Ernst

painted her inscrutable gaze in 1924, but instead of a forehead a scroll rises up from her eyes, suggesting some sphinx-like script in place of a mind.

A final glimpse of the Russian temptress comes from Jimmy Ernst, who ended up in New York (along with his father) as a refugee during World War II. Ernst the younger encountered Gala at a gallery and introduced himself as Ernst's son, the world's smallest Dadaist from the Tyrolean vacations. Gala lit up with convulsive interest, and he instantly smelled a rat. "The impression of a predatory feline was a strong one," he wrote in his autobiography. "This was an unchaste Diana of the Hunt after the kill, a face and body forbidding, detached, yet in constant wait for unnamed sensualities." Encountering nineteen-year-old Jimmy Ernst was an opportunity she couldn't resist: having had the father, to have the son as well. It was a proposition he intuitively knew to refuse. "It was probably fear rather than resentment that told me how to respond to the invitation," he reflected, discovering later that various people in the New York art world were betting on Gala's odds.

By the time his former lover tried to bed down with his son, Max Ernst's long and storied artistic career was at high noon, and he continued his unstoppable creative flowering to the end of his long life in 1976. He, like Man Ray, pioneered a psycho-aesthetic idiom in which what's visible in the artwork extends a secret handshake to what's invisible in the mind. For a while, in Paris anyway, it was called Dada before it transformed into Surrealism.

In the short note Breton penned for Ernst's first Paris exhibit under the auspices of Dada, he characterized the movement in these terms: "It is the marvelous faculty of attaining two widely separated realities without departing from the realm of our experience, of bringing them together and drawing a spark from their contact." More than three years later he reprised the formula in the first "Manifesto of Surrealism," after crediting its source in Pierre Reverdy's definition of the poetic image:

> The image is a pure creation of the mind.
> It cannot be born from a comparison, but from a juxtaposition of two more or less distant realities.
> The more the relationship between the two juxtaposed realities is distant and true, the stronger the image will be—the greater its emotional power and poetic reality.

Reverdy published this in extralarge type on the first page of his journal *Nord-Sud* in March 1918. The same issue concludes with a poem by Tzara. A few months later Reverdy suggested that *Dada* merge with *Nord-Sud*, but Tzara politely declined.

When Breton quoted Reverdy on behalf of Surrealism, he was leapfrogging over Dada. He didn't mention that he'd previously defined it with reference to this model of the image as a juxtaposition of distinct realities. He even fudged the date, acknowledging that the term Surrealism derived from Apollinaire, "who had just died." That was more than a year before Tzara came to Paris, an arrival breathlessly anticipated by Breton and his friends who, needless to say, were far from calling themselves Surrealists, keen instead to join the Dada movement.

So why would Breton play fast and loose with chronology? Simply put, Surrealism was his baby as Dada could never be. In 1922, with Paris Dada on the rocks, but two years before the Surrealist manifesto, Breton wrote, "Never let it be said that Dadaism served any purpose other than to keep us in a state of perfect readiness, from which we now head clear-mindedly toward that which beckons us." It didn't have a name yet, despite the misleading chronology he would provide in the manifesto, but there's no doubt it would rival Dada.

For Breton, Surrealism was everything Dada promised but couldn't live up to. He ran the show with the steely tenacity familiar from the Barrès trial and the Congress of Paris, earning the dubious nickname "Pope of Surrealism." But following his pledge of faith in the image, it's clear that he needed Tzara and Dada far more than they needed him.

Surrealism as convened by Breton in 1924 consisted almost entirely of former Dadaists. Although he regarded Surrealism at first as a literary movement, the contributions of Max Ernst and Man Ray were so indispensible that other artists soon rallied to the cause, like the Spaniards Joan Miró and Salvador Dalí. That's another story, as Surrealism outlived Dada by many decades and fitfully smolders on even today. But for Breton's durable mansion of the marvelous, Dada was the one and only foundation, and like a foundation, out of sight underground, it did its work in the dark.

11

NEW LIFE

As Dada spiraled outward from Zurich in 1916, with a shadow version running parallel in New York, lighting up flashpoints from Berlin to Paris 1920–1921, it never had the consistency of a movement like Futurism. Deliberate strategies of obfuscation and contradiction—different from site to site—prevented any clear appraisal of Dada. Ambiguity prevailed.

The Dadaists themselves were inconsistent practitioners of their own ism. Someone like Duchamp never even claimed to be a Dadaist, while Schwitters' rival enterprise, Merz, was widely thought of as Dada. The so-called Club Dada in Berlin was a loose affiliation, launching a series of public events while leaving its members free to pursue their own divergent goals, ranging from the monomania of Baader to the political commitment of the Herzfeld brothers and Grosz. Only in Paris was there an attempt to forge a disciplined collective out of Dada, but such an enterprise flew in the face of Dada anarchy and proved unsustainable.

Dada spread of its own accord, more of an artistic virus than an ideology. The "virgin microbe" pursued its infectious course, rousing scores of individuals with its feverish animation, inspiring fitful bursts of collective activity here and there. Most of the individuals touched by it were forever grateful for the stimulation but had no personal investment in Dada; only a

few (Huelsenbeck and Tzara, mainly) had any proprietary stake in the origin and evolution of the phenomenon.

Hans Richter's path from Zurich to Berlin is symptomatic of the course followed by a number of Dadaists after the war. Through much of the Dada period he was still caught up in the Expressionist turbulence, which is evident in his series of "visionary portraits" of friends like Emmy Hennings, whose book *Gefängnis* (Prison) he illustrated. A crucial encounter in 1918 with eminent pianist and composer Ferruccio Busoni in Zurich turned his aspirations in a different direction, however, and set him down a path that would both define his legacy and add another dimension to Dada.

Busoni favored a new aesthetic in music, one that would surmount the tempered scale of the keyboard and explore the radiant world of microtones and other sounds resisting conventional notation. This is not to say he embraced the noise machines of fellow Italian Luigi Russolo, whose Futurist manifesto *The Art of Noises* was published in 1913; as a world-renowned concert pianist, Busoni would hardly have agreed with Russolo's characterization of concert halls as "hospitals of anemic sounds." But he did share Russolo's conviction that "our hearing has already been educated by modern life." Take a walk around the modern city, Busoni suggested, and you'll find yourself caught up in a medley of sounds—liquids eddying through pipes and drains, the whoosh of gas through vents, the metallic grind of trolley wheels on streetcar tracks. "We enjoy creating mental orchestrations of the crashing down of metal shop blinds, slamming doors, the hubbub and shuffling of crowds," and all the other sounds of the humming metropolis. Busoni understood the need to organize random sounds into intelligible units, but he recognized another musical principle of organization—counterpoint. Busoni recommended to Richter that he apply counterpoint to his painting. Serendipitously, Tzara introduced Richter to Swedish artist Viking Eggeling. The two men hit it off right away, since they were both intent on finding an alphabet of visible form.

For Richter, the quest for a primal language was part of a broader effort to renew society. He was a cofounder of the artists' group Das Neue Leben (The New Life) in Zurich, which included Eggeling as well as fellow Dadaists Arp, Taeuber, and Janco. In time, this group would come to be regarded as the European vanguard of the nascent international postwar artistic and architectural initiative known as Constructivism.

In some ways, Dada was a precondition of Constructivism and even served as a fitful ingredient. But that depended on the circumstance, since Constructivism came with conspicuous political affiliations that parsed differently from nation to nation. It may have been international, but it was nationally induced. In Germany, where Expressionism still prevailed, Constructivism was a reaction against "the formlessness and anarchy of subjectivism," wrote one critic in 1924. It offered a platform for those who wanted "to put an end to all romantic feeling and vagueness of expression." Even Tzara's apparent nihilism sounded serviceable when he urged, "there is great destructive, negative work to be done. To sweep, to clean."

As George Grosz wrote in the Constructivist periodical G □, "Dadaism was no ideological movement but an organic product that came into existence as a reaction against the cloud-cuckoo-land tendencies of so-called sacred art." A hallmark of the Dadaist outlook was knocking art off its pedestal, as in Zurich where Arp and Taeuber sought to close the gap between so-called fine art and the applied arts. As Arp put it in the *Dada Almanac* (writing under the pseudonym Alexander Partens):

> In principle no difference was made between painting and ironing handkerchiefs. Painting was treated as a functional task and the good painter was recognized, for instance, by the fact that he ordered his works from a carpenter, giving his specifications on the phone. It was no longer a question of things which are intended to be seen, but rather how they could become of direct functional use to people.

Placing an order for an artwork over the telephone was something for which Hungarian Constructivist László Moholy-Nagy would later be famous. Ordering art by phone might seem a characteristic gesture of Dada iconoclasm, but in Moholy-Nagy's case, it reflected his embrace of technological expedience.

The germination of Constructivism was more or less simultaneous with Dada. The journal *De Stijl* was launched in Holland in 1917 while Dada was in its second season in Zurich. It was followed by the Parisian journal *L'Esprit Nouveau* in 1919, when Berlin Dada was hitting its stride. Although *L'Esprit Nouveau* is mainly associated with architect Le Corbusier (whose contributions to the journal were collected in several highly influential

books), its first issues were edited by Paul Dermée, erstwhile Dadaist. Both these journals were devoted to cleansing the Augean stables of contemporary disorder in society and the arts. Allied publications sprouted up all over Europe, many of them indiscriminately mixing Dada and Constructivist contributions, like the Hungarian exile journal *Ma* (Today), Schwitters' *Merz*, and *Mécano* issued by *De Stijl* editor Theo van Doesburg under his Dadaist alter ego, I. K. Bonset. At van Doesburg's urging, Hans Richter started up a major Constructivist journal, G □, the G standing for *Gestaltung*, meaning "form/formation," and the square serving as Richter's homage to El Lissitzky, coeditor with writer Ilya Ehrenburg, of another influential Constructivist journal, the trilingual *Veshch/Objet/Gegenstand*.

Dada, born of the Great War, still had something to contribute to the postwar cleansing represented by Constructivism. Rebuilding a damaged world was never going to be easy, especially when powerful political forces were brewing—like the National Socialists in Germany—determined to turn back the clock to some putative golden age. Constructivism meant looking forward, not back, and found a suitable ally in Dada's contempt for the old pieties.

R ichter's turn to Constructivism—signaled by his encounter with Ferruccio Busoni and his involvement with Das Neue Leben—took place as Germany collapsed after the war ended in November. Richter went back to Berlin, involved in founding another artists' collective, the Novembergruppe, then returned to Zurich where he cofounded an Association of Radical Artists (in effect a change of name, since the participants were the same as those in The New Life). He participated in the culminating Dada soirée at the Kaufleuten on April 9, reading his manifesto "Against Without For Dada," then went to Munich to participate in the recently established Communist government. He was even appointed chairman of an arts committee, but the Bavarian Freikorps smashed the revolution and Richter was imprisoned for several weeks before family connections led to his release.

It was only natural that Richter would end up in Berlin, where the force of Dada as a political weapon was being forged. But rather than joining Club Dada, he settled on his family's estate nearby, where Eggeling joined him and the two embarked on their exploration of visual counterpoint as the basis for a universal language.

The Berlin Dadaists, scornful of art as fetish, spoke of their creative productions as if they were industrial products. At the International Dada Fair in 1920, Heartfield and Grosz brandished a placard with the slogan "Art is dead. What's alive is the new machine art of Tatlin." They knew little about Russian artist Vladimir Tatlin, who in fact had attempted little in the way of anything resembling machine art. But Tatlin had demonstrably weaned himself from easel painting and started producing multimedia reliefs, inspired by a visit to Picasso's studio before the war. Tatlin favored raw materials, unrefined bits of metal and wood, anticipating Schwitters' Merz; and it was this penchant for disavowing the putatively noble materials of the fine arts that made such work seem vaguely endowed with a Dada spirit.

By the time the newly convened Soviet Union conscripted artists for official duty around 1920, Tatlin was widely admired for having already left "art" behind. When the Dada Fair was held in Berlin, Tatlin was in Petersburg working on his *Monument to the Third International*, a work that rivals the fame of Duchamp's *Fountain*. Duchamp's urinal disappeared soon after it was unveiled, and Tatlin's was a model for a monument never built. "It's somehow strange to build a monument to something still alive and developing," Victor Shklovsky, Russian literary critic and writer, couldn't help but notice, though he saluted this project "made of iron, glass and revolution." Tatlin's tower emerged from his professional duties, which included replacing old Czarist monuments with Bolshevik ones. As head of the visual arts department of Narkompros (Commissariat for People's Enlightenment), and on the strength of his legacy as an artist going back before the revolution and even the war, Tatlin was at the center of debates about the role art would play in the new Soviet society.

These debates about Soviet art eventually filtered into the West under the general rubric of Constructivism, but in the USSR it wasn't quite that simple. For one thing, Constructivism was under way before the state got involved. In the annals of Constructivism, "The Realistic Manifesto" is identified as the seminal text. Written by sculptor Naum Gabo and his brother Antoine Pevsner, the manifesto was posted all over Moscow by the brothers on August 5, 1920, in coordination with an outdoors exhibit of their "constructions"—a word that better describes their work than the old term *sculpture*. In fact, the manifesto made no mention of Constructivism. It was, instead, a euphoric embrace of "new forms of life, already born and active,"

which any bypassing Muscovite that late summer day would assume meant the USSR. "Space and time are re-born to us today," the manifesto proclaims in a utopian but nonpartisan way. After a series of swipes against the art academies, Gabo and Pevsner conclude with a pledge:

> Today is the deed.
> We will account for it tomorrow.
> The past we are leaving behind as carrion.
> The future we leave to the fortune-tellers.
> We take the present day.

This dedication has much in common with the pledges of the Dadaists, although its authors might not have thought so (nor were they even aware of Dada's existence). In any event, the two artists did not linger long in their homeland. Gabo moved to Berlin in 1922 and Pevsner to Paris in 1923. Both had long and stellar careers as exponents of Constructivism in the West.

An earlier portent of Constructivism in the USSR occurred when a group of art students decorated Moscow streets for the revolutionary May Day festival in 1918. The experience revealed to the students an arena beyond the easel, opening onto the environment at large, and an art commensurate with the revolution, far removed from the artwork nourished by the refined taste of the old Czarist Academy of Art. The students formed Obmokhu (Society of Young Artists), holding annual exhibitions. Their 1921 exhibit proved influential outside Russia with its display of work by Alexander Rodchenko. Photographs reveal an exhibition space resembling a workshop, the floor covered with cantilevered objects, like easels and music stands cavorting in a space age quadrille. It takes close scrutiny to realize that, yes, there were also a few canvases on the walls. But where Tatlin's explorations concerned materials, Rodchenko was interested in space. His constructions resemble prototypes for something yet to be manufactured.

Constructivism had emerged, in a sense, in opposition to the movement represented by the Russian painter Wassily Kandinsky, who was chosen to organize the Institute of Artistic Culture (INKhUK) in Moscow, a state-funded research center for the arts. He also taught at the Higher Art-Technical Studios (*Vkhutemas*), the industry-oriented school often compared to the Bauhaus. Kandinsky had thrived in the Munich art scene before the

war, but was forced to leave Germany when the war broke out, and had been living in Moscow for the past six years. The artists he found to staff the institute had cut their artistic eyeteeth as members of the Russian avant-garde before the war. Yet early in his tenure, a countertrend was under way by artists objecting to his psychological-spiritual orientation. Kandinsky was always in search of synesthetic wonders, a kind of cross-dressing between different senses and different arts. His own awakening to art, after all, was courtesy of Wagner's opera *Logengrin*, an inaugural encounter he elevated into an archetype of artistic interanimation. So he was polling members of INKhUK on questions like which color resembled the mooing of a cow or the soughing of wind in the pines and whether a given color had a natural affinity for a particular geometric form—questions some saw as irrelevant to the needs of an infant nation.

Little more than a year after organizing INKhUK Kandinsky was gone, back to Germany where he joined the faculty of the Bauhaus in June 1922. Those who had opposed his outlook, meanwhile, organized themselves into a working group of Constructivists in early 1921: Rodchenko, his partner Varvara Stepanova, Liubov Popova, Alexander Vesnin, and others. "Constructivist life is the art of the future," declared Rodchenko in one of his teaching slogans.

The Constructivists said a formal farewell to easel art altogether. Instead of art, they executed laboratory experiments on conceptual and material problems. On behalf of the new society, these Constructivists were willing to abandon the tainted individualism of art, devoting their skills to the productive realization of "a new material organism." "It is time that art entered into life in an organized fashion," Rodchenko insisted, intent on exterminating any lingering decadent indulgence in art as aristocratic prerogative ("Down with art as a beautiful patch on the squalid life of the rich"). With aristocratic art expunged, artistic talent was presumed to seamlessly infuse the body politic with new health.

As the Constructivist ethos spread throughout Europe, this utopian prospect—that art might be a collective mode of social progress—took on the characteristics of a secret handshake. Constructivists pledged themselves to the realization of a new, wholesome society—a veritable "new form of life"—with a leap of faith that artistic talent could be redirected somehow to the practical business of organizing The New Life. The slogan "art into

production" was in the ascendancy in the USSR, and the same rational, utilitarian outlook infused artistic movements to the west of Russia.

But a number of vexing issues never receded when it came to the role of art in the new society. Most obvious was the term itself. The avant-garde contingent, having already been moving in that direction, gladly declared war on art for its tendency to promote the mystifications of religion that they despised—art as soul mongering, not social production. But however much they embraced the new slogans like *production* and *organization*, the practitioners remained "artists." It was a tar baby they couldn't shake, however much they conceived themselves as "workers," participants in the great revolution of the proletariat.

When these debates filtered into Europe, where the prospect of new social formations was fast receding, it was a less politically strident model of Constructivism that took hold. Berlin Dada prefigured the split within its own ranks. Heartfield, Herzfelde, and Grosz were the political ideologues of the group, dedicating their Dada "products" to Communism, while others like Hausmann and Höch made use of the same artistic innovations in works that could be sharply critical of the soft belly of the German bourgeoisie but advocated no particular political program. In short order, this division within the Berlin Dada scene would come to have serious implications for Constructivism, as well.

During 1921, as Constructivism was hotly debated in the USSR, Dada was undergoing final convulsions in Paris. Tristan Tzara persisted in the quixotic task of making Dada a household name in France, while some of his companions in Dada were pressing forward into Constructivism.

The next year, as the last phlegmatic expectorations and public bickering dissolved any pretense that Dada had fuel left in its tank, Constructivism blossomed, especially in Germany. In February and March a Constructivist group was formed in the studio of Hans Richter in Berlin, drawing on the bounty of foreigners then flocking into the city. A Hungarian, a Russian, and a Dutchman were at the heart of it, and their stories provide a vivid picture of Dada's durable if waning force.

By this point Dada was known far and wide, sometimes regarded as run aground, sometimes as a lingering potentiality. Dada's exploits may have achieved legendary status, but it seemed increasingly a thing of the past. Looking

back on the early twenties from mid-decade, Prague writer Bedřich Václavek weighed the benefits of Dada even as he clearly thought its moment had passed. Czechs "missed out on a strong dose of Dada after the war," he lamented, and had to proceed without the torch of Dada to clear dense cultural underbrush. As the Constructivist initiative gained momentum throughout Europe, it was often thought to follow in the wake of a salutary cleansing provided by Dada.

Such was the news brought back to Japan by Tomoyoshi Murayama in early 1923 after a sojourn in Berlin, confirming for his avant-garde country-men that Dada and Constructivism were meaningfully related. Dada was not only associated with grand refusals and negations, its spirited defiance was salutary. The advent of Constructivism provided Dadaists with a renewed focus and an outlet for productive energies. Insofar as Dada truculence per-sisted, it could be seen as a healthy readjustment and training in deportment that the new age required. After all, being a Constructivist demanded almost as much militancy as being a Dadaist.

The first of the aspiring Constructivists to make his way in Berlin was Moholy-Nagy. Nagy being a common Hungarian name, he hyphenated the place name to set it off and was commonly referred to in the short form Moholy. By the time he arrived in Berlin he was twenty-five, still shaking off his military service during the war and the revolutionary aftermath in his native land. Béla Kun had established a short-lived Soviet Republic in Hun-gary, to which Moholy-Nagy, like most of his compatriots in art, sought to lend his support. Once it was overthrown, he joined a community of exiles in Vienna. They strongly identified with the international avant-garde, filtered through the journal *Ma*, edited by Lajos Kassák, first in Budapest then in Vienna (just up the street from Freud's house). Kassák thought of Dada as "the tragic scream of our entire social existence," a formulation suggesting that the political disappointment of the Hungarian revolution infused his group with an outlook comparable to the Berlin Dadaists a few years earlier.

Soon after Moholy-Nagy arrived in Berlin, he picked up the latest issue of *Der Sturm* and was incensed by what he saw. Writing a friend, he com-plained about "a man named Kurt Schwitters who makes up pictures from newspaper clippings, railway tickets, hairs and hoops. What's the point?" Moholy-Nagy seems to have had no prior exposure to Merz or Dada, and at that point had no appreciation for the artistic fertility of Schwitters'

scavenging. He did learn at least tangentially of Dada, since a few weeks later he paid a visit to Herwarth Walden, impresario of Der Sturm gallery and journal, accompanied by the Rumanian artist Arthur Segal, who had participated in Zurich Dada exhibits and activities. Earlier, he'd spent time in Budapest with Emil Szittya, a peripheral participant in the Zurich scene. Despite his indignation at the Merz pictures, Moholy-Nagy soon realized that whatever was going to emerge from the morass of available *isms* in art would have to come to terms with Dada. Besides, he was avid to absorb all the available trends in his relentless search for the *new*.

Moholy-Nagy "never wanted to be left out of anything 'new,'" said fellow Hungarian Sándor Ék. "Even within his circle of friends they sarcastically referred to him as 'fast runner' [*Schnelläufer*], who, no matter what the cost, did not wish to be left behind in the race for 'originality.'" And what could be more original than Dada?

Moholy-Nagy's constant scramble to assimilate the new, as seen by Ék and others, reflected his lack of formal art training. He'd had a few lessons with an eminent Hungarian painter in his youth, but that was all. He was a genuine dilettante, a term the Dadaists embraced in their own declarations, proclaiming the virtue of being untutored but ready for anything. The subtitle of Max Ernst's Cologne Dada journal *Die Schammade* was "dilettantes rise up," a slogan adapted for the International Dada Fair in Berlin, "Dilettantes rise up against art!" As a dilettante, Moholy-Nagy would soon have to come to terms with Dada.

Writing for his fellow Hungarians, Moholy-Nagy profiled the modern trends as he saw them.

Modern man . . . burst open his inherited fetters (Impressionism), and then he tried to create a new unity from the broken pieces (Cubism, Futurism, Expressionism). Once he realized that he could not create something new out of the bits and pieces of the old, he scattered the pieces to the winds with an impotent, desperate laugh (Dadaism). There was new work to be done; for a new ordering of a new world the need arose once again to take possession of the simplest elements of expression, color, form, matter, space.

This passage, along with an offhand reference to "Dadaist gibberish," reveals Moholy-Nagy's lingering discomfort with Dada. But the discomfort was assuaged by personal acquaintance with a number of actual Dadaists. He began frequenting Raoul Hausmann's studio in which no distinction was made between Dadaists and other innovators. Also, Hausmann's father was Hungarian, so they had something in common apart from their artistic interests. Moholy-Nagy even signed a "Manifesto of Elemental Art" with Hausmann, Arp, and Russian artist Ivan Puni, published in *De Stijl* in 1921. He was straddling two worlds, however. In the Hungarian periodicals to which he contributed (with impunity, in his native tongue), he sounded a sharply political note and even cosigned an indictment of the reformist platform of De Stijl as typical bourgeois aestheticism—while at the same time he was fraternizing with its editor van Doesburg and publishing in his journal.

"Production–Reproduction," an essay by Moholy-Nagy published in *De Stijl*, July 1922, was a kind of ground plan for his life's work that would take him from the Weimar Bauhaus to the New Bauhaus in Chicago. This essay was indebted to Dada, not least by association. Moholy-Nagy absorbed the biocentric principles of Hausmann, regarding the potential of art to enhance the receptivity of the organism. The sensibility could be stimulated by art in the more traditional sense of reproduction—art as mimesis—or by investigating the *productive* potential of new technologies, generating original content. In his essay, Moholy-Nagy salutes the abstract films of Viking Eggeling and Hans Richter for instigating "new kinetic realities." "We are faced today," he later wrote in *The New Vision*, "with nothing less than the reconquest of the biological bases of human life."

In another essay, "Dynamic Constructive System of Forces" published in *Der Sturm*, Moholy-Nagy and coauthor Alfred Keményi envision a scenario in which "man, hitherto merely receptive in his observation of works of art, experiences a heightening of his own faculties, and becomes himself an active partner with the forces unfolding themselves." This was a model of Constructivism as biodynamic training, "incessantly initiatory" in the words of fellow Hungarian Ernő Kállai, who regarded Moholy-Nagy's work as "reaching out on the borders of Cubism and Dadaism."

Moholy-Nagy's debt to Dada is evident in his art. Before coming to Berlin he was producing mechanomorphic diagrams closely resembling those of Picabia, which were published in Kassák's journal *Ma* and issued as a book in Kassák's Horizont series. Once in Berlin, however, he fell under the spell of Schwitters and produced topsy-turvy asteroids of numbers, letters, and geometric elements coagulating in space, much like those Schwitters was exhibiting at Sturm Gallery, where Moholy-Nagy had his own first success. He was initially put off by Herwarth Walden, writing a Hungarian friend, "Just as a Dadaist journal correctly stated: he is enriching and decorating his financial genius with plundered intellectual rags, and art serves him as a disguise in making money"—a statement that reveals the credence he placed in Dada resources even as he was prone to relegate Dada to the dustbin of history. Of course his view changed once his work was taken up by this impresario of the international avant-garde.

The impact of the Sturm exhibit on Moholy-Nagy's peers was immediate. Russian Constructivist El Lissitzky hailed it as a reprimand to "jellyfish-like German non-objective painting." A reviewer in *Frankfurter Zeitung* was unstinting in his praise:

> It takes discipline to be modern. This is where the artistic and the arty part company. Moholy-Nagy has the iron discipline of a scientist. Many men paint Constructivistic, but no one paints as he does. Don't talk about coldness, mechanization; this is sensuality refined to its most sublimated expression. It is emotion made world-wide and world-binding.

Clearly, this author recognized that the austere geometric tendencies associated with De Stijl and the protocols of Neoplasticism embodied by the painting of Piet Mondrian, to which Moholy-Nagy's work bore a superficial resemblance, harbored more than met the eye. Shortly after the war, in fact, when Moholy-Nagy returned to civilian life after years of military service, he wondered whether there was any value in art. The revelation came when he saw "It is my gift to project my vitality . . . I can give *life* as a painter."

It may have been his personal sense of vitality that finally led Moholy-Nagy to recognize a similar vigor in the Dadaists with whom he came in contact in Berlin. Dada negation was a *force*, not simply a dispirited wail. When he and Kassák assembled a visual primer called *Book of New Artists*

in 1922, they integrated the destructive verve of Dada into their overall understanding of artistic potential. "Here are the most energetic of the destroyers, and here are the most fanatical of the builders," Kassák wrote in the preface. In an issue of *Ma* in October 1922, Kassák published one of his "picture-architecture" poems that read, in variable type sizes, "Demolish so that you can build and build so that you can triumph." Moholy-Nagy, Kassák, and others developing alliances with Constructivism found they had to come to grips with Dada to unleash the cultural revolution to which they aspired.

When Moholy-Nagy visited Kassák and the circle of Hungarian refugees in Vienna for five weeks early in 1921, he found a milieu steeped in Dada. Kassák's wife, Jolán Simon, was a stage veteran and just before Moholy-Nagy's arrival had performed work by Huelsenbeck and Schwitters at a matinee at which fellow Hungarian Sándor Barta premiered his Dada manifesto, "The Green Headed Man." Of Simon's rendition, a reviewer wrote: "This tragic woman drew the most ghostly secrets out of Huelsenbeck's poems with her astonishingly thin voice. She cried the sequences of senseless sounds (trivial and desperate substitutes for everything inexpressible) so that she achieved a fuller and richer expression of misery than any epic could have achieved."

As Berlin correspondent for *Ma*, Moholy-Nagy served as a practical conduit for Hausmann, Schwitters, and others to appear frequently in the journal. It was a great occasion for Hungarians exiled in Berlin when Kassák and Simon visited the city in November 1923 and performed at Sturm Gallery with recitations of Schwitters, Arp, and Huelsenbeck in Hungarian. German Dada had long since run its course by then, but translation and absorption into other cultures and languages persisted in a slow rolling thunder.

Dada promoted unfettered individualism, but resisted Expressionist absorption in spirituality and pathos. When a group of students at the Bauhaus formed an organization called KURI—standing for Constructive, Utilitarian, Rational, International—they attributed to Dada "destruction as a mode of analysis" and pronounced themselves "free from the zigzag ornamentation, the chaotic disorder and increasing ecstasy of expressionism." This ecstatic Expressionist effluvium permeated fashionable Berlin galleries, where the paintings struck Ilya Ehrenburg as nothing

"but the hysterical outbursts of people armed with brushes and tubes of paint in place of revolvers and bombs." Such work, he found, lacked all restraint and sense of proportion: "the pictures shrieked." Ernő Kállai likewise saw "nothing of building, of logic, of construction. Everything is personal experience, again and again only 'personal experience.'" The old art cultivated personality, inwardness, and a transaction between artist and viewer based on aesthetic contemplation. The geometric order of Constructivism was not meant to nourish contemplative tranquility. These works were blueprints and models.

Constructivists had a number of different ideas about the role that art could play in the postwar world. One of the most rigorous of these was developed by a Russian in Berlin whose closest companions were Dada veterans. He was El Lissitzky, Russian emissary of Constructivism in the West, who coined the term *Proun* (short for "projects affirming the new") for his artworks, which he regarded as way stations for the future, models for a utopia. He had a dramatic sense of the generation into which he was born in 1891. "We were brought up in the age of inventions. When five years old, I heard Edison's phonograph—when eight, the first tramcar—when ten, the first cinema—then airship, aeroplane, radio. Our feelings are equipped with instruments which magnify or diminish." The machine ensemble was a model, and "we need the machine," Moholy-Nagy wrote. "We need it, free from romanticism."

Artists like Lissitzky and Moholy-Nagy shared a growing sense that the practice of painting could produce a preparatory document, not aesthetic finality. "The collectivity of a picture manufactured in a series lies in the fact that one may take it home," Kállai optimistically forecast, and "store or exchange it like a gramophone record." He hadn't reckoned with commodity fetishism, but he was anticipating the phenomenon André Malraux dubbed a museum without walls—now ubiquitous on the Internet, since the proprietary relationship to images is presumably swept away because of their universal accessibility.

These optimistic Constructivist models were worked out under challenging circumstances. American writer Matthew Josephson, coming from the inner sanctum of Paris Dada, found a very different milieu in Berlin.

Unlike the French, these artists didn't hang out in cafés. Josephson became friends with Lissitzky, who one day escorted him to Moholy-Nagy's "barn-like studio."

> Though Moholy lived in dire poverty at the time and boasted no furniture in his big studio, he was a most gallant host. The place was decorated with abstract paintings of his own as well as with machine-sculptures by the Russians Lissitzky, Gabo, and Vladimir Tatlin. . . The Constructivists were threadbare; their women were dressed in shapeless clothes; but they were gay and full of hope and big ideas. Moholy had us all sit down on packing boxes covered with some colored cloth, which were arranged in a circle around a huge bowl of soup in the center of the floor space. We guests advanced with our smaller bowls, filled them with the excellent mess, and returned to our packing boxes, making merry the whole evening over some weak table wine.

Josephson's impression of Lissitzky was typical. Universally welcomed, he was an instant member of the family. Short, balding, perennially sucking on his pipe, with a constant twinkle in his eye, Lissitzky comes across in memoirs as the Bilbo Baggins of his kind. Unassuming and unimposing, he was everyone's favorite houseguest.

Lissitzky was also a fireball of creative intensity. Ehrenburg left an endearing portrait of his friend. "In ordinary life he was mild, exceedingly kind, at times naïve; he was often ill; he fell in love in the way that people used to fall in love in the past century—blindly, self-sacrificingly," he recalled. "But in art he was like a fanatical mathematician, finding his inspiration in precision and working himself up over austerity." His German was good (if heavily accented), as he'd attended architecture school in Darmstadt, the Russian schools being closed to him as a Jew. His early career was spent illustrating and designing Yiddish publications, but in 1919 he returned to his native city of Vitebsk, joining the faculty at the Artistic-Technical Institute established by Marc Chagall. There he became allied with Kazimir Malevich, imperious founder of Suprematism and archrival of Tatlin. They formed a group within the institute called UNOVIS, acronym for Affirmers of the New Art.

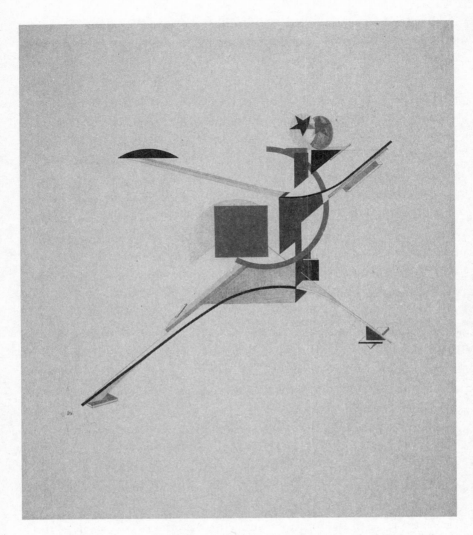

El Lissitzky, The New Man, a Proun from Victory over the Sun *(1923).*

The paintings Lissitzky executed under the category Proun bear out his sense of humankind hurtling into a future inconceivable only a generation earlier. The images in his Proun paintings simultaneously occupy different scales: the lozenge-like free-floating assemblages can be microscopic or galactic. Kállai wrote several articles on the Proun works, suggesting they be compared "to an airman's sensation of space" emancipated from gravity. "The diagonals of a spider's web of razor-sharp, straight lines strive to reach the tip of a Utopian antenna or wireless mast. A technical planetary system keeps its balance, describes the elliptical paths or sends elongated constructions with fixed wings out into the distance, aeroplanes of infinity."

Kállai was shrewd enough to recognize this was "romanticism in disguise," but that didn't deter his admiration. They might be "fictive constructions of fictive mechanisms" and even resemble three-dimensional objects, but they were "immediately recognizable as figments of the imagination." Lissitzky himself would have argued that all inventions first begin as figments in the mind, then are nurtured in the laboratory of mechanical experimentation until an application emerges. So he regarded his Prouns as testing platforms meant to orient mind and body to an emergent sensation of spatiality. "The surface of the Proun ceases to be a picture and turns into a structure round which we must circle, looking at it from all sides, peering down from above, investigating from below," Lissitzky wrote. "Circling round it, we screw ourselves into the space." However much the space evokes the drafting board, Lissitzky regarded these way stations "rising on the ground fertilized by the dead bodies of pictures and their painters." As lines like these indicate, he had a bit of the Dada snarl in his bones, fortified by the Bolshevik Revolution.

Lissitzky recognized that Dada and Constructivism shared a renunciation of "art." Writing to the owner of a Proun, who enquired, innocently enough, about how to hang the painting, Lissitzky noted that the household in question had carpets on the floor and plaster cupids on the ceiling. "When I made my Proun," he wrote, "I did not think of filling one of these surfaces with yet another decorative patch." Lissitzky set to work designing spaces suitable for his Prouns and the work of his Constructivist peers. "We no longer want the room to be like a painted coffin for our living body," he said.

Other marked similarities could be seen between Lissitzky's brand of Constructivism and Dada. He designed a Proun Room for the Great Art Exhibition in Berlin in 1923 on the aggressive principle that "we are destroying

the wall as a resting place for the pictures" of conventional artists. Two display spaces followed in 1927—"Space for Constructivist Art" in Dresden and "Abstract Cabinet" in Hanover—as he purified his mission of alleviating Constructivist work from the malady of the market. "The great international picture-reviews resemble a zoo," he argued, "where the visitors are roared at by a thousand different beasts at the same time." The work he saw himself and his allies producing did not clamor for attention in this subservient capacity, but anticipated a new world order: "Our painting will be applied to the whole of this still-to-be-built world," he wrote, "and will transform the roughness of concrete the smoothness of metal and the reflection of glass into the outer membrane of the new life."

When Lissitzky arrived in Berlin in 1921, more than three hundred thousand Russians were living in the city, many of them fleeing the revolution, but a considerable number were intent on reestablishing cultural and political relations between Germany and the Soviet Union. Everywhere on the streets one could hear Russian spoken. Marc Chagall recalled that he'd never seen so many rabbis or Constructivists at once. In this teeming petri dish, Dada and Constructivism would combine to make an entirely new life-form.

Lissitzky arrived with a mission to spread the gospel of the new Russian art. He and Ehrenburg had modest funds to launch a journal, trilingual for maximum impact: *Veshch/Objet/Gegenstand*. It was propaganda of sorts for Constructivist initiatives coming from the Soviet Union, but the editors were reluctant to embrace the hard line of productivism: "No one should imagine," they wrote, "that by objects we mean expressly functional objects." They still envisioned a place for art, even as they adhered to a Marxist outlook: "We are unable to imagine any creation of new forms in art that is not linked to the transformation of social forms." Lest the journal's title mislead anyone, they spelled out exactly what the *object* meant to them:

Every organized work—whether it be a house, a poem, or a picture, is an "object" directed toward a particular end, which is calculated not to turn people away from life, but to summon them to make their contribution toward life's organization. So we have nothing in common with those poets who propose in verse that verse should no longer be written, or with those painters who use painting as a means of propaganda for the abandonment of painting. Primitive utilitarianism is far from being our

doctrine. *Objet* considers poetry, plastic form, theater, as "objects" that cannot be dispensed with.

Insisting on the international character of modern art, Lissitzky and Ehrenburg acknowledged the "negative tactics of the 'Dadaists'" as a necessary precondition, even as they judged that "the days of destroying, laying siege, and undermining lie behind us." This theme was taken up almost like a collective international chorus, passing from one journal to another during the next few years. But as Constructivism gained momentum, it would never be altogether free of Dada's "negative tactics." The intransigence of old attitudes about art persisted, and the utopian outlook of Constructivism needed the battering ram of Dada to confront it.

Soon after arriving in Berlin, Lissitzky met George Grosz, who put him in touch with his fellow Dadaists. Before long Lissitzky was hanging out with Hausmann, Höch, Richter, and Moholy-Nagy. He became particularly attached to Kurt Schwitters, who towered over the diminutive Russian.

Lizzitzky and Schwitters made quite a pair, and not because they were so mismatched physically. Schwitters introduced the Russian to Sophie Küppers, widow of the former director of the Kestner Society in Hanover. She'd been enthralled by the Prouns on display at the *First Russian Show* in Berlin and arranged for an exhibition of Lissitzky's work, which he suggested be supplemented with work by Moholy-Nagy. She also arranged for him to lecture on the new Russian art, as well as the publication of a Proun portfolio. In return, with the modest means at his disposal, he escorted her to a Chaplin film in Berlin, inaugurating a slow but steady courtship that led to marriage.

Frequenting the circle of Dadaists in Berlin and Hanover hardly made Lissitzky a Dadaist, and by the time he became enmeshed in this scene there were no more Dada events in Berlin anyway. Yet some thought him a Dada insider, like Louis Lozowick, an American artist of the same generation. Because Lozowick encountered Lissitzky often in the company of the Berlin Dadaists, he extended his puzzlement to the Russian. "I could never understand how a man like Lissitzky, quiet, well-behaved, and straightforward, could belong to the group," he wrote. Another figure Lozowick met on his travels was van Doesburg, editor of *De Stijl*, a man "ready to explain

his theories to anyone willing to listen" and, like the Dadaists, perplexing the American artist by looking "more like a businessman than a rebel."

The complexity of van Doesburg's personality begins with his name. He was born Christian Emil Küpper in Utrecht in 1883. His father was out of the picture before he was born, so when he started painting as a teenager he signed his canvases Theo van Doesburg, the "van" indicating the name derived from his stepfather. There were more names to come. In 1917 he told a friend he was thinking of using Küpper as a pseudonym and mentioned he was already publishing articles under the nom de plume Pipifox. In a few years, I. K. Bonset and Aldo Camini would be added to his repertoire of pseudonyms. He started the journal *De Stijl* in 1917, which for several years was mainly invested in modern architecture and design, regularly publishing work by Dutch architects J. J. P. Oud and Gerrit Rietveld, among others.

The most frequent contributor to *De Stijl* was the older painter Piet Mondrian, a theosophist like Kandinsky, bent on calibrating the primary ingredients of the universe with his grid-like canvases and adherence to primary colors. Van Doesburg and other De Stijl artists like Bart van der Leck and the Hungarian Vilmos Huszár produced subtle variants of the Mondrian grid.

It was all very rational and sober, just the opposite of Dada. Esoteric rites of artistic purification notwithstanding, these men were absorbed in everyday life and the practical business of architecture and urban planning. When the war ended and it was possible to travel in France and Germany, however, the world was revealed to them anew—and one of its revelations was Dada.

On an uncommonly warm day early in 1920, van Doesburg and Mondrian were sitting at a sidewalk café in Paris, luxuriating in the sights and sounds of the buzzing thoroughfare. Mondrian, van Doesburg wrote to a friend, "has been inspired by the immense machine that is Paris"—"a highly complex machine," he added, "but when one understands the structure it is marvelous how quickly one becomes one with it."

Mondrian was sketching an article on "The Grand Boulevards" in which he came to regard the city street as a "thought concentrator." "Everything on the boulevard moves," he wrote. "To move: to create and to annihilate." All this motion decomposed the static unities, resulting in something like a

live-action model of a Schwitters collage: "Negro head, widow's veil, Parisienne's shoes, soldiers legs, cart wheel, Parisienne's ankles, piece of pavement, part of a fat man, walking-stick nob, piece of a newspaper, lamp post base, red feather." As these fragments swim into view, "they compose another reality that confounds our habitual conception of reality," producing however not a chaotic throng but "a unity of broken images, automatically perceived." The key term here is *automatically*, because Mondrian recognized something later theorized by the German writer Walter Benjamin—namely, that modern life cannot be absorbed by quiet contemplation but is grasped in a state of distraction, bit by bit. "The particular carries me away," Mondrian wrote, adding "that is the boulevard."

Yielding to the constant stimulus of the modern metropolis was an initiation of sorts into the outlook extolled by the Dadaists. Mondrian had returned to Paris (his home for a few years before the war) in 1919, so getting reacquainted with the city meant being confronted with Dada's French debut. In the summer of 1920 Mondrian signed a letter to van Doesburg, "Your friend, Piet-Dada." No one has ever considered Mondrian a Dadaist, least of all himself ("it was nice to show *enthusiasm*," Mondrian wrote, "but in the long run we just aren't dada"), but *Piet-Dada* acknowledges a moment of influx. You could absorb Dada without becoming one: sitting at a café was enough to make it happen—at least with Theo van Doesburg at hand.

Two years earlier, van Doesburg had a revelation commensurate with Mondrian's, but instead of being prompted by city streets, it was an American export, courtesy of Hollywood. He gushed about the experience to his architect friend Oud:

In maximum movement and light you saw people falling apart, into ever smaller planes which in the same instant reconstituted themselves into bodies. Continual death and rebirth in the same moment. The abolition of time and space! The destruction of gravity! The secret of 4-dimensional movement. Le Mouvement Perpétuel. What miracles American film achieves. How it disrupts closed volumes. What perspectives it opens to the thinking mind. How can it reveal the secret of universal movement: the secret of the rotation of a body on a surface? Why does one seek to solve this with figures on paper? Enough of that. Go watch a film. Not a slow one where the flowing curves of bodies are the outer limit, a surface,

but the rapid, angular, sharp-edged one that deconstructs bodies to planes, to flat fragments, to points, and which in this most marvelous of all games unfolds the secret of the cosmic structure, makes visible that which happens invisibly to everyone's body: destruction and reconstruction in the same instant.

Allowing for the fact that only an artist would be inclined to see in common movie fare a rival version of abstract painting as pioneered by Kandinsky and Mondrian, this is also an exhortation to *be modern*. And that's what Mondrian meant by adding Dada to Piet.

In 1918, then, a year after embarking on the course of *De Stijl*, van Doesburg had his exhilarating vision of "destruction and reconstruction in the same instant." It was a tantalizing blend, reflecting in part the path already taken by Mondrian and Bart van der Leck in their deliberate paring away of the bulky clutter of appearance with its profusion of details. They'd arrived at their pure geometric coordinates by literally *ab-stracting*, that is pulling apart, the subjects of their paintings, dissolving the flesh of experience so only the bones remained. They—and van Doesburg—conceived this process in terms of purification; in fact, there *was* a pure core of dissolution at the heart of it. But what if the destruction were *outed*, so it shared the labor "at the same instant" with "reconstruction"? Posed as a *what if*, the realization crossed van Doesburg's mind in the movie theater that there was a tendency abroad in the world capable of bearing that burden of destruction: Dada.

It wasn't as if van Doesburg was unfamiliar with the process. In 1916, while serving in the military (as a noncombatant, as Holland was not at war), he adopted a radical strategy of reducing naturalistic depiction to its bare minimum. He called it "destroying." It took him several years, though, to acknowledge the pertinence to his strategy of the Dada initiative under way at the same time at Cabaret Voltaire. In 1920 he wrote to *De Stijl* contributor, the painter Georges Vantongerloo, "Only those who perpetually destroy what is behind them to rebuild themselves for the future can arrive at the new and the true." In October 1921 he told Tzara: "The Dadaist spirit pleases me more and more. There is a desire for something new similar to that with which we proclaimed the modernist ideal." Importantly, "I believe in the possibility of really meaningful contact (and synthesis) between Dada and developments in 'serious modern' art." It's ironic that soon after this

letter André Breton would propose his ill-fated Congress of Paris to investigate the modernist ideal. Van Doesburg now realized that Dada and De Stijl (plus Constructivism more broadly) might be allies. "It is only the means that are different."

When he wrote Tzara, van Doesburg was living in Weimar, the city famously associated with Goethe and Schiller, but now a conservative municipality nervously eyeing the new arts academy, Bauhaus, founded by architect Walter Gropius a year earlier. The affinities van Doesburg assumed would exist between the Bauhaus and De Stijl were not what he'd hoped, however.

The Bauhaus in this early period had a cultic aura, much of which derived from Mazdaznan, an American-born neo-Zoroastrian religion that reached Europe in 1907. Johannes Itten integrated Mazdaznan practices into his teaching curriculum, mandatory for all students because he taught the school's preliminary course. Practices included loose robes, shaved heads, meditation, purification rituals, colonic irrigation, and a vegetarian diet. Itten was instrumental in focusing the Bauhaus on this peculiar combination of modern technology and ancient cult.

When van Doesburg arrived in Weimar, he was taken aback, finding the Bauhaus "sick with the pépie of Mazdaznan and wireless expressionism" (a reference to the vogue for depicting modern objects like telephones and petrol pumps in paintings). El Lissitzky also found the place bewildering: "The criminals in Russia were formerly branded on the back with a red diamond ♦ and deported to Siberia. In addition, they had half their hair shaved off their heads. Here in Weimar, the Bauhaus puts its stamp—the red square—on everything, front and back. I believe the people have also shaved their heads." Confronting this odd mix of esotericism and progressive teaching institution, van Doesburg promptly disseminated "the poison of the New Spirit" by setting up a studio right across the street and recruiting Bauhaus students for informal (and eventually formal) seminars and workshops.

With his expertise in stained glass, architecture, painting, poetry, music, typography, and writing, van Doesburg could reasonably present himself as a one-man alternative to the Bauhaus. He'd spent several years doing glass designs by absorbing the structural imprint of Bach's preludes and fugues, along with the musical compositions of his contemporaries: Arnold Schoenberg, Erik Satie, Josef Hauer, Arthur Honegger, Francis Poulenc, Darius Milhaud, and George Antheil. The architectonics of music translated readily

into abstraction, in which lines could be pulses, circles condense into points on a graph and then *bounce*, as both Kandinsky and Walt Disney would elaborate. The musical instinct was enhanced when van Doesburg met pianist Petronella van Moorsel, who became his third and final wife and essential participant in the Dada tour he undertook with Kurt Schwitters.

Van Doesburg's alliance with Schwitters developed in the wake of two momentous Constructivist conferences of 1922. Early in the year he visited Berlin, which was a cross-cultural stew as Russians both Red and White continued to pour into the city. There he called on Hans Richter and Viking Eggeling, who were immersed in their search for a universal language of visual signs, leading at first to sequential scrolls, from which they then made the leap into film. Abstract film. What Richter was doing on film stock bore a striking resemblance to the geometric purifications of De Stijl. He was setting lozenges in motion: squares and lines mostly, elongated and shortened, expanded and compressed in visual counterpoint. The films were no more than two minutes long, and Richter called them rhythm studies.

The challenge of working with a medium like film was financial. Van Doesburg suggested to Richter that he might start up a magazine to generate revenue. The result was G □, but the journal didn't appear until 1923. Back in Richter's Berlin studio in early 1921, a group of individuals committed to Constructivism was gathering. These included the Russians Gabo, Pevsner, Natan Altmann, and Lissitzky; the Hungarians Moholy-Nagy, Alfréd Kemény, Ernő Kállai, and László Péri; van Doesburg and Cornelis van Eesteren from Holland; the Germans Willi Baumeister, Werner Graeff, and Mies van der Rohe; and from Zurich Dada days, Viking Eggeling and Hans Arp, the latter making one of his periodic visits to German cities like Berlin, Hanover, and Cologne where a spark of Dada still glimmered.

Van Doesburg recognized the potential of this lingering spark as he assessed the German milieu. The Bauhaus was constrained by its anachronistic crafts sensibility and the smoldering fever of Expressionism, while elsewhere the more progressive tendencies affiliated with Expressionism, like the Novembergruppe, were retracting their political claws and hedging their bets, anticipating a revived art market. Van Doesburg might be described as a nonpolitical revolutionary, bent on social change by driving an austere aesthetic wedge right through the middle; but the architectural and artistic models to

which he appealed were practically spiritual in their idealism. Yet he was no theosophist like Mondrian and kept hammering away at the need for social reform. He laid out the principles in a lecture he gave throughout Germany, advocating for

definiteness instead of indefiniteness
openness instead of closedness
clarity instead of vagueness
religious energy instead of belief and religious authority
truth instead of beauty
simplicity instead of complexity
relation instead of form
synthesis instead of analysis
logical construction instead of lyrical representation
mechanical form instead of handiwork
creative expression instead of mimeticism and decorative ornament
collectivity instead of individualism

Van Doesburg cited, as evidence of this "will towards a new style," a broad range of activities in the arts, architecture, literature, jazz, and cinema. Van Doesburg differed from most of his allies from other countries about the purpose of this "new style." Instead of the explicitly political Third International, he spoke of an "International of the Mind" motivating "the exponents of the new spirit," whose "wish is solely to give. Gratuitously." But after the political crisis of the 1918 November Revolution, Dadaists and Expressionists alike promoted art as a weapon in the class struggle. Various artists' collectives arose, like the Worker's Council of the Spirit and the Novembergruppe. Identifying the future of art with a spiritual revolution awakened by the avant-garde, the Novembergruppe momentarily galvanized progressive artists in Germany.

By 1921, however, the Dadaists denounced the Novembegruppe's pledge of solidarity with the working class as opportunistic jockeying for preeminence in the art market. The organization, they said, had subsided to "petty trading in aesthetic formulas" led by "a dictatorship of the aesthetes and businessmen." Rather than "attempting to reject the role of drone and prostitute

forced on the artists in capitalist society, the leaders did everything to further their own interests with the help of a rubber stamp membership." This withering assessment was about to come to a head in an arts congress in Düsseldorf.

While Hans Richter was organizing his Constructivist group in February 1922, a more extensive assembly formed as Union of International Progressive Artists. Under the leadership of Gert Wollheim, director of the artist's collective Junge Rheinland, they set about organizing a large exhibition for late May in Düsseldorf, with an accompanying congress on May 29–31, 1922, called the First International Congress of Progressive Artists. Kandinsky provided a brief forward to the exhibition catalogue, reiterating the grand utopian themes from his Blue Rider days. "Everything trembles and shows its Inner Face," he wrote in terms agreeable to Expressionism. The new world will be revealed courtesy of "Inner Necessity." "Thus the Epoch of the Great Spiritual has begun," he triumphantly concluded. It's indicative of the oncoming rift between the Constructivists and the "progressive" artists, that only the latter group would have welcomed the terms with which Kandinsky appraised the future of art. After all, he'd recently been forced out of INKhUK in Moscow by the Working Group of Constructivists.

The congress in Düsseldorf opened without incident, the first day spent on organizational issues such as identifying and electing representatives for each of the constituencies. Van Doesburg, Richter, and Lissitzky did object, however, to the presumption that all in attendance would sign a collective pledge declaring art to be "international." At their insistence, the document was amended so it was basically a record of who was in attendance. The conference was genuinely international, with attendees coming from as far as Japan, though the very setting in the capital city of the state of North Rhine-Westphalia gave the regional German artists a misguided confidence in their own priorities.

Richter and his allies were in for a shock the next day, when a manifesto was read, identifying the union as a practical and economically oriented interest group of artists. Such a blatant resurrection of the art market spurned by the Berlin Dadaists was equally repugnant to the Constructivists in Richter's group, who made a stink by denouncing the proceedings and walking out with loud cries of protest.

On the third and final day the delegates of protesting factions read statements, including van Doesburg for *De Stijl*, Lissitzky for *Objet*, and Richter for a loose amalgamation of artists from Rumania, Switzerland, Scandinavia, and Germany. After a lunch break, Raoul Hausmann applied the perfect Dada touch by announcing he was no more "international" than he was a cannibal. He then stormily exited the building, followed by the protesting groups. Van Doesburg described the scene to a fellow artist back in Holland. "In the end, of course, we had to leave the hall with vigorous protest, as it turned out to be a big mess. It was all based on commercial interests!" But at least they knew where they stood: "We now know whom we can expect to be dealing with in future congresses. The Futurists, Dadaists and a few others left the building with us."

After the departure of the Dadaists and their allies, the congress subsided into inconsequentiality. An art critic witheringly observed, "After the departures the Congress made positive advances, since there were no more points of dispute and everything was as boring as if the place were filled with government officials. German organization held its own."

Although the congress didn't accomplish much on its own terms, it did inspire a healthy—and productive—backlash from the Constructivists that would ally them with the former Dadaists they now counted in their ranks. In just a matter of weeks, a special congress issue of *De Stijl* was published, printing the platforms of the protesting groups, which were collectively organized under the name International Faction of Constructivists (IFdK in its German acronym). The organizers of the congress had stubbornly refused to consider what made art "progressive," despite its conspicuous presence in the group's title. The faction, on the other hand, was more than willing to identify the progressive artist as a combatant against "lyrical arbitrariness" and "the tyranny of the subjective in art." They denounced the Düsseldorf exhibition as little more than "a warehouse stuffed with unrelated objects, all for sale." Most poignant, though, was the faction's admission of its own precarious status: "Today we stand between a society that does not need us and one that does not yet exist."

On the floor of the congress, van Doesburg had read the "Creative Demands of 'De Stijl,'" and when published in *De Stijl* he indicated that two of the points were roundly applauded: one calling for the elimination of art exhibitions in order to make way for demonstrations of teamwork, and another point demanding the annulment of any distinction between life and art. The

documents assembled for the congress issue of *De Stijl* give a vivid sense of the gulf separating the IFdK artists from the so-called progressives. The De Stijl group demanded the suppression of "subjective arbitrariness in the means of expression," a stinging rebuke to the familiar mystification of artistic genius. In his statement, Richter (signing on behalf of Eggeling and Janco) reiterated the point that any social transformation would be achieved "only by a society that renounces the perpetuation of the private experiences of the soul." Lissitzky, too, disavowed "those who minister to art like priests in a cloister" (the Bauhaus' Itten was a recognizable target). His statement reiterated points from the editorial of *Objet*, while adding the sting that the new art was actually endangered "by those who call themselves progressive artists."

With hostility so brazenly declared against the Union of International Progressive Artists, the aura of a benign Constructivism devoted to rational planning suddenly took on a different, more martial character. And given the background of some of the attendees—Hausmann, Höch, Richter, Janco— the specter of Dada made itself evident as a worthy ally in the struggle.

Van Doesburg realized he was at the pivot of Constructism and Dada and decided to issue a folded broadside journal with the name *Mécano*, combining Dada and Constructivism in equal measure. *Mécano* is literally dizzying to peruse, as if a robotic impetus had overtaken the art world and started issuing screen grabs, instantaneous profiles of avant-garde *in the moment*. Three editions of *Mécano* were issued in 1922, in yellow, blue, and red. Unfolded, both sides of the sheet contained a patchwork of eight segments each facing a different direction, with its own typography and images.

Encountering *Mécano* was like sitting at the café with "Piet-Dada." In fact, a short statement by Mondrian ran lengthways facing a reproduction of Hausmann's mechanical head, *The Spirit of Our Time*. Elsewhere on the foldout of this blue issue was a photomontage by Hausmann, adjacent to a buzz-saw blade, van Doesburg's icon for all the issues of *Mécano*. It was echoed by the cogwheels in Man Ray's photogram *Dancer* reproduced in the yellow issue. On the verso of the blue issue—next to Hausmann's manifesto on sound poetry—was Moholy-Nagy's iconic *Nickel Sculpture*, its metallic spiral suggesting the onset of radio transmission, which was only at that moment entering the public sphere. Among its Dadaist contributors were Georges Ribemont-Dessaignes, Paul Éluard, Man Ray, Jean Crotti, Raoul Hausmann, Tristan Tzara, Hans Arp, Max Ernst, and Kurt Schwitters,

most in several issues. Ezra Pound was also on hand, caught up as he was in the swirl of Dada after his move to Paris. Mondrian and others associated with De Stijl were included, along with I. K. Bonset, who nobody knew at the time was another of van Doesburg's alter egos.

Bonset made his debut in *De Stijl* in May 1920, and would become a regular contributor. Van Doesburg confided to Oud that Bonset was a "splintering" of himself needed for his assaults on the old order. De Stijl's penchant for order as such would seem inimical to aggression, so Bonset had a seismic task. Apart from Oud, others were not informed of Bonset's identity. But van Doesburg happily dispensed a modicum of information and arranged for Bonset's participation in the international scene, albeit by correspondence. Having heard Bonset described as "against everything and everyone," Tzara jumped at the bait and asked van Doesburg to invite this Dutch firebrand to contribute to a Dada project. "I'm pretty sure he'll accept," van Doesburg replied, continuing tongue-in-cheek: "Bonset shares our ideas, but he's a funny chap, never showing himself." On one occasion, Tzara and Arp wrote a letter to Bonset, and van Doesburg addressed his alter ego on the back of the envelope: "You see how your reputation for invisibility is attracting ever more followers." There was nothing invisible about Bonset's publications, though, which bore all the hallmarks of Dada invective and civil disobedience.

The blue *Mécano* featured Bonset's "Manifesto 0,96013"—its numerical title a send-up of the consecutively numbered De Stijl manifestos to which van Doesburg signed his own name. It concluded with large underlined type, dramatizing its theme as vividly as Picabia's depiction of an ink splatter as the Virgin Saint:

> The World is a little
> Sperm Machine
> Life—a venereal disease
> All my prayers are de-
> dicated to Saint Veneria

Van Doesburg clearly exulted in brandishing his venom and wit inside the puppet persona of Bonset. "Dada is the cork in the bottle of your stupidity," he heckled in "Antiartandpurereasonmanifesto" in the yellow *Mécano*. "In future I will allow myself to use you as Dada's walking-stick."

Bonset had a regular outlet in *De Stijl*, courtesy of editor van Doesburg, but he also responded to Tzara's request for material, providing several texts (like "Metallic Manifesto of Dutch Shampooing") for Tzara's intended Dada anthology. It never came to fruition, so they were unpublished in van Doesburg's lifetime, but they reveal that he knew of Duchamp's *Fountain*: "Art is a urinal," Bonset wrote in "Manifesto I K B." In another text he made passing reference to "we neovitalist Dadaists, destructive Constructivists." Constructivism needed to hone its blade: that was the incentive behind the invention of Bonset, whose appearances in *De Stijl* marked him less as the raving, impertinent Dadaist reported in the press and more as a Nietzschean type, advancing beyond good and evil. So his repudiation of words like *humanity, love, art*, and *religion*, signaling standard even hackneyed concepts, as *"sentimental deformations of feeling"* was actually concordant with the broader mission of De Stijl as a forum for rational planning.

"The abnormal is the prerequisite of new values" was another of Bonset's aphorisms. In his role as spokesman for Dada negation, Bonset was reasonable if blunt. "The principle of life is completely amoral," he explained. "Before every birth there is annihilation." And, in a yin-yang formulation as dear to van Doesburg himself as to Bonset: "No is the strongest stimulation to yes." In a world benumbed by bourgeois complacency, its art consigned to "the immoral art brothels," the need for a transcendent affirmation was like an ache in the soul, but simply wishing wouldn't make it so. The hammer was *no*.

Short of naming his dog "Dada," van Doesburg resisted the urge to come out of the closet and make a personal appearance as a Dadaist. He was too committed to the austere cleansing program of De Stijl for that. His taste for confrontation and the allure of the stage found in Dada an appealing venue. His alter ego Bonset was one vehicle, and *Mécano* was a most agreeable Dada forum. But could he make a personal appearance on behalf of Dada while maintaining the appearance of neutrality and preserving the integrity of De Stijl? That was the question he would have to come to grips with after the excitement of the Düsseldorf congress.

12

YES NO

After Dada dissipated in Paris, and with many of the German Dadaists absorbed in Constructivism, there would seem little left but recollections of the principals, and fitful outbreaks in far-flung locales when the Dada spirit belatedly penetrated. The Prague appearance of Kurt Schwitters and Raoul Hausmann as "Anti-Dada-Merz" suggested that an afterlife of the movement would involve new alliances and careful repositioning. This was confirmed by Schwitters' partnership with Hausmann, and it took another turn at the initiative of Theo van Doesburg. The Dutchman, itching to stretch his limbs on the Dada circuit, was keen to figure out how to set I. K. Bonset loose on the world without compromising himself as leader of De Stijl. The first steps were tentative, but consequential.

In the aftermath of the convulsive Düsseldorf congress of so-called progressive artists, van Doesburg organized a follow-up affair in Weimar for late September 1922. To the dismay of some of those in attendance, Tristan Tzara and Hans Arp were the representatives of Dada. What's more, Tzara was invited to give a lecture on Dada. He complied with all the disarming wit to be expected of this seasoned veteran of the public occasion.

Tzara began his lecture by admitting that being a Dadaist was tantamount to being a leper. He then offered the disarming disclosure: "First to tender his resignation from the Dada movement *was myself*." He went on to

address the oddity of being invited to appear at this assembly, but professed no intention of explaining Dada. "You explain to me why you exist," he said, turning the issue back on his audience. He elaborated on his basic point that Dada was inseparable from life itself, promoting diversity and intensity as values intrinsic to life. "What we want now is spontaneity," he urged. But he also seemed to be making an appeal to the Constructivist orientation when he suggested, "Dada reduces everything to an initial simplicity." In other contexts he'd used the word *idiocy* instead of simplicity. It was a theme he prolonged with reference to Buddhist indifference, proof he said that "Dada is not at all modern."

Tzara saved the best for last. His concluding words make for one of the more inspired moments in the annals of Dada.

> Dada is a state of mind. That is why it transforms itself according to races and events. Dada applies itself to everything, and yet it is nothing, it is the point where the yes and the no and all the opposites meet, not solemnly in the castles of human philosophies, but very simply at street corners, like dogs and grasshoppers.
> Like everything in life, Dada is useless.
> Dada is without pretensions, as life should be.
> Perhaps you will understand me better when I tell you that Dada is a virgin microbe that penetrates with the insistence of air into all the spaces that reason has not been able to fill with words or conventions.

The Constructivists, staunch advocates for the application of art to the better welfare of society, were confronted here with a vivid reminder of the exigencies of life on earth in the unpretentious encounter of dog and grasshopper, comporting in a realm unsullied by the jargon and pitfalls of human reason. For life's underlings, it seems, the sole aid was *un microbe vierge* (a virgin microbe).

Tzara delivered his lecture in French, a language foreign to some in attendance, many of them already having to make do with German as they came from Russia, Hungary, or Holland. Lázló Moholy-Nagy was one of those in the audience who lacked French, and neither he nor El Lissitzky could follow Tzara's talk. More unsettling was that this Dadaist was there in the first place. Had they known of it, they might have approved Tzara's

view expressed in *Dada Almanac*: "After the carnage we are left with the hope of a purified humanity." Moholy-Nagy later recounted how disturbed he and his comrades were to be confronted with Dadaists at a Constructivist affair, complaining about it to van Doesburg, the organizer. But "Doesburg, a powerful personality," in the words of Moholy-Nagy, "quieted the storm and the guests were accepted to the dismay of the younger, purist members who slowly withdrew and let the congress turn into a dadaist performance."

A famous photo from the Weimar congress shows the Dadaists front and center, acting up in their sportive way. It's a priceless window into the tentative alliance between Dada and Constructivism that few saw coming. In the photo the group is arranged in a mock Dada coronation on the steps of Hotel Fürstenhof where the congress was held. Van Doesburg in the center wears a natty tailored suit with white tie and black shirt. He took pride in being up to the minute: "Modern clothing is above all *sport-clothing*," he told a friend, just the ticket for "the electric atmosphere" of the big city. He's made a crown out of the latest issue of *De Stijl* (reconfigured in a horizontal format when he moved to Weimar, making it feasible to circle his forehead here). His wife, Nelly, extends her hand regally to Tzara, with customary monocle, bending as if to plant a kiss. Another participant blows or whispers something through a rolled up paper extending to Tzara's ear. At the bottom of the frame Hans Richter is on his back, pinned down by Werner Graeff's cane on his torso and hand gripping his ankle (Graeff was editorial assistant on Richter's G □). Most of the others look amused—Arp with a big grin, happy to have regaled the congress with readings from his *Cloud Pump* poems; Lissitzky farther back with a pipe in his mouth gazing on the antics with bemused indulgence; and Hungarian writer Alfred Kemény grinning as well. Moholy-Nagy at the rear looks uncomfortable.

Many of the same people had posed for photographs at the Düsseldorf congress in similar sorts of staging. In one, the group is held in place by a ladder arranged horizontally like a harness over their heads—Graeff, Richter, Marcel Janco, Lissitzky, van Doesburg, and Hausmann among them. Schwitters appears in other photos from the Weimar gathering, towering a full head higher than the diminutive Tzara and Lissitzky.

Schwitters had a way of making an entrance. Richter, who hadn't met him before, was amazed to see the man stride boldly into a room where numerous artists were mingling; without a word he brandished a card with the

Constructivist Congress in Weimar, 1922.
Hans Richter on the ground;
Tristan Tzara is holding Nelly van Doesburg's hand;
behind them is Theo van Doesburg with an issue of De Stijl for a hat;
directly above the hat is El Lissitzky, with pipe; Hans Arp is on the right;
László Moholy-Nagy is on the right of the trio in the rear.

Bauhaus-Archiv, Berlin.

letter *W* and began to pronounce, intone, hum, and render it in full phonetic elasticity for five minutes. "I have never seen such a combination of complete lack of inhibition and business sense," Richter marveled, "of pure, unbridled imagination and advertising talent." Moholy-Nagy was equally astounded. "He started to recite it slowly with rising voice," he recalled. "The consonant varied from a whisper to the sound of a wailing siren till at the end he barked with a shockingly loud tone. This was his answer," Moholy-Nagy realized, to the school of "'babbling-brook' poetry." With his whimsically shrewd way of seizing the day, Schwitters invited several of those in attendance back to Hanover for an impulsively arranged soirée at Garvens Gallery a few days later. First, though, was another Dada presentation in nearby Jena, with van Doesburg nervously giving a talk, Nelly playing piano, and Schwitters getting a rise out of the audience by releasing several dozen mice.

When Dada went through its terminal convulsions in Paris in 1922, it was presumed to be dead and done for. After all, the original group in Zurich had long since disbanded, Club Dada in Berlin expired after the 1920 Dada Fair, and whatever looked like Dada in New York had not been formally affiliated with the movement. In each case, migrations transmitted the microbe elsewhere. Ernst and Tzara ended up in Paris, along with Duchamp, Picabia, and Man Ray. So if the "Dada movement" collapsed in that regal city, it wasn't for lack of resources.

It's fitting, then, that Dada persisted in its purest surrogate in Hanover, in Schwitters' unstoppable Merz activities. Schwitters developed a rewarding friendship with Hausmann and Hannah Höch, and his sense of mission was reinforced by contacts ranging from Ernst in Cologne to Arp and Sophie Taeuber in Zurich. Schwitters may not have been *in* Dada, but he was unmistakably *of* it—and as its spark died off elsewhere, Dada seemed most secure in his fraternal hands. When Moholy-Nagy and Lissitzky came around, relishing his friendship and sheer creative abandon, Merz was like a Mardi Gras mask worn over the countenance of Dada.

Van Doesburg had a hankering to fling Dada like a foul rag in the faces of his fellow Dutchmen, and in the wake of the Weimar congress, it seemed for the first time like a real, practical possibility. The Dada-Merz presentations in Weimar, Jena, and Hanover proved so stimulating to van Doesburg that he

set about trying to organize a Dada tour in Holland. Unfortunately Tzara, Ribemont-Dessaignes, Arp, and Hausmann all declined the invitation, but Schwitters was game. And the Theo-Nelly-Kurt trio had already worked up a repertoire of sorts in Jena after the Weimar congress. Van Doesburg's De Stijl ally, Vilmar Huszár, reminded him of the challenges they would face: "You must prepare the Dadaists for a cool and sober public, so they can really throw abuse to draw them out of their composure."

Even in Dada hot spots like Paris and Berlin, Dada had been misapprehended by the public, not only because of its own tactics of misinformation, but because coverage in the press was both extensive and ill-informed. Beginning with the deft interventions planted by Tzara and Arp in Swiss newspapers, Dada had capitalized on the bankruptcy of journalism, regarded as an immoral war-mongering enterprise during the late conflict. This meant there were swathes of ignorance throughout Europe, occasionally penetrated by misinformation. By and large, Dada remained a rumored event beyond the horizon.

Holland had been insulated from news of Dada. Even aspiring members of the avant-garde in the Low Countries had only a dim idea of what it was all about. Belgian poet Clément Pansaers wrote Tzara in December 1919 to introduce himself as an adherent of Dada, which he took to be part of *le mouvement Apollinaire*. He was under the impression that Jean Cocteau and Pierre Albert-Birot were Dadaists—these being two of the names one could never mention in Breton's company without a sizzling rebuke. Even as late as November 1921, Pansaers published an article describing Dada as "compatible with that which is understood as Symbolism and Cubism," a characterization as misguided as saying that Dada was a civic league for the protection of public morals.

Pansaers had, however, sniffed out the self-electing aspect of Dada. "I became a Dadaist around 1916, as the word Dada was not yet invented; in the same way that John Rodker became a Dadaist in England during the war and Ezra Pound in America. And as many others became Dadaist, without knowing and without the slightest external influence." Pansaers shrewdly noted that the Dada impulse might be traced back to Alfred Jarry, founder of pataphysics, the "science of imaginary solutions." By this point he'd clearly

read various Dada tracts, picking up on its general character as a "theory of *Destruction*" fanning out precariously from "destruction through *construction.*" At this point Pansaers was understood by fellow Belgian writers as a Dadaist—though Dada itself could be misapprehended as "the supreme pinnacle of the modern poetic sentiment"—and he was publishing poems like "Foxtrot," with rocking seasick typography, visually suggesting jazz dance trends had something to do with Dada.

In truth, Pansaers was first exposed to Dada in Berlin in 1918 by German writer Carl Einstein, whose children he had tutored the previous year. Einstein was one of the earliest advocates of the intelligibility and artistic virtue of African art and may have drawn Pansaers' attention to the enthusiasm of Grosz and others for jazz and the "white Negro" aspirations of Club Dada. Pansaers wasted no time publishing a book called *Le Pan Pan au Cul du Nu Nègre* (*The Can-Can on the Ass of the Naked Negro*) in 1919. In a trip to Paris the following August, he finally had a chance to meet the Dadaists themselves, who at that point were still in the first flush of their public manifestations. With assurances of their participation, he booked a hall in Brussels for Dada's Belgian debut, yet was somehow unperturbed when all the participants backed out at the last moment and the event had to be cancelled.

Pansaers' disillusion with the shenanigans of the Parisians reached a breaking point, though, in April 1921 when he was in Paris for the infamous "affair of the wallet." Having found a waiter's wallet in Café Certa (the watering hole immortalized in Aragon's book *Paris Peasant*), the Dadaists debated what to do about it. Some argued that Dada, being beyond good and evil in Nietzsche's sense, obliged them to act against conventional morals and keep the proceeds; others suggested using the purloined funds to finance Dada publications. (Meanwhile, Éluard quietly returned the wallet to the waiter.) After Pansaers reported the incident to Picabia, both men withdrew from the movement. Picabia published Pansaers' oblique account in *La Pilhaou-Thibaou* under the title "A Defused Bomb," with a section named "Accusation and Condemnation" followed by another, "Ragtime Funeral." This infamous episode was typical of the uncertain grasp these brash French youth had on morality, as they struggled to escape their bourgeois upbringing and clung to Dada as the only available skeleton key.

Pansaers was not the sole agent of Dada in the Low Countries. A group associated with the journal *Revue du Feu* held a soirée in February 1920 at which some of Schwitters' *Anna Blume* poems comprised part of an evening of "ultra-stylistic-dadaist-cubist poetry" (though a reporter didn't get the name right, spelling it Schnitters). In Antwerp in 1921 a book-length poem called *Bezette Stad* (Besieged City) appeared, characterized by a reviewer as "a mixture of French Dadaism and Futurism." Its author, Paul van Ostaijen, was fitfully resigned that the press would "interpret this as Dadaist again," following a rudimentary reflex to "open the cupboard and find a label." There was, however, a Dada pedigree, insofar as the book was written in Berlin in the wake of the International Dada Fair in the summer of 1920.

Van Ostaijen was familiar with Berlin Dada and actively disliked Grosz and Mehring (who returned the favor). *Bezette Stad* is one of the supreme typographic performances—"'physioplastic' typography," Ostaijen called it—of modern book art. Its grim depiction of Antwerp under siege during the war is shot through with a panorama of popular entertainments, which were often associated with Dada, jazz in particular, and van Ostaijen felt he was witnessing a "Dada-jazz revolution" sweep over bankrupt Europe after the war. He wrote a film script cum story called "Bankruptcy Jazz," clearly alluding to the role played by *Die Pleite* (Bankruptcy), the journal that featured so many of George Grosz's withering depictions of moral squalor.

"Bankruptcy Jazz" is set in the milieu of a barely disguised Club Dada. "Cabaret Dada Is the Future," a headline declares. "Dadaism as real a value as an oil well. Consortium for the exploitation of Dadaism is founded," van Ostaijen continues, picking up on the Dada Advertising Agency presented in Hausmann's periodical *Der Dada*. Invitations to a grand opening are set in a typographical layout one could have seen in *Der Dada* or any number of other Dada periodicals:

At the opening, pistol shots accompany the jazz band. What ensues is a convulsion of the primal itch incited by jazz, luring students out of a lecture on the music of Wagner as they pour into the streets in a "European exertion to become Negroes." Meanwhile, the economy is plunged into the spiraling inflation that brought the Weimar Republic to its knees. All is solved when Charlie Chaplin becomes Minister of Commerce, smoking the last cigar of debt-laden public currency, and the populace is revived in a paroxysm: "Dada Saves Europe," a headline brays. "Bankruptcy Jazz" was not published in van Ostaijen's lifetime—he died in 1928 at thirty-two, his health ravaged in part by the cocaine habit he'd picked up in Berlin—but the association of Dada with jazz was hardly unique to him.

Nor that of Chaplin: a reader of Huelsenbeck's *Dada Almanac* would have been confronted by "A Voice from Holland." In this open letter the author, Paul Citröen, wrote that Holland was the most unreceptive country in the world to Dada and that the few Dadaists there had to console themselves with cheese and Chaplin films.

Not all the Dutch Dadaists were so deprived. Citröen's fellow Chaplinist Erwin Blumenfeld was actually a Berliner, having fled to Holland after deserting the German army in 1918, where he married Citröen's cousin in 1921. Both men knew many of the future Dadaists in prewar Berlin. Blumenfeld relished his first meeting with Grosz in a urinal on Potsdamerplatz in 1915. While relieving himself, Blumenfeld saw a "young dandy" enter the pissoir and promptly "fixed his monocle in his eye and in one fell swoop pissed my profile on the wall so masterfully that I could not but cry out in admiration." This anatomical extension of Grosz's draftsmanship won Blumenfeld over. "We became friends," and their friendship continued in the United States, where Blumenfeld became one of the leading fashion photographers of his day, providing numerous covers for *Vogue* and other sleek publications. In his youth, though, he was an early master of photomontage, one of which he sent to Tzara with his own face appended to a gauzily attired female nude, proclaiming himself "Bloomfield President Dada-Chaplinist."

Despite Blumenfeld's courtship of the Dada impressario in Paris, it would not be Tzara or any of the other original group from Zurich who would serve as ambassadors of the movement in Holland. Rather, it would be the Hanoverian who from the beginning had been intent on fashioning his own brand of Dada: Kurt Schwitters.

In late 1922, pondering van Doesburg's invitation for a Holland tour, Schwitters wondered what he could actually do, given the linguistic divide. He assumed people would demand his "Anna Blume" poem, assuring van Doesburg he could rattle it off in German, English, and French. Not a stunt, exactly, but then his deadpan demeanor, compounded by one language after another, might plausibly rock the house.

Maybe to hedge his bets, Schwitters' multilingual recitations of his poem were sometimes accompanied by a mechanical puppet manipulated by Huszár. At a performance in Schwitters' hometown, the role of puppet was enacted by Hausmann, who—dancer that he was—delighted the audience by assuming different dramatic poses between lights up, while Schwitters intoned his numerical sequences.

There were three performances in The Hague, and all but one of the others nearby. At the first presentation on January 10, 1923, van Doesburg gave a lecture on Dada, in black shirt and white tie. At a prearranged moment he paused for a drink of water. This was the cue for Schwitters, sitting unnoticed in the audience, to commence barking like a dog. The effect was electric. One or two people even fainted. Press coverage noted the "frantic applause and noisy cheers," while assuming that "dada" meant barking. Strategists that they were, Schwitters and van Doesburg did not reprise the trick, bewildering the audience at the next gig, who, of course, came expecting a canine outburst—getting, instead, Schwitters blowing his nose.

For the most part the programs adhered to the same components. It would begin with van Doesburg on a dark stage, illuminated only by a small table lamp, his white socks and white tie standing out against his otherwise black apparel. His lecture drew largely from a pamphlet he had written called "What Is Dada?" for sale in the lobby, along with the various *Anna Blume* collections. Reporters often noted the commercial aspect of the tour, finding the prices unseemly in view of Schwitters' performances in particular. "Imagine a poem, not consisting of sentences or words, but just of letters or even weirder, of numbers!" exclaimed one who clearly thought such rubbish wasn't worth the price of admission. Another professed guarded admiration for "the unmitigated cynicism with which he carried out his performance." Schwitters was utterly guileless, however. One indignant audience member

called out, "Does it make sense? Is it art?" to which he scrupulously replied, "It makes no sense, but it is art."

Van Doesburg's pamphlet, like his lectures, patiently explained that Dada was "the anational expression of the collective life experience of humanity over the last ten years." That experience seethed with contradictions. Accordingly, "for every 'yes' Dada simultaneously sees the 'no.' Dada is yes-no: a bird with four legs, a ladder without rungs, a square with no corners. Dada possesses positive and negative in equal measure. To hold the opinion that Dada is only destructive is to misunderstand life, of which Dada is the expression." Schwitters regaled the audiences with the full range of his performance works, from the number and letter poems to early versions of the *Ursonate* he'd inaugurated on the Prague tour with Hausmann. Against this backdrop, his recitation of poems by German Romantic Heinrich Heine, accompanied by Nelly playing Chopin, tended to rile the audience. Maybe some felt the classics were being abused, while others clamored for more weirdness. Regardless, howls ensued.

Nelly van Doesburg contributed various musical interludes from contemporary composers catching a headwind from the vogue for jazz, like Igor Stravinsky, Arthur Honegger, and Francis Poulenc. And she adapted an interlude from Erik Satie's ballet *Parade*, presenting it as "Ragtime Dada." The most distinctly Dadaist numbers were by Italian composer Vittorio Rieti: "Wedding March for a Crocodile," "Military March for Ants," and "Funeral March for a Little Bird." Finally, Huszár's mechanical dancing figure lent a shadow-play dimension to an otherwise literary and musical evening.

On one occasion the audience went over the edge and erupted into pure unbridled Dadaism itself, though clearly some advance preparation was involved. Schwitters recounted the episode (in slightly unsteady English) near the end of his life:

In Utrecht they came on the scene, presented me with a bunch of dry flowers and bloody bones and started to read in our place, but Doesburg threw them into the basement where the music uses to sit, and the whole public did dada, it was as if the dadaistic spirit went over to hundreds of people, who remarked suddenly that they were human beings. Nelly lighted a cigarette and cried to the public, that as the public had become

quite dada, we would be now the public. We sat down and regarded our flowers and nice bones.

By "scene" Schwitters means the stage itself—which several men stormed bearing a huge "bouquet" three meters high, consisting of rotting flowers and bones, attached to a wooden support. One of the men commenced to reading from a Bible until van Doesburg (who'd been backstage) intervened, flinging the offender into the orchestra pit ("basement" in Schwitters' terminology). Although not as large an audience as in the Zurich Kaufleuten Hall in 1918, this was the final outbreak of the Dada St. Vitus dance by paying spectators.

As this episode suggests, van Doesburg brooked no shenanigans from the audience. When the audience got rowdy, he'd halt the proceedings until order was restored, declaring a penalty time-out and lowering the curtain. On several occasions he singled out audience members for reprimand, even physical chastisement. This was in keeping with his temperament, but he could hardly have been ignorant of the propensity for Dada performances to whip an audience into a frenzy, so he was most likely playing the straight man to Schwitters' goofball.

The performers invariably pointed out that they were not Dadaists. In the inaugural issue of *Merz*, the first number published to coincide with the tour, Schwitters commented on non-Dadaists spreading the gospel of Dada in Holland. Writing in German with a few Dutch expressions (in italics here) he wrote: "May I introduce us? *Watch out, we are* Kurt Schwitters, not dada, but MERZ; Theo van Doesburg, not dada, but Stijl; Petro van Doesburg you won't believe it, but she calls herself dada; and Huszár, not dada, but Stijl." Taking up the question as to why no actual Dadaists were on the tour, he wrote (again with some Dutch), "*Look, that's the subtlety of our culture*, that a Dadaist, precisely because he's a Dadaist, cannot awaken and artistically clarify the slumbering Dadaism in the audience." We're living in the Age of Dada (Dadazeitalter), the new Dada era (Dadaneuzeit), he wrote: a historical epoch like the Middle Ages or the Renaissance. It wasn't Dadaists who made Dada; the times themselves propitiously excreted Dadaists like lava from a volcano. He went on to explain that he, the van Doesburgs, and Huszár were ideally situated to present Dada because in their search for *style* they were merely holding a mirror up to the audience to cull its opposite, a pure distillation straight from the age itself—and *that*

was Dada. The points Schwitters made in *Merz* were repeated almost verbatim for reporters.

A year later Schwitters revisited and elaborated these views for the Polish avant-garde periodical *Blok*, again insisting he was no Dadaist, "because Dadaism, being only a means, a tool, cannot constitute the being of a person as does, for example, a world view." He then broached a distinction, using accent marks, between dáda and dadá, mirror images of one another. He assigned the former to "established mindless tradition," while dadá was the great leveling medium, best experienced during performances like those in Holland "where everybody recognizes their own stupidity." It was a tool, or weapon, that "will always reappear anew whenever too much stupidity collects itself."

In the same interview, Schwitters cited the Holland tour's success as "proof that further colonizing work is necessary" and offered a historical profile of Dada's continuing development. The "old" Dada, he suggested, dated back to 1918 when the "chronic diarrhea" of Expressionism was all the rage and needed to be opposed. The "new" Dada of 1924 was Constructivism. He didn't use that term, but his list of exemplars makes the case: Lissitzky, Moholy-Nagy, Walter Gropius, Mies van der Rohe, Richter, and Schwitters himself. If Merz could be regarded as Dada by another name, so too could Constructivism. Curiously—or carelessly?—van Doesburg was omitted from Schwitters' list.

The Holland tour was avidly followed in the press. Van Doesburg counted eighty-eight articles and numerous invitations for him and Schwitters to publish their views on Dada in their own writings or in interviews—but the point they most often reiterated was that "Dada is the essence of our time." That strategy made sense, especially in the wake of reports of the barking episode in the first performance. They wanted a crowd expecting novelty, which they could certainly provide, but they also saw themselves on a mission. "Dada is the moral solemnity of our time and prepares the road to the future," they repeatedly proclaimed as a one-liner.

Odd, really, to think of moral solemnity at the core of Dada, but wasn't it always that way? Hugo Ball was a man haunted by the pressure of destiny, and in Berlin the putrid atmosphere of military supremacy collapsing into Weimar Republic squalor was more than enough to incense anyone able and willing to see through the puffery. Van Doesburg's investment in De Stijl as an absolute

condition of moral reckoning never wavered, and that commitment is evident in other avant-garde movements. Yes, it was a kind of buffoonery—but consider Shakespeare's plays, in which it's the clowns who spell out the truth to heedless royalty. When van Doesburg said in an interview, "One cannot set up a new building before the old one is pulled down," he was affirming the sobering truth that rotten institutions can only shore up the façade for so long.

After the "Anti-Dada-Merz" tour with Hausmann and the Holland tour, Schwitters' performance skills were honed to a fine pitch. Asking 400 marks an appearance, he maintained a grueling schedule, traveling throughout Germany and Holland, with forays into Czechoslovakia, Switzerland, and France—not to mention monthly performances at home, after which he would let off steam by cranking up the gramophone at home and dancing tangos and rhumbas with any pretty girls who happened to be on hand, while emitting a low masculine growl, as his lifelong friend Kate Steinitz fondly recalled. In a performance at the famous Café les Deux Magots in Paris, he made an impact by smashing a plate, and after the frantic applause, he contritely explained, "It's an obbligato! It's written in the text!" The audience demanded an encore, and sure enough, there went another plate. This went on for a half dozen more encores, with a delighted Tzara footing the bill for the damage.

Nothing more emphatically embodied Schwitters' artistic spirit than his own house in Hanover. Yes, there were the odors of baby and cooking and paste for collages, but select visitors were given a glimpse of the inner (or upper) sanctum of Merz. If you were lucky, you got a private tour, or ended up having a "shrine" devoted to you. It was *that* personal, yet strangely esoteric. It came to be known as the Merzbau, or Merz-building. An entire floor of the Schwitters' household was gradually overtaken by a kind of private "installation."

Artists' studios have a legacy of glamorous intrigue, generally speaking. It's where the magic happens. Once photography offered access to these sites, artists like Brancusi and Picasso were careful to arrange their space to make the mystery glow. But Schwitters was a different case. He lived and worked at home, in a domesticated realm where the avant-garde inextricably mingled with bedspreads, cooking utensils, and household pets, like the guinea pigs he cultivated.

An early intimation of the Merzbau was announced in the first issue of *Merz*: "Experiments are being conducted in secret with white mice that are

living in Merz pictures specially constructed for the purpose." He could've gone on gluing urban litter onto his Merz assemblages, but why stop at a rectilinear frame? Why not make a space into which you can wedge yourself, a sensory immersion, like a rodent burrowing into soil?

The Merzbau started innocently enough with a few columns, sculptural assemblages like the Merz paintings. One was a shrine to his first son, with a death mask of the infant's head. These shrines were freestanding composites, several feet high. In the early stages, it seems, they weren't destined for a commemorative role. In 1919 and 1920 Richard Huelsenbeck and Ernst visited Schwitters' studio and noted that these rising conglomerates served mainly as repositories for the refuse Schwitters needed for his Merz pictures—both "respectable and less respectable" items, Huelsenbeck noted.

After the Holland Dada tour, Schwitters set to work in earnest on the *space* in his home studio, erecting enclosures and expanding the material around these cubbyholes until eventually there were walk-in and walk-through areas. Ultimately there were at least forty of these grottos, as he called them. "I am building a composition without boundaries," he explained to Museum of Modern Art director Alfred Barr, "each individual part is at the same time a frame for the neighboring parts."

By 1930 the Merzbau had become so complex that Schwitters was employing a carpenter, an electrician, and a painter. Friends were pressed into service. He sought Moholy-Nagy's help in constructing a "White Palace" as housing for his guinea pigs within the expanding structure. His son Ernst got involved as well. He described how the project evolved from the original rudimentary planar form of Merz pictures. His father "started by tying strings to emphasize this interaction. Eventually they became wires, then were replaced with wooden structures which, in turn, were jointed with plaster of Paris. This structure grew and grew and eventually filled several rooms on various floors of our home, resembling a huge abstract grotto." A key term here is *abstract*, in that the few surviving photographs reveal intersecting, undecorated planes rising from floor to ceiling. But it wasn't like that inside, which consisted of grottos, caves, and rooms, though it's not clear what differentiated them. There was a Biedermeier Room, and a Stijl Room, for instance, but the Nibelungen Hoard sounds more like a cave, and the Luther Corner sounds like none of the above. Clearly, themes were spawned, attaching themselves to structural supports and dedicated zones.

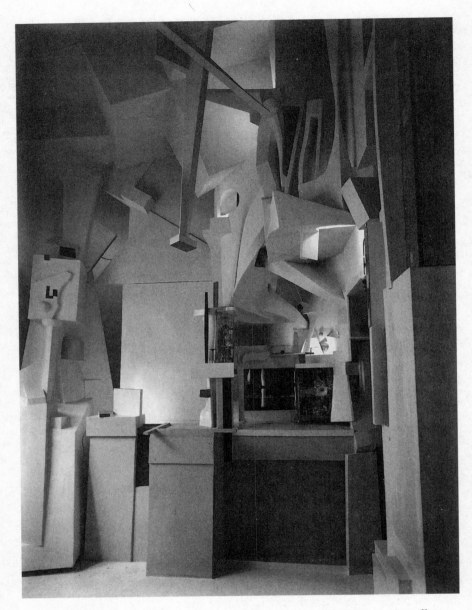

Merzbau, detail from interior of Kurt Schwitters' house in Hanover. Installation: ca. 393 x 580 x 460 cm. WV-Nr. 1199 (Abb. 19). Inv. KSA 2008,12.

Photo: Wilhelm Redemann. bpk, Berlin / Sprengel Museum, Hannover, Germany / Wilhelm Redemann / Art Resource, New York. Copyright © 2014 Artists Rights Society (ARS), New York / VG Bild-Kunst, Bonn.

As the Merzbau swelled, it was on its way to becoming the uninhibited externalization of Schwitters' consciousness—even his manifest *unconscious*. The grottos were devoted to topics or individuals. Schwitters was prone to filching little items from his friends, depositing them as fetishes in the grottos devoted to them. Steinitz and Höch were permitted the rare privilege of assisting in the design of their own grottos, and Höch even had two of her own. Richter forfeited some locks of hair for his grotto, while Taeuber relinquished a bra.

Schwitters purloined a whole sheaf of pencils from Mies van der Rohe's architectural drafting board. Perhaps some of them went into the Goethe cave, with its clutch of pencils ground down to nubs, suggesting the fertility of the great German poet. There were signature touches like the *Monna Hausmann*, in which Schwitters superimposed his friend Raoul's face onto Leonardo's famous lady, though it also served as homage to the deft touch applied by Duchamp several years earlier.

Given that the original column was called *Cathedral of Erotic Misery*, a place was reserved for grim subjects from the outset, like the love grotto commemorating a spate of sex murders in Hanover in 1924. This dark side of the Merzbau, along with the fetishistic aura of the grottos, didn't necessarily tickle the fancy of visitors confronted with objects like the bottle of urine "solemnly displayed so that the rays of light that fell on it turned the liquid into gold," as Steinitz recalled. Museum director Alexander Dorner was appalled, finding the whole project "a kind of fecal smearing—a sick and sickening relapse into the social irresponsibility of the infant who plays with trash and filth." Richter, less judgmentally, described it as "like some jungle vegetation, threatening to keep on growing forever."

The walls and ceilings of the house itself limited the growth, though at one point it broke through an exterior wall to incorporate a balcony and even plunged down below the foundation. But space was limited, so the Merzbau's expansion eventually meant contraction. Schwitters characterized this aspect of the project as a reflection of the times: "This is an age of abbreviations." Biographer Werner Schmalenbach put it well. "His real aspiration was toward infinity, but an infinity located, so to speak, inside space."

In contrast to the discomfort felt by Dorner, such aspirations could elicit a sense of awe, as registered by Arp: "Without parallel in either the ancient or the modern world, this monumental structure by no means

suggested the merely odd works of eccentric hobbyists. Quite the contrary: the beauty of its rhythms set it alongside the masterpieces of the Louvre." Masterpieces? Louvre? Arp was making a point, but he surely knew that Schwitters' world of rubbish would be unwelcome in the grand sanctuaries of Western art.

The Merzbau's more plausible connection was with architecture, not art. Schwitters had, in fact, studied architecture at the Technical University in Hanover in 1918, just before he found his way into the adventure of Merz. In April 1919, the same month he issued the founding declaration of the Bauhaus, Gropius published a pamphlet in connection with an exhibition at the Neumann Gallery in Berlin, site of the original Dada event in the city. Addressing artists, he exhorted them to "smash the frames of 'salon art' around your paintings; go into the buildings, endow them with fairy tales of color, engrave your ideas onto their naked walls—and build in fantasy, without regard for technical difficulties."

Schwitters directed the invasion of his home by an overflow of Merz like a film set (think *The Cabinet of Dr. Caligari*) without actors. If there'd been a film, the only motion would have been the occasional peekaboo of a guinea pig. The whitewashed, interpenetrating planes of the edifice obscured the "fecal" interiors, coming to resemble more and more the sleek productions of Schwitters' friends—the Prouns of Lissitzky and the intermedia explorations of Moholy-Nagy like his *Light Reflector*, an almost Rube Goldberg contraption that spins and wobbles, while casting delicate geometric shadows on a wall or screen.

In March 1923, Moholy-Nagy was appointed to the Bauhaus as Johannes Itten's successor. Van Doesburg, having moved to Weimar in hopes of such an appointment for himself, now saw the futility of his aspirations and relocated to Paris. By this point, and for years to come, Schwitters' circle of friends consisted of these and other Constructivists. The rubbish gathering for Merz productions never ceased, but he began executing planar compositions that resembled something that might've come from a factory. He was a fellow worker in a cause, and as in everything he did, he threw himself into it wholeheartedly.

Schwitters' financial outlook mirrored that of many of his fellow countrymen in Weimar Germany. During a family vacation on the Baltic in 1923 (one of several with the Arps and Höch), Schwitters' father had to sell some

property to afford the return travel cost. There was little chance of making a living from art, though Schwitters did have support from Katherine Dreier, who arranged for a Societé Anonyme show of his work in New York. On a visit to Hanover, she splurged and rented an entire movie theater so Schwitters' son Ernst could see a Chaplin film, such fare deemed unsuitable for junior viewers in Germany at the time.

Schwitters' vocations naturally overflowed the recognized boundaries of the arts, and he embraced the Constructivist view that the art impulse could and should be extended to everyday life. So he learned the rudiments of graphic design and in short order was getting civic commissions from the city of Hanover.

In 1927 he founded a league of abstract artists (*die abstrakten hannover*), holding the first meeting in his house, commemorating the occasion by tossing a recently deceased guinea pig on the hearth fire. Afterward, he ushered one of those in attendance upstairs to the Merzbau, where Rudolf Jahns experienced "a strange, enrapturing feeling" in the absolute silence of "the grotto whirling around me."

A few months later Schwitters organized an international group of typographers, *rings neuer werbgestalter*, which included, among others, Moholy-Nagy, Dutchman Piet Zwart, and the Swiss Jan Tschischold, author of the influential manifesto-treatise *The New Typography* (1928). Tschischold designed Schwitters' completed *Primal Sonata* in 1932. The aspiration of the typographic organization was to persuade commercial clients that "an advertisement is only as good as its design." Products have come and gone, but their ads are perpetuated even today in histories of graphic design.

Schwitters had inaugurated his little magazine for the Holland Dada tour, and while it has legendary associations with Dada, *Merz* became a vehicle for showcasing Schwitters' wide-ranging interests and affinities. It was also a practical forum in which he could display his skills as a graphic designer. *Merz* 11 was a portfolio for the Pelikan company. The first several issues share a design sensibility with van Doesburg's *Mécano*—and van Doesburg was a regular contributor.

Merz quickly blossomed as a vehicle in which Merz and Dada poems and artwork merged seamlessly with international Constructivist style. In the fourth issue, Lissitzky's "Topography of Typography," with its eight bulleted

points, shared a page with a wooden assemblage by Arp. Proclaiming that "the new book demands the new writers. Ink-stand and goose-quill are dead," Lissitzky forecast, without further comment but in full caps: THE ELECTRO-LIBRARY.

In this same issue, a photogram by Moholy-Nagy, a De Stijl chair by Rietveld and an architectural model by Oud and van Doesburg mingle with a potpourri of Dada "banalities" by Tzara (reported to be "cultivating his vices"), Ribemont-Dessaignes, Hausmann, Arp, and Josephson, as well as an article called "Disclosed Pseudonyms," a riot of word play and disinformation.

Arthur Segal, represented by a painting in this issue, is given a fictitious pseudonym, and his first name is rendered "8 Uhr"—pronounced, in German, *acht-ur*, a phonetic meltdown of Arthur. Accompanying a spurious photograph of I. K. Bonset is a caption: "In the battle for Truth and Beauty the editor hastens to inform the public, that the HIGHLY ESTEEMED MISTER THEO VAN DOESBURG has never existed. Derived from the name SODGRUBBE, he is a badly veiled pseudonym for I. K. Bonset (see illustration)." In short, Dada hijinks were alive and thriving in *Merz*.

Most of the issues were published in 1923–1924, though a few more appeared sporadically into 1932. The double issue number 8/9, from the summer of 1924, was a collaboration with Lissitzky, bearing the title *Nasci* after the Latin for birth, production, development, though Schwitters initially hoped to call it *Isms*. This issue, in large format and glossy paper, was a visual portfolio in the vein pioneered by *The Book of New Artists* Moholy-Nagy edited with fellow Hungarian Lajos Kassák.

Lissitzky's introduction to *Nasci* began by lamenting the routinized celebration of machine culture in Constructivist circles, contrasting it with the perpetual disequilibrium of creation: EVERY FORM IS THE FROZEN INSTANTANEOUS PICTURE OF A PROCESS. THUS A WORK IS A STOPPING-PLACE ON THE ROAD OF BECOMING AND NOT THE FIXED GOAL."

This acknowledges a perhaps unpredictable point of convergence and solidarity between the ecumenical embrace of trash in Merz and

Lissitzky's own Proun works as transitional junctures between pictures and architecture.

The two artists were benefitting from the anti-art purview of Dada, as they embraced the spirit of perpetual exploration in which the individual work, no matter how fully realized, was a Janus-faced entity assimilating the past while looking into the blank slate of the future. Nothing symbolized that blank more than the legendary black canvas of Russian Suprematist Kazimir Malevich, Lissitzky's mentor, which filled the better part of a page of *Nasci* as if it were the gateway to any further creative gambit. In truth, however, *Nasci* coincided with an endpoint of sorts—for Lissitzky, at least.

During the preparation of *Nasci*, Lissitzky fell ill and was diagnosed with pulmonary tuberculosis. Schwitters rallied the help of his friend Steinitz, whose husband was a doctor, and the Russian artist was able to travel to a sanitarium in Switzerland. He stopped on the way in Zurich to spend time with Arp, "a downright good, kind fellow," he wrote. "Absolutely no smell of sharp practice," he added, sounding a note of potential suspicion that would unfortunately be a premonition of things to come. For the time being, he delighted in Arp's work, and the two men came up with the idea of mounting an exhibition of "post-cubist" art. Although that never occurred, Lissitzky was able to get going in its place an idea he'd originally proposed to Schwitters, for a book profiling the march of the avant-garde. Schwitters didn't take the bait, but Arp did.

Once he settled into the sanitarium, though, Lissitzky felt frustrated. He complained he was getting no support or even any news from Arp. He began to suspect his coeditor of being untrustworthy and at the same time cast a suspicious glance at Moholy-Nagy, imagining that with the Hungarian's new eminence as a Bauhaus master he was trying to change history and make everything look like it culminated in that institution. He was not alone: Moholy-Nagy's former friend Alfred Kem nyi accused him of usurping Constructivism for "unauthorized self-propaganda."

Clearly Lissitzky's illness was weighing on him, as he even had to probe Taeuber back in Hanover with the query, "How is Kurtschen?"—his nickname for Schwitters—"Is he still offended? Tell him that of all the artists in Germany I like him the best." Nevertheless, the Russian soldiered on. By the

end of the year, Lissitzky was finalizing *The Isms of Art*, "going marvelously now that I am seeing to the whole thing by myself." But he bore the grudge of disappointment: "Zurich is spoilt for me now because of Arp." Communication was still necessary, some of it filtered through Sophie, whom he cautioned not to let Arp know the full extent of his feelings. Lissitzky was even forced to wonder about the source of his animus, admitting "I'm getting worried myself now about my mistrust of people." Not long after the book was published, early in 1925, he returned to Russia where he spent the rest of his life, with a few return trips to the West to arrange exhibitions.

The falling out between Arp and Lissitzky was not one-sided. Arp felt slighted by his partner's refusal to acknowledge his historical role in the delicate issue of the square. Odd as it sounds, this rudimentary geometrical figure spread like wildfire through the arts during and after the war, along with claims to priority. Arp thought he and Taeuber had "invented" it around 1915 in Zurich, the date given in fact in a work of his reproduced in *The Isms of Art* in the section on abstraction. He even considered patenting the square. Nevertheless, he felt enough proprietary interest to fly into a rage when his collaborator, Lissitzky, staked his own claim.

In 1922, Lissitzky published an illustrated book called *About Two Squares: A Suprematist Tale* dedicated "to all children," in which a black square and a red square jostled for supremacy in a hyperspace that includes a globe. Lissitzky was dutifully paying simultaneous homage to the nascent revolution and to the formidable *Black Square* of his mentor Malevich, whose famous painting was executed about the same time as Arp's and Taeuber's squares in Zurich. More literally, Lissitzky was mobilizing, in a sequence of book pages, Malevich's 1915 *Suprematist Painting: Black and Red Square*. At the 0.10 exhibition in Petersburg in 1915, Malevich's *Black Square* had been positioned at the corner of two walls and the ceiling, a site normally consecrated for icons in Russian households.

A black square fills much of the cover of a pamphlet Malevich circulated at the exhibit, *From Cubism and Futurism to Suprematism*, in which he boldly declared: "I have transformed myself *in the zero of form* and have fished myself out of the *rubbishy slough of academic art*." Had the Dadaists in the West known of this proclamation, they would likely have embraced it as a slogan.

If competition in Russia was so frantic, one can only imagine the dismay Lissitzky felt when he arrived in Germany a few years later and found the sacred

square jostling for position with art of every stripe, even by artists who'd never heard of Malevich. In 1923, Paul Westheim published "Remarks on the Quadrangle at the Bauhaus," observing the trend swelling into a heady pedagogic fad:

> At the Bauhaus one tortures oneself with stylizing squares according to the idea. After three days in Weimar, one has had enough of squares to last a lifetime. Malevich invented the square as early as 1913. What a stroke of luck that he hadn't put it under patent. The height of the Bauhaus sensibility: the individual square . . . In Jena, the people from 'Stijl' are putting on a protest exhibition: they claim to possess the only true squares.

The reference to De Stijl is a reminder that the entire ethos of the Dutch program was predicated on squares and their variants. In 1920 van Doesburg deployed two black squares for the cover of his booklet *Classical–Baroque–Modern*. It was a belated if emphatic gesture when, in the 1924 *Nasci* issue of *Merz*, Schwitters and Lissitzky filled a page with Malevich's *Black Square* as if it were a portal to the future. Like every door it had two sides, facing back and into the future at once.

The Isms of Art is an eclectic but fairly accurate profile of movements and trends in modern art from 1914 to 1924. Lissitzky gives himself a two-page spread as creator of Proun, but Arp managed to carve out five pages for Dada, showcasing work by Picabia, Hausmann, Ernst, Arp, Man Ray, Höch, and Taeuber, as well as a separate profile of Merz. Only Cubism and the general category of abstraction garnered more space.

Like *The Book of New Artists*, *The Isms of Art* is essentially a picture book with four pages of text at the beginning; the book being trilingual, even these pages don't amount to much. What's more, the authors' grasp of English was shaky, making these entries intriguing to read. Here's Arp on Dada, spelling preserved from the original:

> The dadaïsm has assailed fine-arts. He declared art to be a magic purge gave the clyster to Venus of Milo and allowed "Laocoon & Sons" to absent themselves at last after they had tortured themselves in the millennial fight with the rattlesnake. Dadaïsme has carried affirmation and negation up to nonsense. In order to come to the indifference dadaïsme was distructive.

The "clyster" to which he refers is from the German word *Klistier*, meaning "enema."

A few of the other entries in *The Isms of Art* were quotes by the originators of, or participants in, the various isms. The entire text on Merz, from Schwitters: "All that artist spits is art" (*Alles, was ein Künstler spuckt, ist Kunst*). Schwitters, like his friend Moholy-Nagy, had an ecumenical outlook and would no more disqualify the abject from eligibility for art than any other material. Once Dada had its say, the way was open for Merz to begin its long mission of baptizing and redeeming the unwashed material plenitude of the entire world.

Schwitters was indifferent to trends and fashions, resenting that "old rubbish from attics and scrap heaps could not be used as material for paintings on an equal footing with pigments manufactured in factories." His solicitous embrace of such materials as he moved ahead, merzing and barking and cultivating caves and grottos in the Merzbau, sought to remedy this situation. But as the Third Reich grew in force, compliant Aryan artists churned out airbrushed classical nudes, stalwart heroes, and salt-of-the-earth types clad in lederhosen. When the exhibition of *official* German art opened near the *Degenerate Art* exhibit in Munich in 1937, it was woefully underattended, while crowds flocked to see the vilified examples of Dada, Expressionism, Fauvism, Cubism—*any* ism in fact, for art had consistently transcended itself, ism by ism, for nearly a century by then.

The earliest Dada exhibitions in Zurich had been patently little more than collections of the most recent isms, and Arp in particular would be associated with subsequent isms like Surrealism and abstraction, incompatible though they were. For him, as for many others, it was the privilege of Dada to poach from anything with zest and character, anything that cleansed, delighted, or startled the senses. The spectrum he assembled with Lissitzky for *The Isms of Art* suggests a vast, ecumenical, cooperative tendency running through all the arts in their advanced mode. The ism-oriented sensibility was consistently international (even his nationalism didn't stop F. T. Marinetti from spreading Futurism far and wide). Dada, born in a hive of international refugees during the conflagration of belligerent nations, held true to that embrace of artistic sapience crossing all boundaries. With time the boundaries faded, and it would be harder to verify the historical parameters of Dada as it began to take on mythic proportions.

13

TRUTH OR MYTH?

Was Dada ever really a movement? Of all the Dadaists, Tristan Tzara was keenest on the idea. He even had stationery made up, befitting his self-ordained role as director of the international Dada movement. But then, growing up in Rumania, far from the center of things, his goal was to get to Paris, lodestar of isms, where everything seemed destined for the avant-garde.

Ironically, of course, it was in Paris that Dada foundered on the shoals of conflicting ambitions, finally going belly up in 1923 in the melee spawned at the "Soirée of the Bearded Heart." Only a bona fide *movement* could collapse with such verve. Yet even as it flared out in this final incendiary event in Paris, something else called Dada persisted—a state of mind, an attitude, a posture donned for an occasion. Some of these occasions—ranging from exhibitions to soirees, performances, and publications—were meant to herald Dada, or benefit from its name. There were also urban legends, reports in the press of events that may or may not have happened, eventually labeled Dada, like graffiti sprayed on an overpass. Dada could be like a magician's conjuring routine, deliberately misleading beholders. Its founders often preferred it that way: they didn't try to straighten anyone out on the subject and dispensed misinformation whenever possible. If you were spooked and needed to call your startled twitch Dada, go right ahead.

Artists around the world did take up the mantle of Dada in this way, especially in Eastern Europe, as word of Dada trickled into countries adrift after their long sojourn in the Austro-Hungarian Empire, as it collapsed after the Great War. Case in point: the delicate assimilation of Dada with the emergence of Constructivism in the exiled Hungarian circle around Lajos Kassák's *Ma* in Vienna.

Prague, for its part, might have emerged as an eastern capital of Dada, given the periodic visits and performances by Raoul Hausmann, Richard Huelsenbeck, Johannes Baader, and Kurt Schwitters. But the Czechs never got around to "Dada's destructive work" when the time was ripe, a circumstance that Bedřich Václavek, contemplating it in 1925, rued. By then, it was too late. Yet Prague, like Holland, had not been passed over by Dada completely. If not a bastion of Dada, the Czech city could still serve as an incubator.

It wasn't Czechs at all who made a splash with Dada in Prague; rather, it was two young Serbian residents. Dragan Aleksić and Branko Ve Poljanski (the latter a pseudonym for Branislave Virgilije Micić) mounted a large Dada soirée on Štěpánská Street in 1921, drawing over a thousand people. After the usual programmatic declarations, poems were read. Aleksić made a spectacular impression reading from a scroll he claimed was twenty-five meters long. One of his pieces is like a literary adaptation of a mechanomorphic drawing by Francis Picabia.

> A young lady like straw
> Two car batteries
> Stop my flickering brothers,
> Two-three converters.
> Salicium calcii pulveri
> oxygenium, baxi pulveri,
> cantharides, nitrocarbonati
> pulvus mixtus genui Malveri.

Titled "Pharmocopeia of Love," this poem set off a riot in the audience. Revolvers were brandished in the melee, and the event collapsed in on itself. The occasion inspired Hausmann to pledge to raise a monument to commemorate Aleksić if he should perish in the cause of Dada. Aleksić planned

a follow-up, but he was knifed in a bar the evening before it was scheduled to take place. The authorities then banned such events altogether.

Returning to his Serbian homeland, Aleksić found "a dough pliable enough for the dada rolling pin" in the journal *Zenit*, edited by Poljanski's brother, Ljubomir Micić. For Micić, Dada was a lot of hot air, but he was willing for the time being to tolerate a bit of it in *Zenit*.

Zenit was modeled in part on Kassák's *Ma* as an organ of the international avant-garde, though Micić's journal included more works in original languages. Its first few issues prominently featured Yvan Goll, the Alsatian poet who was negotiating a postwar turn from German to French. His long poem *Paris Burns* (versions exist in both languages) was first issued in a Serbian translation under the Zenit imprint. *The Zenitist Manifesto* (1921) included proclamations by Goll, Micić, and Boško Tokin. Micić extolled "The Naked Man Barbarogenius" of the Balkans, recalling various proclamations of Dadaists as naked babes. Micić specifically promoted a Balkan-Slavic antidote to the decadent West. Goll, playing another card from the Dada deck, insisted, "We need modern NEGRO SONGS," and declared the New Poet *"always INTERNATIONAL."* Tokin identified Zenitism as a transcendent assimilation of Cubism, Futurism, and Expressionism. *"One needs to be a barbarian,"* he wrote, without however making any reference to Dada.

Micić gave Aleksić space in *Zenit* to promote Dada, but the journal also distanced itself from the movement. An anonymous article (by "a Zenitist") in the second issue surveyed Dada only to end on a dismissive note. Declaring Dada old hat, "already a fashion *passe-temps*," the author admitted, "It's fun, but not a religion, a conviction, and a new art." As an art, this Zenitist surmised, Dada was already familiar by way of abstract art. As for literature, a famous and much reprinted poem by Louis Aragon was quoted. Originally in Picabia's journal *Cannibale* in April 1920, for obvious reasons it became a universally accessible specimen of Dada:

<div align="center">

SUICIDE

A b c d e f

g h i j k l

m n o p q r

s t u v w

x y z

</div>

In the next issue of *Zenit*, Aleksić published the participatory appraisal of Dada he'd read to the thousandfold crowd in Prague, just before whipping it into a frenzy with "Pharmocopeia of Love." In the article, he followed a lead from Huelsenbeck, whose essays and manifestos had been translated into Czech, Hungarian, and Ukrainian—and soon into Serbian by Aleksić himself. "Art is what the *nerves* express," Aleksić wrote. "Nerves are primitive"— and sounding a note that brings Dada into the orbit of the "barbarogenius" of Zenitism, "Nerves are primeval, unspoiled." Dada carried a torch for the spirit of carpe diem, since "we live in minutes, seconds, not years."

Aleksić saw Dada as the natural cry of youth howling at the moon. Simply put, "DADA is a term for getting happy," and "DADA is looking for 300,000 circuses to popularize art—(why work?)." He followed up this piece a few months later with a high-spirited profile of Schwitters, concluding that he "isn't merely a quiver of a DADA network, he is the very lasso that will drag the world into Pandadayamic neofuturism." A similar blend of references occurs in the 1930 Ukrainian *Avantguarde Almanac*, where a "panfuturist system" is said to combine destructive and constructive tendencies in art, a clear nod to lingering traces of Dada.

Aleksić was a regular contributor to *Zenit* for another year, as a representative of Yougo-Dada (Yugoslavian Dada), but Micić finally got fed up when Aleksić's poem "Taba Ciklon II" appeared in a Dada-themed issue of *Ma* in Vienna. Pointedly positioned above a photo of a modernist apartment block from *De Stijl*, the poem is an unabashed performance text in Schwitters' vein:

tAbA
TaBu tabu mimemamo tabu
tAbA
Tabu ABU TaBu aBu TabU
bu tAbbbu
Tabu
aBu taBu /popokatepetl/
aBu/popopo/TaBu/kakakaka/
abua abuU abuE abuI
aBuKiabu abukiabu
TaBa ubata tabu
TaBau TaBau /riskant/
tabu u tabau ubuata

Taba U
abU TABUATA TUBATAUBA
taba
re re re RE RE
Rn Rn Rn Rn
Reb en en Rn
Ren RN ReN ErNReN
abu tabu abua u tabu abuaaa
aba tabu abaata
babaata tabu tabauuuta
taba RN
tabaren
tabarararan/rentabil/
tabaren ENEN tabarerenn/parlevufranse/

That cheeky little French twist at the end may have gotten under Micić's skin, or maybe it was just the objectionable indulgence in Dada *bruitism*; to the Serb it probably seemed like infantile babbling. In any case, Micić disavowed both Aleksić and Mihailo S. Petrov, a fellow Dadaist artist, in a formal excommunication published in *Zenit* 14 in May 1922.

The upshot of the Dada-induced falling out between Micić and Aleksić was a flurry of punch and counterpunch publications, one-off journals that sent the sulfurous flare of Dada into the sky once more. Accompanying the *Zenit* excommunication was the announcement of a new periodical called *Dada-Jok* (*jok* meaning "no"), edited by Micić's now compliantly ex-Dadaist brother, Poljanski. On one page, under the slogan "Happy New Year 1922," is a clutch of nonsense words in different fonts arranged by Micić, from which a cartoon rendering of Chaplin juts out. Above him a cathedral hangs upside down, its double towers forming a menacing stiletto. As a retort to Aleksić, *Dada-Jok* presents the *Zenit* editor as

The great master of all Dadaists
first great Antidada
Contradada
Zenitist
Contrapseudozenitist
GOD OF DADAISTS

Hard on the heels of *Dada-Jok* came two little periodicals edited by
Aleksić, *Dada-Tank* and *Dada-Jazz*. The former included work by Schwitters
and Tzara and excerpts from Aleksić's translation of Huelsenbeck's preface
to the *Dada Almanac*. The second reprinted Aleksić's piece on Dada from
Zenit (a kind of *et tu, Brute?* aimed at Micić) and a translation of Tzara's
"Manifesto of Mr. Aa the Antiphilosopher." Both publications would cement
Dada's place in the Serbian art scene.

Befitting its title, *Dada-Jazz* ran ads for jazz bars in Zagreb where "mod-
ern and eccentric dancing" could be indulged. The journal's address was
listed as the central office for a Dada club. Dada matinees ensued in Novi
Sad at the Bar Americaine, where Aleksić appeared in boxing gear, and in
movie theaters in Osijek and Subotic. Access to film screens made it possible
to project images of artwork by Hausmann, Picabia, Lázló Moholy-Nagy,
and others. Aleksić included Zenitist literary works on the programs, until a
defiant telegram from Micić forbade further use. (As a reward for his labors,
Aleksić was known by the nickname "Dada" to the end of his life.)

Although he genuinely despised Dada, Micić's disavowal was part of a
widely shared sense in Eastern European countries that Dada was someone
else's movement, and the new political circumstances (whether cause for op-
timism or despair) entitled them at least to their own and not a derivative
avant-garde. The Czechs were busy cultivating an optimistic, free-spirited
enterprise they called Poetism, for instance, and it took them a while to re-
alize that Dada shared their enthusiasm for Charlot, the European moni-
ker for Charlie Chaplin. Prominent Poetist Karel Teige's book *On Humor,
Clowns, and Dadaists* was published in 1924, after he reluctantly came around
to the view that Dada had something to offer.

Teige's friend and ally in Poetism, Vítězslav Nezval, acknowledged the
destructive efficacy of Dada: "Dadas are furniture movers. They have thor-
oughly dismantled the modern bourgeois' living room." As a consequence,
"We are now standing in the demolished room. It is necessary to make a new
order." "The modern spirit is a spirit of construction. It is a spirit of wisdom,"
Teige wrote, realizing, however, that "it is healthy to add a grain of folly to
every wisdom." When Schwitters performed in Prague in May 1926, it was
in this spirit that he was appreciated. Noting the laugher and applause he
provoked, journalist and editor Arthur Černík reflected that "Dada is only
the foam of life. It wants to provoke us in our everyday content and make

us laugh—remove us from our ordinary problems for a few moments." This diminished interpretation of Dada as agreeable froth is reflected in an invitation Nezval sent to friends before he took a trip to Paris in 1924 for a farewell party, anticipating its high spirits as "Poetism in the praxis of DADA."

There was one earnest engagement with Dada in Prague by way of *Tam Tam*, a journal presented as a "musical handbill," edited by composer and theatrical producer Emil Burian in 1925. The title itself echoes Dada as well as the smack of a tambourine. "Aesthetics, formerly the Science of Ugly Beauty, Now the Science of Beautiful Ugliness" was Burian's opening provocation. He was among the earliest to welcome jazz in Prague, but behind it he discerned the spirit of Dada. "Through Dadaism we got truly enriched in beautiful corporeality and optimism," he wrote.

Dada showed us street melodies and squeaking orchestrations, brought us jazz and pianolas, the lewd melancholy of bar girls, introduced our sensibility to the finest vibrations of absolute sound beauty. After Dada we appreciate ugliness and chance—these unquestionable advantages of admirable eccentricity, of a noisy, foolish fox-trot and a drunken hottentot.

In 1927 Burian premiered his Voiceband under the Dada auspices of the Frejka Theatre. The Voiceband was a multivoiced group drawing on jazz syncopation spiced with the sort of vocalizing Burian may have picked up from the performances of Schwitters and Hausmann. But by the mid-twenties when Burian published *Tam Tam*, jazz was spreading at a frenetic pace, while Dada increasingly seemed a diminishing relic. The same seemed true to the east of Prague, as well.

Dada never made much headway in Russia or Poland. In addition to politics, which thwarted Dada's development, a lively manifestation of Futurism had preceded Dada in both countries. Futurism presaged many of the characteristics associated with Dada and therefore robbed Dada of much of its power when it did arrive in these locales.

In Poland, the Futurist surge was postwar, but Futurists were still dutifully aware of their debt to preceding isms. "Manifesto of Polish Futurism" published in Kraków in 1921 observed, "Cubism, expressionism, primitivism, dadaism outbid all other 'isms,'" puckishly adding, "The only remaining

unexploited energy in art is onanism." Like the Dada rebuke of Expression-
ist soul-mongering, Futurist Bruno Jasieński declared: "We are breaking off
once and for all from the pathos of eternity in relation to works of art."

Kraków was a hotbed of Futurism and exhibited many aesthetic parallels
with Dadaist stomping grounds like Paris and Berlin. Jasieński organized
soirées at which the actress Helena Buczyńska indulged in a "word-plasticity"
the Dadaists would have recognized. Jan Nepomucen Miller unsuccessfully
tried to integrate Dada into a new movement he called Dadanaizm, after the
term *dadana*, a phonetic refrain in Polish folk poetry. His poems consisting
solely of punctuation marks, on the other hand, moved closer to Dada.

The same spirit could be seen in Warsaw, where two younger writers who
would become major figures in Polish letters, Alexander Wat and Anatol
Stern, cavorted in public—Stern parading the naked Wat around the city
in a wheelbarrow—advertising a "subtropical soirée organized by white ne-
groes." Stern's illustrated book-length poem *Europa* (1928) is festooned with
images of black prizefighters and opens with the familiar figure of Charlie
Chaplin as emcee of the book. As if literally swallowing the "virgin microbe"
of Tzara, *Europa* concludes with a vision of the proletariat as a cellular up-
rising: "this throng of raging bacchantes / is one centimeter of my skin." The
most curious, if sidelong, glimpse of Dada in Poland is not a manifesto but a
"Festo-Mani" issued by that singular artist and playwright Stanisław Ignacy
Witkiewicz with its provocative answer to the question "How can one out-
strip Futurism and Dadaism? BY PURE HOAXING." Witkiewicz's own
hoax was to sign the document Marceli Duchański-Hoax.

Russia, like Poland, exhibited artistic strains that were certainly compat-
ible with Dada. Futurism was again an important part of this story. Before
the war there were energetic collaborations between poets and painters in
various Russian Futurist groups. In Moscow in 1912, the Hylaea group, one
of these collaborations, published an almanac whose very title, *Slap in the Face
of Public Taste*, anticipates Dada aggression. Promenading in city streets with
painted faces, the Hylaeans issued a manifesto in 1913, "Why We Paint Our
Faces." "We have joined art to life," they declared, anticipating both Dada and
Constructivism. "We have loudly summoned life and life has invaded art, it is
time for art to invade life. The painting of our faces is the beginning of the in-
vasion." Also, presaging the development of sound poetry in Zurich, the poets
Alexei Kruchenykh and Velimir Khlebnikov, members of Hylaea, were intent

on what they called *zaum*, a "transrational" or "beyonsense" poetic practice that emancipated the word from the sentence and the letter from the word.

If *zaum* seems to approach an absolute limit, another poet from a rival Futurist group outdid even these wordless sound poems. In *Death to Art* (1913), Vasilisk Gnedov included "Poem of the End." Culminating a collection in which several poems were just a single line or even a single syllable, this particular item consisted solely of a title atop a blank page. At public readings, Gnedov performed this piece with aplomb. Formally dressed, he would fiddle with his glasses, adjust the book on the lectern, brush a speck of dust from his jacket, consult his watch, and make a series of hand gestures over his head, raising his eyes heavenward and displaying the acute expressivity of a poet in the throes of passionate exhortation—persisting in this silent pantomime until the restive audience would be driven to voice its impatience.

After the war, and during the early years of the revolution, one Russian group knowingly modeled itself after Dada, but refrained from using the word because it would be heard as an affirmative, *da, da*, meaning "yes, yes" in Russian. These were the Nothingists, after all, who declared, "In poetry there is nothing, only the nothingists."

When Tzara and his fellows in Zurich claimed that Dada was encircling the globe, and when Huelsenbeck reiterated these claims in the *Dada Almanac* in 1920, they knew that so simple and supple a word couldn't help but find these international niches as it migrated beyond their control and their expectations. Virgin microbe indeed: infection without intention, but accomplished like a destiny foretold.

Japan, for instance, heard about Dada but—like Poland and Russia—managed to subsume the virgin microbe into its own artistic anatomy without so much as a sniffle. News of Dada in Japan tended to fit readily into a cultural outlook prepared by Buddhism and Taoism. *Dada* in Japanese means "childish willfulness," and the book *Poems of Shinkichi the Dadaist* (1923) evoked this association. Takahashi Shinkichi himself seized on the term when he read a newspaper account of Dada in 1922, in which the author explained that Dada was a Western term for nothingness.

Closer to Europe, Tiblisi in Georgia emits a whiff of what Dada might have been like as a purely Slavic manifestation by a group naming itself after the formula for sulfuric acid, H_2SO_4. Its members promenaded city streets

with a muzzled bear. Another Tiblisi group known as 41° shared many points of orientation and activities with Dada, but was ignorant of it until 1921. One member of the group, Ilya Zdanevich, who published under the name Iliazd, moved to Paris in time to participate in the final stages of Dada's run. It was he who helped Tzara organize his "Soirée of the Bearded Heart," in part because it was an agreeable venue for the performance of Russian poems, but also because Dada had used up all the available goodwill of theatrical agents, and nobody would rent a space to a known Dadaist. Iliazd remained in Paris for the rest of his life and in 1949 produced one of the glories of avant-garde book publishing. *Les mots inconnus* (Unknown Words) is an international compendium of sound poetry, *zaum*, and similar exercises in burrowing beneath the familiar surface of language to unearth jubilation right from the presemantic source. Iliazd designed each page as a visual template to showcase his entrancing specimens, many of which are from the annals of Dada.

Bucharest, Rumania, was also a site for Dada shenanigans of a sort. Tzara's Rumanian countrymen knew about him, of course, but the Bucharest vanguard was primarily receptive to Constructivism, like most other Eastern European capitals. Still, a bit of Dada irreverence spiced up the proceedings from time to time, like the "Activist Manifesto for Young People" published in the journal *Contimpuranul* in 1924.

> Down with Art
> For it's prostituted itself!
> Poetry is merely a press to squeeze the lacrimatory glands of
> young girls of every age;
> Theatre, a recipe for the merchants of canned goods;
> Literature, a leaky enemy syringe;
> Drama, a jar of berouged fetuses;
> Painting, a diapered nature, extended through displaced salons;
> Music, a means of locomotion in heaven;
> Sculpture, the science of massaged spines;
> Politics, the employment of gravediggers and brokers;
> Architecture, an enterprise of tarted-up mausoleums

This litany concludes with the spirited cry, "Let's kill our own dead."

High spirits and cunning invective come naturally to youth, but for Tzara Dada transcended juvenile euphoria. He had been the youngest Dadaist, but the avid participation and influence of older men like Hugo Ball and Picabia had matured Tzara and fortified his sense of mission. Conversely, it was a point of honor with him that he'd somehow been innately Dada even before moving from Bucharest to Zurich. When Rumanian poet and writer Saşa Pană proposed publishing Tzara's Rumanian poems under the title "Poems Before Dada," he objected, insisting his development had been continuous. Writing to French couturier and avid collector of Dada ephemera Jacques Doucet, he claimed, "Already in 1914 I had tried to take away from words their meaning, and to use them in order to give a new global sense of the verse by the tonality and the auditory contrast."

Getting away, overcoming, release: these were the terms in which Tzara thought. Despite all the fervor of destruction associated with Dada, and all the havoc he meticulously pioneered, he was in search of something most Dadaists sought: clarity and equilibrium. He made this explicit in a statement, "End of Dada," printed as an insert for a limited number of copies of *Seven Dada Manifestos* in 1924—inconveniently timed, since that's when the whole enterprise came crashing down. Speaking surreptitiously, out of the ruins, what he has to say is confidential, not a manifesto. Making an appeal to the strong and the weak, the healthy and the sick, he tells them that if they read his book, they'll be cured. Everybody's nuts, so logic has to go by the wayside: there's neither good nor evil; everything is permitted. One can only strive for the zero point. "Indifference is the sole legal and effective drug, indifference without effort, without consequence."

The indifference of which Tzara wrote in "End of Dada" was a touchstone for Hausmann and others in Berlin, who'd found it persuasively elaborated in the concept of "creative indifference" extolled by Mynona—that is, Salomo Friedländer, Hausmann's personal friend. He had even spent a long vacation with him in 1916, fervently working through the concept. Hausmann's term *Presentism* owes an obvious debt to Friedländer, who'd published "Presentism: The Earth-Emperor's Address to Humanity" in *Der Sturm* in 1913. In the piece, the primal earth spirit of the title avows itself to be extrahuman: "not a person, I am nobody and everyone, indifferentist." Situating himself at a central point of nullity—"*I am the imperial nothing*"—the earth emperor

breathes an inspirational sort of nihilism with his claim, "I have expunged all the opposites within me, gaining power thereby."

Even if they didn't know Mynona's philosophy, Dadaists intuitively carried around the nugget of insight he propounded, where the neutral point in which opposites dissolve makes peace with the ever-propagating stuff of the universe, leaving in its wake a kind of Buddhist tolerance for ungovernable profusion. There have always been writers, thinkers, creative spirits whose imaginations soar beyond, into a realm where the wisecrack cavorts with the gem of wisdom. Dada added an element previously unexplored: it was *collective*. Dada was simultaneously composed of a hundred-headed Hydra, in which one of the heads was always "Anonymous." How convenient, then, that creative indifference would be the brainchild of a man who forged his nom de plume by spelling anonymous backward.

Collectives are hard to sustain, especially when the inspirational germ is as free spirited as Dada. Dada thrived for all of five months in Zurich, then kept fitfully sparking back into life over the next two-plus years. The momentum it picked up in Berlin kept it going there for two and a half years. In Cologne, by contrast, it barely got off the ground, managing two exhibitions and a sputter of one-off periodicals. In Paris, to the increasing annoyance of all involved, it motored on for two years before the wheels started to come off the vehicle. In Holland, it was an "invasion" lasting less than a month. In New York, it was an afterthought, while in the Balkans and elsewhere in Eastern Europe, it was more like a slow burn in a roadside culvert, sparked by a discarded cigarette.

Given the volatile temperaments of the personalities who created and were faced with sustaining Dada, it's a marvel it lasted longer than a wild weekend. But Dada wasn't something you could become or join (despite the hawking ads of Club Dada in Berlin). Dada was just something you *were*.

Surveying the post-Dada activities of the principals, it's hard not to conclude that their involvement with the movement put them in a league unto themselves. Dada left them invigorated for life, as if they'd been to the grail temple and tasted the elixir. For most of them, that elixir included the magic potion of longevity. Philippe Soupault lived to the ripe old age of 93, and Georges Ribemont-Dessaignes made it to 90. Both Hannah Höch and Marcel Janco reached 89, Hans Richter 88, Man Ray 86. Takahashi Shinkichi,

self-proclaimed Dada of Japan, also lived to 86. Despite enduring exile in middle age, Hans Arp, Max Ernst, Raoul Hausmann, and Walter Mehring all lived to be 85. Richard Huelsenbeck, Johannes Baader, and Marcel Duchamp lived beyond 80. Beatrice Wood, sweetheart of New York Dada, takes the cake, reaching 105. For a generation in which only 5 percent achieved that age, you'd have to say of Dada it was something in the water.

By comparison, John Heartfield, Francis Picabia, and André Breton, who lived to be 70 or more, died relatively young. Tristan Tzara passed away at 67, as did George Grosz. In a few cases mortality was impacted by circumstance, historical or medical, with Kurt Schwitters gone at 61, Sophie Taeuber at 54, the Baroness Elsa at 52, Theo van Doesburg at 48—and youngest of all, the founder of Cabaret Voltaire, Hugo Ball taken at 41. He was survived by his beloved Emmy Hennings, who only made it to her early sixties.

None of the founders were Dada for life, at least in the sense of continuing to play that particular card. Soon enough, those who'd been the ringleaders and creative mojos were on to other things. But most of them still kept a flame lit in a private sanctuary of memory and imagination. Few could divest themselves of Dada as cleanly as Picabia, who tossed off a parting bon mot: "When I've finished a cigarette I'm not one for keeping the butt."

Given the timing of Dada, and the relative youth of those involved, it meant they were destined for a harrowing ride through the midcentury calamities that pulled the avant-garde and everything else into a maelstrom. For those who made a Beatrice of Dada's destruction, what lay ahead were a series of bumps, rough landings, and, to a surprising degree, happy endings—all ahead of the curve of more woeful destructions that lay ahead on the world stage.

When Ball finally wrenched himself free from Dada in 1917, he plunged into an alternate life. He was burning with projects, which he pursued with singular zeal. At first he devoted himself to political causes, joining the radical newspaper *Die Freie Zeitung* in Bern, while back in Zurich Dada played out its final act. In 1919 he published a substantial book, *A Critique of German Intelligence*, in which he diagnosed the authoritarian streak in his native land with unflinching probity.

Soon, however, Ball would turn from politics back to his lifelong lodestar: religion. Ball and Hennings finally married in 1920, and he eventually

reaffirmed the Catholic faith of his upbringing, embarking on a study of the early church fathers and publishing a well-received scholarly tome, *Byzantine Christianity*, in 1923. He became close to the writer Hermann Hesse, author of the wildly popular *Demian* and *Siddhartha*. Ball did not live to read Hesse's *Steppenwolf* (1929), but shortly before he died of stomach cancer in 1927, his book *Hermann Hesse: His Life and Work* appeared in time to celebrate his friend's fiftieth birthday.

That same year Ball's *Flight Out of Time*, a compendium of his Dada diaries, was published, one of the most thoughtful and revealing books of its era and almost the only record of what went on at Cabaret Voltaire. Ball was regarded as a local saint by the mountain folk in the canton of Ticino, Switzerland, where he lived out his final years. "Death is the one credible condition of perfect indifference," he wrote, "and this is the prerequisite of all philosophizing." In the end, he left philosophizing behind, choosing instead the devotional path, but the terms of his devotion were inscribed in the heart of the Dada he helped define in the first place: "One must be astonished totally, yet more and more softly. This is how eternity wonders at the times and changes them. One must wonder at the wonders. And also at the wounds, the deepest and last wounds, and elevate them to the wondrous."

Arp cherished the memory of Zurich's "Dadaland" and regarded Ball as one of the great German writers. He credited his friend with revealing the "magic treasure" that "connects man with the life of light and darkness, with real life, the real collectivity." Over the years, Arp penned tributes to his companions like epigrammatic fairy tales. "The stars write at an infinitely slow pace and never read what they have written."

Arp claimed to have learned how to read all over again as an adult. His own oneiric poems christened the good ship Surrealism before it was launched. With the Surrealists he had a special fondness for puns and the untranslatable slippage inside a language, like the title of his book of poems *Weisst du schwarzt du*. It plays on the words for black and white while seizing on the fact that the verb "to know" (wissen) takes the second-person form *weisst* (weiss means "white"), matching it by making a verb of the word *black* (*schwarzt*): "Do you know do you black" doesn't begin to translate this nimble title. Arp indulged his inimitable spirit of linguistic play equally in German

and French, and when he and Taeuber moved to France in 1926, he switched Hans for Jean.

It's a testament to Arp's seemingly guileless character that he was able to straddle incompatible artistic tendencies. During the twenties and thirties, he was a member of the Surrealists, while at the same time participating in a group of abstract artists, the Abstraction-Création. Jean Hélion, one of its organizers, recalled with awe: "Arp left our group of strict abstractionists, who had very nasty things to say about Surrealism, and joined Breton and his cronies at the Cyrano, a café near the Place Pigalle. He managed this very smoothly, without a clash and without so much as a thought that it might be considered treasonous."

No doubt Arp's unpretentiousness helped him navigate between competing artistic shoals like these. But amidst the rivalries of artistic schools, his constant pledge was to nature, to simplification. "Sometimes we learn to 'understand' better by observing the motion of a leaf, the evolution of a line, a word in a poem, the shriek of an animal, or by creating a piece of sculpture." Increasingly, the sculptures he created aspired to be anonymously and unobtrusively deposited into the world. Carola Giedion-Welcker—a Swiss friend and champion of Arp, Max Ernst, James Joyce, and others—tellingly juxtaposed a photo of snow on a creek bed with his sculpture *Human Concretion* to make the point. His is simply the part that won't melt.

Giedion-Welcker, a devoted chronicler of advanced art and literature, also commemorated the unique interior design of a renovation project that brought Arp and Taeuber together with van Doesburg. This was the Aubette, a historical building on Place Kléber, the grandest square in Strasbourg, in which "surely those who had the good fortune to dance in this modern prehistoric cavern moved not merely to the sounds of jazz, but were also inspired by the visual vitality and rhythm of Arp's creations," she recalled, "reaching out like monumental tentacles." Emmy Hennings compared the effect to that of "the lamp with which Aladdin lighted the marvelous cave."

The renovation project came about because of Taeuber. She was still an instructor at the Zurich School of Applied Arts, a post she'd held since 1916 when Cabaret Voltaire was just getting started. Her own art developed slowly but surely, and by 1925 she was on the jury of the monumental International Exposition of Modern Industrial and Decorative Arts in Paris, famous for consolidating Art Deco as a reigning design style. Everything in Taeuber's

work—ranging from puppets and textiles to drawings, reliefs, gouaches, and interior design—reflected her magnanimous personality, which resonates in the advice she gave her goddaughter. "I think I have spoken enough to you about serious things," she wrote, "which is why I speak of something to which I attribute great value, still too little appreciated—gaiety. It is gaiety, basically, that allows us to have no fear before the problems of life and to find a natural solution to them."

Taeuber's upbeat sensibility infused the Aubette renovation from the beginning. The owners had asked her to remodel the building. The job was lucrative enough to enable her and Arp to move to Paris afterward, where she designed and oversaw the decor of their own house with his and her studios. For the Aubette, Arp decked out the café with biomorphic "toadstool trees" on the walls; Taeuber derived colors and shapes from the wall paintings of Pompeii for the tearoom and foyer bar.

Van Doesburg, meanwhile, seized on the project as the perfect forum in which to implement the De Stijl aesthetic he'd been promoting for years in his journal. Intent as he was on architecture, he'd had few opportunities to undertake a major project. After the redesigned Aubette was opened in 1928, he lost no time in devoting an entire lavishly illustrated issue of De Stijl to it. Soon after the Aubette's reopening, however, he was distressed to find that its clean geometrical design met with resistance. The waiters were sprucing up the place with colored lights and artificial flowers to make it seem cozy: "The public is not ready to leave its 'brown' world," he lamented, "and stubbornly rejects the new 'white world.'"

Van Doesburg impetuously—and unfairly—took the lion's share of the credit for the redesigned Aubette. The popping colors and the overall look have an unmistakable feel of De Stijl, for sure, but Arp and Taeuber had been steadfastly working in a similar vein before De Stijl was under way. The blending of their styles was seamlessly achieved in the Aubette, van Doesburg's claims of credit to the contrary.

Taeuber chafed under van Doesburg's use of the Aubette to promote his own career, neglecting to mention the preponderant role she and Arp played. It must have been challenging for Arp and Taeuber, in light of all this, to end up building their house in Meudon outside Paris, just up the street from Theo and Nelly van Doesburg. Initially, it had been planned as a duplex for both couples, but the Aubette project put an end to that prospect.

As Taeuber noted, van Doesburg was desperate for the kind of attention the Aubette began to garner for him; during a trip to Barcelona, he was received with standing ovations as a pioneer of modern design. But it was not to last. He died in March 1931 of a heart attack brought on by a bout of asthmatic bronchitis. He was only forty-eight.

The final issue of *De Stijl* commemorated van Doesburg's life and work. In it, Schwitters recalled the striking impression made by his friend during the Holland Dada tour: "Standing on the stage in his tuxedo, with an elegant black dicky and a white bow tie, wearing his white powder and monocle, his features maintaining an imperturbable seriousness, Doesburg already seemed every inch the Dadaist, illustrating his own maxim, 'Life is an extraordinary invention.'"

As fate would have it, Taeuber, too, died an early death, though not before an absorbing, productive, and happy decade with Arp in Meudon, where they were active in several organizations devoted to abstract art. The cause of abstraction was becoming increasingly politicized during those years. Unlikely as it may seem, the simple act of distributing rectangles and triangles and circles and squares over a canvas could be regarded in some quarters as an assault on civilization. In his introduction to the catalogue of the 1936 exhibit, *Cubism and Abstract Art*, at the Museum of Modern Art, Alfred Barr dedicated the event "to those painters of squares and circles (and the architects influenced by them) who have suffered at the hands of philistines with political power"—adding, in a sobering footnote: "As this volume goes to press the United States Customs has refused to permit the Museum of Modern Art to enter as works of art nineteen pieces of more or less abstract sculpture under a ruling which requires that sculpture must represent an animal or human form."

It was a fraught moment. Art thought to deviate from mimetic norms was persecuted simultaneously in the United States (as nonart), in the USSR (as an "infantile disorder of Leftism"), and in Nazi Germany (as artistic Bolshevism). No wonder French painter Fernand Léger regarded abstraction as "a dangerous game that must be played."

It was not their pursuit of elementary purification that got Arp and Taeuber into trouble, though, but rather global warfare. The outbreak of World War II made them refugees, like so many other artists. They hoped

to come to America, but couldn't get visas. Luckily Picabia's former wife Ga-
brielle took them in, then Peggy Guggenheim, before they made their way to
the safety of Switzerland, reestablishing their lives in a setting that at least
was familiar, unlike the fate of so many others.

The war was not what ultimately cut short Taeuber's life, however. On
a January night in 1943—with the war raging all around the Alpine nation
once again, as it had in 1916 when Ball compared it to a cage of canaries—
Taeuber was staying in Zurich at the home of her artist friend Max Bill,
signing lithographs. Tired at the end of the day, she opted to stay overnight,
where an inadequately ventilated bedroom led to her asphyxiation from a
leaking gas stove.

Taeuber's death was a debilitating blow to Arp, who poured out his grief
in poems for years to come, somehow retaining his innate sense of wonder
in the face of tragic loss. "You painted the clarity that makes the heart beat,"
he wrote, "the sweetness that stirs the lips." The unforeseen end made itself
felt as part of the composition:

> You departed clear and calm.
> Near you, life was so sweet.
> Your final painting was done.
> Your brushes neatly arranged.

Arp lived on for decades in a perpetual swoon of artistic ripeness. A late
photo shows him in his studio, surrounded by sculptural dollops, "concre-
tions" he called them, as if they were figments of a buoyant imagination
compelled by the twinkle of a divine eye to settle on earth as large smooth
chunks of marble, merging anonymously into a world of glacial effluvia pour-
ing down as if detached from passing clouds into Alpine meadows, settling
into the mossy turf to prove that some lumps take only a spring to be worked
back into the sum, while others require millennia.

The resolute simplicity and purity of Arp's art stands in sharp contrast to
that of Schwitters—at least as far as what meets the eye. Both men were
simple souls at heart, fond of laughter, devoted to the natural world. They
had been cosigners (with Moholy-Nagy and Ivan Puni) of a "Call for Elemen-
tary Art" in 1921. Arp was astonished, and tickled, by the nonchalance of his

friend. On one occasion Arp tossed aside a collage in frustration. With this dismissive gesture, the collage passed from art to trash, Schwitters promptly claimed the trash, as he was wont to do. With Arp's permission, he turned it upside down, pasted "a little bit of Merz in one corner," and signed his name to it, converting it from trash back to art. On another occasion Arp observed Schwitters struggling with a piece of glass that wouldn't quite attach to a construction. Asked what he was going to do, Schwitters responded: "Put up the price."

Schwitters persisted with his ever-expanding Merzbau, in which there was naturally a grotto dedicated to Arp and another to Taeuber. Even so, there was no falling off in his production of portable artworks and writing. Fairy tales especially rustled up into the light of day with their unmistakable Schwitters touch. One of them filled a whole issue of *Merz* in 1925, a typographic tour de force done in collaboration with van Doesburg and Kate Steinitz. It was a simple tale about a scarecrow, composed like a cartoon in which letters provide visual animation. Most of Schwitters' fairy tales were written texts without any ostentatious visual dimension, but they swell in the imagination like the main character of "He," a tale published in *Der Sturm* in 1927. The story begins in medias res: "In the meantime he had become a fully grown man." The crucial word is *grown* (*ein ausgewachsener Mensch*), and that's what he does incessantly for eight or nine pages. He is conscripted into the military where his unceasing growth becomes a tactical liability, so he's jailed until his expansion bursts the prison asunder and in the process crushes the entire army. Court-martialed, he gets the death sentence, "guilty because he had refused to reduce himself." His magnitude, however, makes it impossible to procure adequate means to execute him, and in the end he obeys the order to drown himself.

"He" is a parable reflecting the unchecked inflation of the Deutschmark during the early years of the Weimar Republic, but it's also a dark premonition of the remilitarization in the Third Reich. "He's a little too tall to order about," an officer grimly observes. Schwitters was apolitical by nature—that's what kept hard-line Berlin Dadaists like Grosz and Heartfield from welcoming him into their ranks—but that didn't mean he had no opinions. Quite the opposite. In "National Art" (1925), published in the Flemish journal *Het Overzicht*, he squarely addressed the issue of art in the service of, and in opposition to, the state. "There's art, and also nations and proletariat, but

no national or proletarian art," he argued. "Unfortunately there are nations. The consequence of nations is war. National art should serve the feeling of human togetherness, known as a nation. National art helps the preparation for war," he soberly concluded.

Before long, Schwitters' ideas earned him some very dangerous enemies. In 1934 he was visiting Moholy-Nagy in Berlin, when the formidable Futurist F. T. Marinetti was in town. Both men were invited to a celebratory banquet for the Italian. Moholy didn't want to go, being under threat of possible arrest, but, out of friendship, he went with Schwitters.

The fête was grand and grotesque, filled with Nazi high command. Hitler wasn't there, but Göring and Goebbels were. Seated between the director of the National Socialist Organization for Folk Culture and the leader of the "Strength Through Joy" movement, the artists' discomfort could only be relieved by the plentiful liquid spirits on hand. Moholy began to be alarmed when Schwitters, lit up by the alcohol, began declaring to their tablemates that he, too, had something to offer in the spirit of strength through joy. Worse, he played the race card: "I'm Aryan—the great Aryan MERZ. I can think Aryan, paint Aryan, spit Aryan." It was a desperate, drunken impulse that could only escalate suspicion about his Dada affiliations. Not that there was any reason to single out Dada from all the rest of modern art isms. In the eyes of the Nazis, it was all unredeemable filth.

Schwitters was a marked man, and he sensed it. Nevertheless, in 1935 he smuggled microfilm photos of Hitler posters in Hanover defaced by resisters to Tzara in Paris, who saw to their publication. Had Schwitters been identified as the source, of course, the Gestapo would have dealt with him summarily.

Schwitters took annual vacations in Norway through the decade, alerted to the uniqueness of the country by Höch. Each summer he traveled the fjords, paying for the trip by painting conventional (that is, marketable) landscapes and portraits. On the day after Christmas, 1936, he finally fled his homeland as signs of impending danger became all too clear. Apart from his prominence as a "degenerate" artist, Schwitters was an epileptic, and the Nazis had placed the malady high on their list of "hereditary diseases" to be exterminated by exterminating those afflicted. Schwitters was accompanied by his son Ernst, taking up residence in Norway as political refugees—and not a moment too soon. Only days after their departure, the Gestapo came

knocking with a warrant for his arrest. He heard about it from wife, Helma, who'd stayed behind to care for her elderly parents. He and Ernst were never to see her again. Learning of her death in 1945, Schwitters would reflect, "That was my best friend for all time gone."

The Norwegian exile lasted until spring 1940. Ernst described their subsequent flight from the invading German army. Twice they were arrested, and twice escaped. "In spite of these setbacks," wrote his son, "his sense of humor never left him. For two unforgettable months he had travelled through Norway by land and water, often across the ever-advancing front lines, carrying in one pocket a small piece of sculpture in birch wood and, in another, two white mice."

Eventually Schwitters and his son made their way to England, and after some time in an internment camp on the Isle of Wight, they were released. A small cadre of artists in London welcomed Schwitters, but he was impoverished and life was miserable anyway in the city during the blitz. He ended up in Ambleside in the Lake District, just a few miles south of William Wordsworth's cottage outside Grasmere, fabled center of English Romanticism. In Norway he'd spent three years working on a new Merzbau, and now here in England a third arose in a stone barn. The original in Hanover, alas, was obliterated in an Allied bombing raid on the night of October 8, 1943.

After the war, in June 1946, Schwitters was astonished to receive a letter from his old friend Raoul Hausmann. He fired back a reply, detailing the plight of his exile, and signing it, "Love, MERZ." They struck up a correspondence that's both touching and chastening to read, not least because they communicated in English—a passable if sometimes odd English. Both men felt German to be compromised, and both had been in exile long enough to feel as comfortable, if not more so, using another language. "I think that you are like me in a state," he wrote Hausmann, "that you can no more speak propper German, but do not really propper speak any language."

The friends reflected on their time in and out of Dada. Hausmann revealed the constraints he felt working within that rubric. "I am absolutely conform with you, that we have to go far off from early dada, but you shall retain, that in my means were many things, dada never understood." Schwitters, ever focused on art, came up with a wonderful and concise epigram: "A play with serious problems. That is art"—and, one could add, that is Dada. As the friends warmed to mutual admiration, Schwitters courteously

suggested Hausmann was "an important member of the avantgarde. You are much consequenter than I myself."

Early in his exchange with Schwitters, Hausmann detailed his penury ("I had no farthing for living") and his physical woes ("I am nailed in bed"). Schwitters responded with sympathy and disclosures of his own. "I am 59. But I cannot run, I have high bloodpressure. In the moment I am allmost without teeth, because they had to come out, otherwise I would have died." On October 10 he described how, the previous year, "I had to lie [in bed] first 5 weeks, then 3 weeks for falling on my leg. After that I had to lie in bed for 5 weeks with a flu. But I was blind 2 weeks and needed 3 months recovering."

Things got worse for Schwitters. Two days after composing his October 10 letter, he broke his leg and was bedridden again. Despondent, he backed out of a project he and Hausmann had hatched to make a magazine called *Pin*, and a paranoid Hausmann suspected scoundrels in Paris had set Schwitters against him. It took some effort to get their exchange back on track.

The end came far too swiftly. On November 22, 1946, Schwitters wrote sadly to Walter Gropius, former Bauhaus director now at Harvard, "I would like to see once USA. Who would invite an old lad, who cannot walk, as I?" Barely able to drag himself around, he nonetheless kept working away in the freezing Merzbau barn until he collapsed. Bedridden for the last time, he wasted away through December, finally dying in his sleep on January 8, 1948. Ironically, the previous day he had been awarded British citizenship.

Despite the maladies he had enumerated to Schwitters, Hausmann lived on for several more decades following the death of his friend. The long interval between the end of Dada in Berlin and the time he got in touch with Schwitters was varied and productive. His ill-fated affair with Hannah Höch finally sputtered out in 1922. "He needed constant encouragement in order to be able to carry out his ideas and achieve anything at all lasting," she recalled decades later. "If I hadn't devoted much of my time to looking after him and encouraging him, I might have achieved more myself."

After he and Höch broke it off, Hausmann's need for female support seems only to have escalated. In addition to his wife, he had another constant female companion through the twenties, and when the Hausmanns ended up in exile during the Third Reich, a young Frenchwoman named Marthe Prévot rounded out the trio for the last thirty years of his life. "I see in him

only the artist, the friend of animals and nature," she told Hans Richter after Hausmann's death, "an extraordinarily sensitive being of the greatest tenderness." Richter was amazed that his old Dada companion could "set up house with two women within a monogamous society (and often without any financial means)."

For a few years after Dada, Höch and Hausmann were both close to Schwitters, and both were in and out of the Berlin studios of Lissitzky, Moholy-Nagy, Richter, and others. On her own, Höch took periodic vacations on the coast with the Schwitters family, where Schwitters introduced her to a Dutch artist, Till Brugmann, with whom she developed a lesbian relationship that lasted many years. The couple lived for a time in Holland, where they could often be found in high spirits with Theo and Nelly van Doesburg, at least until the van Doesburgs moved to Paris in 1924. But Brugmann proved to be as overbearing as Hausmann had been, Höch found, and they split up after a decade.

Höch lived the rest of her long life in Berlin. Everything was different under the Nazis, and she had to be vigilant not to reveal anything to her neighbors about her Dada past. Dada was vilified most triumphantly at the 1937 exhibition of so-called degenerate art, which opened in Munich then traveled around the country, parading a vast corpus of modern masterpieces. Twice Höch attended this slanderous show in Munich, where she observed the whole panorama of modern art, past which crowds filed speechless, astonished, and "disciplined" as she put it. The exhibit was arranged to taunt and besmirch, with Dada a prominent target, yet she saw no indication that those attending were anything but reverent.

As the malignancy of the Third Reich expanded, the whole configuration of Europe began to fracture, from East to West, sending people everywhere into exile, internal and external. Even before France was invaded in 1940, the flight from Paris was under way. For the Surrealists led by André Breton, there was a wholesale relocation to New York, transforming it into a capital of the avant-garde.

Max Ernst was among those who made it to New York, but not without harrowing detours. After the complexities of the ménage à trois with Paul and Gala Éluard, he had settled into Paris just in time to ride the wave from Dada into Surrealism, becoming for much of the twenties *the* Surrealist

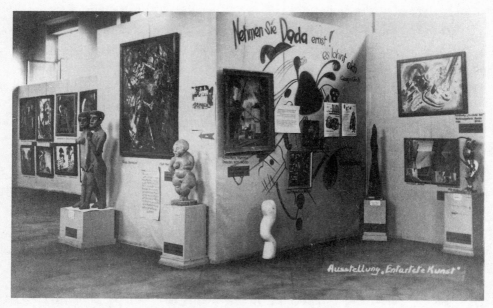

Degenerate Art Exhibition, Munich, 1937. The Nazis took an original Dada slogan, "Take Dada seriously," and splashed it mockingly across the wall.

bpk, Berlin / Kunstbibliothek, Staatliche Museen, Berlin / Art Resource, New York.

artist, especially through the medium of his collage books. Breton, ruling the group with a capriciously iron hand, was always in danger of alienating allies and friends, so maybe it's a testament to the thick hides of former Dadaists that so many of them appear in a group portrait of Surrealists from 1932. Arp, Tzara, Ernst, Éluard, and Man Ray—along with Breton—make up all but three of the men in the picture. Dalí is there in the middle, at the time a wunderkind of the movement, while behind him is the painter Yves Tanguy and writer René Crevel. Ten years after the torments of the second Dada Season in Paris, here was the aging but still youthful face of Dada.

The 1930s had been a productive decade for Ernst. Vacationing in the Swiss Alps with Alberto Giacometti in 1935, Ernst wrote that the two men were "afflicted with sculpture-fever" while extracting granite blocks from a glacial moraine. "Wonderfully polished by time, frost and weather, they are in themselves fantastically beautiful," he observed. "Why not, therefore, leave the spadework to the elements and confine ourselves to scratching on them

the runes of our own mystery?" It sounds like he was channeling the voice of Arp. A year earlier Tzara wrote, "No one better than Max Ernst has understood how to turn the pockets of things inside out." He, like Arp, Ernst, and Schwitters, maintained a fidelity to whatever the world itself tossed up. If there are pockets, where art is concerned, why not pick them? Let nature do the work. The artist only needs eyes, and as a famous Surrealist montage suggests (to say nothing of Duchamp's "anti-retinal" conviction), not even eyes. Imagination suffices for seeing into the heart of things. Seeing into the heart of things, regrettably, doesn't correlate with the way political winds blow. Before long, Max Ernst would be caught in the crosshairs of his native homeland.

The thirties was a decade of expansion for Surrealism, with outposts established in Prague, Brussels, and London. In the English capital, Ernst met a young writer named Leonora Carrington. As with Gala, it was a classic head-over-heels plunge into erotic enthrallment.

Ernst's relationship with Carrington blossomed as Breton took aim at Paul Éluard and demanded that the Surrealists, one and all, renounce him. This was more than Ernst could bear after all they'd been through together. Splitting with Surrealism, he and Carrington moved to the south of France, buying a dilapidated farmhouse north of Avignon in Saint-Martin-d'Ardèche, where they undertook a wholesale sculptural renovation of the exterior, a kind of three-dimensional update of the frescoes he'd applied to the interior of the Éluard household long ago. But this was 1938, and time was running out.

As soon as hostilities were declared in September 1939, Ernst was interned as an enemy alien. Only in December, through the intervention of Éluard, was he released. But soon the German invasion was at hand, leading to further arrests.

Despite all odds, Ernst survived. Twenty years later, the still-astonished voice of friend and early biographer John Russell reflected on the ignominy of his plight and his fortitude:

In May 1940 Max Ernst was taken away in handcuffs, like a common malefactor. For the rest of the year, he was to live through adventures as labyrinthine as anything in *Candide*—but with the different that the governing forces behind them were in no way Voltairean. How he was

interned, managed to escape, got back to Saint-Martin, was denounced and re-arrested, and escaped again only to find that his petition for release had been accepted and he was legally free—all this can be presented as a story of ingenuity and self-command: but what it amounted to in fact was the harrying of someone who, as his friend Joë Bosquet said, had for many years "borne the terrible burden of walking ahead of a whole generation." It would be an act of inhumanity to play up the hairbreadth escapes of that period, when the real drama lay in the artist's return to Saint-Martin to find that before leaving the region Leonora Carrington had been crazed by his departure to the point of selling his house for a bottle of brandy, so that in the winter of 1940–41 he was alone and homeless in a countryside where nearly everyone had turned against him.

Miraculously, Ernst would survive the war in spite of his many trials and losses. Not all of his fellow Dadaists would have such harrowing adventures, but history weighed on them nonetheless.

As Ernst underwent these potentially lethal ordeals, Tzara was in the same region in the south of France, active in the French resistance movement along with Éluard. Tzara, after all, had more to lose than either of them, adding the category of Jew to the stigma of vanguard artist and Communist.

Tzara's adherence to the party was shared with Wieland Herzfelde and brother John Heartfield, who would live out the rest of their lives behind the Iron Curtain in East Germany while Tzara remained in Western Europe. Arp may have had Tzara in mind when, after the Second World War, he observed: "Some old friends from the days of the Dada campaign, who always fought for dreams and freedom, are now disgustingly preoccupied with class aims and busy making over the Hegelian dialectic into a hurdy-gurdy tune. Conscientiously, they mix poetry and the Five Year Plan in one pot; but this attempt to lie down while standing up will not succeed. Man will not allow himself to be turned into a scrubbed, hygienic numeral." From the perennial viewpoint of pacifist Switzerland, it would always be hard for Arp to come to terms with the demands of political commitment.

Tzara's political commitment—an extension of the irascible determination with which he led the Dada charge—would be sustained after the war, though he continued to write poetry that could hardly pass as "committed"

in the conventional sense, and he nurtured, with devotional zeal, his growing collection of African art, which gave resolve to the anti-colonialist position he held for decades. His collection was housed in the striking modernist house built for him (with the financial means of his wealthy Swedish wife) by Viennese architect Adolf Loos, who'd famously declared ornament a crime and extolled a theme dear to Tzara's heart: "If human work consists only of destruction, it is truly human, natural, noble work."

It was in this house, in Montmartre, where Tzara met his end in 1963, younger than most of his colleagues in Dada, but full of years in terms of lived experience. What he wrote in a eulogy to Schwitters could apply as well to him: "He is among those who have decapitated the haloed capital A from the word *art* and have placed this word again on the level of human manifestations."

From the outset, Tzara had been a fastidious documentarian of the Dada movement, but he was a junior member, generationally speaking, and by the time he was thirty, Dada was far behind him. By the time of his death from lung cancer, Tzara had been in and out of the Surrealist movement headed by Breton; the French Dadaists could be described as Surrealists who didn't know it yet. Indeed, an unfortunate aftereffect of the rise and long reign of Surrealism is that Dada got haplessly appended to it, as if it were little more than a staging ground for the main event. (This phrasal tic was perpetuated in numerous exhibitions, starting with "Fantastic Art, Dada, Surrealism" at the Museum of Modern Art in 1936, and revisited at MoMA in 1968 with "Dada, Surrealism, and Their Heritage." As late as 2009 there was a large "Dada e Surrealismo" exhibition in Rome. In 1971 the journal *Dada/Surrealism* made its debut. Although it subsided in 1990, it was resurrected under the same title in 2013. So the afterlife of that two-headed calf continues.)

Tzara's rival, Huelsenbeck, likewise issued a veritable gusher of documents, compendia, manifestos, and historical overviews of Dada, beginning soon after he carried the sacred word like a delicate robin's egg into the cauldron of Berlin in 1917. And life overtook Huelsenbeck, too, as he was drawn into the professional roles of physician, novelist, and foreign correspondent. The popular paper *Berlin Illustrirte Zeitung* sent him to China in 1928, providing material for his travel book *Der Sprung nach Osten* (The Leap to the East) and a novel, *China frisst Menschen* (China Devours People). Further

assignments sent him to Haiti, Cuba, and the United States. He was expelled from the Writer's Union in 1933 when Hitler came to power and spent several anxious years trying to emigrate.

Finally, in 1936, Huelsenbeck and family were admitted into the United States. He'd been preceded by George Grosz, and both men fervently made themselves over into their own versions of the typical American. Grosz's fierce satires were replaced by bucolic nature studies, and in his revisionary autobiography—*A Little Yes and a Big No*—Dada was demoted to a relatively minor episode. Huelsenbeck became Richard Hulbeck, practicing existentialist psychotherapy. In the 1950s he was determined to remake Dada in the image of existentialism, then all the rage. After retirement he spent his remaining years in Switzerland, like a homing pigeon returning to the foundational experience of his life in the land of Dada.

Tzara and Huelsenbeck may have ended their lives far apart, but distance didn't heal their relationship. The two had been sniping away at each other practically from the beginning of Dada. Their rivalry was exacerbated by the fact that the German's *Dada Almanac* made Huelsenbeck a prominent archivist and authority on the movement, while Tzara was increasingly caught up in the turmoil of the Parisian scene.

Hostility between Tzara and Huelsenbeck came to a head when, a quarter century later, American artist Robert Motherwell thought it would be useful to assemble a dossier of primary Dada documents for the English language market. Max Ernst suggested that Tzara might contribute an overview of the subject, and the next year while Arp was visiting New York, a scheme was set in motion to produce a collective "Dada Manifesto 1949" to be signed by a half dozen or more of the living Dadaists.

The problem began when Huelsenbeck was asked to produce a text for "Dada Manifesto 1949." Upon seeing it, the others dropped out one by one, and then Tzara dropped the bombshell: if it were included, he would refuse permission for his own contribution—"Introduction to Dada"—to share the pages of the collection. Huelsenbeck was likewise distressed by the refusal of the others to sign his manifesto.

It took considerable diplomacy behind the scenes for Motherwell to arrive at a solution. The book would include neither Huelsenbeck's "Dada Manifesto 1949" nor Tzara's "Introduction to Dada." Instead, they would be printed as twenty-five-cent pamphlets to be sold separately. (Only when *The*

Dada Painters and Poets was reprinted by Harvard University Press thirty years later, in 1981, were these two contentious texts included in the book itself, where they remain to this day, consigned to the back of the bus, seated side by side between the bibliography and the index.)

Since Tzara and Huelsenbeck composed their essays independently, there's no formal give and take, no evident point of contention between the two. Both men assume the high ground. "Dada was born of a moral need," wrote Tzara, the need of a particular generation to extricate itself from the unfolding calamity of "notions emptied of all human substance, over dead objects and ill-gotten gains." Huelsenbeck made the same point from a slightly different angle: "The misunderstanding from which Dadaism suffered is a chronic disease that still poisons the world. In its essence it can be defined as the inability of a rationalized epoch and of rationalized men to see the positive side of an irrational movement."

So what led to the fuss, what raised the ruckus? It didn't help that way back in 1920 Huelsenbeck had publically dismissed Tzara in his *Dada Almanac*, saying he "had himself enthroned, anointed and elected pope of the world Dada movement." As for Tzara, he persisted in his narrow understanding of Dada as a literary affair ("a brief explosion in the history of literature"), one that was moreover inseparable from the Surrealism that succeeded it.

The trouble arose from Huelsenbeck's presumptuousness in speaking on behalf of others (though admittedly asked to do so). "Dada Manifesto 1949" makes repeated references to its "signers" and "the undersigned," though of course no signature but his own remained by the time it was published in 1951. Near the end, he writes: "Previous Dada manifestoes have been documents of accusation. This last Dada manifesto is a document of transcendence." Bravo for the thought, but it turned out to be prelude to a parting shot. There followed a seemingly neutral "Note": "For reasons of historical accuracy, the undersigned consider it necessary to state that Dadaism was not founded by Tristan Tzara at the Cabaret Voltaire in Zurich." Ouch.

To have passed so swiftly from the claim that this manifesto transcended previously accusatory tactics, to unscrupulous insistence on "historical accuracy," contravened the whole spirit of Dada, which had always been cavalier about facts. And then there was the unresolved business of patrimony, which already by 1922 had grown so fraught that Hans Arp came up with the

deliriously Dadaist solution of proclaiming Tzara's priority because he, Arp, could attest to having been there with his dozen children ("only imbeciles and Spanish teachers bother about dates," he added). What it came down to was this: Do you want the truth? Or do you want the myth? It's the old tale that continues to haunt every human endeavor. It later became immortalized in the film *Who Shot Liberty Valance?* Replace James Stewart and John Wayne with a pint-sized Rumanian and a sneering German, and John Ford's classic Western is a parable of Dada.

Dada's history was up for grabs, but calling it "history" was compromised by the backstory of Motherwell's anthology. Living Dadaists, it seemed, were too invested in their own versions of Dada to compromise. But as time went on, the snarl of contentions receded, and in any case the chronicle awaited another teller.

Hans Richter was up next as participant-historian of Dada. Because his participation was transitory if vital, his investment in tending the flame savors friendship over rivalry. Already in Zurich, as soon as he met Viking Eggeling, he was off in pursuit of the "ground bass," the master figure or signature of universal validity. That led him into explorations of new media, and as the twenties went on he became a filmmaker. He had a hand in organizing a seminal cinema festival, "The Absolute Film," in Berlin in 1925, and he was tapped to organize the film section of the large and innovative "Film and Photo" exhibition in Stuttgart in 1929, leading to his book *Enemies of Film Today—Friends of Film Tomorrow.*

Before he was forced to flee Germany, Richter made about two dozen films, among them *Ghosts Before Breakfast,* in which a world of inanimate objects becomes animated, thanks to trick photography. He also made topical documentaries, like *The New Dwelling* and *Russia and Us.* Resettled in the United States, he found a community of aging fellow Dadaists and other exiles from Europe on hand, willing to dress up for episodic forays into Dadaland in films like *Dreams That Money Can Buy, 8 x 8: A Chess Sonata,* and *Dadascope.* During this time he was writing *Dada: Art and Anti-Art,* published in Germany in 1964 and the following year in English translation. It was a commissioned work, and he was encouraged to think of it in part as a showcase of texts and images. In the end the publisher insisted on cutting

about sixty pages, some of which provided the basis for an exhibition he prepared for the Goethe Institute in Munich two years later.

Enlivened by Richter's personal acquaintance with most of the key figures, *Dada: Art and Anti-Art* remains in print to this day. Much of its value reflects the geographical and historical distance that, at the time of writing (almost fifty years later), gives his account an air of impartiality. His subtitle (not used) for the original German version reflects his outlook: "Contributions to the Cultural Development of the Twentieth Century." He had few axes to grind, no pony in the race, just a store of memories seasoned by long friendship, revisited with a discerning eye. He felt obliged to end with a chapter on Neo-Dada, a phrase and an outlook that had recently come into vogue to refer to happenings and Pop art. He was curious but skeptical. "It is pointless to employ a shock effect that no longer shocks," he observed, even as he conceded that each generation must have its own avant-garde.

The past was another story. As one of the original participants, Richter knew that *that* story would always be dominated by personal memory. Yet he was gentle with the memories, knowing that memory is never infallible, but the stories that emerge tell their own kind of truth. "From the beginning," he wrote, Dada was "replaced by a thoroughly blurred mirror image of itself. Since then even the mirror has broken. Anyone who finds a fragment of it can now read into it his own image of Dada," reflecting the personal viewpoint of the beholder. "Thus Dada has become a myth." Myth, legend, history, memory: How do we find the trail of crumbs through the forest that would lead us back to Dada? To reprise a refrain, only the Oberdada knows—and he's not telling.

Afterword

THE AFTERLIFE OF DADA

The founders of Cabaret Voltaire in 1916 watched as their world was destroyed by the Great War. As Dada flickered into life amidst this calamity, its adherents invested it with all their hopes for the future. They clung to Dada with the tenacity of shipwreck survivors on a life raft, even as they reeled with memories of a vanished culture.

Outraged by a world tearing itself apart while mouthing traditional pieties, the Dadaists responded in kind, brandishing destruction as a creative weapon. Realizing there would be no return to normal life after the hostilities ceased, the Dadaists assaulted any lingering fantasy of normality. Yet despite their principled reaction to the insanity of the Great War, the label of nihilism has stuck to Dada, not to the military and political leaders who sanctioned the carnage.

Ezra Pound was among the first to accurately appraise the legacy of Dada: "They have satirized the holy church of our century (journalism), they have satirized the sanctimonious attitude toward 'the arts' (toward the arts irrespective of whether the given work of art contains a communication of intelligence). They have given up the pretense of impartiality." Pound realized, more acutely than anyone outside the Dada movement at the time, that the press deserved a lashing, that "art" merited its comeuppance; and that in a world gone haywire it made no sense to profess impartiality. You picked your

battles and lived with the consequences. Pound admired the Dadaists for having done just that.

Dada was a model of what became known as "committed" art and literature in the politically fraught thirties. But Dada rarely allowed its commitments to look conventional. Its iconoclasm was unlimited, and only in the unique circumstance of the November Revolution in Berlin was a political platform embraced by Dadaists (and then, only by a few). Dada iconoclasm was predictably diagnosed as irreverent, juvenile: "jesters in the tragedy of Europe's destruction" they were called. But they recognized, long before it was named, the catch-22 absurdity memorialized in Joseph Heller's novel of the Second World War—a war that gave rise to the word *snafu* (acronym for "situation normal, all fucked up"). Dada was first to survey that convoluted terrain.

Dada helped create other memorable landscapes, as well. A year after his appraisal of Dada, Pound was living in Paris, where Picabia was a close friend. When T. S. Eliot gave him the draft of a poem called "He Do the Police in Different Voices" to look over, Pound took his scissors to it in true Dada fashion, helping its author produce *The Waste Land*, the most influential poem of the twentieth century.

Critics were incensed by *The Waste Land*, much as they had been with Dada. *Time* magazine cynically profiled Eliot's poem under the headline, "Has the Reader Any Rights Before the Bar of Literature?" Suggesting *The Waste Land* was a hoax, the reviewer compared it to *Ulysses*, in which "Joyce had taken some half million assorted words" and "shaken them up in a colossal hat"—reprising (without mentioning, possibly without knowing) Tristan Tzara's formula for producing a Dada poem. An English reviewer called Eliot's poem "so much waste paper," consigning it to that rubbish heap from which Kurt Schwitters extracted such unfathomable loveliness.

Other observers, however, saw in *The Waste Land* the same kind of microbial life that people had identified in Dada years before. Eliot's friend Conrad Aiken, for one, recognized that the poem succeeded precisely "by virtue of its incoherence." Aiken saw a furtive exhortation smuggled into *The Waste Land* not by the author but by the shambles of modern civilization—an exhortation pungently expressed in the title of a 1984 Talking Heads album: *Stop Making Sense*. As the Dadaists recognized from the beginning in Zurich, the

sort of sense made by rational decisions to butcher an entire generation in combat was unacceptable.

For Dada, everyday effluvia proved an admirable mirror for whatever art was expected to reflect back to society. Their art was not about artistry. Chance and choice sufficed. Embracing everything, Dada validated the lowly and the unofficial, redeeming the whole category of rubbish. In the case of Schwitters, this meant literal street refuse like discarded tram tickets and broken bicycle wheels, while Marcel Duchamp optioned hardware like a bottle rack or a shovel, augmented only by the titles he applied. Both artists revealed that curiosity and ingenuity have no natural limits.

As this redeeming sensibility migrated out from Dada, the entire world of "worthless" stuff was revealed as a teeming warehouse. American poet John Ashbery recognized in this domain "a language which existed before Dada and has always existed," although "the way back to this language is what Dada forcibly laid bare." It's the language of creative innocence glimpsed by Hugo Ball when he saw the Dadaists as swaddling babes of a new Gnostic sect. Simon Rodia probably never heard of Dada while building his Watts Tower, and the French postman Ferdinand Cheval couldn't have, because he completed his backyard Palais Idéal before Cabaret Voltaire was founded, but these are among the artists and homespun monuments that now take their place in the lineage of Schwitters and his Merzbau. The carnivalesque assault of the 1920 Berlin Dada Fair likewise became a prototype for major museum and gallery exhibitions in which the artwork is assimilated into a total environment.

Dada's recognition of the inherent artistic potential of rubbish and clutter, wreckage and chaos has had an enduring impact on subsequent artwork in every medium. As the twentieth century wore on, the iconoclastic animation of Dada would make it a vital source of inspiration for artists of all stripes. Far from being strictly a medium of destruction, Dada proved itself capable of being an inspiration, a progressive force.

Enduring features of the Dada toolkit are irreverence and ingenuity, an indifference to cultural estimations of high and low, a penchant for interactive environments, and the mixed-media outlook that anthropologist Claude Levi-Strauss identified with the handyman (*bricoleur*). Given the inherent

conservatism of cultural institutions, these were the very ingredients that could only be assimilated furtively by lone artists or small groups.

It was only much later, after the Second World War, that the impact of Dada could be assessed. Robert Motherwell's anthology was an important historical resource in America, and in 1952 the French writer and curator Michel Tapié published *Un art autre* (Another Kind of Art), in which he took Dada to be the starting point for a great artistic emancipation. Thanks to Dada, he thought, there would be no more isms, no need for collaborative battering rams pounding away at officious and haughty institutions. After Dada, he said, "there is only adventure by the individual."

Yes, Dada was collective, historically speaking. But the individual prevailed, and this book has charted the divergent and idiosyncratic course of figures unparalleled in their individuality: Hugo Ball, Tristan Tzara, Raoul Hausmann, Kurt Schwitters, Francis Picabia, Marcel Duchamp—come to think of it, there's not a compliant, anonymously low-key personality to be found in the annals of Dada.

Dada was inseparable from the personal buoyancy and pluck of its individual agents. As it migrated into different contexts by way of these avatars, Dada dissolved like a lozenge in various cultural receptacles, energizing the contents with its own inimitable solution even if nobody knew it was there. After all, what we now know about Dada wasn't always easy to come by. The Dadaists' own irreverence, combined with their penchant for disbursing misinformation, troubled the picture for decades.

Take the Beatles: their album cover of *Sgt. Peppers Lonely Hearts Club Band* looks like a Dada soirée, but they topped that with *The White Album*, a gesture of pure retraction that could only work in the hands of the most famous musicians in the world. *The White Album* is a testament to the large blank deposited by Dada, a reminder that retraction and creation are reciprocal. Nothing is created from scratch. To create always absorbs or destroys something else. The virgin blank of the page is scored with marks (like the ink splatter of Picabia's *Virgin Saint*); the whiteness of the canvas is muddied with color; the ball of clay is remorselessly mutilated by the human torso emerging from it.

These examples pertain to the arts, but the Dadaists like so many modernists wanted the arts to spill over into life. Denouncing art as a form of commerce, they blurred and overran boundaries so you could never tell when

or where art might hit you—or whether it was art at all. This turned out to be a fertilizing indeterminacy.

Denouncing the notion of art as sanctuary, the Dadaists made it a practical medium of rebirth and resurrection, an agent in the arduous task of coming back to life, getting a fresh start in the wake of historical trauma. That didn't stop them from using art as a weapon to bludgeon any resurgent regression and oppose any return to the ahistorical solace of some hoped-for Shangri-La.

While it's easy to overemphasize Dada aggression, it's also important to recall its humor, however sharp edged. That humor could be glimpsed in Walter Mehrings adaptation of ancient Greek drama for a marionette spoof of the Weimar Republic, or Tzara's plays in which body parts strut about the stage mouthing inanities, a pastiche of the body politic. Dada had an affinity with slapstick, though Dadaists were hardly alone in their adoration of Charlie Chaplin. Perhaps the Marx Brothers, rather than Chaplin, offer the closest match. Being the same age as Schwitters, Hausmann, and other Dadaists, the Marx Brothers were veterans of vaudeville, a venue embraced by Dada in its origins with Cabaret Voltaire. *Duck Soup* (1933), with its send-up of war and the political posturing of international diplomacy, may be the purest apparition of Dada by non-Dadaists. "Get me headquarters, not hindquarters"—a line from a battle scene—could be straight out of a Berlin Dada skit, as well as: "Remember you're fighting for this woman's honor, which is more than she ever did!" Humor with an edge was also innate in Kurt Schwitters' poems and tales. It's easy to imagine Anna Blume on a joyride with Groucho or Harpo.

It can be challenging to distinguish the actual influence of Dada from its rumored legacy. Adjectives like *Dadaist* and *surreal* come easily to mind for many who know nothing of the history behind the terms. It can also be hard to estimate how much concrete information informed activities seemingly indebted to Dada. Comedy collectives like Monty Python and the Firesign Theatre have a clear affinity with the Dada spirit, but by the time they got under way in the 1960s, Dada was historically remote and not nearly as well documented as it is now: legacy (something in the air) or influence (transmission by contact)?

In art, demonstrable traces of Dada are everywhere, especially in the do-it-yourself sensibility that resists the entitlements of professionalism, polish, and credentials. Schwitters' nurturing relation to rubbish became an

inspirational model, enabling an artist like Robert Rauschenberg to get out from under the suffocating burden of Abstract Expressionism, with its heroic posturing. When Rauschenberg first encountered Schwitters' work at the Janis Gallery in 1959—after he'd famously mounted a car tire on a stuffed goat in one of his "combine" paintings—the American said of the inventor of Merz, "I felt like he made it all just for me."

The embrace of raw materiality was a godsend to Josef Beuys. The thrall of mass media publications provided postwar artists like the Englishman Richard Hamilton and the American James Rosenquist a cornucopia of primary materials ready to hand for Pop art. Behind the swirling provocation of urban graffiti from which Jean-Michel Basquiat emerged, stands the graffiti-styled doodles of George Grosz (the German artist would've admired Basquiat's early street pseudonym SAMO, for "same old shit"). Extending the list of examples would overwhelm an epilogue. The short form says it best: to quote the Dadaists themselves, Dada triumphs, and its triumph was sufficient to its own time and place.

In its own time, Dada's triumph wore the visage of its individual exponents. But the Dada spirit would migrate, its virgin microbe infecting later generations. As pundits began attributing characteristics of Dada to later artists, it was not always welcomed. The term *Neo-Dada* emerged in the late 1950s, though many of those to whom it was applied, like Daniel Spoerri in Europe and Allan Kaprow (pioneer of happenings) in America, took it to be derogatory—as in "old hat," "done before," "why bother?" They had a point: but to think of Dada as just another art movement with a bag of perishable tricks is to misapprehend Dada altogether, which tended to unravel whenever it took on the characteristics of a movement. That's why it foundered in Paris, as Tzara tried to maintain its integrity in the face of Breton's congress on the "modern spirit." Dada, Tzara insisted, was not *modern*. That didn't mean Dada was ancient, or immune to its moment. Quite the contrary, Dada was all about the moment, not the monument. In his 1918 manifesto, Richard Huelsenbeck called Dada "the most primitive relation to surrounding reality," with its "audacious everyday psyche."

As the world changed, so did Dada's influence. During the Cold War, the baleful historical pressures that gave rise to Dada had a comparable impact on another generation. The "anti-art" orientation of Dada was no longer a

reproach from the margins. Art Brut, Cobra, Brutalism, Gutai, Kineticism, Lettrism, the Situationist International, Nouveau Réalisme, Semina and the Rat Bastard Protective Association, Fluxus, Viennese Actionism, Arte Povera: this global roll call of art initiatives spawned during the Cold War bears the imprint of Dada, as if Dada were the angel of history envisioned by Walter Benjamin, helplessly blown into the future with an escalating heap of debris.

If Dada was the creative face of destruction for postwar artists, its influence culminated in 1966 with the Destruction in Art Symposium, organized in London by Gustave Metzger. Metzger, an orthodox Jew, had taken refuge from the Nazis in England in 1939 at age thirteen. As a mature artist, he came to see the prospect of nuclear devastation as more threatening than the Holocaust. He pioneered "auto-destructive" art as "a valuable instrument of mass psychotherapy in societies where the suppression of aggressive drives is a major factor in the collapse of social balance."

Unlike the general tendency to exonerate anything unruly as Neo-Dada, Metzger's therapeutic outlook was faithful to Dada—a response to the Cold War emboldened by Dada's alarm at the Great War. At the London symposium, Yoko Ono gave a talk in which she too reaffirmed the deep pledge of Dada: "The only kind of intentional destruction that I'm interested in at this point," she said, "is a kind of destruction that brings about larger construction."

In addition to Dada's lingering reputation as "nihilistic," the abject materials that Dada artists embraced made cultural institutions wary about handling, let alone preserving, perishables. Also, Dadaists like Arp and Taeuber resisted the egotism endemic in exalted media and the heroic posturing of the artist. Instead, Dada championed the dilettante ("Dilettantes rise up!" was the slogan of Max Ernst's journal *Die Schammade*), defying the culture of obsequious professionalism. Aspiring to topple "art" from its pedestal, Dada inspired a relentless iconoclasm.

All the arts have an inherited vocabulary for minor diversions, like the bagatelle in music, the cartoon in visual art, the limerick in poetry. It's a way of saying, "this isn't really art, but it's fun to goof around from time to time." When Dada treated the minor as if it were the whole show, though, everything changed, not because the "major" modes were demoted but because Dada celebrated the primordial spirit of *play*, as evident on an architect's drafting table as in a game of hopscotch chalked on the sidewalk.

The most pervasive impact of Dada following its demise had little to do with its iconoclasm, its critique of cultural institutions, its politics, or even its agile gamesmanship in artistic circles. Tracing Dada's legacy, the devil is in the details. The cut-up methods of Dada, along with its fertile repurposing strategies, soon permeated culture at large.

Rapid cutting in visual media, the sampling procedures of hip-hop, and the mash-up aesthetic prevalent today are evidence that Dada initiatives continue to thrive in new media. Surfing the Internet resembles a creative practice that Tzara once prescribed: cut up a newspaper article and draw the phrases out of a hat. Lately, the rise of social media sites confirms Tzara's startling twist: *the poem will resemble you*. The recent poetry movement Flarf trawls the Internet for combustible vocabulary, executing Tzara's maneuver with mouse clicks not a top hat.

Another pervasive legacy of Dada is photomontage. As a technical innovation over which Berlin Dadaists squabbled for paternity rights, photomontage was embraced by people indifferent to its origins. In short order it became a basic tool of advertising. If anybody working in a Madison Avenue firm knew anything about Dada, they weren't talking, but they all used photomontage.

That's not the only way modern advertising bears the imprint of Dada, which is also reflected in that medium's nonlinear organization, asymmetry, incongruity, and the use of evocation in place of rational explanation. A magazine advertisement from pre-Dada days offers a straightforward image of the product, cocooned in a fine-print description of its qualities. Look at the same pitch by the 1930s and you may see no product at all. Instead, several seemingly unrelated images may be pinballed into a cockeyed space in which a slogan quivers like an enigmatic tail feather, like something the Baroness Elsa might have promenaded on Fifth Avenue.

Dada dispensed with the logic of the frame and the privileged perspective, ushering in the tactile immediacy that caught Marshall McLuhan's attention in *The Mechanical Bride* (1951). A student of modernism, McLuhan noticed that commercial advertising bore an intriguing structural resemblance to the most "advanced" literature. The consumer responded subliminally to advertising strategies that were visually disruptive and no longer addressed to the rational mind. Yet these same strategies encountered in the museum or in a poem were regarded as incomprehensible, even nihilistic. In the end, as

commerce absorbed the tactics of the avant-garde, it was easier to understand everything from a social gesture to an artwork as "advertisements for myself," to use Johannes Baader's title—reprised by Norman Mailer forty years later.

It's widely assumed that Dada brokered the "anything goes" ethos so conspicuous in modern art. The stigma associated with that attitude is that it's no longer about art, but about self-promotion. The wily exploits of the Oberdada, along with the widespread Dada embrace of modern advertising, and the tongue-in-cheek reports of an Alpine duel between Dadaists, all seem indistinguishable from Ben Hecht's bulletins from Berlin, profiling a race between a sewing machine and a typewriter. Myth and truth seamlessly merge in the slaphappy environs promoted by Dada.

But influence is a byzantine process, and cultural fertilization yields surprising offspring. In *Lipstick Traces* (1989), Greil Marcus claimed a Dada paternity for punk rock, but is every seething, indignant amateur a latent Dadaist? Can any sort of dissidence be tallied up on the balance sheet of Dada? Marlon Brando gunning his motorcycle in *The Wild One*? Elvis Presley's swiveling hips? Charles Manson's big ears for "Helter Skelter"? The issue comes down to this: by disavowing programmatic declarations (and spoofing them), Dada opened itself up to any and every claim of affinity. In the culture of narcissism, even the most unsuitable mirror will do.

Dada persists today as our glimpse in peripheral vision and rearview mirror of certain colorful individuals passing swiftly in the street, off to destinations almost unimaginable from a twenty-first century vantage. Temporality crunches the numbers, and in the end, historical difference prevails. The gap widens between us and them. Yet something in the air lingers, persisting beyond all the smoke and mirrors, the pranks and hoaxes— some quest for a better outcome, a more humane disposition, something like Hugo Ball's sage advice: "Let us be thoroughly new and inventive. Let us rewrite life every day."

ACKNOWLEDGMENTS

This project could not have been completed without the patient exactitude of my editor, Alex Littlefield. Kate Mueller's scrupulous attention to the text, word by word, extended my appreciation of the charmed circle at Basic Books. My wife, Suzi Wong, read what I thought was a final draft and convinced me it wasn't. Without the resourcefulness of my research assistants Dan Citro and Gabriel Lovatt, there would be neither pictures nor notes. Thanks above all to my agent, Andrew Stuart, who took me by surprise during a phone conversation when, seemingly out of the blue, he asked whether I'd be inclined to write a history of Dada.

The notes attest to sources quoted in the text, but it's beyond the limits of this volume for any comprehensive documentation of all the resources from which I benefited. A general shout out, then, is owed to the thriving world of Dada scholarship, without which this book would not exist.

NOTES

Translations from other language sources are mine unless otherwise credited in the bibliographic citations. Full bibliographic details are given only with the first citation. A "Bibliographic Resources" following this list summarizes useful resources.

INTRODUCTION

- x **Of making many books:** Ecclesiastes 12:12, King James Version.
- x **Dada is daring per se:** Richard Huelsenbeck, ed., *Dada Almanac* (London: Atlas, 1993), 44.
- x **Self-kleptomania is the normal:** Robert Motherwell, ed., *Dada Painters and Poets*, 2nd ed. (Cambridge, MA: Harvard University Press, 1989), 92.
- x **Dada is the essence of our time:** Hubert F. van den Berg, *The Import of Nothing: How Dada Came, Saw, and Vanished in the Low Countries (1915–1929)* (New Haven, CT: G. K. Hall, 2002), 158.
- x **Dada reduces everything:** Motherwell, *Dada Painters and Poets*, 248.
- x **The true dadas are against DADA:** Ibid., 92.
- xi **To be against this manifesto:** Ibid., 246.
- xi **In principle I am against manifestos:** Ibid., 76.
- xi **creative indifference:** Ibid., 43.
- xi **elasticity itself:** Huelsenbeck, *Dada Almanac*, 11.
- xi **Dada, a scarecrow:** Motherwell, *Dada Painters and Poets*, 167.
- xi **virgin microbe:** Ibid., 95.
- xi **We were a very naughty group:** Lucy Lippard, ed., *Dadas on Art* (Englewood Cliffs, NJ: Prentice-Hall, 1971), 70.
- xiii **dancing epidemic . . . parts of the world:** Dawn Ades, ed., *The Dada Reader* (London: Tate, 2006), 102.
- xiii **Dada came over the Dadaists:** Motherwell, *Dada Painters and Poets*, 32.
- xiii **One has to be enough of a Dadaist:** Huelsenbeck, *Dada Almanac*, 21

xv **I don't keep the butt:** Francis Picabia, *391* 17 (June 1924), unpaginated [4].

xv **Everyone has become mediumistic:** Hugo Ball, *Flight Out of Time: A Dada Diary*, ed. John Elderfield, tr. Ann Raimes (New York: Viking, 1974), 108.

CHAPTER ONE: CABARET VOLTAIRE

1 **I have difficulty in feigning . . . a creature of air:** Hugo Ball, *Flight Out of Time: A Dada Diary*, ed. John Elderfield, tr. Ann Raimes (New York: Viking, 1974), 27.

2 **We've got contortionists:** Hugo Ball, *Briefe 1904–1927*, vol. 1, eds. Gerhard Schaub and Ernst Teubner (Göttingen, Germany: Wallstein, 2003), 92.

3 **Young artists of Zurich:** Ball, *Flight Out of Time* 50.

4 **the world's only hygiene:** Umbro Apollonio, ed., *Futurist Manifestos* (New York: Viking, 1973), 22.

4 **nothing but violence:** Ibid., 23.

5 **poems you can roll up:** Ball, *Flight Out of Time* 25.

5 **The demonic no longer:** Ibid., 12.

5 **I think in opposites:** Ibid., 21.

5 **I never bring all my forces:** Ibid., 23.

5 **The stamp of the times:** Ibid., 26.

5 **I tend to compare:** Ibid., 30.

6 **it is we, the poets and thinkers:** Ibid., 29.

6 **self-help:** Ibid., 45.

6 **Make your own existence:** Ibid.

7 **Her voice hops across:** Annabelle Melzer, *Dada and Surrealist Performance* (Baltimore, MD: Johns Hopkins University Press, 1994), 28.

7 **I never felt at ease:** Hans Richter, *Dada: Art and Anti-Art*, tr. David Britt (New York: Abrams, 1965), 26.

7 **I was ashamed:** Hans Richter, *Encounters from Dada till Today*, tr. Christopher Middleton (Los Angeles County Museum of Art, 2013), 53.

7 **She looked at me somewhat suspiciously:** Friedrich Glauser, "Dada-Errinerungen," *Als Dada Begann*, ed. Peter Schifferli (Zurich: Sanssouci, 1957), 26.

7 **Emmy, you're tipsy:** Ibid., 27.

8 **Ball was such a rare person:** Ibid., 28.

8 **the opposite of a happy man:** Bernhard Echte, ed., *Emmy Ball Hennings 1885–1948: "ich bin so vielfach . . .": Texte, Bilder, Dokumente* (Frankfurt am Main: Stroemfeld, 1999), 122.

8 **He pleads for stronger rhythm:** Ball, *Flight Out of Time*, 51.

9 **The Gorgon's head:** Ibid., 56.

9 **pig's bladder kettle drum:** *Blago Bung Blago Bung Bosso Fataka! First Texts of German Dada by Ball, Huelsenbeck, Walter Serner,* tr. Malcolm Green (London: Atlas, 1995), 55.

9 **Things have really gone too far:** Ibid., 82.

10 **They were weapons . . . My first canvas of exorcism:** Jack Flam and Miriam Deutch, eds., *Primitivism and Twentieth-Century Art: A Documentary History* (Berkeley: University of California Press, 2003), 33.

10 **fixed ecstasy:** Carl Einstein, "Negro Sculpture," tr. Charles Haxthausen and Sebastian Zeidler, *October* 107 (Winter 2004), 137.

10 **tragic-absurd dance . . . the horror of our time:** Ball, *Flight Out of Time,* 64–65.

11 **great matadors:** Hans Arp, *On My Way: Poetry and Essays 1912–1947* (New York: Wittenborn, 1948), 45.

12 **The Cabaret Voltaire was a six-piece band . . . with all his soul:** Richter, *Dada,* 27.

12 **the safety-valve was off:** Ibid., 57.

14 **Straight lines and honest colors:** Arp, *On My Way,* 50.

14 **a picture or a sculpture without any object:** Ibid.

14 **the ineffable tenderness:** Echte, *Emmy Ball Hennings,* 135.

14 **wish to lead a simple life:** Ades, *The Dada Reader,* 33.

14 **in which all difficulties . . . spirituality has returned to us:** Ibid., 43.

15 **Pull down thy vanity!:** Ezra Pound, "Canto LXXXI," *The Cantos* (New York: New Directions, 1995), 541.

15 **Arp speaks out against:** Ball, *Flight Out of Time,* 53.

15 **recommends plane geometry:** Ibid.

15 **concerned not so much with richness:** Ibid.

16 **The star of the cabaret:** Ibid., 63.

16 **even the commonplace:** Ball, *Flight Out of Time* 53

17 **What more is possible? :** William Butler Yeats, *The Autobiography of William Butler Yeats* (New York: Macmillan, 1953), 210

17 **Everyone has been seized:** Ball, *Flight Out of Time,* 51–52.

17 **Our attempt to entertain:** Ibid., 54.

17 **As long as the whole city:** Ibid., 57.

17 **The cabaret needs a rest:** Ibid.

18 **worked out as a problem . . . living human beings:** Ibid., 54.

18 **The image of the human . . . for similar reasons:** Ibid., 55.

18 **Adopt symmetries:** Ibid., 56.

18 **The distancing device:** Ibid.

18 **What we are celebrating:** Ibid.

20 **What can a beautiful, harmonious poem:** Ibid., 58–59.

20 **My equanimity when first subjected . . . in fact, by comparison:** Wyndham Lewis, *Blasting and Bombardiering: An Autobiography (1914–1926)*, (London: Calder, 1982), 33.

20 **You will be astonished to find:** Ibid., 4.

21 **Where the honny suckle wine . . . oh yes yes yes:** "L'amiral cherche une maison à louer," *Cabaret Voltaire* (1916), 6–7.

21 **he could feel my breasts:** James Joyce, *Ulysses* (New York: Vintage, 1990), 783.

22 **the value of the voice . . . the mechanistic process:** Ball, *Flight Out of Time*, 59.

22 **Our cabaret is a gesture . . . winning our respect:** Ibid., 61.

22 **they cannot persuade us:** Ibid., 67.

22 **The remarkable thing . . . Tzara against Arp, etc.:** Ibid., 63–64.

22 **They are men possessed:** Richter, *Dada*, 20.

23 **Tzara keeps on worrying:** Ball, *Flight Out of Time*, 63.

23 **My proposal to call it 'Dada':** Ibid.

23 **a sign of foolish naïveté:** Ibid., 63.

23 **virgin microbe:** Robert Motherwell, ed., *Dada Painters and Poets*, 2nd ed. (Cambridge, MA: Harvard University Press, 1989), 95.

24 **The Dadaist loves the extraordinary:** Ball, *Flight Out of Time* 65.

24 **no longer believes . . . the point of self-disintegration:** Ibid.

24 **There is a gnostic sect . . . babes-in-arms of a new age:** Ibid., 66.

25 **gentle simplicity surprised the audience . . . we welcomed the child:** Ibid., 65.

25 **We are Rimbaudists:** Ibid., 68.

25 **long, gigantic, and rational:** Arthur Rimbaud, *Complete Works, Selected Letters*, tr. Wallace Fowlie (Chicago: University of Chicago Press, 1966), 307.

26 **seek out the absolute:** Ball, *Flight Out of Time*, 86.

26 **What we call dada is a farce . . . the bloody pose:** Ibid., 65–66.

26 **We have now driven the plasticity . . . magical complex image:** Ibid., 67.

26 **magic bishop:** Ibid., 71.

26 **witch doctor's hat:** Ibid., 70.

27 **gadji beri bimba:** Ibid.

CHAPTER TWO: MAGIC BISHOP AND MR. ASPIRIN

29 **new tendency in art:** Hugo Ball, *Flight Out of Time: A Dada Diary*, ed. John Elderfield, tr. Ann Raimes (New York: Viking, 1974), 220.

29 **Dada Tzara, dada Huelsenbeck:** Ibid.

30 **How does one achieve . . . saying dada:** Ibid.

30 **I let the vowels fool around:** Ibid., 221.

30 **Dada is the heart of words . . . the first importance:** Ibid.

30 a thinly disguised break . . . they felt so too: Ibid., 73.

30 Has the first manifesto: Ibid.

30 It is with language that purification: Ibid., 76.

30 Becoming a human being is an art: Ibid., 81.

31 Dada is our intensity . . . in consequential bayonets: Robert Motherwell, ed., *Dada Painters and Poets*, 2nd ed. (Cambridge, MA: Harvard University Press, 1989), 75.

31 Dada remains within: Ibid.

31 in principle I am against manifestos . . . against principles: Ibid., 76.

32 couldn't do anything . . . one scream: Giorgio J. Wolfensberger, ed., *Suzanne Perrottet, Ein Bewegtes Leben* (Bern: Benteli, n.d.), 135.

33 the extraordinary quality: Walter Sorell, ed., *The Mary Wigman Book* (Middletown, CT: Wesleyan University Press, 1975), 35,

33 A person's proper aim . . . festive being: Martin Green, *Mountain of Truth: The Counterculture Begins, Ascona 1900–1920* (Hanover, NH: University Press of New England, 1986), 97

33 There was always Laban . . . the grinning faun!: Sorell, *Mary Wigman Book*, 33.

33 Into this rich field . . . went together: Hans Richter, *Dada: Art and Anti-Art*, tr. David Britt (New York: Abrams, 1965), 70.

33 It was very stormy . . . married life: Cleve Gray, ed., *Hans Richter by Hans Richter* (New York: Holt, Rinehart and Winston, 1971), 43.

34 all the cafés with delusions: Evelyn Doerr, *Rudolf Laban: The Dancer of the Crystal* (Lanham, MD: Scarecrow Press, 2008), 66.

34 A gong beat is enough: Ball, *Flight Out of Time*, 102.

34 a poetic sequence . . . penetrating intensity: Ibid.

34 tressli bessli . . . zack hitti zopp: Karl Riha and Waltraud Wende-Hohenberger, eds., *Dada Zürich: Texte, Manifeste, Dokumente* (Stuttgart: Reclam, 1992), 67.

36 I'm a bit distant: Hugo Ball, *Briefe 1904–1927*, vol. 1, eds. Gerhard Schaub and Ernst Teubner (Göttingen, Germany: Wallstein, 2003), 118.

36 No more anti-bourgeois . . . likewise difficult: Ibid., 129.

36 I have a burning desire: Ibid., 130.

36 Are you trying to seduce: Ibid.

37 I won't be involved . . . That's my goal: Ibid., 152.

37 I ran across Tzara: Ibid., 139.

37 Tzara has become . . . not a Dadaist, not 'weary': Ibid., 146.

37 reacquaint myself with Dada: Ibid., 134.

38 Everything had become very distinguished: Debbie Lewer, "From the Cabaret Voltaire to the Kaufleutansaal: 'Mapping' Zurich Dada," *Dada Zurich: A Clown's Game from Nothing*, eds. Brigitte Pichon and Karl Riha (New York: G. K. Hall, 1996), 53.

38 **We have surmounted:** Ball, *Flight Out of Time*, 101.

39 **We stand before the new pictures:** Wassily Kandinsky and Franz Marc, eds., *The Blaue Reiter Almanac* (New York: Viking, 1974), 252.

39 **sound effects . . . hair-raising cacophonies:** Fred Wasserman, "Schoenberg & Kandinsky in Concert," *Schoenberg, Kandinsky, and the Blue Rider*, eds. Esther da Costa Meyer and Fred Wasserman (New York: Jewish Museum, 2003), 20.

39 **In daily life we would rarely:** Kandinsky and Marc, *Blaue Reiter Almanac*, 153.

40 **The artists of these times . . . struggle against madness:** Ball, *Flight Out of Time*, 225.

40 **the strongest affinity:** Ibid.

40 **One should go . . . Kandinsky the monk:** Ibid., 226.

40 **daring purification of language:** Ibid., 234.

40 **They will scarcely be seen:** Ibid., 103.

40 **By day it is a kind of teaching body:** Ibid., 112.

41 **Negro music and dance:** Richard Huelsenbeck, ed., *Dada Almanac* (London: Atlas, 1993), 24.

41 **It must have looked strange:** Ball, *Flight Out of Time*, 106.

42 **if poets had to cut their poems:** Ibid., 41.

42 **nourished the emaciated . . . glow of a star:** Ibid., 68.

42 **Artistic creation is a process . . . effect is magic:** Ibid., 104.

42 **We are playing:** Ibid., 109.

43 **modern artists are gnostics:** Ibid., 101.

43 **there is today an aesthetic gnosis:** Ibid., 114.

43 **all contain a philosophy . . . its very own territory:** Ibid., 98.

43 **The painters and poets:** Ibid.

43 **The nervous systems:** Ibid., 108.

43 **Absolute dance, absolute poetry:** Ibid.

44 **It is perhaps not a question:** Ibid., 115.

44 **To understand cubism:** Ibid., 93.

45 **a great artist:** Huelsenbeck, *Dada Almanac*, 110–111.

45 **Discard the Ego . . . made of skins:** *Flight Out of Time*, 29.

45 **Hardly anyone has exceeded . . . rather, my laughter:** Ibid., 191.

45 **I realized that the whole world:** Ibid.

CHAPTER THREE: FANTASTIC PRAYERS

48 **bedding down on a volcano:** Richard Huelsenbeck, *Memoirs of a Dada Drummer*, ed. Hans J. Kleinschmidt, tr. Joachim Neugroschel (New York: Viking, 1974), 52.

49 **None of us had much appreciation:** Robert Motherwell, ed., *Dada Painters and Poets*, 2nd ed. (Cambridge, MA: Harvard University Press, 1989), 23.

49 **If you had the money . . . sparrow stew:** Anton Gill, *A Dance Between Flames: Berlin Between the Wars* (London: Murray, 1994), 6.

49 **city of tightened stomachers:** Motherwell, *Dada Painters and Poets*, 39.

49 **I felt as though I had left:** Ibid.

49 **Germany always becomes the land:** Ibid.

49 **We consider everything Expressionism . . . a new skin color:** Huelsenbeck letter.

50 **I tried to invent new flowers:** Arthur Rimbaud, *A Season in Hell*, tr. Louise Varèse (New York: New Directions, 1961), 87.

50 **We who are new:** Friedrich Nietzsche, *The Gay Science*, tr. Josefine Nauckhoff (Cambridge, UK: Cambridge University Press, 2001), 246.

50 **No one knew what exactly:** Robert Musil, *The Man Without Qualities*, tr. Sophie Wilkins (New York: Vintage, 1996), 53.

50 **The new man transforms:** Richard Huelsenbeck, "Der neue Mensch," *Neue Jugend* 1 (May 1917), 3.

51 **the new man, the pioneer:** Alexandra Richie, *Faust's Metropolis: A History of Berlin* (New York: Carroll & Graf, 1998), 310.

52 **We all hung like Absalom . . . world catastrophe:** Ludwig Meidner, Extracts from "Aschaffenburg Journal," *Ludwig Meidner: An Expressionist Master* (Ann Arbor: University of Michigan Museum of Art, 1978), 32.

53 **July had beaten my brains . . . jigging in a row:** Carol Eliel, *The Apocalyptic Landscapes of Ludwig Meidner* (Los Angeles: Los Angeles County Museum of Art, 1989), 65.

53 **His ash-blond hair:** Wieland Herzfelde, "Ein Kaufmann aus Holland," *Pass Auf! Hier Kommt Grosz: Bilder, Rhythmen und Gesänge 1915–1918* (Leipzig: Reclam, 1981), 65.

53 **Being German always means:** George Grosz, *Briefe 1913–1959*, ed. Herbert Knust (Reinbek, Germany: Rowohlt, 1979), 44.

53 **Every Shot Hit the Spot:** Andrés Mario Zervigón, *John Heartfield and the Agitated Image: Photography, Persuasion, and the Rise of Avant-Garde Photomontage* (Chicago: University of Chicago Press, 2012), 78.

53 **Hatred is holy:** Grosz, *Briefe*, 45.

53 **Grosz was a genius of hatred:** Hans Richter, *Encounters from Dada till Today*, tr. Christopher Middleton (Los Angeles: Los Angeles County Museum of Art, 2013), 68.

54 **permanently unfit:** Ralph Jentsch, *George Grosz: Berlin–New York* (New York: Skira, 2008), 66.

54 **I am up to my neck:** Uwe Schneede, *George Grosz: His Life and Work*, tr. Susanne Flatauer (London: Fraser, 1979), 48.

55 unworthy of wearing: Lucy Lippard, ed., *Dadas on Art* (Englewood Cliffs, NJ: Prentice-Hall, 1971), 90.

55 We have created a movement . . . quick action: Hanne Bergius, *Dada Triumphs!: Dada Berlin 1917–1923; Artistry of Polarities; Montages, Metamechanics, Manifestations*, tr. Brigitte Pichon (New Haven, CT: G. K. Hall, 2003), 44.

55 a new international . . . Cubist dances: Richard Huelsenbeck, ed., *Dada Almanac* (London: Atlas, 1993), 111.

55 We were pro-war: Ibid., 112.

56 every hour snatch the tatters: Ibid., 45.

56 The word Dada . . . to be a Dadaist!: Ibid., 46.

57 People accumulated like high waves: Veronika Fuechtner, *Berlin Psychoanalytic: Psychoanalysis and Culture in Weimar Republic Germany and Beyond* (Berkeley: University of California Press, 2011), 154.

58 My abdication: Anton Gill, *A Dance Between Flames: Berlin Between the Wars* (New York: Carroll & Graf, 1994), 14.

58 naturally treated me . . . a secret code: Bergius, *Dada Triumphs*, 37.

58 Each page must explode: Huelsenbeck, *Dada Almanac*, 126.

59 Dada-medical faculties . . . intend to become such: Bergius, *Dada Triumphs!*, 41.

59 What is Dada? . . . a fire extinguisher?: *Der Dada* 2 (December 1919), unpaginated [5].

59 Advertise with Dada!: Ibid., [7].

60 Gautama thought he was: "Legen Sie Ihr Geld in dada an!" *Der Dada* 1 (June 1919), unpaginated.

60 Communist, Poet, and Pirate: Bergius, *Dada Triumphs!*, 69.

61 Superdada, President of the Earth: Johannes Baader, *Oberdada: Schriften, Manifeste, Flugblätter, Billets, Werke und Taten*, eds. Hanne Bergius, Norbert Miller, and Karl Riha (Lahn-Gießen, Germany: Anabas, 1977), 104.

61 Baader was just the man: Raoul Hausmann, *Am Anfang war Dada*, eds. Karl Riha and Günter Kämpf (Lahn-Gießen, Germany: Anabas, 1972), 55.

61 Watch out for Baader: Bergius, *Dada Triumphs!*, 54.

61 Berlin Has New Art . . . art of government: Chicago *Daily News* (May 9, 1919).

62 Stands on His Head . . . attended our evening: Chicago *Daily News* (May 27, 1919).

62 Hindendorf, Ludenburg: Johannes Baader, "Reklame für mich," *Der Dada* 2 (December 1919), unpaginated [6].

62 The new era commences: *Der Dada* 1 (June 1919), unpaginated [1].

62 obligation of all clergy . . . sexual center: Karl Riha, ed., "Was ist der Dadaismus und was will er in Deutschland?," *Dada Berlin: Texte, Manifeste, Aktionen* (Stuttgart, Germany: Reclam, 1977), 61–62.

63 **its author is the Supreme:** Richard Sheppard, ed., *New Studies in Dada: Essays and Documents* (Driffield, UK: Hutton Press, 1981), 150–151.

63 **Each evening these idle hordes . . . for hours on end:** Alfred Döblin, *A People Betrayed*, tr. John E. Woods (New York: Fromm, 1983), 6.

64 **His descriptions of them:** Harry Kessler, *In the Twenties: The Diaries of Harry Kessler*, tr. Charles Kessler (New York: Holt, Rinehart and Winston, 1971), 90.

64 **indefinite, general swooning:** Dawn Ades, ed., *The Dada Reader* (London: Tate, 2006), 89.

64 **The shooting goes on:** Lippard, *Dadas on Art*, 81.

CHAPTER FOUR: DADA HURTS

65 **The masses couldn't care less:** Dawn Ades, ed., *The Dada Reader* (London: Tate, 2006), 84.

65 **the professional arrogance:** Rose-Carol Washton Long, ed., *German Expressionism: Documents from the End of the Wilhelmine Empire to the Rise of National Socialism* (New York: G. K. Hall, 1993), 274.

65 **a large-scale swindle . . . moral safety valve:** Robert Motherwell, ed., *Dada Painters and Poets*, 2nd ed. (Cambridge, MA: Harvard University Press, 1989), 43.

65 **Dada is forever the enemy:** Ibid., 281.

66 **fangs of the bloodsuckers . . . oppose culture and art!:** Anton Kaes, Martin Jay, and Edward Dimendberg, eds., *The Weimar Republic Sourcebook* (Berkeley: University of California Press, 1994), 485, 486.

66 **There is no longer room . . . *Der blutige Ernst*:** Uwe Schneede, *George Grosz: His Life and Work*, tr. Susanne Flatauer (London: Fraser, 1979), 64.

66 **an aesthetic harmonization:** Ades, *The Dada Reader*, 88.

66 **Who is the German . . . our own enemies:** Ibid.

67 **The child's discarded doll:** Raoul Hausmann, *Bilanz der Feierlichkeit: Texte bis 1933*, vol. 1, ed. Michael Erlhoff (Munich: Text + Kritik, 1982), 14.

67 **the simultaneous perception:** Hanne Bergius, *Dada Triumphs!: Dada Berlin 1917–1923, Artistry of Polarities: Montages, Metamechanics, Manifestations*, tr. Brigitte Pichon (New Haven, CT: G. K. Hall, 2003), 14.

67 **cartoons seemed to us:** Frank Whitford, ed., *The Berlin of George Grosz: Drawings, Watercolors and Prints 1912–1930* (London: Royal Academy of Arts, 1997), 13.

68 **The devotion of his art:** Harry Kessler, *In the Twenties: The Diaries of Harry Kessler*, tr. Charles Kessler (New York: Holt, Rinehart and Winston, 1971), 187–188.

69 **an explosion of viewpoints:** Lucy Lippard, ed., *Dadas on Art* (Englewood Cliffs, NJ: Prentice-Hall, 1971), 65.

69 **Great quality guaranteed:** Bergius, *Dada Triumphs!*, 19.

69 **The beauty of our daily life . . . in workshops:** Raoul Hausmann, "PRÉsentismus," *De Stijl* 4: 9 (September 1921), 139.

69 **expressionistic brightly colored . . . clarity of engineering drawing:** Schneede, *George Grosz*, 66.

70 **One cannot understand Dada:** Richard Huelsenbeck, ed., *Dada Almanac* (London: Atlas, 1993), 9–10.

70 **One has to be enough of a Dadaist:** Ibid., 9.

70 **Dada is the scream of brakes:** Ibid., 44.

71 **the international expression:** Ibid., 47.

71 **Something like a public lavatory:** Schneede, *George Grosz*, 58.

71 **you're not going to hand out:** George Grosz, *A Little Yes and a Big No* (New York: Dial Press, 1946), 183.

72 **Beethoven, Bach Are Dead:** Ben Hecht, *Letters from Bohemia* (Garden City: Doubleday, 1964), 136.

72 **melted into the spring night:** Ibid., 137.

72 **no applause:** Ibid., 136.

72 **what compelling examples:** Ben Hecht, Chicago *Daily News* (May 27, 1919).

72 **The 'artists' appear:** Bergius, *Dada Triumphs!*, 62.

73 **There's no cooperative planning:** Richard Sheppard, ed., *New Studies in Dada: Essays and Documents* (Driffield, UK: Hutton Press, 1981), 115.

73 **Since we usually did a bit of drinking . . . that was all:** Grosz, *A Little Yes and a Big No*, 83.

73 **respectable folks . . . spirit of constant profit:** Raoul Hausmann, *Sieg Triumph Tabak mit Bohnen: Texte bis 1933*, vol. 2, ed. Michael Erlhoff (Munich: Text + Kritik, 1982), 17.

73 **libretto machines:** Bergius, *Dada Triumphs!*, 209.

73 **chaotic oral cavity:** Ibid., 104.

74 **the art of hairdressers:** Hausmann, *Sieg Triumph Tabak mit Bohnen*, 49.

74 **We must realize that our customary way:** Hausmann, *Bilanz der Feierlichkeit*, 181.

74 **trains, airplanes, photography:** Ibid., 182.

74 **husband and wife:** Karoline Hille, *Hannah Höch und Raoul Hausmann: Eine Berliner Dada-Geschichte* (Berlin: Rowohlt, 2000), 75.

75 **Right from the beginning:** Ibid., 76.

75 **Which of my friends:** Cornelia Thater-Schulz, ed., *Hannah Höch, Eine Lebenscollage*, vol. 1, part I (Berlin: Argon, 1989), 124.

75 **5 stories, 3 parks, 1 tunnel:** Michael White, "Johannes Baader's *Plasto-Dio-Dada-Drama*: The Mysticism of the Mass Media," *Modernism/Modernity* 8: 4 (2001), 584–585.

75 **architecture of the imponderable:** Bergius, *Dada Triumphs!*, 262.

77 woods and fields and mountains: Johannes Baader, *Oberdada: Schriften, Manifeste, Flugblätter, Billets, Werke und Taten*, eds. Hanne Bergius, Norbert Miller, and Karl Riha (Lahn-Gießen, Germany: Anabas, 1977), 11.

79 an anatomical museum: Harriet Watts, ed., *Dada and the Press* (New Haven, CT: G. K. Hall, 2004), 89.

79 Painted Sabotage: *Entartete Kunst* exhibition catalogue (Munich, 1937), 15.

79 To perfectly grasp this artwork: *Dada-Messe: Katalog* (Berlin: Burchard, 1920), unpaginated.

80 Dadaists on Trial as Army Defamers: Watts, *Dada and the Press*, 412.

80 All Dadaists in the world . . . perversion, and anaesthetics: Ibid., 88–89.

80 What you see in this exhibition: *Dada-Messe: Katalog*, unpaginated.

84 to indicate that human consciousness: Raoul Hausmann, *Am Anfang war Dada*, eds. Karl Riha and Günter Kämpf (Lahn-Gießen, Germany: Anabas, 1972), 20.

84 because, obviously, the spirit: Timothy O. Benson, *Raoul Hausmann and Berlin Dada*, 161.

84 Man is no longer shown . . . the collective community: Whitford, *The Berlin of George Grosz*, 36.

85 free to adopt any mask: Huelsenbeck, *Dada Almanac*, 14.

85 8,590 articles on dada: Ibid., 34.

86 you discover that it is possible: Ibid., 50.

86 Dadaism is thus not an art movement: Ibid.

86 In the fine art of advertising: Ibid., 52.

86 A Kurt Schwitters dressed up: Ibid., 42.

86 Jews out, stomachs in: Ibid., 54.

86 Expressionism . . . land of dumplings: Ibid., 152.

86 the world is only a branch: Ibid., 86.

86 Whatever *dada* is: Baader, *Oberdada*, 75.

CHAPTER FIVE: MERZ

88 home cooking: Richard Huelsenbeck, *Memoirs of a Dada Drummer*, ed. Hans J. Kleinschmidt, tr. Joachim Neugroschel (New York: Viking, 1974), 64.

88 to be against this manifesto: Robert Motherwell, ed., *Dada Painters and Poets*, 2nd ed. (Cambridge, MA: Harvard University Press, 1989), 246.

89 I am a painter: John Elderfield, *Kurt Schwitters* (New York: Thames and Hudson, 1985), 35.

89 I have never spent a penny: Ibid., 146.

90 a cold-blooded, deliberate rape: Gwendolen Webster, *Kurt Merz Schwitters: A Biographical Study* (Cardiff, UK: University of Wales Press, 1997), 37.

92 Essentially, the word Merz: Elderfield, *Kurt Schwitters*, 50.

92 **everything is rubbish:** David Bowie, *Fresh Air*, NPR radio (2002).

92 **it is unimportant whether or not:** Elderfield, *Kurt Schwitters*, 50.

92 **aims at direct expression:** Ibid., 51.

92 **a prayer about the victorious end:** Werner Schmalenbach, *Kurt Schwitters* (New York: Abrams, 1967), 96.

93 **"Kuh Witter":** Kurt Schwitters, *Wir spielen, bis uns der Tod abholt: Briefe aus fünf Jahrzehnten*, ed. Ernst Nündel (Frankfurt am Main: Ullstein, 1974), 75.

94 **a herring skeleton:** Joan Ockman, "Reinventing Jefim Golyscheff: Lives of a Minor Modernist," *Assemblage* 11 (1990), 94.

94 **trash-romantic . . . expressionist genre-art:** Elderfield, *Kurt Schwitters*, 53.

94 **O thou, beloved:** Kurt Schwitters, "Anna Blossom Has Wheels," from *Poems, Performance Pieces, Proses, Plays, Poetics*, ed. and tr. Jerome Rothenberg and Pierre Joris, 16. Copyright © Jerome Rothenberg and Pierre Joris (Philadelphia: Temple University Press, 1993; Cambridge, MA: Exact Change, 2002).

95 **phonetic orgasms:** Walter Mehring, *The Lost Library: The Autobiography of a Culture*, tr. Richard and Clara Winston (Indianapolis: Bobbs-Merrill, 1951), 135.

95 **the humdrum is confronted . . . important personages:** Carola Giedion-Welcker, "Schwitters: or the Allusions of the Imagination," *Magazine of Art* 41: 6 (October 1948), 219.

96 **I am moved by your sympathy . . . health resort:** Webster, *Kurt Merz Schwitters*, 65.

96 **the most revolting piece of writing:** Ibid., 66.

97 **All my parts were back together . . . almost done:** Kurt Schwitters, *Das literarische Werk: Prosa 1918–1930*, ed. Friedhelm Lach (Munich: Deutscher Taschenbuch Verlag, 2005), 25–26.

97 **I was dying to know:** Schwitters, *Poems, Performance Pieces, Proses, Plays, Poetics*, 126.

98 **Schwitters is the Dadaistic genius:** Webster, *Kurt Merz Schwitters*, 63.

99 **It uses as given parts:** Schwitters, *Poems, Performance Pieces, Proses, Plays, Poetics*, 213.

99 **the first to publish:** Ibid., 214.

99 **I'm not Grosz. . . . not Schwitters either:** Webster, *Kurt Merz Schwitters*, 80.

99 **Dada fundamentally and emphatically:** Richard Huelsenbeck, ed., *Dada Almanac* (London: Atlas, 1993), 14.

100 **Today the striving for expression:** Elderfield, *Kurt Schwitters*, 26.

100 **Merz stands for freedom:** Motherwell, *Dada Painters and Poets*, 59.

100 **a windmill, a head:** Ibid., 60.

100 **aims only at art:** Elderfield, *Kurt Schwitters*, 26.

100 **I play off sense against nonsense:** Ibid., 45.

101 **For example, you marry:** Motherwell, *Dada Painters and Poets*, 63.

101 **the just plain baby smell:** Kate Steinitz, *Kurt Schwitters: A Portrait from Life*, tr. Robert B. Haas (Berkeley: University of California Press, 1968), 9.

101 **That's what becomes of the great:** Steinitz, *Kurt Schwitters*, 27.

101 **The interior does not give the impression:** Elderfield, *Kurt Schwitters*, 144.

102 **My ultimate aspiration:** Ibid., 31.

102 **The imitative picture . . . could be:** Ibid., 137.

102 **astral imbecility:** Raoul Hausmann, *Bilanz der Feierlichkeit: Texte bis 1933*, vol. 1, ed. Michael Erlhoff (Munich: Text + Kritik, 1982), 16.

102 **you will recognize . . . bulging fragility:** Timothy O. Benson, *Raoul Hausmann and Berlin Dada*, 80.

103 **the poem makes itself:** Raoul Hausmann, *Am Anfang war Dada*, eds. Karl Riha and Günter Kämpf (Lahn-Gießen, Germany: Anabas, 1972), 13.

104 **Hausmann always gave . . . repressed impulses:** Hans Richter, *Dada: Art and Anti-Art*, tr. David Britt (New York: Abrams, 1965), 139.

104 **A play with serious problems:** Kurt Schwitters letter, August 8, 1946, Getty Research Center, Los Angeles.

104 **You are a type:** Raoul Hausmann letter, September 30, 1946, Getty Research Center, Los Angeles.

104 **There was a woman:** Hausmann, *Am Anfang war Dada*, 68.

104 **I hope he will be undadaistic . . . don't blame me:** Webster, *Kurt Merz Schwitters*, 138.

105 **I'm good company . . . sleep on the floor:** Ibid., 100.

105 **We've got fifteen minutes:** Ibid., 185.

105 **a Song of Songs:** Schmalenbach, *Kurt Schwitters*, 112.

106 **The poet is not a writer . . . poetry is the art:** Ibid., 252, note 4.

106 **Abstract poetry evaluates:** Ibid., 193.

107 **a difficult, roughened:** Victor Shklovsky, *Art as Technique: Russian Formalist Criticism*, tr. Lee Lemon and Marion Reis (Lincoln: University of Nebraska Press, 1965), 22.

107 **he did not stop all day . . . a bit much:** Hausmann, *Am Anfang war Dada*, 67.

107 **I heard Schwitters . . . twelve-tone system:** Schmalenbach, *Kurt Schwitters*, 216.

108 **Schwitters stood on . . . the same generals:** Richter, *Dada: Art and Anti-Art*, 142–143.

108 **I find I incorporate:** Walt Whitman, *Poetry and Prose*, ed. Justin Kaplan (New York: Library of America, 1982), 246.

109 **Unscrew the locks:** Ibid., 210.

109 **They don't realize:** Russell Jacoby, "When Freud Came to America," *Chronicle of Higher Education* (September 21, 2009), accessed online.

CHAPTER SIX: SPARK PLUGS

112 **Food Descending a Staircase:** Marilyn Kushner and Kimberly Orcutt, eds., *The Armory Show at 100: Modernism and Revolution* (New York: New York Historical Society, 2013), 350.

112 **I always keep my word:** L. Frank Baum, *The Patchwork Girl of Oz* (Chicago: Reilly and Britton, 1913), 106.

113 **nuttists, dope-ists:** Frederick Opper, "The 'New Art' Fest," *New York American* (February 27, 1913), 20.

114 **for the elimination of thought:** *The Bookman*, vol. 35 (March 1, 1912), 15.

114 **diabob . . . these diabobs, perhaps:** Gelett Burgess, *Burgess Unabridged: A New Dictionary of Words You Have Always Needed* (New York: Frederick A. Stokes, 1914), 14.

114 **a lifetime given to the study:** Kenyon Cox, "The New Art," *Documents of the 1913 Armory Show: The Electrifying Moment of Modern Art's American Debut* (Tucson, AZ: Hol Art Books 2009), 22.

114 **the deification of Whim:** Ibid., 21.

114 **victims of auto-suggestion:** Ibid., 20.

114 **no longer a matter of sincere fanaticism:** Ibid., 21.

115 **irresponsible nightmares:** Frank Jewett Mather Jr., "Old and New Art," *Documents of the 1913 Armory Show*, 47.

115 **essentially epileptic:** Ibid., 43.

115 **one's feeling . . . more exciting than a lady:** Ibid., 42.

115 **a clever hoax:** Ibid., 45.

115 **Everyman Jack of them:** *Chicago Evening Post*, "The Great Confusion," *Documents of the 1913 Armory Show*, 28.

115 **We are in an anaemic condition:** Steven Watson, *Strange Bedfellows: The First American Avant-Garde* (New York: Abbeville Press, 1991), 177.

115 **It makes us live:** Ibid., 172.

115 **When one leaves this exhibition:** Ibid., 175.

116 **Picabia, Art Rebel:** Maria Lluïsa Borràs, *Picabia* (New York: Rizzoli, 1985), 107.

116 **It is in America that I believe . . . an open mind:** William Camfield, *Francis Picabia: His Art, Life, and Times* (Princeton University Press, 1979), 43.

116 **the most national things:** Watson, *Strange Bedfellows*, 307.

117 **qualitative conception:** Camfield, *Francis Picabia*, 50.

118 **musical emotion:** Ibid., 25.

118 **emulating the musicians:** Ibid., 45.

118 **I paint only the conception:** Judith Zilczer, "Music for the Eyes," *Visual Music: Synaesthesia in Art and Music Since 1900* (London: Thames and Hudson, 2005), 38.

118 **I am still groping:** Simon Shaw-Miller, *Visible Deeds of Music: Art and Music from Wagner to Cage* (New Haven, CT: Yale University Press, 2002), 124.

118 **pure visual music:** Arthur Jerome Eddy, *Cubists and Post-Impressionism*, rev. ed. (Chicago: McClurg, 1919), 117.

118 **This new expression . . . comparing it to music:** Camfield, *Francis Picabia*, 50.

118 **a song of colors . . . motifs of symphonic music:** Borràs, *Picabia*, 106.

118 **I improvise my painting:** Ibid., 111.

118 **just as music is only a matter:** Ibid., 109.

118 **It was Bill Nye:** Ibid.

118 **memories of America:** Camfield, *Francis Picabia*, 60.

119 **remarkably large . . . fluent English and German:** Borràs, *Picabia* 108.

119 **for us what the alphabet is:** Ibid., 110.

119 **Did I paint the Flatiron:** Ibid., 107.

119 **the mental fact or emotive fact:** Ibid.

119 **Creating a painting without a model:** Ibid., 110.

119 **You New Yorkers can readily understand:** Ibid.

119 **Do you think he shows . . . globs of color:** Camfield, *Francis Picabia*, 49.

119 **were about the cleanest:** Ibid., 56.

120 **Marcel Duchamp has arrived:** "Marcel Duchamp Visits New York," *Vanity Fair* 5: 1 (September 1915), 57.

120 **I tried to make a painting . . . call it a portrait:** "Francis Picabia and His Puzzling Art," *Vanity Fair* 5: 3 (November 1915), 42.

120 **Almost immediately upon coming:** Camfield, *Francis Picabia*, 77.

121 **Yes, but . . . No, because:** Michel Sanouillet and Elmer Peterson, eds., *Salt Seller: The Writings of Marcel Duchamp* (New York: Oxford University Press, 1973), 167.

121 **A dangerous and enticing:** Francis Picabia, *I Am a Beautiful Monster: Poetry, Prose and Provocation*, tr. Marc Lowenthal (Cambridge, MA: MIT Press, 2007), 48.

121 **Apollinaire often took part:** Robert Motherwell, ed., *Dada Painters and Poets*, 2nd ed. (Cambridge, MA: Harvard University Press, 1989), 257.

121 **Duchamp later called Picabia:** Watson, *Strange Bedfellows*, 48.

121 **mania for change . . . what Picabia did all his life:** Pierre Cabanne, *Dialogues with Marcel Duchamp*, tr. Ron Padgett (New York: Viking Press, 1971), 37.

122 **It was a real turning point . . . groups after that:** Calvin Tomkins, *Duchamp: A Biography* (New York: Holt, 1996), 83.

122 **Everyone for himself:** Ibid., 85.

122 **even now I find it really astonishing:** Ibid., 111–112.

122 **We immediately fell for each other:** Source untraced, but widely cited on the Internet.

122 **Eroticism was a theme:** Cabanne, *Dialogues with Marcel Duchamp*, 88.

124 **Having been lucky:** Ibid., 15.

124 **enormously lazy:** Ibid., 72.

124 **society painter:** Tomkins, *Duchamp*, 142.

124 **missionary of insolence:** Cabanne, *Dialogues with Marcel Duchamp*, 49.

125 **I'm making it a 'readymade' . . . nothing to do with it:** Ibid., 157.

125 **like sparrows:** Wallace Stevens, *Letters of Wallace Stevens*, ed. Holly Stevens (New York: Knopf, 1966), 185.

125 **Do you?:** William Carlos Williams, *The Autobiography of William Carlos Williams* (New York: New Directions, 1967), 137.

127 **to a point where it demands:** Ezra Pound, "Paris Letter," *The Dial* 74: 3 (March 1923), 275.

127 **There was no such thing:** Arturo Schwarz, *Man Ray: The Rigor of Imagination* (London: Thames and Hudson, 1977), 51–52.

128 **Dada cannot live in New York:** Irene Gammel, *Baroness Elsa: Gender, Dada, and Everyday Modernity* (Cambridge, MA: MIT Press, 2002), 290.

128 **in America everything is DADA:** Richard Huelsenbeck, ed., *Dada Almanac* (London: Atlas, 1993), 106.

128 **young Americans . . . Dadaists look timid:** Edmund Wilson, "The Aesthetic Upheaval in France," *Vanity Fair* (February 1922), 49, 100.

128 **search for fresh booty . . . being Americanized:** Matthew Josephson, "After and Beyond Dada," *Broom* 2 (1922), 347.

129 **Pig Cupid:** Mina Loy, *The Lost Lunar Baedeker: Poems*, ed. Roger L. Conover (New York: Farrar, Straus, Giroux, 1996), 53.

130 **Whether Mr. Mutt:** "The Richard Mutt Case," *The Blind Man* 2 (May 1917), unpaginated.

131 **all the ideas expressed . . . milk in the mouth:** Jean-Jacques Lecercle, *The Violence of Language* (London: Routledge, 1990), 61.

131 **sexual force alone:** Michel Pierssens, *The Power of Babel: A Study of Logophilia*, tr. Carl Lovitt (London: Routledge, 1980), 94.

131 **all words were suckled:** Pierssens, *Power of Babel*, 97.

131 **The pronoun *I*:** Ibid., 94.

131 **forget with my hand:** Tomkins, *Duchamp*, 127.

131 **Thought is made in the mouth:** Motherwell, *Dada Painters and Poets*, 87.

131 **For some there is no stopping:** Charles Demuth, "For Richard Mutt," *The Blind Man* 2 (May 1917), 6.

132 **Thus each bit of work:** Alfred Stieglitz, letter to the editor, *The Blind Man* 2 (May 1917), 15.

132 **If you can help to stimulate:** Frank Crowninshield, "From a Friend," *The Blind Man* 2 (May 1917), 10.

132 **terrorized by the power of plumbing:** Jane Heap, "Independents, Etc.," *The Little Review* 9: 2 (Winter 1922), 22.

132 **Marcel, Marcel, I love you:** Gammel, *Baroness Elsa*, 173.

133 **thou becamest like glass . . . in a mirror!:** Elsa von Freytag-Loringhoven, "Love–Chemical Relationship," *The Little Review* 5: 2 (June 1918), 58.

133 **proud engineer . . . it is why I eat!:** Elsa von Freytag-Loringhoven, "The Modest Woman," *The Little Review* 7: 2 (July 1920), 38.

133 **my ecstasies in toilet:** Ibid., 37.

133 **an ancient human notebook . . . effect of feathers:** Djuna Barnes, "How the Villagers Amuse Themselves," *New York Morning Telegraph Sunday Magazine* (November 26, 1916), Section Two.

134 **royal gesture . . . dyed vermilion:** Gammel, *Baroness Elsa*, 201–202.

134 **courageous to an insane degree:** Ibid., 273.

134 **the first American Dada . . . contribution to nonsense:** Jane Heap, "Dada—," *The Little Review* 8: 2 (Spring 1922), 46.

134 **dada cannot live in New York:** Gammel, *Baroness Elsa*, 290.

135 **Dada belongs to everybody . . . of free facets:** Tristan Tzara, "Eye-Cover, Art-Cover, Corset-Cover, Authorization," *New York Dada* (1921), unpaginated [3].

137 **pioneer of nonsense:** Winthrop Sargeant, "Dada's Daddy," *Life* (April 28, 1952), 100.

CHAPTER SEVEN: LAST LOOSENING

140 **Picabia could not live . . . 'Come down':** William Camfield, *Francis Picabia: His Art, Life, and Times* (Princeton University Press, 1979), 101–102.

140 **the woodwinds of the Jazz-Bands:** Juliette Roche, *Demi-Cercle* (Paris: La Cible, 1920), unpaginated.

140 **At best her life . . . human denominator:** Agnes Ernst Meyer, "Mental Reactions," 291 2 (April 1915), unpaginated [3].

141 **Of all those who have come . . . obtained results:** Marius de Zayas, untitled, 291 5–6 (July–August 1915), unpaginated [6].

141 **the most truthful:** Francis Picabia, untitled, 291 12 (February 1916), unpaginated [3].

142 **391 is not as well done . . . nothing, nothing, nothing:** Camfield, *Francis Picabia*, 93.

142 **only use symbols drawn:** Dawn Ades, ed., *The Dada Reader* (London: Tate, 2006), 110.

142 **Picasso repents . . . modern forms:** "Odeurs de Partout," 391 1 (January 25, 1917), unpaginated [4].

143 **freeloading angel:** Francis Picabia, *I Am a Beautiful Monster: Poetry, Prose and Provocation,* tr. Marc Lowenthal (Cambridge, MA: MIT Press, 2007), 42.

143 **my indecent gibberish:** Ibid.

143 **I have but one tongue:** Ibid., 40.

143 **I want my life for myself:** Ibid., 47.

143 **one must be many things:** Ibid., 49.

143 **I demand the ravishing:** Ibid., 45.

143 **Won't I go:** Ibid., 38.

143 **Near the table:** Ibid., 41.

144 **animal squeal:** Ibid., 44.

144 **Artists of speech:** Ibid., 26.

144 **Picabia's poetry:** Marcel Douxami, "Dear Sir," *Rongwrong* (May 1919), unpaginated.

144 **Dada Putting the Jazz:** Harriet Watts, ed., *Dada and the Press* (New Haven, CT: G. K. Hall, 2004), 395.

144 **Art must not scorn:** Hugo Ball, *Flight Out of Time: A Dada Diary*, ed. John Elderfield, tr. Ann Raimes (New York: Viking, 1974), 53.

145 **I pointed out . . . the fox trot:** T. S. Eliot, *The Letters of T. S. Eliot, Volume 1: 1898–1922*, ed. Valerie Eliot (London: Faber, 1988), 70.

145 **it is a jazz-banjorine:** Ibid., 357.

145 **Vorticist dances . . . the wide room:** William Wees, *Vorticism and the English Avant-Garde* (Toronto: University of Toronto Press, 1972), 49.

145 **Cubo-futurist?:** Alan Young, *Dada and After: Extremist Modernism and English Literature* (Manchester, UK: Manchester University Press, 1981), 49.

145 **jazz-dancing elephants:** Denise Taylor, "La Musique pour tout le monde: Jean Wiéner and the Dawn of French Jazz," PhD thesis, University of Michigan, Ann Arbor (1998), 24.

145 **They enjoy themselves:** Anton Kaes, Martin Jay, and Edward Dimendberg, eds., *The Weimar Republic Sourcebook* (Berkeley: University of California Press, 1994), 560.

145 **a six-piece band:** Hans Richter, *Dada: Art and Anti-Art*, tr. David Britt (New York: Abrams, 1965), 27.

146 **Like a Cubist painting . . . its discord:** F. W. Koebner, *Jazz und Shimmy: Brevier der neuesten Tänze* (Berlin: Eysler, 1921), 17.

146 **places of perpetual improvisation . . . aesthetic skepticism:** Timothy O. Benson and Éva Forgács, eds., *Between Worlds: A Sourcebook of Central European Avant-Gardes 1910–1930* (Cambridge, MA: MIT Press, 2002), 581.

146 **vast snobbery . . . serious, 'greater art':** Gilbert Seldes, *The 7 Lively Arts* (New York: Harper, 1924), 311.

146 **our independence, our carelessness:** Ibid., 95.

146 **became part of a motley . . . jazz and alcohol:** Robert Motherwell, ed., *Dada Painters and Poets*, 2nd ed. (Cambridge, MA: Harvard University Press, 1989), 258.

147 **Isadora hid me here:** Maria Lluïsa Borràs, *Picabia* (New York: Rizzoli, 1985), 177.

147 **I feel nothing but disgust:** Motherwell, *Dada Painters and Poets*, 7.

147 **Metzinger, a failure:** Ibid., 9.

147 **A bit of good advice:** Ibid., 7.

147 **Genius is nothing but:** Ibid.

147 **Arthur Cravan is another:** "Odeurs de Partout," *391* 1 (January 25, 1917), unpaginated [4].

148 **What a wonderful lecture:** Motherwell, *Dada Painters and Poets*, 16.

149 **Picabia, with or without:** Borràs, *Picabia*, 197.

149 **propaganda for us:** Richter, *Dada*, 48.

150 **on modern art . . . shall remain secret:** Michel Sanouillet, *Dada in Paris*, rev. ed. by Anne Sanouillet, tr. Sharmila Ganguly (Cambridge, MA: MIT Press, 2009), 389.

150 **I live quite isolated:** Ibid., 386.

150 **May I call you my friend? :** Ibid., 389.

150 **Dear sir and friend:** Ibid., 390.

150 **different, cosmic blood . . . chaos and asceticism:** Ibid., 389.

150 **expresses every philosophy:** Ibid., 391.

150 **individual principle . . . in strong individuals:** Ibid.

151 **I've never passed up . . . to assassinate beauty:** Ibid., 392.

151 **just flew by:** Ibid., 394.

151 **Picabia's first appearance . . . a global war!:** Richter, *Dada*, 71.

151 **a radical belief:** Ibid., 72.

152 **I met Picabia only a few times:** Ibid., 74.

152 **the anti-painter:** Motherwell, *Dada Painters and Poets*, 239.

152 **Let us destroy let us be good:** Richard Huelsenbeck, ed., *Dada Almanac* (London: Atlas, 1993), 28.

152 **Dada means nothing:** Motherwell, *Dada Painters and Poets*, 239.

152 **We found him busy . . . gratuitous machines:** Jean Arp, *Arp on Arp: Poems, Essays, Memories*, tr. Joachim Neugroschel (New York: Viking, 1972), 260–261.

154 **a certain Mr. *Benjamin*:** Sanouillet, *Dada in Paris*, 396.

154 **His eyes are staring:** Walter Benjamin, *Illuminations: Essays and Reflections*, ed. Hannah Arendt, tr. Harry Zohn (New York: Shocken, 1969), 257–258.

154 **There is no document:** Ibid., 256.

155 **The work of art of the Dadaists:** Ibid., 238.

155 **the 'state of emergency':** Ibid., 257.

155 **an alarm clock:** Walter Benjamin, *The Arcades Project*, ed. Rolf Tiedemann, tr. Howard Eiland and Kevin McLaughlin (Cambridge, MA: Harvard University Press, 1999), 205.

155 **profane illumination:** Walter Benjamin, *Selected Writings, Volume 2: 1927–1934*, eds. Michael Jennings, Howard Eiland, and Gary Smith (Cambridge, MA: Harvard University Press, 1999), 209.

155 **exchange, to a man:** Benjamin, *Selected Writings*, 218.

155 **This is the first time . . . bore me before long:** Sanouillet, *Dada in Paris*, 401.

156 **elegant and malicious:** Motherwell, *Dada Painters and Poets*, 240.

157 **really clever lad:** Walter Serner, "Letzte Lockerung Manifest," *Dada* 4/5, German edition (May 1919), unpaginated.

157 **What Napoleon had to do:** Richter, *Dada*, 78.

157 **This is our curse:** Mary Ann Caws, ed., *Manifesto: A Century of Isms* (Lincoln: University of Nebraska Press, 2001), 321.

157 **Dada has succeeded:** Huelsenbeck, *Dada Almanac*, 33.

157 **a psychosis that explains wars:** *Dada* 4/5, German edition (May 1919), unpaginated.

157 **Sensational Duel . . . on his left thigh:** Karl Riha and Waltraud Wende-Hohenberger, eds., *Dada Zürich: Texte, Manifeste, Dokumente* (Stuttgart: Reclam, 1992), 122.

158 **To be dangerous:** Ades, *The Dada Reader*, 55.

158 **The ultimate disappointment?:** Ibid., 58.

158 **one becomes malicious:** Ibid., 60.

159 **in the destructive element:** Joseph Conrad, chapter 20 in *Lord Jim* (1900).

159 **destruction was my Beatrice . . . only by *elimination*:** Stéphane Mallarmé, *Selected Letters*, ed. and tr. Rosemary Lloyd (Chicago: University of Chicago Press, 1988), 77.

159 **destroying the usual effect:** Motherwell, *Dada Painters and Poets*, 105.

CHAPTER EIGHT: A NEED FOR COMPLICATIONS

162 **At the station:** Michel Sanouillet, *Dada in Paris*, rev. ed. by Anne Sanouillet, tr. Sharmila Ganguly (Cambridge, MA: MIT Press, 2009), 336.

162 **Of living poets . . . Are we friends?:** Ibid., 337.

162 **projected onto Tzara . . . never have disappointed:** André Breton, *The Lost Steps*, tr. Mark Polizzotti (Lincoln: University of Nebraska Press, 1996), 81.

162 **I like your attitude . . . bourgeois species:** Sanouillet, *Dada in Paris*, 344–345.

162 **It is only natural . . . need for complications:** Ibid., 349.

162 **I have too little energy:** Ibid., 347.

162 **I proposed the word . . . the 'Dada movement':** Ibid., 350.

163 **He is the most hateful . . . nothing but you:** Ibid., 357.

164 **You are one of the three:** Ibid., 423.

164 **you are truly the man:** Ibid., 425.

164 **Leave us alone:** Germaine Everling, *L'Anneau de Saturne* (Paris: Fayard, 1970), 96.

165 **Back to Zurich!:** Sanouillet, *Dada in Paris*, 105.

165 **Vivent les concubines:** *Dada* 6, Bulletin Dada (February 1920) unpaginated [1].

166 **Anti-dadaism is a disease:** Ibid., [2].

166 **Self-kleptomania:** Ibid.

166 **Workplace injuries:** Ibid.

166 **The International Dada Company:** *Der Dada* 3 (April 1920), unpaginated.

166 **avant-garde, free, public:** Marius Hentea, *The Real Life and Celestial Adventures of Tristan Tzara* (Cambridge, MA: MIT Press, 2014), 138.

166 **No more painters . . . nothing, nothing, nothing:** Louis Aragon, "Manifeste du mouvement Dada," *Littérature* 13 (May 1920), 1.

167 **I've long admired your talent:** Sanouillet, *Dada in Paris,* 70.

167 **work of destruction:** Robert Motherwell, ed., *Dada Painters and Poets,* 2nd ed. (Cambridge, MA: Harvard University Press, 1989), 81.

168 **I can't go on, I'll go on:** Samuel Beckett, *The Unnamable* (New York: Grove Press, 1958), 179.

168 **A man comes back to life:** *Littérature* 10 (December 1919), 11.

168 **a kind of surrealism:** Guillaume Apollinaire, *Apollinaire on Art: Essays and Reviews 1902–1918,* ed. LeRoy C. Breunig, tr. Susan Suleunan (New York: Viking, 1972), 452.

168 **Carry on, the wheel turns:** Dawn Ades, ed., *The Dada Reader* (London: Tate, 2006),193.

169 **heavy and excessively fleshy:** Richard McDougall, tr., *The Very Rich Hours of Adrienne Monnier* (New York: Scribner's, 1976), 89.

169 **You all stand accused . . . you're all chumps:** *DADAphone* 7 (March 1920), unpaginated [3].

169 **Listen to them . . . Dada lives!:** William Camfield, *Francis Picabia: His Art, Life, and Times* (Princeton University Press, 1979), 143.

169 **Chimney Sperm . . . while vomiting:** *391* 12 (March 1920), unpaginated.

170 **the order was drawn:** *Littérature* 13 (May 1920), 1.

170 **I am writing a manifesto . . . stupid as me:** Philippe Soupault, "Littérature et le reste," *Littérature* 13 (May 1920), 8, 7.

170 **it's possible that I'm dreaming . . . slogan in peacetime:** André Breton, "Patinage Dada," *Littérature* 13 (May 1920), 9–10.

170 **god-swatter:** Ades, *The Dada Reader,* 189.

170 **If you exterminate:** Georges Ribemont-Dessaignes, "Les plaisirs de Dada," *Littérature* 13 (May 1920), 11.

170 **Before I come down . . . we're warning you:** Ades, *The Dada Reader,* 192–193.

171 **the global representative . . . for six hours:** Walter Conrad Arensberg, "Dada est américaine," *Littérature* 13 (May 1920), 15.

171 **My friends are the ones:** Louis Aragon, "Révélations sensationnelles," *Littérature* 13 (May 1920), 21.

171 **Dada will survive:** Sanouillet, *Dada in Paris,* 144.

172 **The day the word Dada . . . as a group:** Ibid., 143.

172 **Dada, all that is shapeless:** Ibid., 145.

172 **Tzara Thoustra:** Maria Lluïsa Borràs, *Picabia* (New York: Rizzoli, 1985), 181.

172 **Tzar Tristan:** Hans Arp, "aus dem 'cacadou supérieur,'" *Die Schammade* (April 1920), unpaginated.

172 **sensitive and aggressive:** Hans Richter, *Encounters from Dada till Today*, tr. Christopher Middleton (Los Angeles: Los Angeles County Museum of Art, 2013), 6.

172 **Dada has been a purely personal:** Sanouillet, *Dada in Paris*, 277.

172 **merchants of dementia:** Mason Klein, *Alias Man Ray: The Art of Reinvention* (New York: Jewish Museum, 2009), 183.

173 **Dada Ltd . . . exploitation of vocabulary:** Sanouillet, *Dada in Paris*, 159.

173 **Subscribe to DADA:** Ibid., 160.

173 **An unprecedented act:** Ibid., 125–126.

173 **Picabia has a pair:** Borràs, *Picabia*, 205.

173 **You look at life:** Francis Picabia, *I Am a Beautiful Monster: Poetry, Prose and Provocation*, tr. Marc Lowenthal (Cambridge, MA: MIT Press, 2007), 250.

173 **Dear artists, fuck off:** Ibid., 240, translation modified.

174 **a lack of courage:** Motherwell, *Dada Painters and Poets*, 113.

174 **Dadaists Disappoint:** Hentea, *Real Life and Celestial Adventures of Tristan Tzara*, 148.

174 **They were serious:** Jindřich Toman, "Now You See It, Now You Don't: Dada in Czechoslovakia," *The Eastern Dada Orbit: Russia, Georgia, The Ukraine, Central Europe, and Japan*, eds. Gerald Janecek and Toshiharu Omuka (New York: G. K. Hall, 1998), 18.

174 **some scatological crudities:** J.-N. Faure-Biguet, "Dada, ou le Triomphe du Rien," *L'Echo de Paris* (May 27, 1920), 2.

175 **Tzara installed himself:** Hentea, *Real Life and Celestial Adventures of Tristan Tzara*, 159, footnote 27.

175 **I consider myself very likeable:** Tristan Tzara, *Seven Dada Manifestos and Lampisteries*, tr. Barbara Wright (London: Calder, 1977), 32.

176 **I prefer the poet:** Ibid., 33.

176 **We have always made mistakes:** Ibid., 34.

176 **Thought is made in the mouth:** Ibid., 35.

176 **Anti-dadaism is a disease:** Ibid., 38.

176 **working with all its might:** Ibid., 42.

176 **Take a newspaper:** Ibid., 39.

177 **with ceremonious gestures:** Stephen Walsh, *Stravinsky, A Creative Spring: Russia and France 1882–1934* (New York: Knopf, 1999), 309.

CHAPTER NINE: NOTHING, NOTHING, NOTHING

179 **The transient Dadaists:** Lucy Lippard, ed., *Dadas on Art* (Englewood Cliffs, NJ: Prentice-Hall, 1971), 164.

180 a scissors-painter: Jane Heap, "Comments," *The Little Review* 9: 4 (Autumn/ Winter 1923–1924), 40.

180 to transform into a drama: Lippard, *Dadas on Art*, 64,

181 It's raining on a skull: Michel Sanouillet, *Dada in Paris*, rev. ed. by Anne Sanouillet, tr. Sharmila Ganguly (Cambridge, MA: MIT Press, 2009), 182.

181 the swindling mysticism . . . present sustains Dada: Werner Spies, ed., *Max Ernst, Life and Work: An Autobiographical Collage* (Cologne: Dumont, 2005), 76–78.

182 Man Ray is the subtle chemist . . . that it exists: Georges Ribemont-Dessaignes, "Dada Painting or the Oil-Eye," *The Little Review* 9: 4 (Autumn/Winter 1923–1924), 11.

182 the matter-of-fact realist . . . its poetical backside: Hans Richter, *Encounters from Dada till Today*, tr. Christopher Middleton (Los Angeles: Los Angeles County Museum of Art, 2013), 56.

183 Monsieur Ray was born: Sanouillet, *Dada in Paris*, 218.

185 My interest is in demonstrating: Ibid., 153.

185 rather recall the catalogues: Motherwell, *Dada Painters and Poets*, 301.

186 Love, sensitivity, death . . . Which is to say, everything: Sanouillet, *Dada in Paris*, 193.

186 My words are not mine . . . commodities of conversation: Hentea, *Real Life and Celestial Adventures of Tristan Tzara*, 166, footnote 63.

186 I don't trust justice . . . a bunch of bastards: Sanouillet, *Dada in Paris*, 191.

187 adopted a bourgeois point of view: Robert Motherwell, ed., *Dada Painters and Poets*, 2nd ed. (Cambridge, MA: Harvard University Press, 1989), 119.

187 Modernism is of no interest . . . but a protest: Sanouillet, *Dada in Paris*, 236.

187 At this time the undersigned: Ibid., 240.

187 part of a more general movement: André Breton, *The Lost Steps*, tr. Mark Polizzotti (Lincoln: University of Nebraska Press, 1996), 113.

187 Yes, Tzara did walk . . . veritable coup d'état: Ibid., 123.

187 delivered us from the concept: Ibid., 88.

187 It would not be a bad idea: Ibid., 122.

187 omnipotence and tyranny: Ibid., 75.

187 Never let it be said: Ibid., 82.

188 that disquiet whose only flaw: Ibid., 104.

188 the man who provides: Ibid., 97.

188 This *Congress of Paris*: Sanouillet, *Dada in Paris*, 239.

188 to teach people how to mass-produce: Ibid., 239.

188 ministry of the mind: Ibid., 238.

188 encyclopedic liberty . . . secret of civilization: Guillaume Apollinaire, *Selected Writings*, tr. Roger Shattuck (New York: New Directions, 1971), 229, 235.

189 **Dada—it has become Parisian:** Dawn Ades, ed., *The Dada Reader* (London: Tate, 2006), 134.

189 **I was getting terribly bored:** Sanouillet, *Dada in Paris*, 195.

189 **I had the impression:** Ibid.

189 **I separated from Dada:** Francis Picabia, *I Am a Beautiful Monster: Poetry, Prose and Provocation*, tr. Marc Lowenthal (Cambridge, MA: MIT Press, 2007), 265.

189 **The painter makes a choice:** Sanouillet, *Dada in Paris*, 214.

190 **One thing opposes . . . find the explanation:** Picabia, *I Am a Beautiful Monster*, 207.

191 **Children are closer to:** Ibid., 208.

191 **DADA wants nothing:** Ibid., 200.

191 **Life has only one form:** Ibid., 213.

191 **I am for incineration:** Ibid., 276.

191 **I approve of all ideas:** Ibid., 262.

191 **You have to be a nomad:** Ibid., 263.

192 **My feet have started to think:** Jean Crotti, "Sous-Entendu," *Le Pilhaou-Thibaou* 391: 15 (July 1921), 3.

192 **To those talking . . . since all of you know:** Picabia, *I Am a Beautiful Monster*, 271.

192 **Can't you sense:** Ibid., 273.

192 **After a long convalescence:** Jean Cocteau, "La Guérison de Picabia," *Le Pilhaou-Thibaou* [391 15] (July 1921), 11.

194 **they move without losing sight:** Breton, *Lost Steps*, 114.

194 **hyper-Socratic destructivity:** Ezra Pound, "Paris Letter," *The Dial* 71: 4 (October 1921), 457.

194 **very clear exteriorization . . . moves stark naked:** Richard Sieburth, "Dada Pound," *South Atlantic Quarterly* 83: 1 (winter 1984), 50.

194 **a Sunday about 1921:** Ezra Pound, *Guide to Kulchur* (London: Faber, 1938), 84.

194 **intellectually dangerous . . . cage full of leopards:** Ezra Pound, *Jefferson and/or Mussolini* (London: Nott, 1935), 92.

194 **There was never a rubber button:** Ezra Pound, *Selected Prose 1909–1965*, ed. William Cookson (London: Faber, 1973), 429.

194 **an animal with claws:** Marianne Moore, *The Poems of Marianne Moore*, ed. Grace Schulman (New York: Penguin, 2003), 178.

195 **Your modesty is so great:** Picabia, *I Am a Beautiful Monster*, 283.

195 **quite simply Dada disguised:** Ades, *The Dada Reader*, 143.

195 **Our head is round:** Picabia, *I Am a Beautiful Monster*, 283.

196 **a thick-set bully:** Jane Heap, "Comments," *The Little Review* 9: 3 (Spring 1923), 28.

196 **Leave everything:** Breton, *Lost Steps*, 78–79.

CHAPTER TEN: A DOSTOYEVSKY DRAMA

198 **with the sweetness:** William Camfield, *Max Ernst: Dada and the Dawn of Surrealism* (Munich: Prestel, 1993), 40.

198 **What I first noticed . . . a superior irony:** Louise Straus-Ernst, *The First Wife's Tale: A Memoir by Louise Straus-Ernst*, tr. Marilyn Richter and Marietta Schmitz-Esser (New York: Midmarch Arts, 2004), 38.

199 **we were the leaders:** Camfield, *Max Ernst*, 48.

199 **I had the impression:** Ibid., 57.

199 **As a Dadaist he was:** Hans Richter, *Encounters from Dada till Today*, tr. Christopher Middleton (Los Angeles County Museum of Art, 2013), 48.

200 **Dada has nothing in common:** Camfield, *Max Ernst*, 58.

200 **methodical madness:** Ibid., 63.

201 **counterfeits of Dada . . . piss without ideologies:** John Russell, *Max Ernst: Life and Work* (New York: Abrams, 1967), 62.

201 **One day as Baader:** Vera Broido-Cohn, *The Twenties in Berlin* (London: Annely Juda Fine Art, 1978), 4.

201 **We have turned away . . . amuse the middle class:** Camfield, *Max Ernst*, 77.

201 **A mad gruesome war . . . make people howl:** Angelika Littlefield, *The Dada Period in Cologne* (Toronto: Art Gallery of Ontario, 1988), 22.

202 **You go through a door . . . are 'natural originals':** Camfield, *Max Ernst*, 71.

202 **We said quite plainly:** Ibid.

202 **I curse you:** Ibid., 74.

203 **important conference:** Ibid., 101.

203 **Please decide and telegraph me:** Ibid.

204 **Max Ernst is giving each Dada:** Ibid., 102.

204 **almost magical presence . . . frank, uninhibited authority:** Camfield, *Max Ernst*, 104.

204 **I declare that Tristan Tzara found:** *Dada Intirol au Grand Air der Sängerkrieg* (September 1921), unpaginated [4].

205 **A friend from New York:** Ibid., [1].

205 **naturally has a much insaner effect:** Camfield, *Max Ernst*, 105.

207 **This slippery, scintillating creature:** Ibid., 109.

207 **Eluard liked group sex . . . watched or joined in:** Tim McGirk, *Wicked Lady: Salvador Dalí's Muse* (London: Hutchinson, 1989), 32.

207 **While there were certain inconveniences:** Matthew Josephson, *Life Among the Surrealists* (New York: Holt, Rinehart and Winston, 1962), 119.

208 **You've got no idea what it's like:** Robert McNab, *Ghost Ships: A Surrealist Love Triangle* (New Haven, CT: Yale University Press, 2004), 44.

208 **carried himself with much aplomb:** Josephson, *Life Among the Surrealists*, 179.

208 **Of course we don't give a damn:** Ibid.

208 one of the most lovable: Ibid., 180.

208 I could never make love to a woman: Ibid., 181.

208 I never loved you as passionately: Straus-Ernst, *First Wife's Tale*, 45.

209 the drunkenness of Éluard . . . those of marble statues: Camfield, *Max Ernst*, 51.

209 The exterior of the house: McGirk, *Wicked Lady*, 35.

210 surpasses in horror: McNab, *Ghost Ships*, 52.

210 André's so sad: Ibid., 108.

210 gloomiest concerns . . . make sense of anything: Ibid., 109.

210 To simplify everything: Ibid.

210 You left without saying goodbye: Ibid., 106.

210 in reality each of the characters: Philippe Soupault, "Épitaphes," *Littérature* 14 (June 1920), 8.

210 24 March 1924. Dear Father: McNab, *Ghost Ships*, 53.

211 It's him, no doubt . . . holiday, that's all: Ibid., 117.

211 disappearing act . . . Oceania by steamer: Ibid.

212 Gala, my little Gala: Ibid., 227.

212 He dared what no one . . . not see Max again. EVER: Éluard, *Letters to Gala*, 4–5.

212 None of this is possible: Ibid., 201.

212 burning cigarette eyes: McNab, *Ghost Ships*, 105.

213 The impression of a predatory . . . respond to the invitation: Jimmy Ernst, *A Not-So-Still Life* (New York: St. Martin's, 1984), 152, 153.

213 It is the marvelous faculty: Russell, *Max Ernst*, 77.

213 The image is a pure creation: Pierre Reverdy, "L'Image," *Nord-Sud* 13 (March 1918), unpaginated [1].

214 who had just died: André Breton, *Manifestoes of Surrealism*, tr. Richard Seaver and Helen R. Lane (Ann Arbor: University of Michigan Press, 1969), 24.

214 Never let it be said: Breton, *Lost Steps*, 82.

CHAPTER ELEVEN: NEW LIFE

216 hospitals of anemic sounds: Umbro Apollonio, ed., *Futurist Manifestos* (New York: Viking, 1973), 75.

216 our hearing has already been educated: Ibid.

216 We enjoy creating mental orchestrations: Ibid., 85.

217 the formlessness and anarchy . . . vagueness of expression: Victor Margolin, *The Struggle for Utopia: Rodchenko, Lissitzky, Moholy-Nagy 1917–1946* (Chicago: University of Chicago Press, 1997), 76.

217 there is great destructive: Richard Huelsenbeck, ed., *Dada Almanac* (London: Atlas, 1993), 131.

217 **Dadaism was no ideological movement:** Dawn Ades, ed., *The Dada Reader* (London: Tate, 2006), 310.

217 **In principle no difference:** Huelsenbeck, *Dada Almanac*, 95.

219 **It's somehow strange . . . iron, glass and revolution:** V. Shklovsky, "The Monument to the Third International," *Tatlin*, ed. Larissa Zhadova (New York: Rizzoli, 1988), 170.

219 **new forms of life, already born:** Stephen Bann, ed., *The Tradition of Constructivism* (New York: Viking Press, 1974), 9.

220 **Space and time . . . the present day:** Ibid., 11.

221 **Constructivist life:** Selim Khan-Magomedov, *Rodchenko, The Complete Work*, ed. Vieri Quillici (Cambridge, MA: MIT Press, 1987), 291.

221 **a new material organism:** Christina Kiaer, *Imagine No Possessions: The Socialist Objects of Russian Constructivism* (Cambridge, MA: MIT Press, 2005), 13.

221 **It is time that art entered . . . squalid life of the rich:** Khan-Magomedov, *Rodchenko*, 291.

223 **missed out on a strong dose:** Timothy O. Benson and Éva Forgács, eds., *Between Worlds: A Sourcebook of Central European Avant-Gardes, 1910–1930* (Cambridge, MA: MIT Press, 2002), 369.

223 **the tragic scream:** Lee Congdon, *Exile and Social Thought: Hungarian Intellectuals in Germany and Austria 1919–1933* (Princeton, NJ: Princeton University Press, 1991), 161.

223 **a man named Kurt Schwitters:** Oliver A. I. Botar, *Technical Detours: The Early Moholy-Nagy Reconsidered* (New York: Art Gallery of The Graduate Center, City University of New York, 2006), 93.

224 **never wanted to be left out . . . race for 'originality':** Ibid., 142–143.

224 **Modern man . . . his inherited fetters:** Krisztina Passuth, *Moholy-Nagy* (New York: Thames and Hudson, 1985), 287.

225 **new kinetic realities:** László Moholy-Nagy, *Vision in Motion* (Chicago: Paul Theobald, 1947), 160.

225 **We are faced today:** Ibid., 13.

225 **man, hitherto merely receptive:** Passuth, *Moholy-Nagy*, 290.

225 **incessantly initiatory . . . of Cubism and Dadaism:** Ibid., 416.

226 **Just as a Dadaist journal:** Ibid., 388.

226 **jellyfish-like German:** El Lissitzky, *El Lissitzky: Life, Letters, Texts*, ed. Sophie Lissitzky-Küppers, tr. Helen Aldwinkle (New York: Thames and Hudson, 1968), 345.

226 **It takes discipline:** Sibyl Moholy-Nagy, *Moholy-Nagy: Experiment in Totality* (Cambridge, MA: MIT Press, 1969), 32.

226 **It is my gift to project . . . *life* as a painter:** Ibid., 12.

227 **Here are the most energetic:** Congdon, *Exile and Social Thought*, 161.

227 **Demolish so that you can build:** Ibid., 145.

227 **This tragic woman:** Éva Forgács, "Constructive Faith in Deconstruction: Dada in Hungarian Art," *The Eastern Dada Orbit: Russia, Georgia, The Ukraine, Central Europe, and Japan,* eds. Gerald Janecek and Toshiharu Omuka (New York: G. K. Hall, 1998), 72.

227 **destruction as a mode of analysis:** Benson and Forgács, *Between Worlds,* 455.

227 **free from the zigzag:** Congdon, *Exile and Social Thought,* 185.

227 **but the hysterical outbursts . . . pictures shrieked:** Ilya Ehrenburg, *Memoirs: 1921–1941,* tr. Tatania Shebunina (New York: Grosset & Dunlap, 1966), 11, 12.

228 **nothing of building:** Congdon, *Exile and Social Thought,* 153.

228 **We were brought up:** Lissitzky, *El Lissitzky: Life, Letters, Texts.* 330.

228 **we need the machine . . . free from romanticism:** Passuth, *Moholy-Nagy,* 287.

228 **The collectivity of a picture . . . gramophone record:** Ibid., 418.

229 **barnlike studio . . . weak table wine:** Matthew Josephson, "After and Beyond Dada," *Broom* 2 (1922), 211.

229 **In ordinary life:** Ehrenburg, *Memoirs,* 23.

231 **to an airman's sensation . . . figments of the imagination:** Lissitzky, *El Lissitzky: Life, Letters, Texts,* 380–381.

231 **The surface of the Proun:** Ibid., 347.

231 **rising on the ground:** Ibid.

231 **When I made my Proun:** Ibid., 348.

231 **We no longer want:** Ibid., 365.

231 **we are destroying:** Ibid.

232 **The great international:** Ibid., 366.

232 **Our painting will be applied:** Ehrenburg, *Memoirs,* 34–35.

232 **No one should imagine:** Bann, *The Tradition of Constructivism,* 56.

232 **We are unable to imagine . . . cannot be dispensed with:** Ibid.

233 **negative tactics . . . lie behind us:** Ibid., 55.

233 **I could never understand:** Louis Lozowick, *Survivor from a Dead Age: The Memoirs of Louis Lozowick,* ed. Virginia Marquardt (Washington, DC: Smithsonian Institute, 1997), 214.

233 **ready to explain his theories . . . than a rebel:** Ibid., 190–191.

234 **has been inspired . . . becomes one with it:** Hans Janssen and Michael White, *The Story of De Stijl: Mondrian to Van Doesburg* (New York: Abrams, 2011), 130.

234 **thought concentrator:** Ibid.

234 **Everything on the boulevard . . . is the boulevard:** Piet Mondrian, *The New Art—The New Life: The Collected Writings of Piet Mondrian,* ed. and tr. Harry Holtzman and Martin S. James (Boston: G. K. Hall, 1986), 126, 128.

235 **Your friend, Piet-Dada:** Janssen and White, *Story of De Stijl,* 132.

235 **it was nice to show *enthusiasm*:** Hubert F. van den Berg, *The Import of Nothing: How Dada Came, Saw, and Vanished in the Low Countries (1915–1929)* (New Haven, CT: G. K. Hall, 2002), 120.

235 **In maximum movement:** Janssen and White, *Story of De Stijl*, 50.

236 **destruction and reconstruction:** Ibid.

236 **Only those who perpetually destroy:** Ibid., 124.

236 **The Dadaist spirit . . . that are different:** Marc Dachy, "Life is an extraordinary invention: Doesburg the Dadaist," *Van Doesburg & the International Avant-Garde*, eds. Gladys Fabre and Doris Wintgens Hötte (London: Tate, 2009), 28.

237 **sick with the pépie:** Theo van Doesburg, *What is Dada??? And Other Dada Writings*, tr. Michael White (London: Atlas, 2006), 51.

237 **The criminals in Russia:** Lissitzky, *El Lissitzky: Life, Letters, Texts*, 35.

237 **the poison of the New Spirit:** Doris Hötte, "Van Doesburg Tackles the Continent: Passion, Drive and Calculation," *Van Doesburg & the International Avant-Garde*, eds. Gladys Fabre and Doris Hötte (London: Tate, 2009), 10.

239 **definiteness instead of indefiniteness:** Joost Baljeu, *Theo van Doesburg* (New York: Macmillan, 1974), 123.

239 **will towards a new style:** Ibid.

239 **International of the Mind . . . to give. Gratuitously:** Baljeu, *Theo van Doesburg* 114.

239 **petty trading . . . rubber stamp membership:** Rose-Carol Washton Long, ed., *German Expressionism: Documents from the End of the Wilhelmine Empire to the Rise of National Socialism* (New York: G. K. Hall, 1993), 220–221.

240 **Everything trembles . . . Great Spiritual has begun:** Wassily Kandinksy, *Kandinsky: Complete Writings on Art* (New York: Da Capo, 1994), 479.

241 **In the end . . . organization held its own:** Maria Müller, "Der Kongress der 'Union Internationaler Forschrittlicher Künstler' Düsseldorf," *Konstruktivistische Internationale Schöpferische Arbeitsgemeinschaft 1922–1927: Utopien für eine Europäische Kultur* (Düsseldorf: Kunstsammlung Nordrhein-Westfalen, 1992), 21.

241 **the tyranny of the subjective . . . does not yet exist:** Bann, *The Tradition of Constructivism*, 68–69.

242 **subjective arbitrariness:** Ibid., 64.

242 **only by a society that renounces:** Ibid., 67.

242 **those who minister . . . call themselves progressive artists:** Ibid., 63.

243 **splintering . . . against everything and everyone:** Michael White, "Theo van Doesburg: A Counter-life," *Van Doesburg & the International Avant-Garde*, 71.

243 **I'm pretty sure he'll accept . . . ever more followers:** Dachy, "Life is an extraordinary invention," 31.

243 **The World is a little Sperm Machine:** van Doesburg, *What is Dada???*, 47.

243 **Dada is the cork . . . Dada's walking-stick:** Ibid., 45.

244 **Art is a urinal:** Ibid., 39.

244 **we neovitalist Dadaists:** Ibid., 35.

244 ***sentimental deformations:*** Ibid., 56.

244 **The abnormal is the prerequisite:** Ibid., 55.

244 **The principle of life . . . there is annihilation:** Ibid., 58.

244 **No is the strongest:** Ibid., 61.

CHAPTER TWELVE: YES NO

245 **First to tender his resignation:** Robert Motherwell, ed., *Dada Painters and Poets*, 2nd ed. (Cambridge, MA: Harvard University Press, 1989), 246.

246 **You explain to me:** Ibid., 247.

246 **What we want now:** Ibid., 248.

246 **Dada reduces everything:** Ibid.

246 **Dada is not at all modern:** Ibid., 247.

246 **Dada is a state of mind:** Ibid., 251.

246 **un microbe vierge:** Tristan Tzara, *Oeuvres Complètes*, vol. 1 (Paris: Flammarion, 1975), 385.

247 **After the carnage:** Richard Huelsenbeck, ed., *Dada Almanac* (London: Atlas, 1993), 123.

247 **Doesburg, a powerful personality:** Lucy Lippard, ed., *Dadas on Art* (Englewood Cliffs, NJ: Prentice-Hall, 1971), 111.

247 **Modern clothing . . . electric atmosphere:** Hans Janssen and Michael White, *The Story of De Stijl: Mondrian to Van Doesburg* (New York: Abrams, 2011), 148.

249 **I have never seen:** Gwendolen Webster, *Kurt Merz Schwitters: A Biographical Study* (Cardiff, UK: University of Wales Press, 1997), 123.

249 **He started to recite . . . 'babbling-brook' poetry:** Harriet Janis and Rudi Blesh, *Collage: Personalities, Concepts, Techniques* (Philadelphia: Chilton, 1967), 66.

250 **You must prepare the Dadaists:** Theo van Doesburg, *What is Dada??? And Other Dada Writings*, tr. Michael White (London: Atlas, 2006), 14.

250 **compatible with that which:** Hubert F. van den Berg, *The Import of Nothing: How Dada Came, Saw, and Vanished in the Low Countries (1915–1929)* (New Haven, CT: G. K. Hall, 2002), 30.

250 **I became a Dadaist . . . destruction through *construction*:** Ibid., 30–31.

251 **the supreme pinnacle:** Ibid., 48.

252 **ultra-stylistic-dadaist-cubist poetry:** Ibid., 66.

252 **interpret this as Dadaist . . . find a label:** Ibid., 97, translation modified.

252 **'physioplastic' typography:** Ibid., 96.

252 **Dada-jazz revolution:** Ibid., 88.

252 **Cabaret Dada . . . exploitation of Dadaism is founded:** Paul van Ostaijen, *Patriotism, Inc.: And Other Tales*, tr. E. M. Beekman (Amherst: University of Massachusetts Press, 1971), 147.

253 **European exertion to become Negroes:** Ibid., 151.

253 **Dada Saves Europe:** Ibid., 159.

253 **young dandy . . . cry out in admiration:** Erwin Blumenfeld, *Eye to I: The Autobiography of a Photographer*, tr. Mike Mitchell and Brian Murdoch (London: Thames and Hudson, 1999), 127.

254 **frantic applause:** John Elderfield, *Kurt Schwitters* (New York: Thames and Hudson, 1985), 105.

254 **Imagine a poem:** Harriet Watts, ed., *Dada and the Press* (New Haven, CT: G. K. Hall, 2004), 477.

254 **the unmitigated cynicism:** Ibid., 458.

255 **the anational expression:** van Doesburg, *What is Dada???*, 30–31.

255 **for every 'yes':** Ibid., 34.

255 **In Utrecht they came:** Schwitters letter, November 14, 1946, Getty Research Center, Los Angeles.

256 **May I introduce us? . . . Dadaism in the audience:** Kurt Schwitters, "Dadaismus in Holland," *Merz* 1 (January 1921), 5.

257 **because Dadaism . . . their own stupidity:** Andrzej Turowski, "Dada Contexts in Poland," *Eastern Dada Orbit*, eds. Gerald Janecek and Toshiharu Omuka (New York: G. K. Hall, 1998), 118.

257 **will always reappear:** Ibid., 119.

257 **proof that further colonizing:** Ibid., 120.

257 **chronic diarrhea:** Ibid., 119.

257 **Dada is the essence:** van den Berg, *The Import of Nothing*, 158.

257 **Dada is the moral solemnity:** Ibid.

258 **One cannot set up a new building:** Ibid., 160.

258 **It's an obbligato!:** Webster, *Kurt Merz Schwitters*, 196.

258 **Experiments are being conducted:** Ades, *The Dada Reader*, 296.

259 **respectable and less respectable:** Huelsenbeck, *Memoirs of a Dada Drummer*, 66.

259 **I am building a composition:** Elderfield, *Kurt Schwitters*, 156.

259 **started by tying strings:** Ibid., 148.

261 **solemnly displayed:** Steinitz, *Kurt Schwitters*, 90.

261 **a kind of fecal smearing:** Elderfield, *Kurt Schwitters*, 162.

261 **like some jungle vegetation:** Ibid., 191.

261 **This is an age of abbreviations:** Schmalenbach, *Kurt Schwitters*, 130.

261 **His real aspiration:** Ibid., 139.

261 **Without parallel:** Ibid., 132.

262 **smash the frames . . . for technical difficulties:** Ulrich Conrads and Hans Sperlich, *Fantastic Architecture*, tr. Christiane and George Collins (London: Architectural Press, 1963), 137, 138.

263 **a strange, enrapturing feeling:** Elderfield, *Kurt Schwitters*, 154.

263 **an advertisement is only:** Schmalenbach, *Kurt Schwitters*, 56.

264 **the new book demands:** Lissitzky, *El Lissitzky: Life, Letters, Texts*, 359.

264 **In the battle for Truth and Beauty:** van den Berg, *The Import of Nothing*, 118.

264 **Every form is frozen:** Elderfield, *Kurt Schwitters*, 137.

265 **a downright good, kind fellow:** Lissitzky, *El Lissitzky: Life, Letters, Texts*, 38.

265 **unauthorized self-propaganda:** Margolin, *Struggle for Utopia*, 76, footnote 101.

265 **How is Kurtschen? :** Lissitzky, *El Lissitzky: Life, Letters, Texts*, 53.

266 **going marvelously now . . . because of Arp:** Ibid., 55.

266 **I'm getting worried:** Ibid., 57.

266 **I have transformed:** Kasimir Malevich, "From Cubism and Futurism to Suprematism: The New Painterly Realism," *Russian Art of the Avant-Garde: Theory and Criticism 1903–1934*, ed. and tr. John Bowlt (New York: Viking, 1976), 118.

267 **At the Bauhaus:** Selim Chan-Magomedow, *Von der Malerei zum Design: Russische konstruktivistische Kunst der Zwanziger Jahre* (Cologne: Galerie Gmurzynska, 1981), 39.

267 **The dadaïsm has assailed:** El Lissitzky and Hans Arp, *Die Kunstismen: 1914–1924* (Zurich: Eugen Rentsch, 1925), x.

268 **All that artist spits is art:** Ibid., xi.

268 **old rubbish from attics:** Schmalenbach, *Kurt Schwitters*, 96.

CHAPTER THIRTEEN: TRUTH OR MYTH?

270 **Dada's destructive work:** Timothy O. Benson and Éva Forgács, eds., *Between Worlds: A Sourcebook of Central European Avant-Gardes 1910–1930* (Cambridge, MA: MIT Press, 2002), 369.

270 **A young lady:** Dragan Kujundžić and Jasna Jovanov, "Yougo-Dada," *The Eastern Dada Orbit: Russia, Georgia, The Ukraine, Central Europe, and Japan*, eds. Gerald Janecek and Toshiharu Omuka (New York: G. K. Hall, 1998), 44.

271 **a dough pliable enough:** Ibid., 43.

271 **The Naked Man:** Dubravka Djurić and Miško Šuvaković, eds., *Impossible Histories: Historical Avant-gardes, Neo-avant-gardes, and Post-avant-gardes in Yugoslavia 1918–1991* (Cambridge, MA: MIT Press, 2003), 525.

271 **We need modern . . . *always INTERNATIONAL*:** Benson and Forgács, *Between Worlds*, 290.

271 ***One needs to be a barbarian:*** Ibid., 291.

271 **already a fashion . . . and a new art:** "Dada—Dadaizam," *Zenit* 2 (March 1921), 17.

271 SUICIDE: Louis Aragon, "Suicide," *Cannibale* (April 1920), 4.

272 Art is what the *nerves* express . . . seconds, not years: Benson and Forgács, *Between Worlds*, 348.

272 DADA is a term for getting happy . . . (why work?): Ibid., 350.

272 isn't merely a quiver: Ibid., 354.

272 panfuturist system: Myroslava Mudrak, *The New Generation and Artistic Modernism in the Ukraine* (Ann Arbor: UMI Research Press, 1986), 212.

272 tAbA: Dragan Aleksić, "Taba Ciklon II," *Ma* VIII: 8 (August 1922), 13.

273 The great master: *Dada-Jok* (May 1922), unpaginated.

274 modern and eccentric dancing: Kujundžić and Jovanov, "Yougo-Dada," 51.

274 Dadas are furniture movers . . . a new order: Jindřich Toman, "Now You See It, Now You Don't: Dada in Czechoslovakia," *The Eastern Dada Orbit: Russia, Georgia, The Ukraine, Central Europe, and Japan*, eds. Gerald Janecek and Toshiharu Omuka (New York: G. K. Hall, 1998), 28.

274 The modern spirit . . . folly to every wisdom: Ibid., 22.

274 Dada is only the foam: Ibid., 29.

275 Poetism in the praxis: Ibid., 30.

275 Aesthetics, formerly the Science: Ibid., 26.

275 Through Dadaism . . . drunken hottentot: Ibid., 27.

275 Cubism, expressionism . . . is onanism: Andrzej Turowski, "Dada Contexts in Poland," *Eastern Dada Orbit*, eds. Gerald Janecek and Toshiharu Omuka (New York: G. K. Hall, 1998), 110.

276 We are breaking off: Ibid., 113.

276 word-plasticity: Ibid., 110.

276 this throng of raging bacchantes: Anatol Stern, *Europa* (London: Gaberbocchus, 1962), unpaginated.

276 How can one outstrip: Turowski, "Dada Contexts in Poland," 340.

276 We have joined art to life . . . of the invasion: John Bowlt, ed., *Russian Art of the Avant-Garde: Theory and Criticism 1903–1934* (New York: Viking, 1976), 81.

278 Activist Manifesto for Young People: Stephen Bann, ed., *The Tradition of Constructivism* (New York: Viking Press, 1974), 20.

279 Already in 1914: Michael Impey, "Before and After Tzara: Romanian Contributions to Dada," *Eastern Dada Orbit*, eds. Gerald Janecek and Toshiharu Omuka (New York: G. K. Hall, 1998), 129.

279 Indifference is the sole legal: Tristan Tzara, *Oeuvres Complètes*, vol. 5 (Paris: Flammarion, 1982), 249.

279 not a person . . . gaining power thereby: *Der Sturm* 144/145 (January 1913), 1.

281 When I've finished a cigarette: Francis Picabia, *391* 17 (June 1924), unpaginated [4].

282 Death is the one credible condition: Hugo Ball, *Flight Out of Time: A Dada Diary*, ed. John Elderfield, tr. Ann Raimes (New York: Viking, 1974), 198.

282 **One must be astonished:** Ibid., 196.

282 **magic treasure . . . real collectivity:** Lucy Lippard, ed., *Dadas on Art* (Englewood Cliffs, NJ: Prentice-Hall, 1971), 34.

282 **The stars write:** Jean Arp, *Arp on Arp: Poems, Essays, Memories*, tr. Joachim Neugroschel (New York: Viking, 1972), 287.

283 **Arp left our group:** Aline Vidal, "Arp and the Abstraction-Création Group: An Interview with Jean Hélion," *Arp 1886–1966* (Minneapolis: Minneapolis Institute of Arts, 1987), 173.

283 **Sometimes we learn:** Arp, *Arp on Arp*, 293.

283 **surely those who had the good fortune:** Carola Giedion-Welcker, *Jean Arp* (New York: Abrams, 1957), xxx.

283 **the lamp with which Aladdin:** Carolyn Lanchner, *Sophie Taeuber-Arp* (New York: Museum of Modern Art, 1981), 13.

284 **I think I have spoken . . . solution to them:** Ibid., 18.

284 **toadstool trees:** Hans Janssen and Michael White, *The Story of De Stijl: Mondrian to Van Doesburg* (New York: Abrams, 2011), 214.

284 **The public is not ready:** Ibid., 216.

285 **Standing on the stage:** Marc Dachy, "Life is an extraordinary invention: Doesburg the Dadaist," *Van Doesburg & the International Avant-Garde*, eds. Gladys Fabre and Doris Wintgens Hötte (London: Tate, 2009), 34.

285 **to those painters of squares . . . or human form:** Alfred H. Barr Jr., *Cubism and Abstract Art* (New York: Museum of Modern Art, 1936), 18.

285 **infantile disorder:** Ibid., 16.

285 **a dangerous game:** Fernand Léger, *Functions of Painting*, tr. Alexandra Anderson (New York: Viking, 1973), 83.

286 **You painted the clarity:** Jean Arp, "Tu étais claire et calme," from *Jours effeuillés: Poèmes, essais, souvenirs 1920–1966*, 141, 185. Copyright © Paris: Editions Gallimard, 1966.

286 **You departed clear and calm:** Arp, *Jours effeuillés*, 188.

287 **a little bit of Merz:** Gwendolen Webster, *Kurt Merz Schwitters: A Biographical Study* (Cardiff, UK: University of Wales Press, 1997), 70.

287 **Put up the price:** Ibid., 107.

287 **In the meantime he had become:** Kurt Schwitters, *Lucky Hans and Other Merz Fairy Tales*, tr. Jack Zipes (Princeton, NJ: Princeton University Press, 2009), 85.

287 **guilty because he had refused:** Ibid., 99.

287 **He's a little too tall:** Ibid., 96.

287 **There's art, and also nations . . . for war:** Kurt Schwitters, *Manifeste und kritische Prosa*, ed. Friedhelm Lach (Munich: Deutscher Tachenbuch Verlag, 2005), 199.

288 **I'm Aryan—the great Aryan:** Sibyl Moholy-Nagy, *Moholy-Nagy: Experiment in Totality* (Cambridge, MA: MIT Press, 1969), 101.

289 **That was my best friend:** Schwitters letter, June 18, 1946, Getty Research Center, Los Angeles.

289 **In spite of these setbacks:** John Elderfield, *Kurt Schwitters* (New York: Thames and Hudson, 1985), 64.

289 **Love, MERZ:** Schwitters letter, June 18, 1946, Getty Research Center, Los Angeles.

289 **I think that you are like me:** Schwitters letter, July 24, 1946, Getty Research Center, Los Angeles.

289 **I am absolutely conform with you:** Hausmann letter, September 2, 1946, Getty Research Center, Los Angeles.

289 **A play with serious problems:** Schwitters letter, August 8, 1946, Getty Research Center, Los Angeles.

290 **an important member:** Schwitters letter, December 19, 1946, Getty Research Center, Los Angeles.

290 **I had no farthing . . . nailed in bed:** Hausmann letter, September 30, 1946 Getty Research Center, Los Angeles.

290 **I am 59. But I cannot run:** Schwitters letter, June 27, 1946, Getty Research Center, Los Angeles.

290 **I had to lie:** Schwitters letter, October 3, 1946, Getty Research Center, Los Angeles.

290 **I would like to see once USA:** Schwitters letter, Getty Research Center, Los Angeles.

290 **He needed constant encouragement:** Lucy Lippard, ed., *Dadas on Art* (Englewood Cliffs, NJ: Prentice-Hall, 1971), 75.

290 **I see in him . . . greatest tenderness:** Hans Richter, *Encounters from Dada till Today*, tr. Christopher Middleton (Los Angeles: Los Angeles County Museum of Art, 2013), 16.

291 **set up house with two women:** Ibid.

291 **disciplined:** Dawn Ades and Daniel F. Herman, eds., *Hannah Höch* (Munich: Prestel, 2014), 171.

292 **afflicted with sculpture-fever . . . our own mystery?:** Carola Giedion-Welcker, *Contemporary Sculpture: An Evolution in Volume and Space*, rev. ed. (New York: Wittenborn, 1960), 300.

293 **No one better than Max:** Russell, *Max Ernst*, 119.

293 **In May 1940 Max Ernst:** Ibid., 127.

294 **Some old friends . . . scrubbed, hygienic numeral:** Robert Motherwell, ed., *Dada Painters and Poets*, 2nd ed. (Cambridge, MA: Harvard University Press, 1989), xl.

295 **He is among those:** Tristan Tzara, "Kurt Schwitters," 2, Getty Research Center, Los Angeles.

297 **Dada was born . . . ill-gotten gains:** Motherwell, *Dada Painters and Poets*, 402–403.

297 **The misunderstanding from which:** Ibid., 398.

297 **had himself enthroned:** Ibid., 35.

297 **a brief explosion:** Ibid., 406.

297 **Previous Dada manifestoes . . . Cabaret Voltaire in Zurich:** Ibid., 401.

298 **only imbeciles:** Dawn Ades, ed., *The Dada Reader* (London: Tate, 2006), 68.

299 **It is pointless to employ:** Hans Richter, *Dada: Art and Anti-Art*, tr. David Britt (New York: Abrams, 1965), 209.

299 **From the beginning . . . become a myth:** Ibid., 10.

AFTERWORD: THE AFTERLIFE OF DADA

301 **They have satirized the holy church:** Ezra Pound, "The Island of Paris: A Letter," *The Dial* 69: 4 (October 1920), 407–408.

302 **jesters in the tragedy of Europe's destruction:** Harriet Watts, ed., *Dada and the Press* (New Haven, CT: G. K. Hall, 2004), 461.

302 **Joyce had taken some half million assorted words:** "Shantih, Shantih, Shantih: Has the Reader Any Rights Before the Bar of Literature?" *Time* (March 3, 1923), 12.

302 **so much waste paper:** Charles Powell, untitled, *Manchester Guardian* (October 31, 1923), 7.

302 **by virtue of its incoherence:** Conrad Aiken, "An Anatomy of Melancholy," *The New Republic* (February 7, 1932), in T. S. Eliot, *The Waste Land: Authoritative Text, Contexts, Criticism*, ed. Michael North (New York: Norton, 2001), 152.

303 **a language which existed:** John Ashbery, *Reported Sightings: Art Chronicles, 1957–1987* (New York: Knopf, 1989), 82.

304 **there is only adventure by the individual:** Charles Harrison and Paul Wood, eds., *Art in Theory 1900–2000* (Oxford: Blackwell, 2003), 630.

306 **I felt like he made it all just for me:** Mary Lynn Kotz, *Rauschenberg, Art and Life*, rev. ed. (New York: Abrams, 2004), 91.

306 **the most primitive relation:** Richard Huelsenbeck, ed., *Dada Almanac* (London: Atlas, 1993), 46.

307 **a valuable instrument of mass psychotherapy:** Dario Gamboni, "Sixty Years of Ambivalence," *Damage Control: Art and Destruction Since 1950* (Munich: Prestel, 2013), 178.

307 **The only kind of intentional destruction:** "Yoko Ono Talk," *Damage Control: Art and Destruction Since 1950* (Munich: Prestel, 2013), 81.

309 **Let us be thoroughly new:** Hugo Ball, *Flight Out of Time: A Dada Diary*, ed. John Elderfield, tr. Ann Raimes (New York: Viking, 1974), 56.

BIBLIOGRAPHIC RESOURCES

Exquisite Dada: A Comprehensive Bibliography edited by Jörgen Schäfer (2005) runs to more than six hundred pages of fine print. This bibliography is the tenth and final volume of *Crisis and the Arts: The History of Dada* under the general editorship of Stephen C. Foster, inaugurated in 1996. The variable format of each volume makes it more useful to scholars than the general reader. The titles most useful for my account, often cited above, are *Dada Triumphs!* by Hanne Bergius and *The Import of Nothing* by Hubert van den Berg, along with *The Eastern Dada Orbit* edited by Gerald Janecek and Toshiharu Omuka and *Dada and the Press* edited by Harriet Watts.

The only history of Dada written for a general audience is *Dada et les dadaïsmes* by Marc Dachy (1994, expanded 2011). Dachy's massive, abundantly illustrated *Archives Dada/Chronique* (2005) is also very useful. Most Dada histories focus on a particular locale. Recommended in English: *Dada in Paris* by Michel Sanouillet (2009), *New York Dada 1915–23* by Francis M. Naumann (1994), and *Generation Dada: The Berlin Avant-Garde and the First World War* by Michael White (2013).

Biographies of leading Dadaists are plentiful and extensively cited in the preceding Notes. Translations of primary works vary in scope. Arp, Ball, Breton, Picabia, and van Doesburg are amply available in English, while Tzara and Schwitters are not so abundantly represented relative to the corpus of their writings. Little is available in translation by Hausmann, Baader, and Serner.

There are many catalogues of Dada exhibitions, but nothing can rival in scope and ingenuity the thousand-page *Dada* edited by Laurent Le Bon for the 2006 Centre Pompidou exhibit, arranged alphabetically in true Dada fashion so even the introduction doesn't appear until page 512 under the letter *I*.

The most convenient resource for English readers is *Dada* edited by Rudolf Kuenzli (2006), a richly illustrated portfolio with copious translations of original Dada writings. The most convenient compendium of translations remains Robert Motherwell's pioneering *Dada Painters and Poets* (1951), usefully supplemented by *Dadas on Art* edited by Lucy Lippard (1971), Richard Huelsenbeck's *Dada Almanac* (1993), and *The Dada*

Reader edited by Dawn Ades (2006), which consists solely of translations from Dada journals.

For Dada periodicals and books, an invaluable Internet resource is the International Dada Archive at the University of Iowa (www.lib.uiowa.edu/dada). Its "Digital Dada Library" includes high-resolution scans of more than thirty periodicals (mostly complete runs) and a hundred books. Of course, nearly all these documents are in languages other than English, but well worth looking at for their presentation. Another invaluable online repository is UbuWeb, an archive of visual and sound poetry, on which you can find recordings by many Dadaists as well as later renditions of Dada works.

INDEX

6/2015.